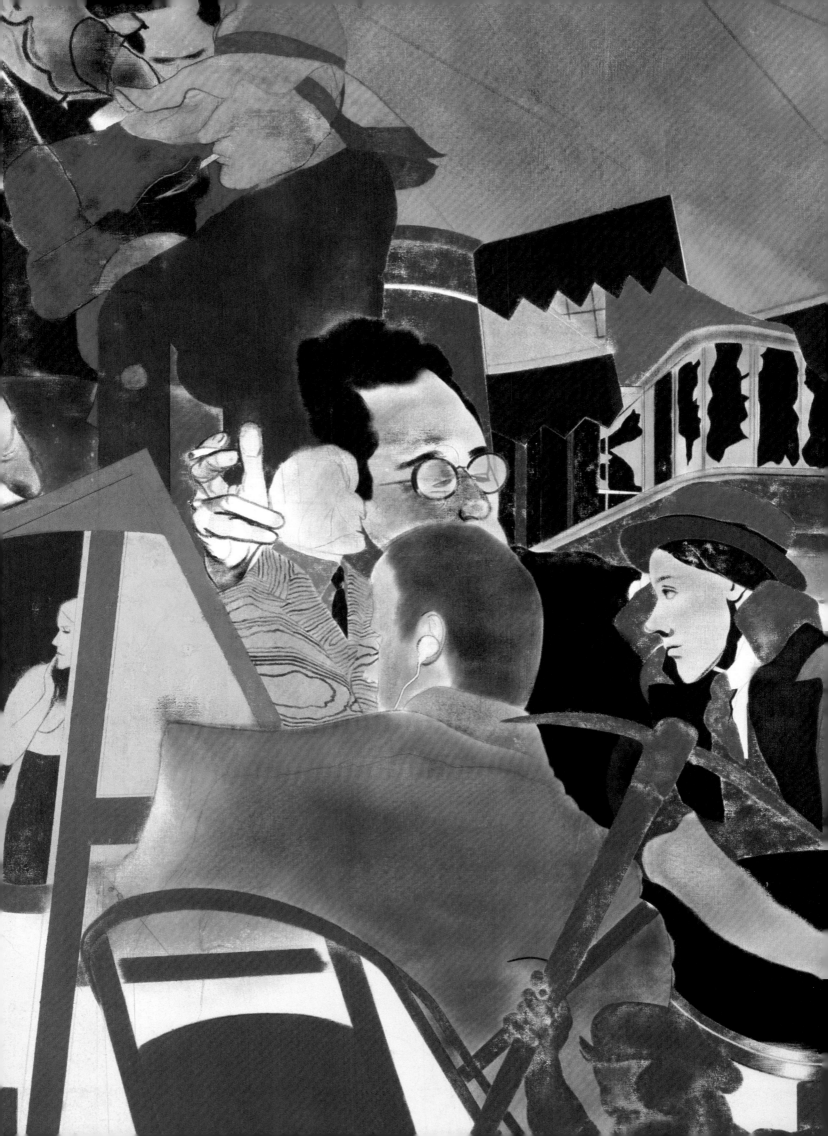

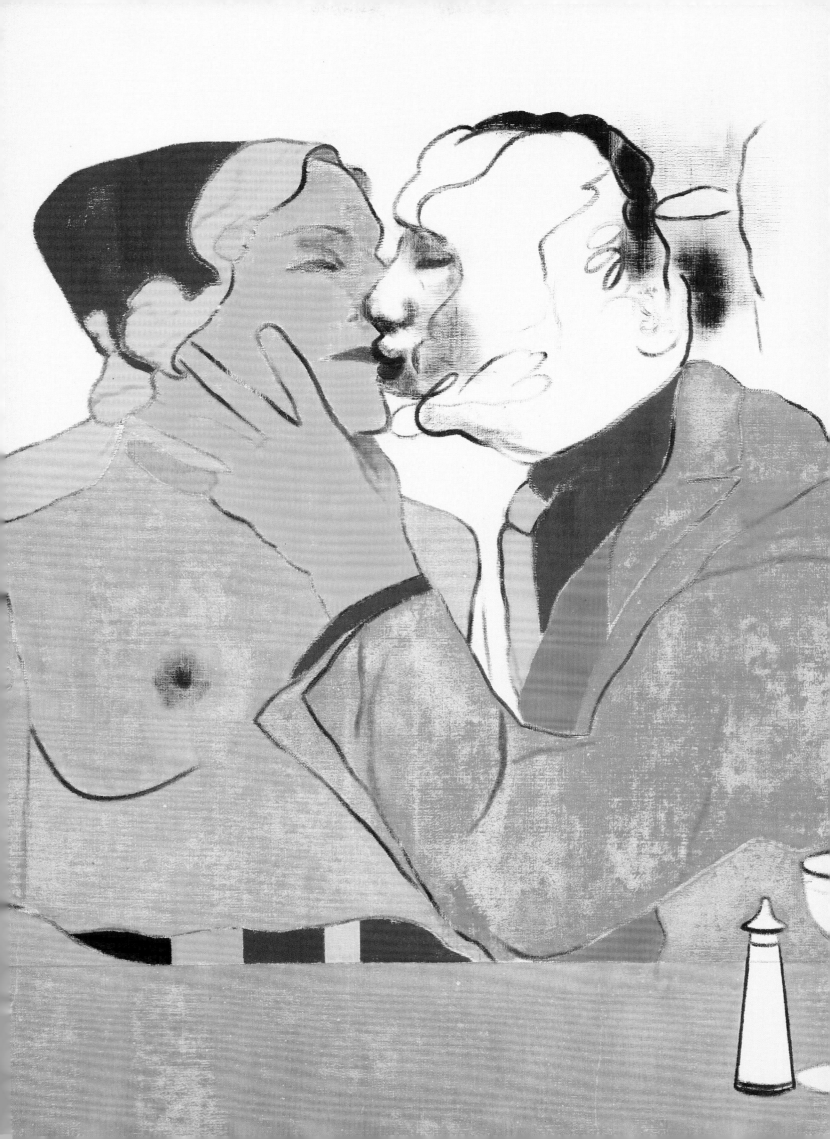

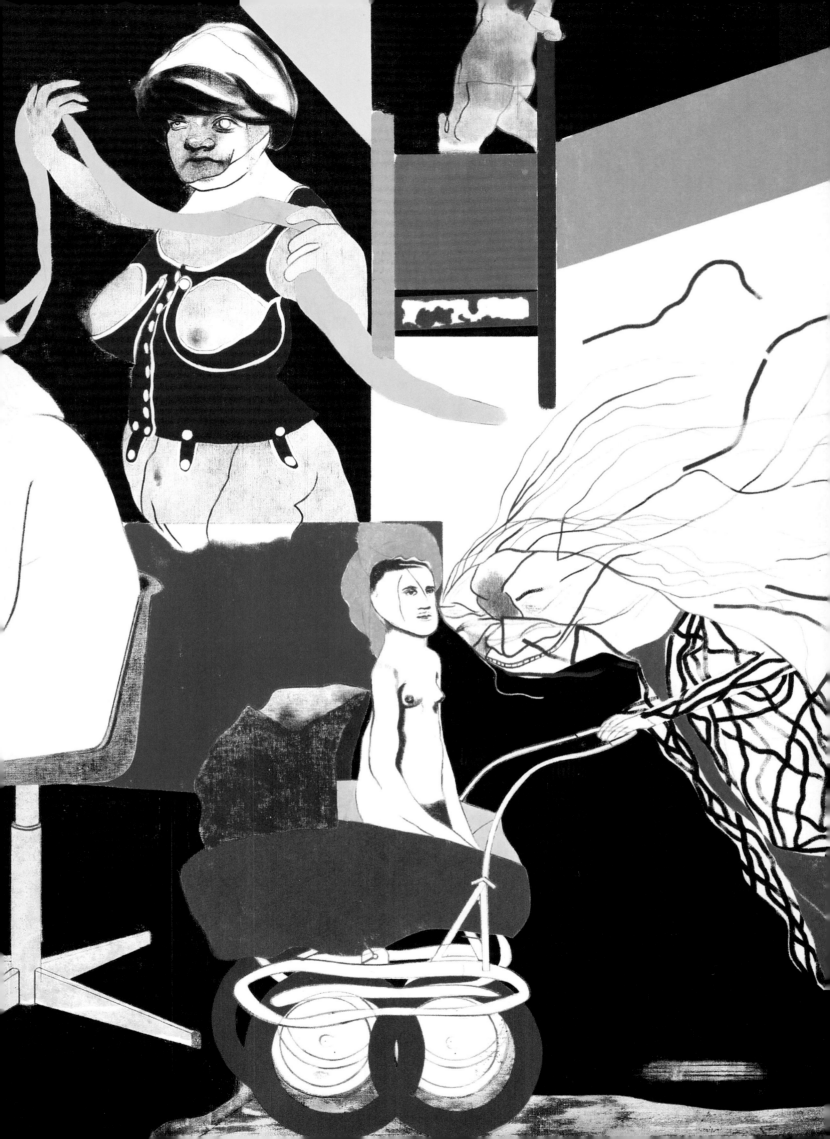

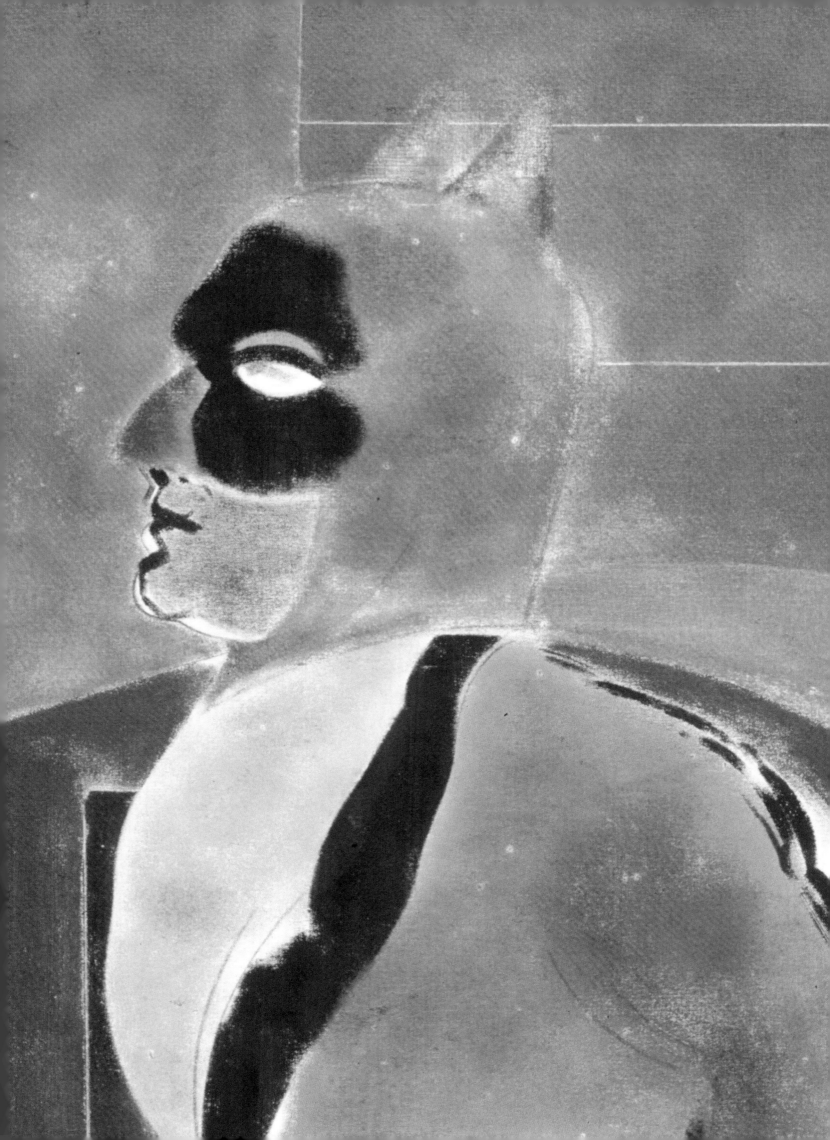

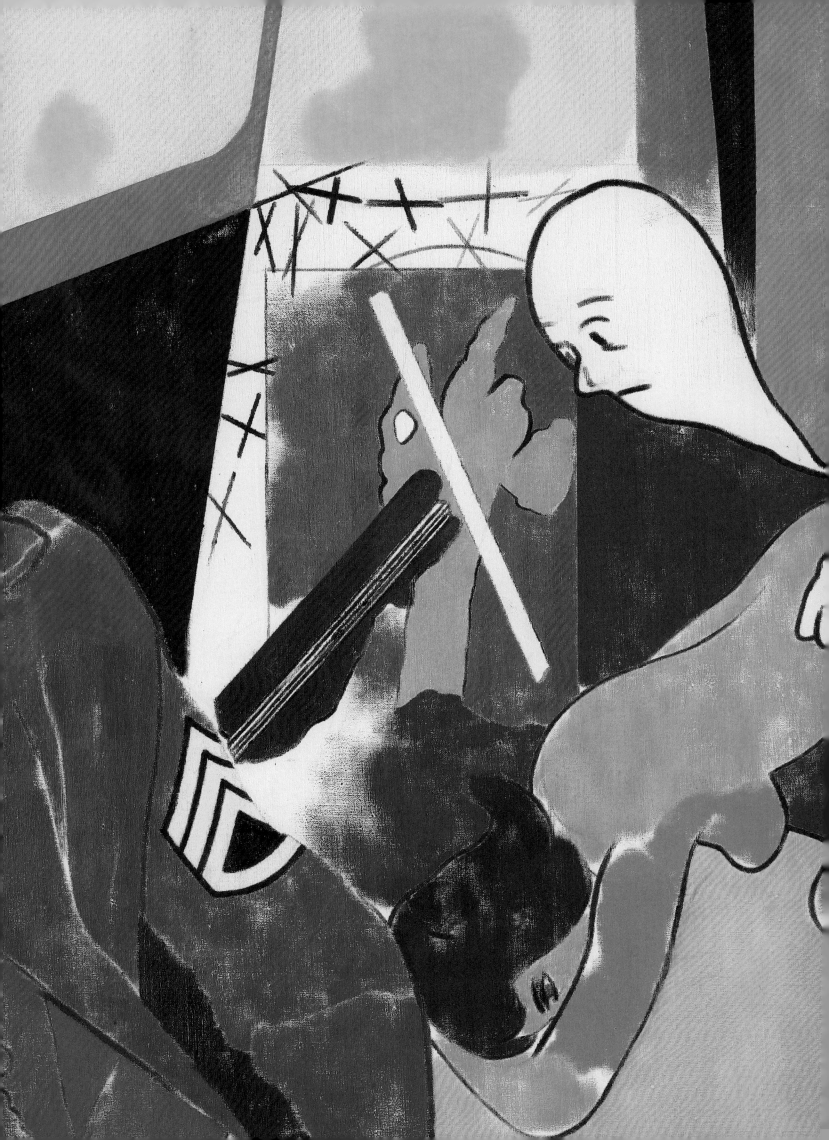

Cilly Kugelmann, Eckhart Gillen, Hubertus Gaßner

Obsessions
R. B. Kitaj
1932–2007

KERBER ART Jewish Museum Berlin

Contents

Acknowledgments

Thank you to everyone who loaned us exhibits:

Astrup Fearnley Collection
Oslo, Norway

Pallant House Gallery
Chichester, UK

Tate

Kaare Berntsen
Oslo, Norway

Birmingham Museums & Art Gallery

Charles E. Young Research Library, UCLA. Library Special Collections

Collection Albright-Knox Art Gallery
Buffalo, New York

Collection of Halvor Astrup

Collection of the Israel Museum
Jerusalem

Collection of Joseph Kitaj

Collection of R.B. Kitaj Estate

Collection of Michael Moritz & Harriet Heyman

Collection of David N. Myers and Nomi M. Stolzenberg.

Collection Tel Aviv Museum of Art

FORART–Institute for Research within International Contemporary Art

Friedlander Family Collection

Gemeentemuseum
Den Haag

Hamburger Kunsthalle

The Jewish Museum
New York

The Lem Kitaj Collection

Laing Art Gallery
Newcastle upon Tyne

Los Angeles County Museum of Art

Marlborough Fine Art
London

Museo de Bellas Artes de Bilbao

Museo Nacional Centro de Arte Reina Sofía
Madrid

Museo Thyssen-Bornemisza
Madrid

Museum Boijmans Van Beuningen
Rotterdam

The Museum of Modern Art
New York

National Portrait Gallery
London

Royal College of Art Collection

Sammlung Ludwig
Koblenz

Scottish National Gallery of Modern Art
Edinburgh

Stedelijk Museum
Amsterdam

Stiftung Museum Kunstpalast
Düsseldorf

UBS Art Collection

Walker Art Gallery
Liverpool

Leon Wieseltier

and all those who do not wish to be named who have made the exhibition possible.

Foreword

Cilly Kugelmann
Hubertus Gaßner

R. B. Kitaj is one of the most interesting and significant artists of the twentieth century who, both in life and art, occupied the uncomfortable position of being caught in the middle. Driven by an unwavering interest in the conditions of "Jewishness" throughout his entire life he sought to explore this against the background of anti-Semitism and tolerance in the wider society. With similar passion he pondered on the concept of a Diasporist existence, both to lend meaning to his way of life as an artist and an intellectual, and to substantiate the theory and practice of a form of Jewish art. His relationship to women, eroticism and sexuality was emotionally difficult and characterized by all kinds of theoretical considerations, particularly regarding a passion for prostitutes and the topos of the brothel as a metaphor for the complexity of modern life in the fundamentally hostile city. Ultimately, tragic deaths overshadowed his life and these were reflected in his work in the form of symbols and references. His first wife, Elsi Roessler, took her own life in 1969, and his second wife Sandra Fisher died suddenly and unexpectedly in 1994 in the middle of a flood of negative reviews, which Kitaj regarded as a smear campaign by art critics against his retrospective at the Tate Gallery. Kitaj himself was found dead in Los Angeles in October 2007, a few days before his 75th birthday. Now, the Jewish Museum Berlin is dedicating the first retrospective in fourteen years to this multifaceted artist, whose works were celebrated and collected throughout Europe and the USA into the early twenty-first century. The distraught artist's withdrawal from the public eye in the final years of his life, motivated by illness, and despair over the death of his wife Sandra, have led to his unjustly falling into obscurity. The retrospective, which the Jewish Museum Berlin has entitled *Obsessions*, is the first for which it has been possible to draw on R. B. Kitaj's extensive personal archive and estate, and thus present a more objective picture of the artist's oeuvre independent of his quirks.

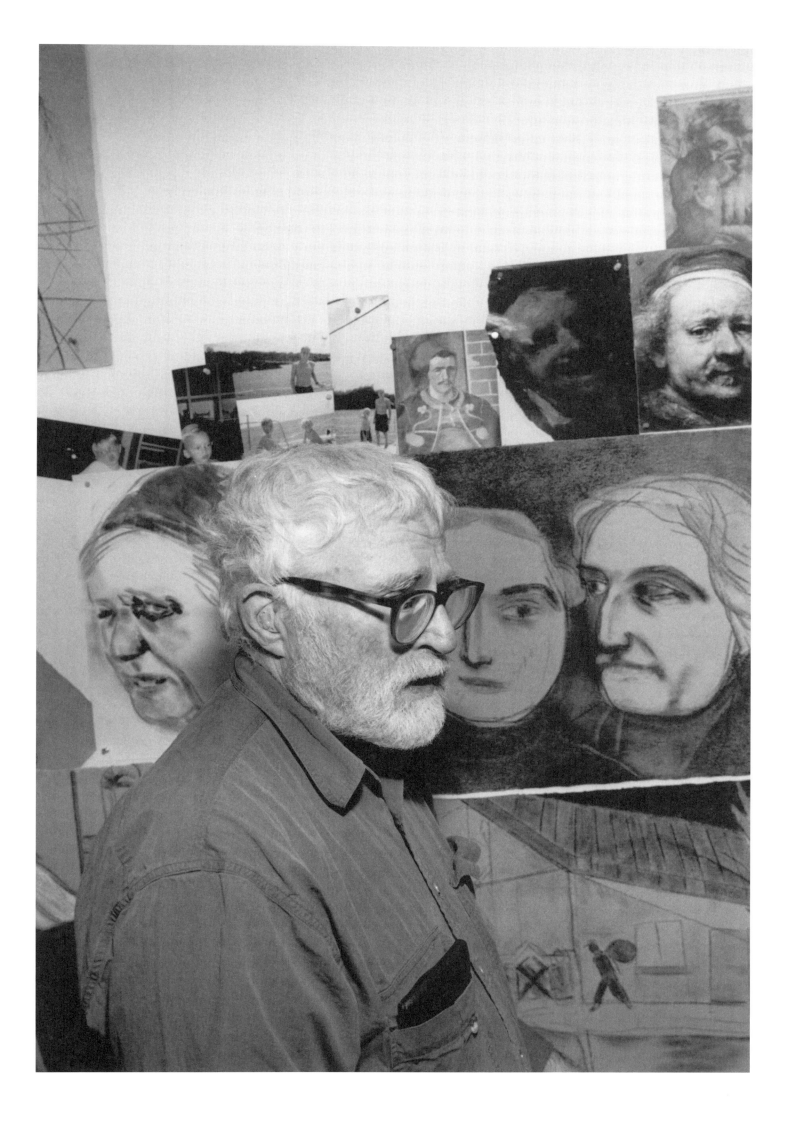

1
A Fragmented World

Homage to Herman Melville, 1960

Oil on canvas, 137 × 96 cm

"The Herman Melville painting was one of the earliest pictures I made at the College. Melville had been part of my youth and fired my resolve to leave art school in N.Y. and go to sea as an ordinary seaman, thus instigating an expatriate life at the age of 17 as a kind of double Diasporist."
• R.B. Kitaj, 1988

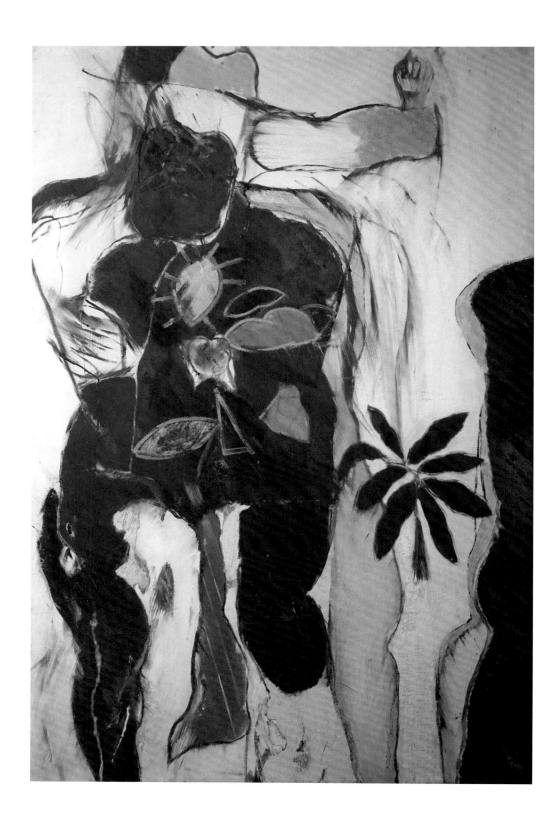

Erasmus Variations, 1958

Oil on canvas, 105 × 84 cm

"One of the first books I read in Oxford was Huizinga's *Erasmus* in the delicious little Phaidon Press series of classic gems Bela Horowitz used to publish along with his incomparable art books. The pretext form of my painting was a page of doodles Erasmus has drawn in the margins of a manuscript. They looked like the surrealist automatic art I had been digesting unquietly for years."
• R. B. Kitaj, 1994

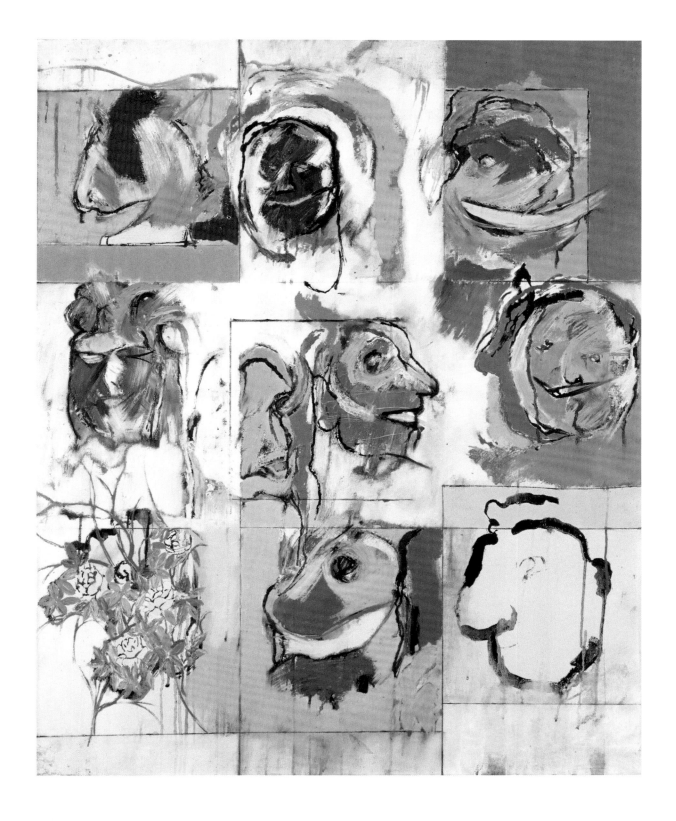

The Murder of Rosa Luxemburg, 1960

Oil and collage on canvas, 153 × 152 cm

"My Rosa painting ... was not as radical as she was, but radical enough for a student in an art college. The catalog is dedicated with a beautiful line by the Jewish philosopher Karl Popper: To the Open Society. Although Rosa was of course, a Communist, I never was. [...] It's just that Jewish cultural life with all its disasters, brilliance, learning, evasions and daring has conducted me and my art like an excited zombie or Golem stumbling into real trouble, like my Jews so often do." • R. B. Kitaj, ca. 2003

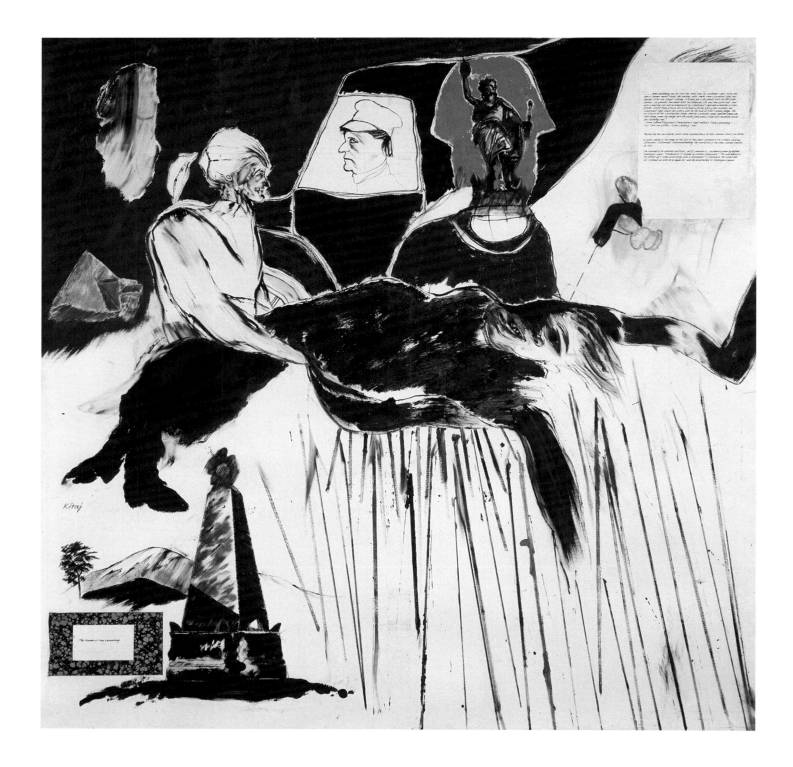

The Red Banquet, 1960
Oil on canvas, 122 × 122 cm

"In February 1854, Mr. Saunders, the American Consul, gave a banquet to a dozen of the principal foreign refugees in London. Among the guests were Alexander Herzen, Garibaldi, Mazzini, Orsini, Kossuth, Ledru-Rollin, Worcell, and other refugee leaders. The party was completed by the American Ambassador James Buchanan, a future President of the United States. Herzen is apostrophised on the left in this picture with the image of Michael Bakunin planted in his midsection… (Bakunin was not present but arrived in London late in 1861.) This 'Red Banquet' is described by E. H. Carr in his book *The Romantic Exiles* (Penguin, 1949)." • R. B. Kitaj, ca. 2003

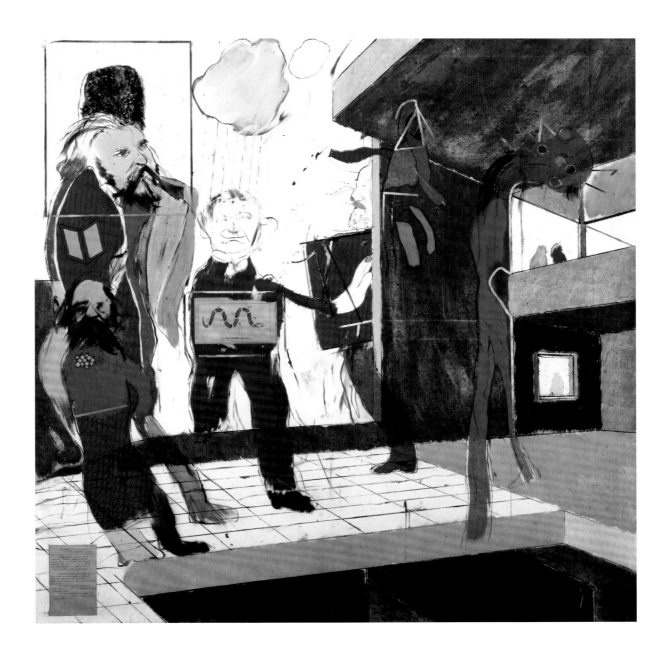

Portrait of Aby Warburg, 1958–62
Oil on canvas, 15 × 13 cm

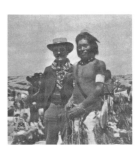

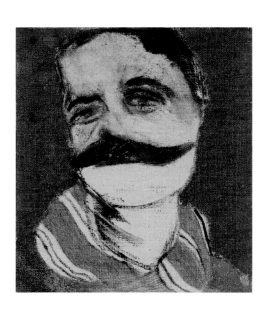

Warburg as Maenad, 1961|62

Oil and collage on canvas, 193 × 92 cm

"Warburg had foreseen the outcome of the war from the beginning, and throughout its course watched with growing anxiety every bad omen of political, moral and intellectual decline. In the autumn of 1910, when the world round him fell to pieces, he broke down. Just before and during the war he had been concerned with a historical period also filled with forebodings of catastrophes he had made a study of Luther's and Melanchthon's attitude towards astrology and portents through the imagery found in prognostications, calendars and the reformer's letters and lampoons." • Gertrude Bing, 1957

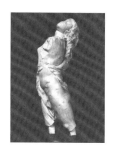

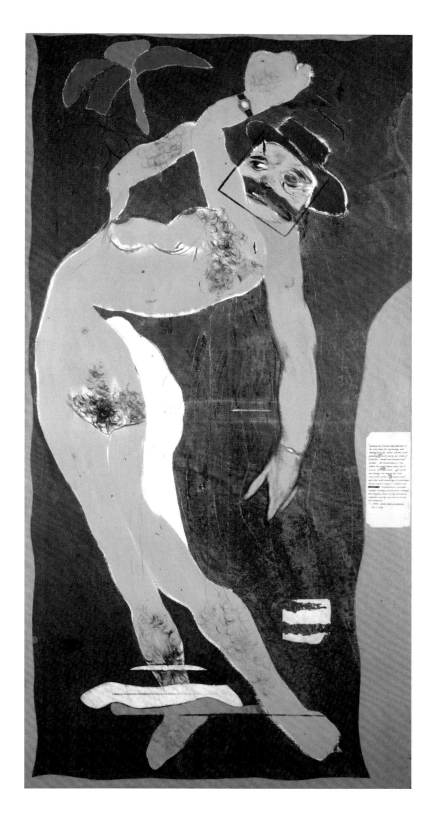

23

Reflections on Violence, 1962
Oil and collage on canvas, 152 × 153 cm

"When I arrived in London, one thing I did was to seek out Vorticism and its milieu at the Tate because I'd been reading Wyndham Lewis and his anti-liberal friends. Very soon they would bore me, but from that circle, it was T.E. Hulmes' translation of *Reflections on Violence* by Georges Sorel that caused this picture to happen. [...]

Isaiah Berlin, in his classic essay on Sorel... calls him an outsider of outsiders who prized only total independence and who still has the power to upset. Sounds like red meat for a hungry young painter for whom such books were as trees for a landscapist." • R. B. Kitaj, 1994

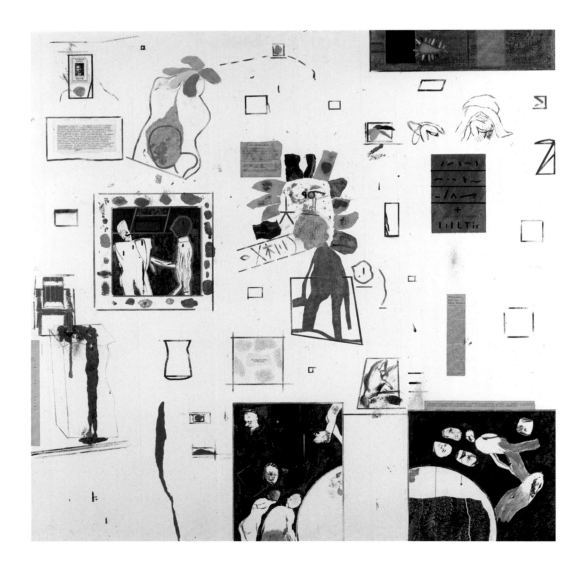

Specimen Musings of a Democrat, 1961

Collage, 102 × 128 cm

"This collage painting was suggested by the type of crazy chart by [Catalan mystic Ramon] Lull which had been treated with contempt by previous scholars as useless speculation, not unlike the way Cabbalism was treated until our own time. Lullism and Cabbalism… were both born around the same time in the Catalan province of Girona, where I spent some of my sunniest hours among Catalan anarchist friends who fed me, the Democrat, some of the useless Surreal musings and correspondences which found their way into this student work long ago." • R.B. Kitaj, 1994

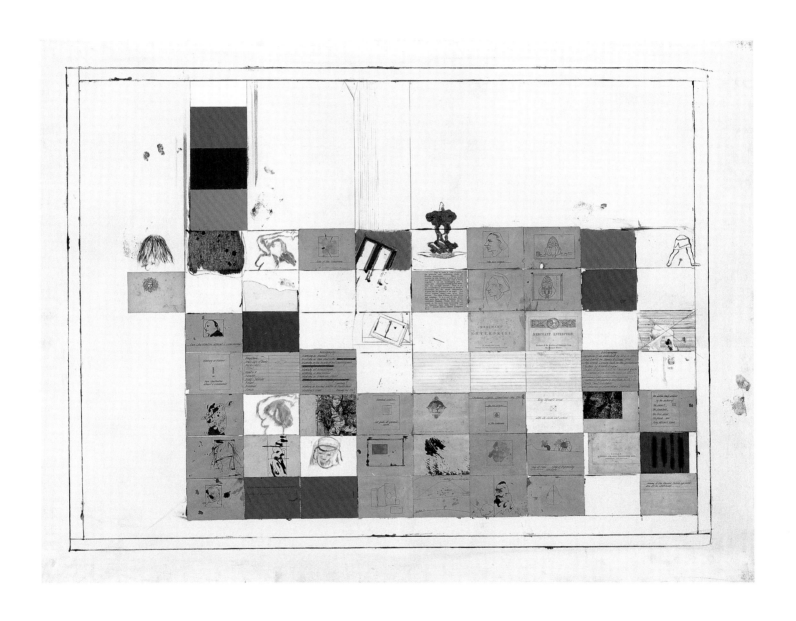

02

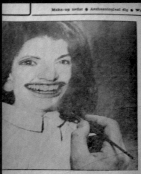

Only men are beautiful

03

I

His New Freedom, 1978
Pastel and coal on paper, 77 × 56 cm

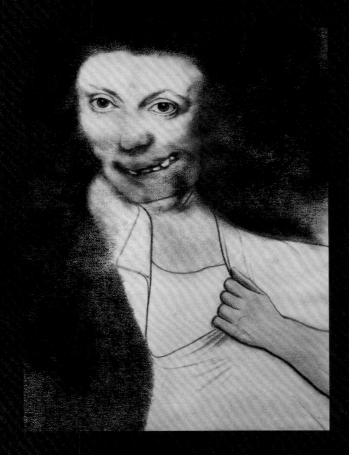

01

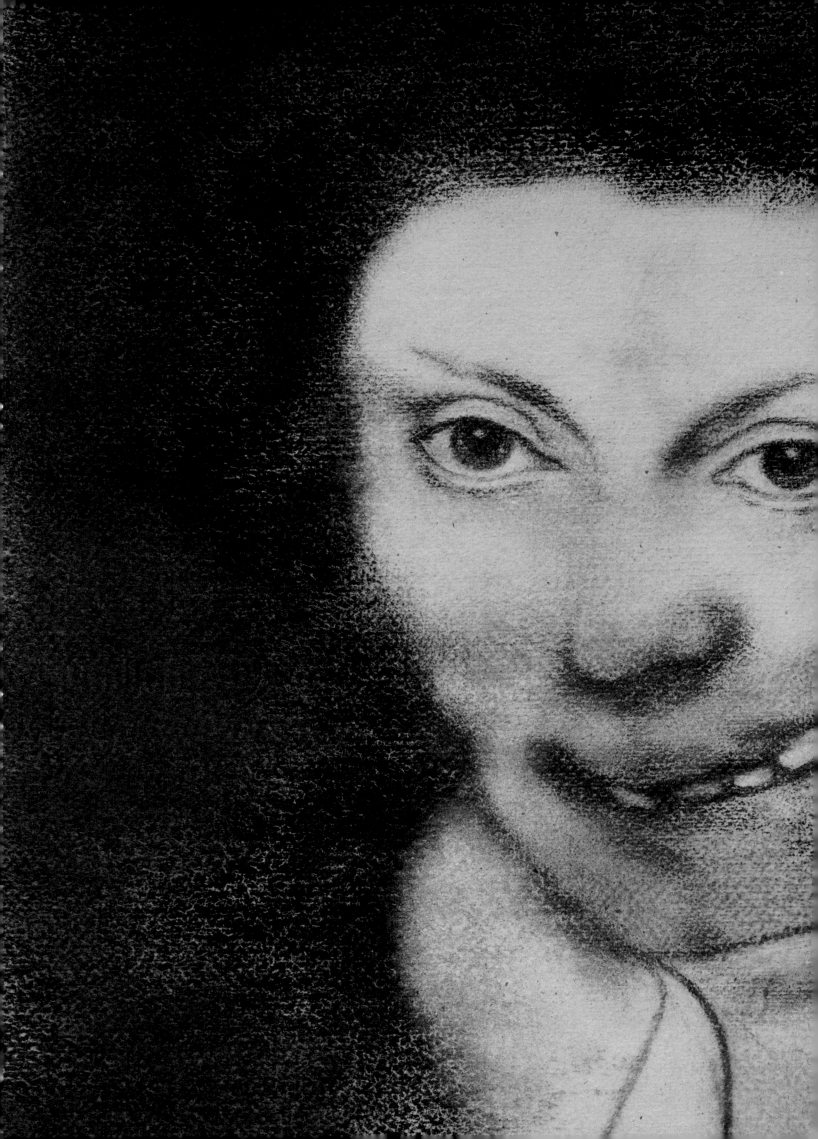

R. B. Kitaj
Erstes Manifest des Diasporismus
Arche

können als in seinem Volk. Es wurde vernichtet, als seine Emanzipation in Blüte stand. Größte Gefährdung und größte Freiheit (nämlich die emanzipierte Assimilation an die Moderne) scheinen Hand in Hand gegangen zu sein. Die jüdische (und meine) Malerei fällt geschichtlich mit der deutlich modernsten und verletzlichsten Phase des Diasporismus zusammen. Beckmann war kein Jude, aber er sah mit seiner freien Auffassung von Modernität voraus, wie eine diasporistische Malkunst Gefährdungen, Freiheiten und nahezu unerklärliche Paradoxien der Identität ineinander verschmelzen würde, auf die manche von uns in der eigenen Kunst beharren. Der Diasporismus steht dem Paradoxen näher als selbst der Surrealismus, weil die Paradoxien leben, während sie gemalt werden. Die Zwänge und Rätsel wie die kurzen Freiheiten der Diaspora erscheinen ebenso real, wie sie surreal sind.

99

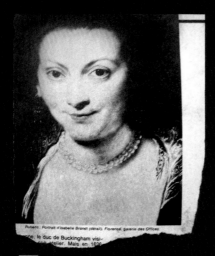

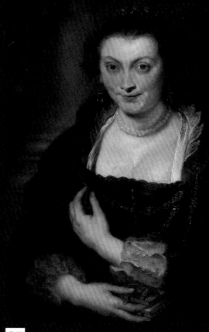

Rubens : Portrait d'Isabelle Brandt (détail). Florence, galerie des Offices.
...one, le duc de Buckingham visi-
...son atelier. Mais en 1626...

04

05

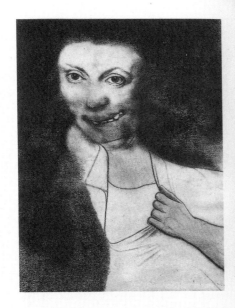

His New Freedom, 1978

97

Seine neue Freiheit

*Ein »Selbst« zu werden, ist immer der Drang aller noch we-
senlosen Seelen. Dieses »Selbst« suche ich im Leben – und
in meiner Malerei.*

Max Beckmann

*Diasporistische Maler sind häufig was man »emanzipiert«
nennt, und darin liegt einiges an erfreulichem Wider-
spruch. Der Diasporist bleibt unruhig, traut seiner neuen
Freiheit kaum, ist heimatlos, oft völlig fremd – es sei denn, er
fühlt sich gleich oder später irgendwo wirklich zu Hause –,
dann begreift er sich allerdings kaum mehr als Diasporist
(bis zum nächsten Knall). Währenddessen spürt der Diaspo-
rist den schattenhaften Mythen einer nervösen Geschichte
nach und nimmt sie für sich in Anspruch bis in die unwegsa-
men Sümpfe vieldeutiger Malerei. Der einzige Ort, der
eine gewisse Zuflucht vor der unwirtlichen Welt zu sein
scheint, ist der Raum, in dem der Diasporist seine Bilder er-
arbeitet. Sie kreisen um die diasporistische Welt außerhalb
seiner Klause und werden von ihr, dem Grauen, das aus Bü-
chern und den Tagträumen, die von innen aufsteigen, be-
stimmt. Aber alle guten Maler müssen in ihrem Raum blei-
ben. Nietzsche definiert sehr schön, wie ich meine, Kunst
als das Verlangen nach einem Anders-Sein und den Wunsch
eines Anderswo-Seins. Maler sind eine Herde anders-sein-
wollender Einzelgänger, Diasporisten auch (dazu sind sie
noch »anderswo«). Der europäische Jude hätte, vor allem
auf dem Weg zu seiner Ermordung, kaum einsamer sein*

His Hour, Ausschnitt, 1975

06

Isaac Babel Riding with Budyonny, 1962
Oil on canvas, 183 × 152 cm

Books and Ex-Patriot, 1960
Oil on wood, 74 × 22 cm

Priest, Deckchair and Distraught Woman, 1961
Oil on canvas, 127 × 102 cm

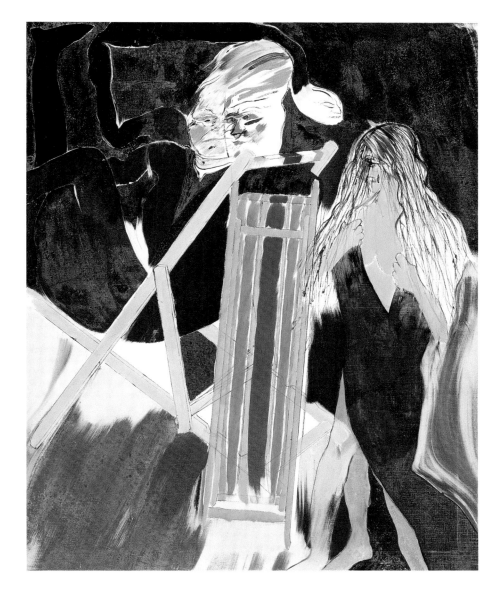

Republic of the Southern Cross, 1965

Collage on wood frame, 125 × 64 cm

See screen print, p. 39

Work in Progress, Eduardo Paolozzi, 1962
Collage, paper and sheet metal in wood frame, 85 × 100 cm

Boys and Girls!, 1964

Screen print, 61.3 x 43.2cm

"Associated with the 2nd movement
of the 2nd symphony. At the
bottom right is Werner Krauss
playing the lead in the anti-Semitic
movie 'Jud Suess.' The central
photo was taken from a post-war
German nudist mag." • R. B. Kitaj,
1965

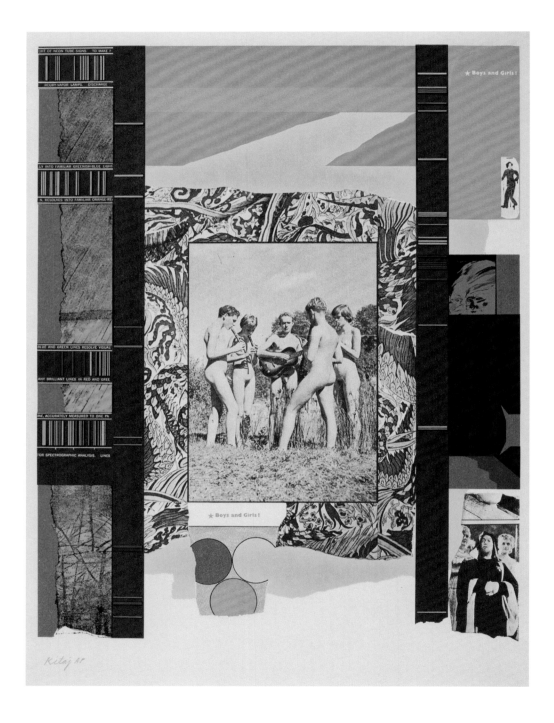

Collage, 1965
Mixed media and collage, 51 × 43 cm

Good God, Where is the King?, 1964
Collage, 85 × 59 cm

Mahler becomes Politics, 1964–67
15 screen prints

What is a Comparison?
Screen print, 79 × 56 cm

"Jonathan Williams has written 41 poems responding to Mahler's symphonies and I have begun (Fall 1964) to make a run of prints using the music, the poems, the Mahler literature and times and a good deal else as a compound crutch upon which to hang much that cannot be made to splice easily with Mahler. In this light Mahler's own ambiguous, lifelong attitude towards 'The vexed problem of programme music' is worth noting and he reminds us that 'The creative urge for a musical organism certainly springs from an experience of its author…'"
• R. B. Kitaj, 1965

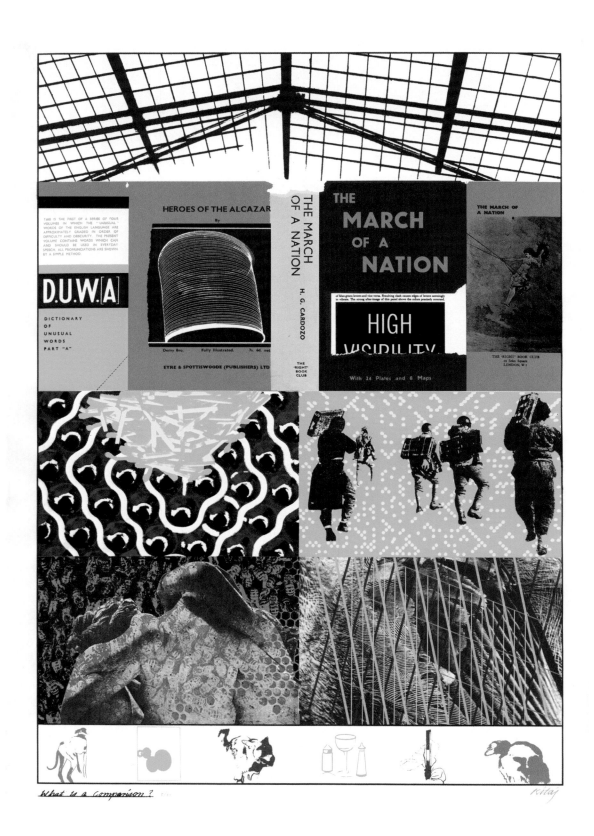

Republic of the Southern Cross

Screen print, 78 × 57 cm

See collage, p. 34

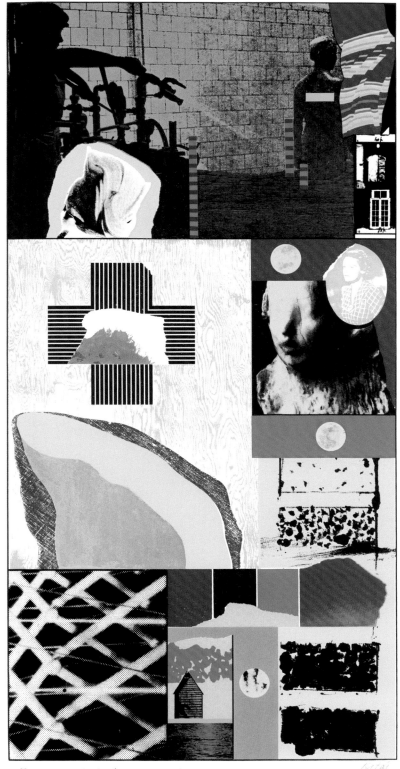

The Gay Science
Screen print, 77 × 58 cm

Hellebore for Georg Trakl
Screen print, 79 × 57 cm

His Every Poor, Defeated, Loser's, Hopeless Move, Loser, Buried (Ed Dorn)
Screen print, 77 × 50 cm

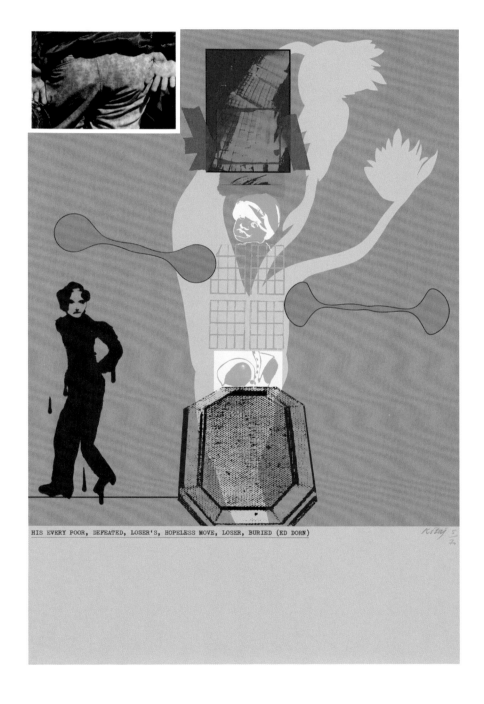

Go and Get Killed Comrade.
We Need A Byron in the Movement
Screen print, 81 × 55 cm

The Cultural Value of Fear, Distrust,
And Hypochondria
Screen print, 52 × 78 cm

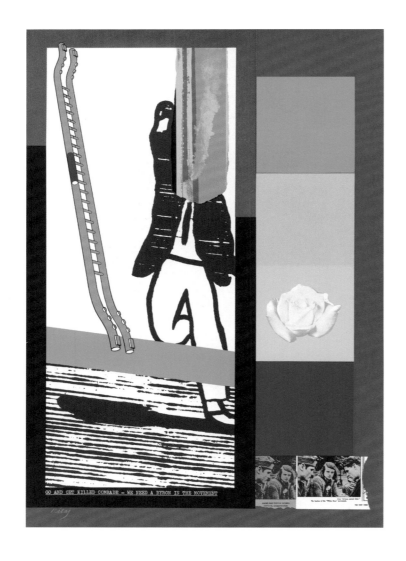

Let us Call it Arden & live in it
Screen print, 88 × 58 cm

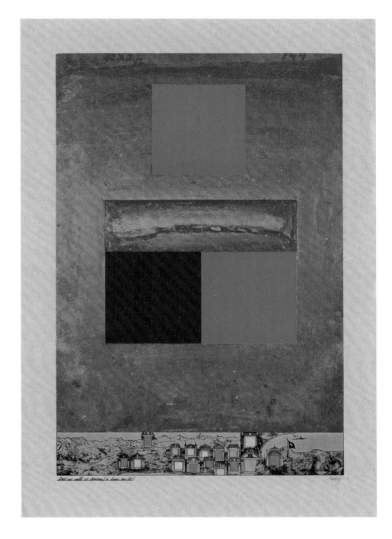

Heart
Screen print, 60 × 81 cm

I've Balled Every Waitress In This Club
Screen print, 58 × 83 cm

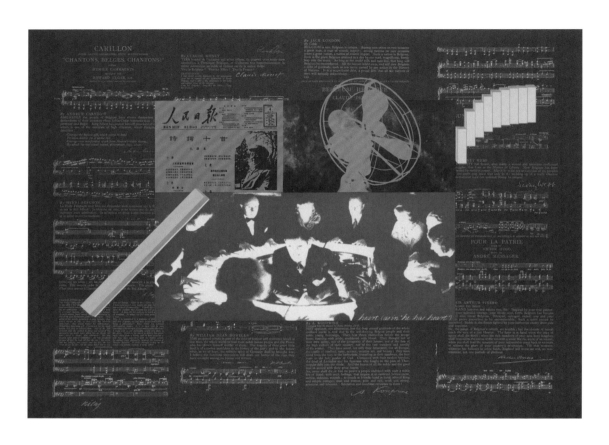

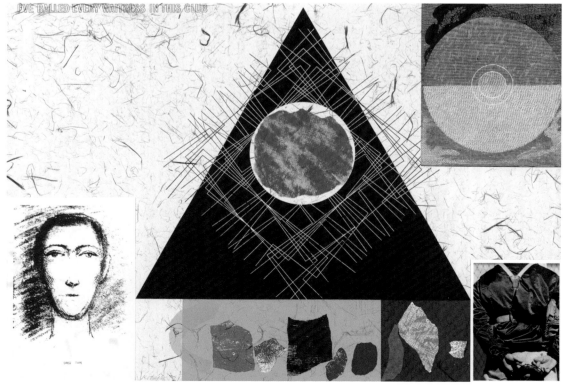

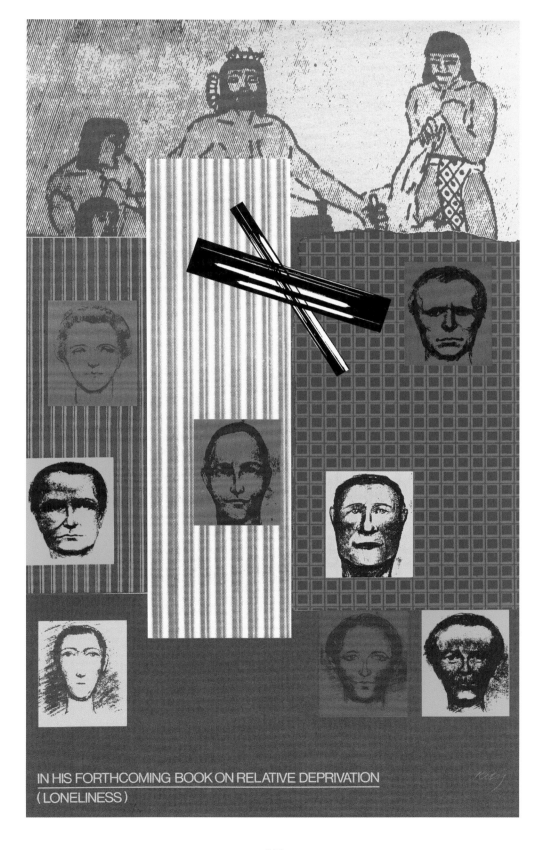

Glue-Words
Screen print, 84 × 58 cm

for fear
Screen print, 51 × 84 cm

Nerves, Massage, Defeat, Heart
Screen print, 84 × 57 cm

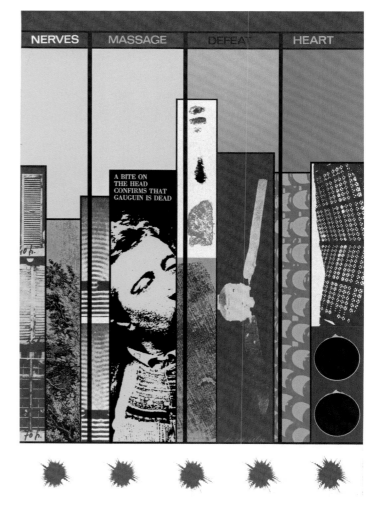

The Flood of Laymen
Screen print, 83 × 56 cm

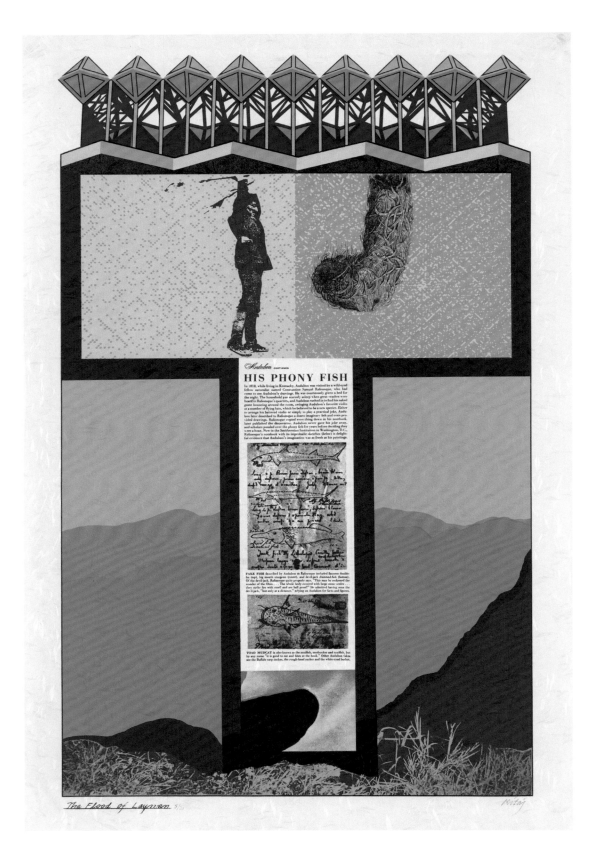

2
Catalonia as Trigger to Diaspora

Where the Railroad Leaves the Sea, 1962

Oil on canvas, 122 × 152 cm

"Where The Railroad Leaves The Sea and *Kennst Du Das Land* were deeply sentimentalist, good, honest sighs of love for Spain, my hommage to Catalonia, my own untimely Catalonia, which helped inspire me to become a strange Jew, maybe the first Jew who would wish to make a new Jewish Art unbound." • R. B. Kitaj, ca. 2003

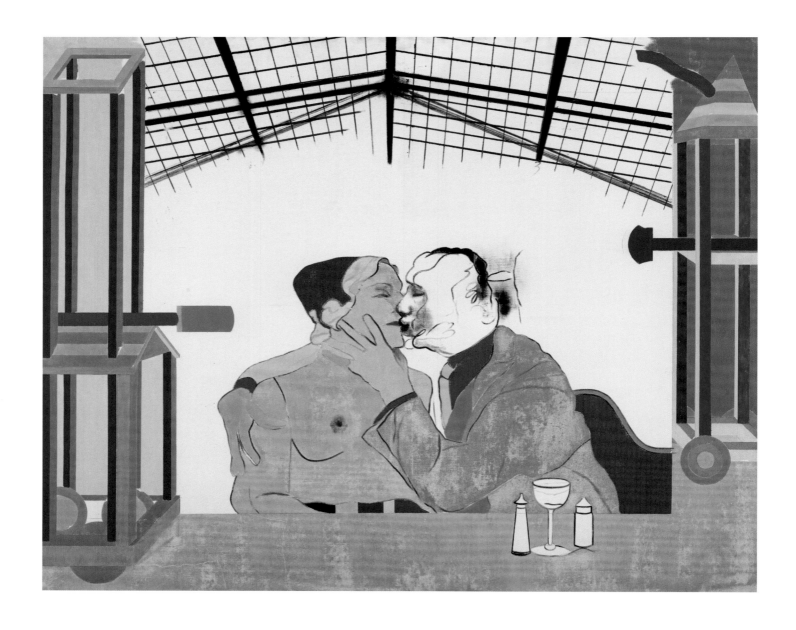

La Pasionaria, 1969

Oil on canvas, 39 × 40 cm

José Vicente (unfinished study for The Singers), 1972–74

Oil and coal on canvas, 122 × 61 cm

"He became a saint of mine for life. He became Sant Feliu, Catalonia, Spain for me. [...] He has always been slender and aquiline and moustached and socialist and quick and witted and, maybe above all, Catalan—half his life in the face of Franco, and the last half in the fullness of his nation, race, person. What he called 'Our War' was central in his blood. I believe that Josep and his Catalonia were early beacons of the sleepy Jewishness in me which would become a torrent."
• R.B. Kitaj, ca. 2003

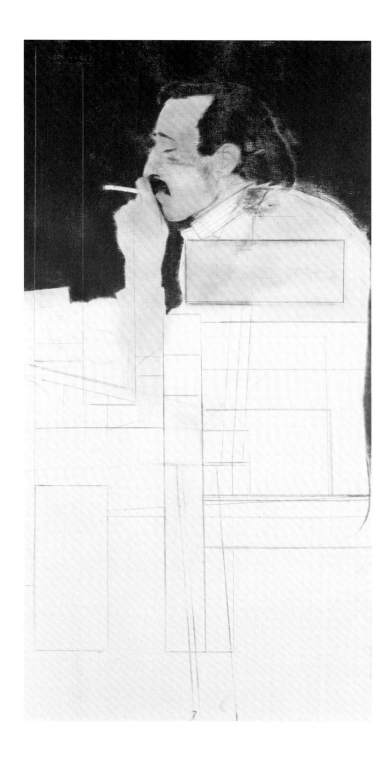

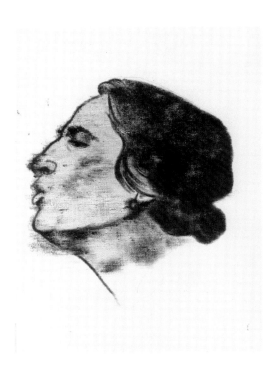

Junta, 1962

Oil and collage on canvas, 91 × 213 cm

including (from left to right):
What Thou Lovest Well Remains,
The Rest is Dross
Born in Despotic
Dan Chatterton at Home
Old and New Tables (Doppelgänger)
and
His Flower-Bedecked Bomb
Teratology • R. B. Kitaj, 1964

Kennst Du das Land?, 1962

Oil and collage on canvas, 122 × 122 cm

"Goethe meant Italy of course in his famous lines, but my picture is about Spain [...]. What I loved even more than Catalonia was my friendship with Josep... and this painting, begun in his house high over the sea is really about what he called 'our war' which tore his Spain apart and burned its way into the souls of so many people I've known. [...] I've kept this painting many years. It swings in my attic, creaking nostalgia, and reminds me that fascism is not dead after all (as if one needs reminding)." • R. B. Kitaj, 1994

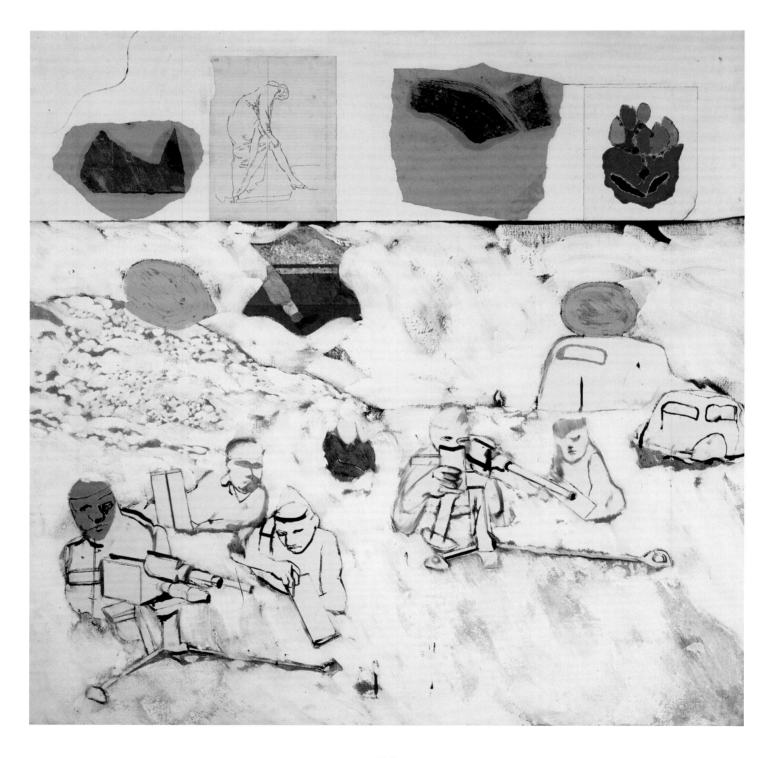

3
Kitaj – Analyst of His Time

The Baby Tramp, 1963|64
Oil and collage on canvas, 183 × 61 cm

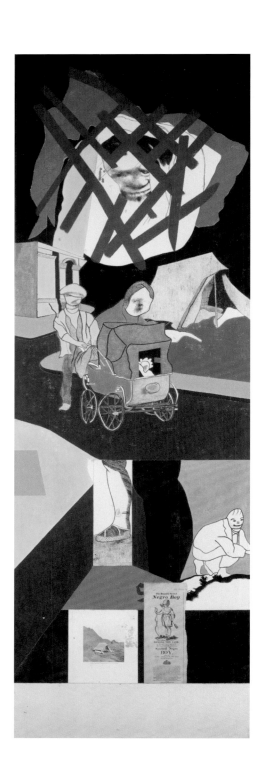

The Ohio Gang, 1964

Oil and graphite on canvas, 183 × 183 cm

"*The Ohio Gang* is an 'automatic' painting freely associated like a depictive surreal abstraction, but now, almost 25 years later, I would like to suggest some dream 'meaning.' If only for myself, delving there in a half-conscious reverie, after the fact of the painting, which like a dream, carries a trace of organisation... "
• R.B. Kitaj, 1988/89

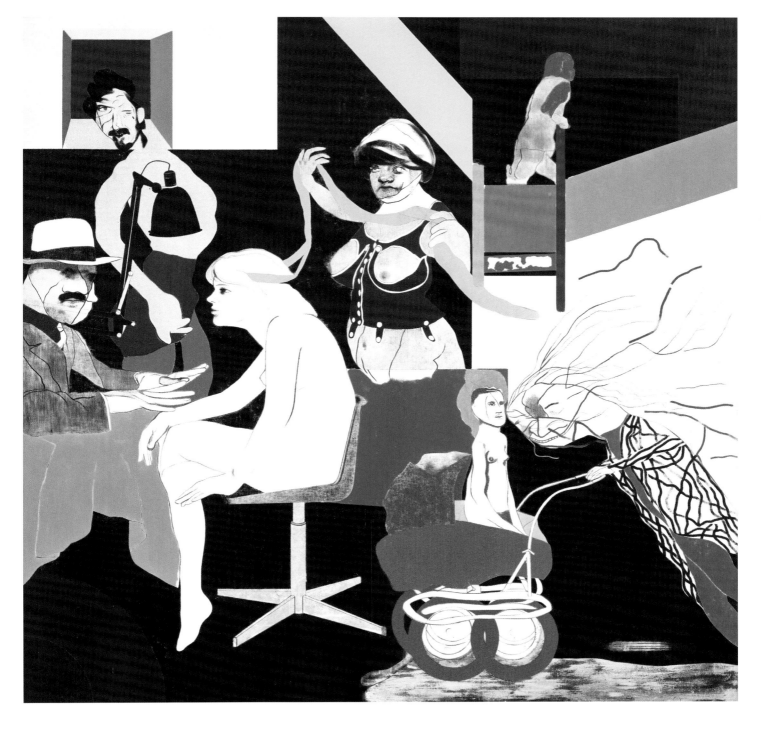

Walter Lippmann, 1966

Oil on canvas, 183 × 213 cm

"Every day since I was in high school I read political criticism of many stripes. [...] Walter Lippmann, at stage right, is the voyeur and explainer of complex events he was in my youth. I took the liberty of embroidering those serious events in terms of romance, intrigue, spies and alpine idyll, like movies did in those days, often made by refugees, themselves escaping from serious events." • R. B. Kitaj, 1963

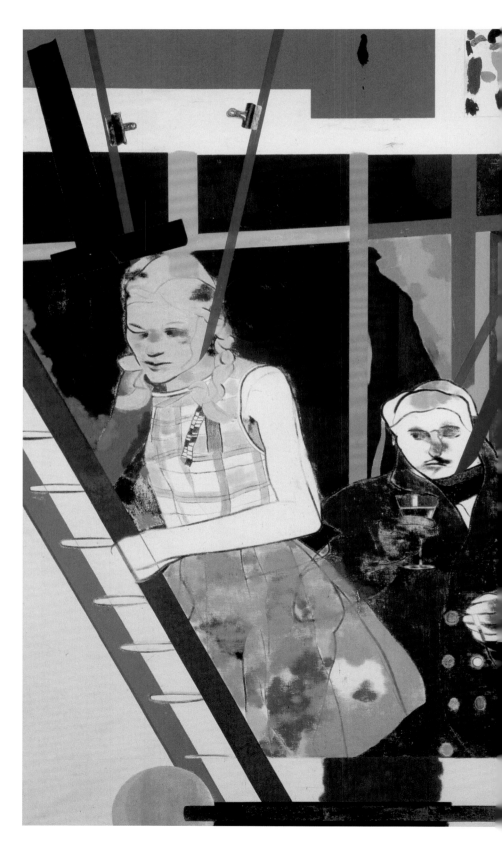

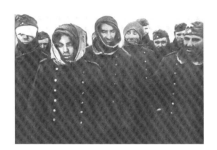

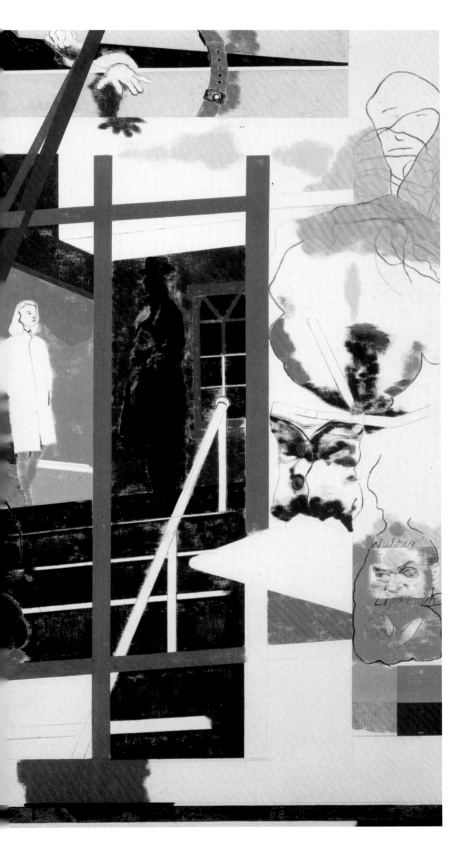

Synchromy with F. B. – General of Hot Desire
1968 | 69

Oil on canvas, diptych, both 152 × 91 cm

"Francis Bacon, (and often his own doomed George Dyer), was a few steps away from my flat [...] I saw Bacon infrequently in our gallery and I took a photograph of him in his studio which may be the best photo I ever did, and I'm no photographer. I also sketched him in caput mortem. Our relations were quite cordial and the Great Immoralist was even more Immoral than I was."
• R. B. Kitaj, ca. 2003

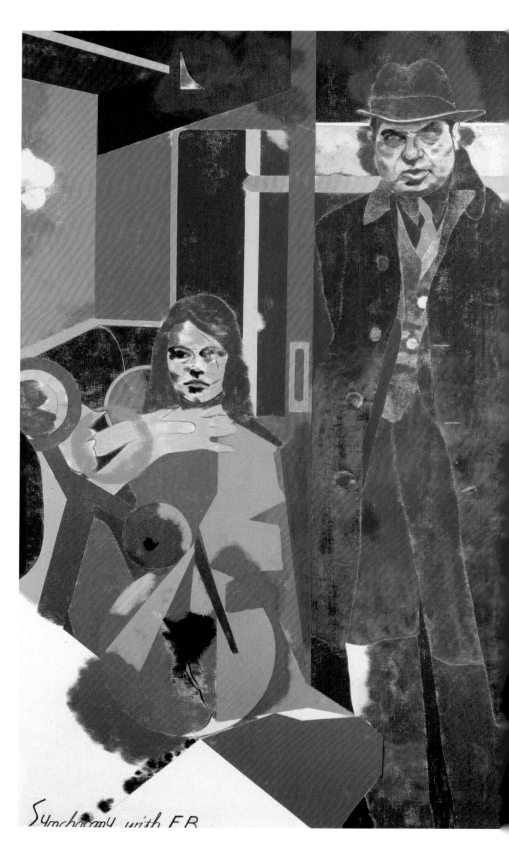

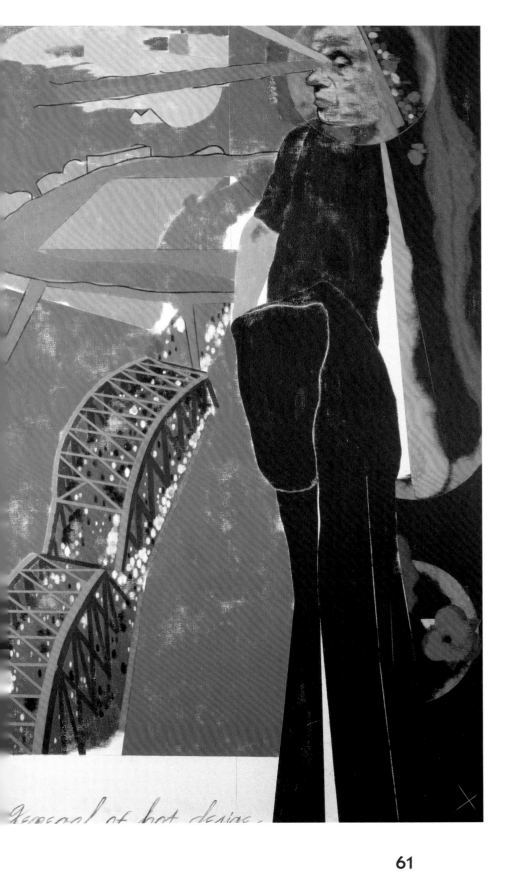

Dismantling the Red Tent, 1963–64

Oil and collage on canvas, 122 × 122 cm

"Kennedy had just been killed and I meant 'The Red Tent' to paraphrase the surprising longevity of an American democracy which works pretty well and which belongs to a quite rare species: government by consent. The Red Tent was a beacon used by polar explorers in the wastes. Men could return to it in some hope and I designed a nice Red Tent to come home to."
• R. B. Kitaj, 1994

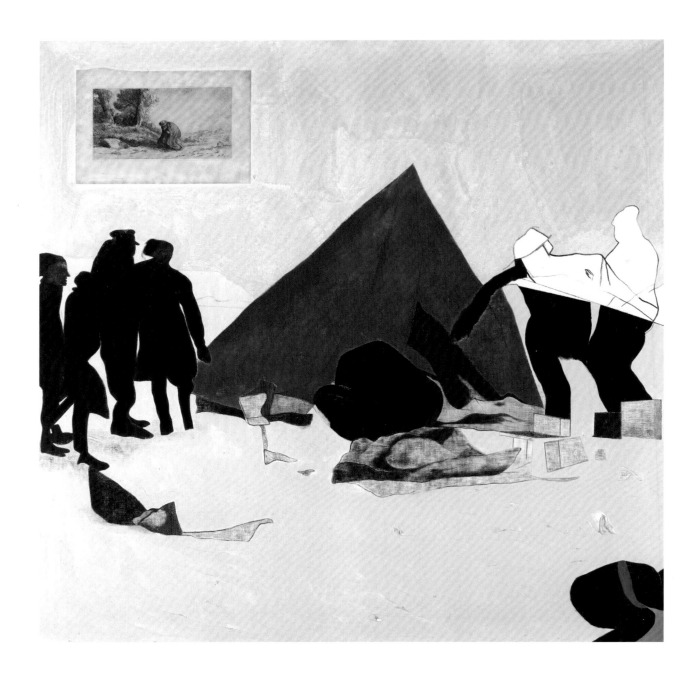

Juan de la Cruz, 1967

Oil on canvas, 183 × 152 cm

"This is the only picture I did about Vietnam (partly) […] I used to spend my summers in Franco's Spain and I became very interested in Juan who spent forty-nine years in and out of the claws of the Inquisition. He was born to an underclass, like my Sgt. Cross, torn between devotion to his calling and tradition on the one hand and St Teresa's Reform on the other, like the American Black soldier must have been in Vietnam."
• R. B. Kitaj, 1994

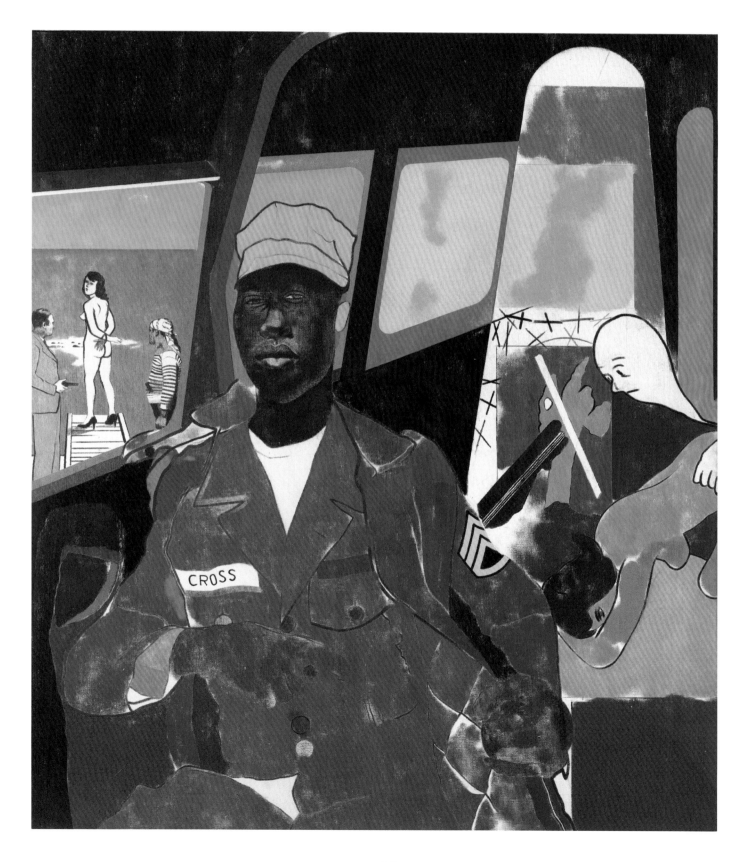

London by Night: Part I, 1964
Oil on canvas, 145 × 185 cm

4
A Circle of Friends

If Not, Not, 1975 — 76

Two main strands come together in the picture. One is a certain allegiance to Eliot's *Waste Land* and its (largely unexplained) family of loose assemblage. Eliot used, in his turn, Conrad's *Heart of Darkness*, and the dying figures among the trees to the right of my canvas make similar use of Conrad's bodies strewn along the riverbank.

Eliot said of his poem "To me it was only the relief of a personal and wholly insignificant grouse against life; it is just a piece of rhythmical grumbling". So is my picture … but the grouse here has to do with what Winston Churchill called "the greatest and most horrible crime ever committed in the whole history of the world" … the murder of the European Jews. That is the second main theme, presided over by the Auschwitz gatehouse. This theme coincides with that view of the Waste land as an antechamber to hell. There are (disputed) passages in the poem where drowning, "Death by Water" is associated with either the death of someone close to the poet or the death of a Jew … like most of the poem, these passages are fraught with innuendo.

The man in the bed with a child is a self-portrait detail in the waste-like middle ground which also shows scattered fragments (such as the broken Matisse bust) being sucked up as if in a sea of mud. This sense of strewn and abandoned things and people was suggested by a Bassano painting, of which I had a detail, showing a ground after a battle. Love survives broken life "amid the craters", as someone said of the poem.

The general look of the picture was inspired by my first look at Giorgione's "Tempesta" on a visit to Venice, of which the little pool at the heart of my canvas is a reminder. However, water, which often symbolises renewed life, is here stagnant in the shadow of a horror … also not unlike Eliot's treatment of water. My journal for this painting reports a train journey someone took from Budapest to Auschwitz to get a sense of what the doomed could see through the slats of their cattle cars ("beautiful, simply beautiful countryside") … I don't know who said it. Since then, I've read that Buchenwald was constructed on the very hill where Goethe often walked with Eckermann.

02

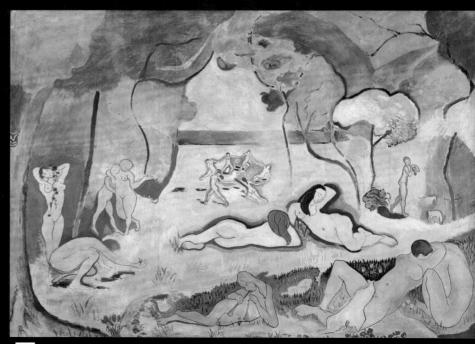

03

If Not, Not, 1975 – 76
Oil and black chalk on canvas, 152 × 152 cm

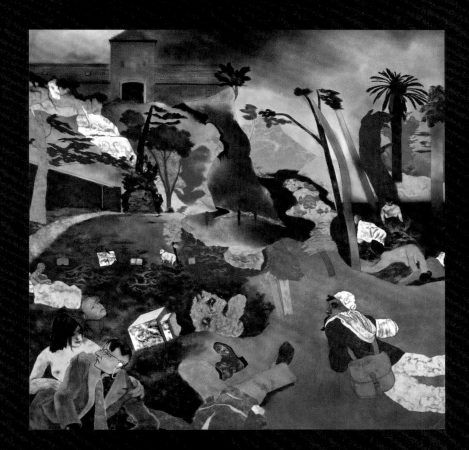

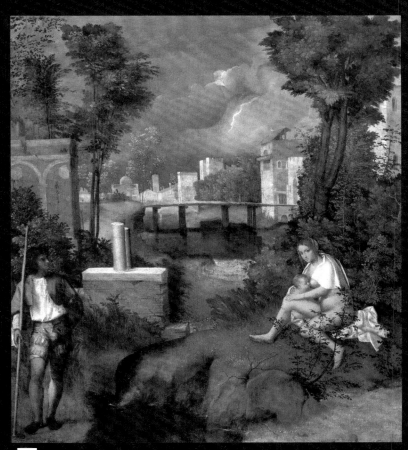

01

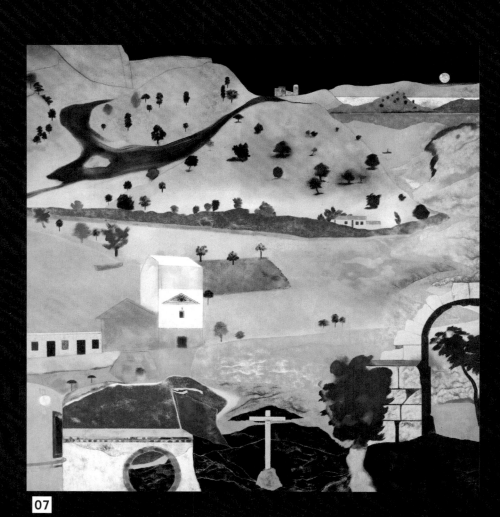

07

01 Giorgione, *The Tempest,* ca. 1507/08, oil on canvas, Gallerie dell'Accademia, Venice.

02 R.B. Kitaj, "If Not, Not, 1975/76", in: Richard Morphet (ed.), *R.B. Kitaj. A Retrospective,* exh. cat., Tate Gallery, London 1994, p. 120.

03 Henri Matisse, *Le bonheur de vivre,* 1905/06, oil on canvas, Barnes Foundation, Merion, Pennsylvania.

04 Auschwitz gatehouse

05 R.B. Kitaj, handwritten on a lined yellow pad, in: *Kitaj papers,* UCLA.

06 Detail: R.B. Kitaj, *The Jew Etc.,* 1976–1979, oil and coal on canvas, Tate, London.

07 R.B. Kitaj, *Land of Lakes,* oil on canvas, private collection, London.

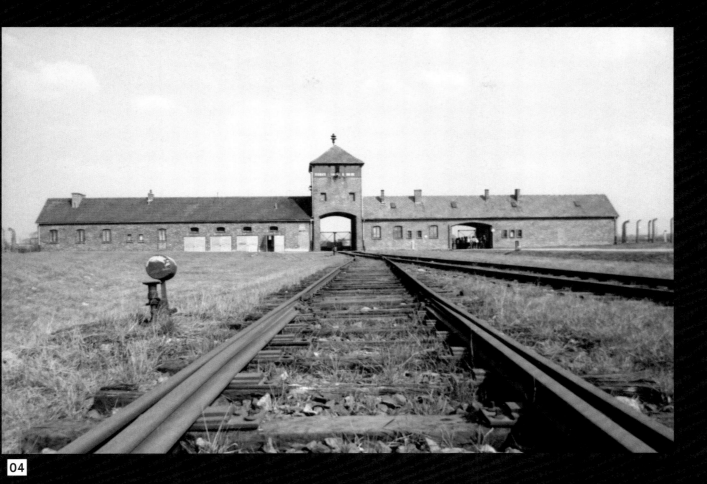

04

06

05

It is impossible to exhaust the meaning of
The Waste Land. Many, many interpretations have
been written since its publication in 1922. It has
also had many detractors, put off by what they
could not or would not understand. Eliot's famous
notes to the poem foresaw the controversy. To his
protagonists, the notes ▆▆▆ are hints which lead to
certain meanings. To his antagonists, the notes are
like waving a red flag at a bull.

I make no comprehensive claims for my design. ▆▆▆▆
a tapestry to be figured on a loom only in the new National Library at
Euston designed by Colin St John Wilson.
I've only played upon some of the many strings of this
wonderful poem, so difficult, still so modern, always
so elusive as it makes its way through many histories,
public and personal. You must look up for yourself the general
structuring of the poem in the Grail legend and Eliot's other sources.
I will only give here some few hints of my own.
The large, stalking woman in blue at Terezín

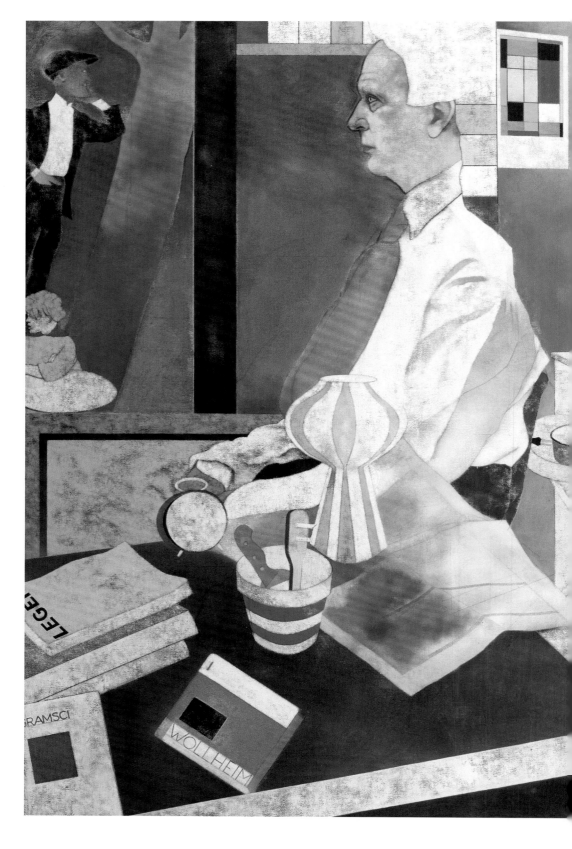

From London (James Joll and John Golding), 1975 | 76
Oil on canvas, 152 × 244 cm

James Joll (1918-1994), British historian and specialist in Anarchism and Socialism, met John Golding in 1955; they lived together until his death.
John Golding (1929-2012), artist, art historian and curator. As art historian and abstract painter, he was convinced that abstract art did indeed have content and wrote on Mondrian, Malevich, Léger and Rothko. This painting is full of references to the pair's interests: an exhibition poster by Mondrian, books by Léger, Gramsci and Richard Wollheim. • Note by the Editors

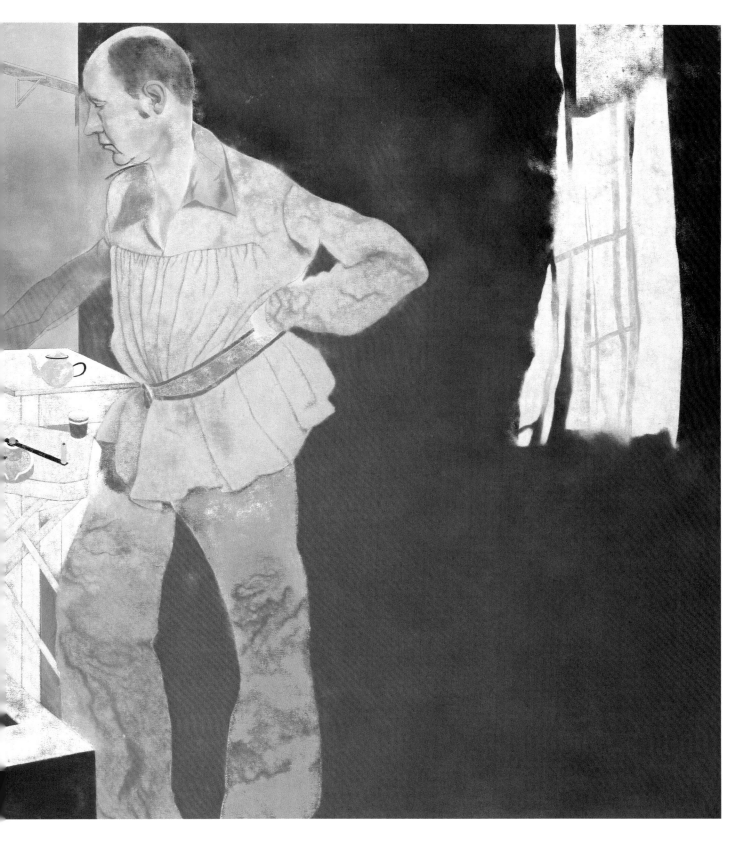

Kenneth Anger and Michael Powell, 1973

Acrylic on canvas, 244 × 152 cm

"This painting celebrates two strange friendships of mine during the 1970s. They are both film legends and had done their work (or so it seems) by the time I met them, introduced them and brought them together in London for this picture. It was a vibrant time of my life. Elm Park Rd was humming with people and children and I was in a social mood and mode. Maybe this colorful picture reflects that." • R. B. Kitaj, n.d.

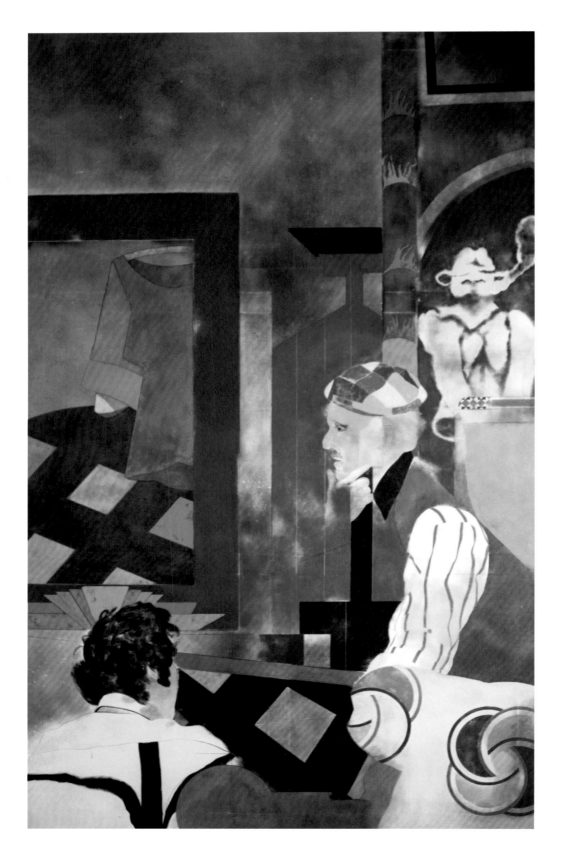

The Autumn of Central Paris (After Walter Benjamin),
1972 | 73

Oil on canvas, 152 × 152 cm

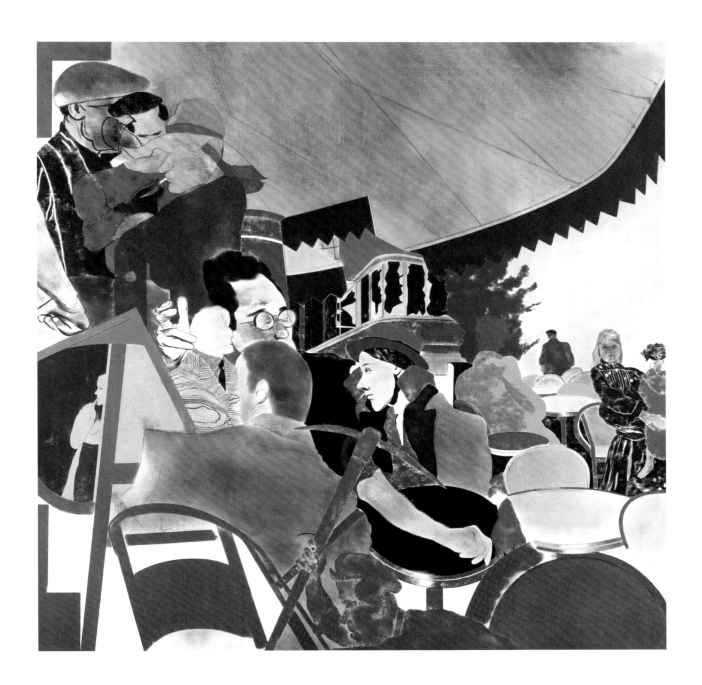

A Visit to London (Robert Creeley and Robert Duncan), 1977

Oil and coal on canvas, 183 × 61 cm

"Creeley and Duncan are very different poets. Creeley's poetry is spare, 'skinny', tense, often about love, about women. Someone said reading Creeley was like walking through a minefield. Duncan is… dense, oblique, difficult, gay, alchemical, *but* they are very, very old friends [...]. There was *every* reason to celebrate them together in a painting. They are like Picasso and Braque, something like that – very often coupled in the history of modern poetry."
• Julián Ríos, 1994

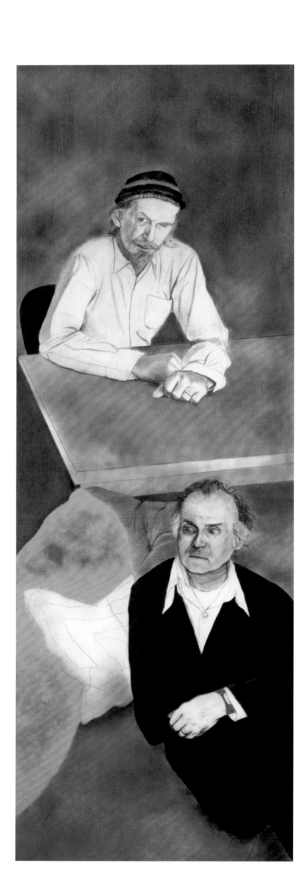

Two London Painters
(Frank Auerbach and Sandra Fisher), 1979
Pastel and coal on paper, 56 × 78 cm

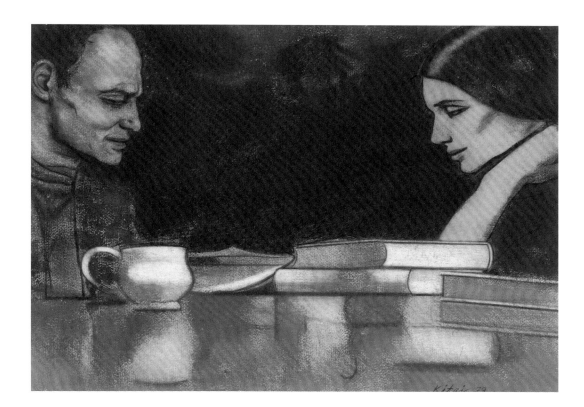

Pacific Coast Highway (Across the Pacific), 1973

Oil on canvas, diptych, 153 × 249 cm, 153 × 153 cm

"This is a large painting (in two parts) which I see quite often because it hangs in the London house of very dear friends (who kept by my side during the picture's origins). Whenever I enter their beautiful room, I always go over to the picture to scrutinize it, to see how I painted it, as if it had been done in another age, in faded memory—which is kind of true. […] I cannot spell out the secret live of the picture—the painful parts." • R. B. Kitaj, ca. 1993.

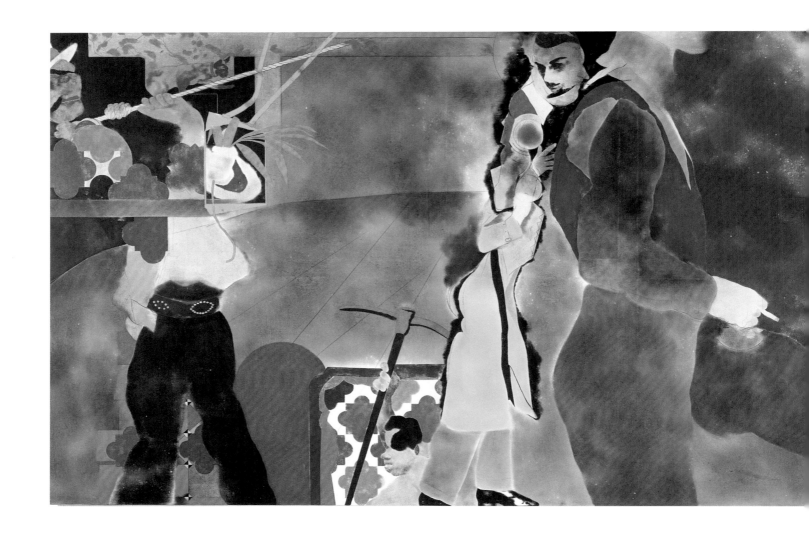

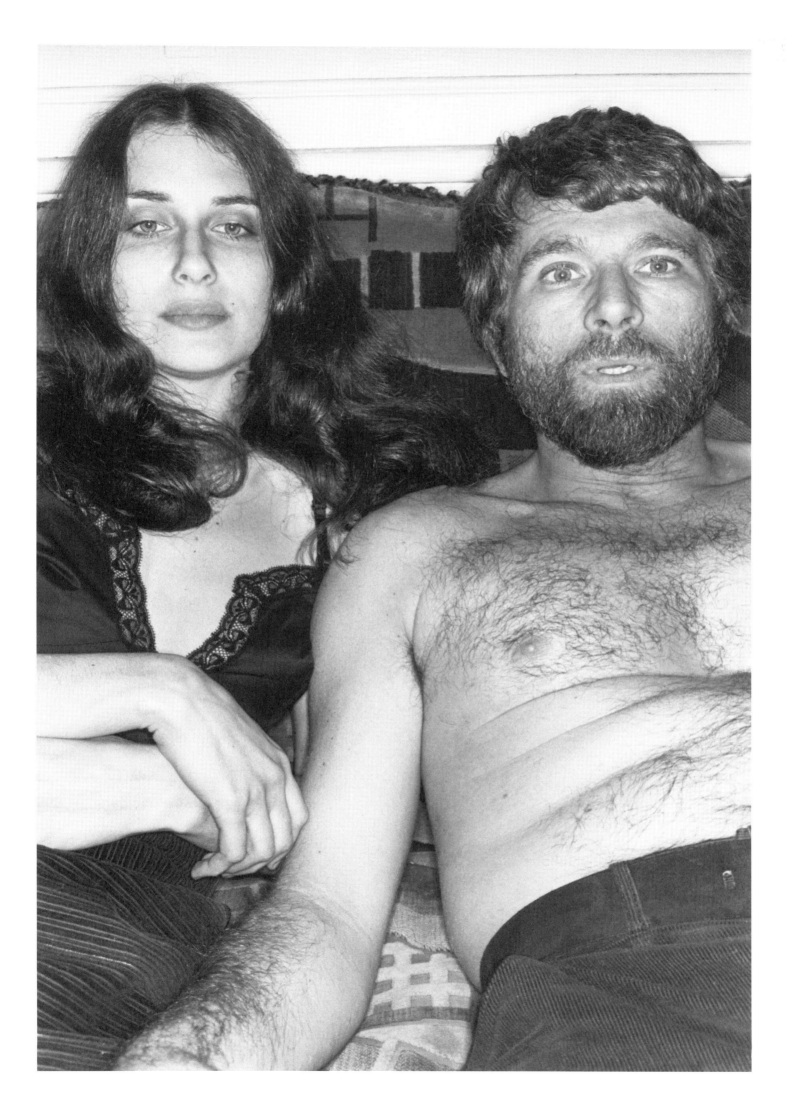

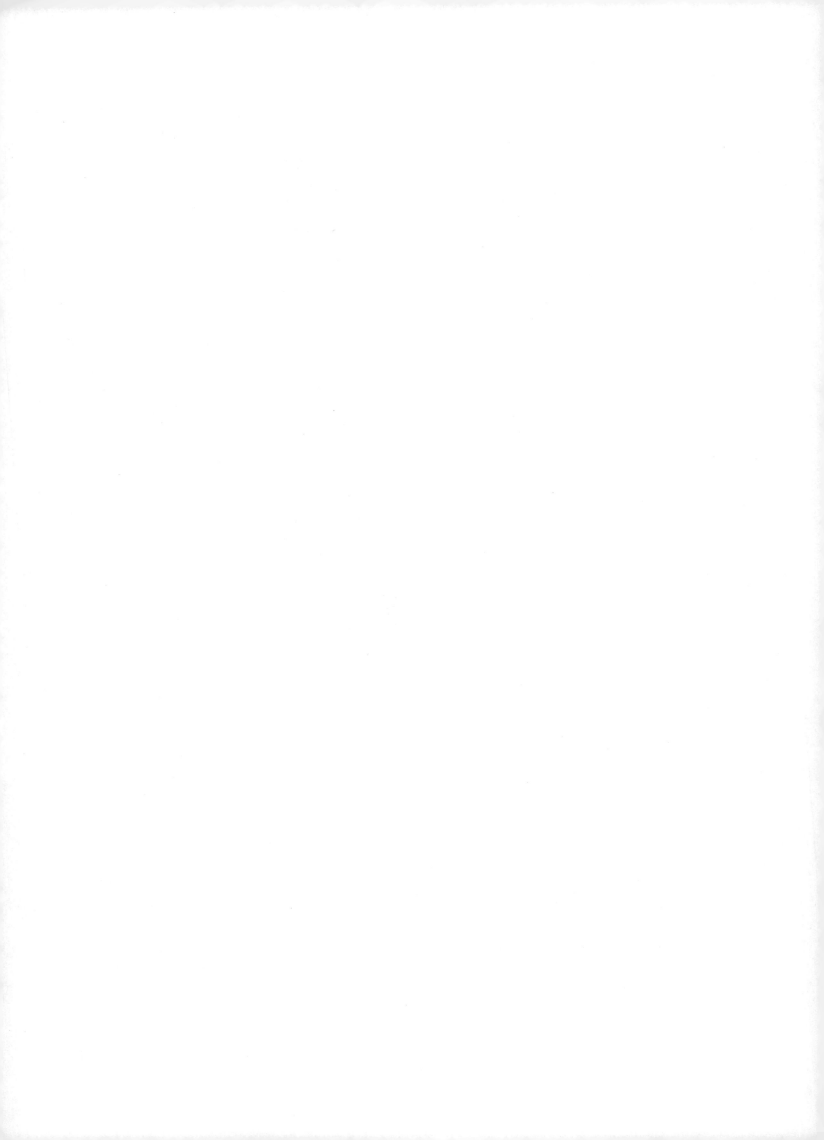

R.B. Kitaj—Secret Jew and Avowed Diasporist

Eckhart Gillen

1 See Michael Brenner, *Kleine jüdische Geschichte* (Munich, 2008), pp. 121–125.

2 See Marco Livingstone, *Kitaj* (London 2010), p. 36, note 70.

3 Ibid., p. 36.

The Secret Jew

A man with white hair and red shorts is sitting casually with naked crossed legs on a fashionable Seventies sofa. His feet are in two elegant slippers, albeit of different colors. His black tie hangs loosely round his neck and his collar button is undone. The man boasts a black beret and has a blue phone receiver in his hand.

What catches the eye is the discrepancy between the small head of the man in the back corner of the picture, his head turned to one side and conspiratorially talking into the phone, and the male legs that dominate the center of the image. The demonstrative exhibition of his unconventional lifestyle and his sexual libertarianism contrasts starkly with the mysterious whispers into the phone. The entire scene seems constrained, given the wooden paneled background with one window that shows an empty gray-blue sky.

The title of the painting, *Marrano (The Secret Jew)* (1976) | **p. 137** marries this scene from the 1970s with the days of Jewish persecution on the Iberian Peninsula. As of the fifteenth century, people in Spain commonly used the word "Marrano" (Spanish for a pig) as an insult when confronting Jews with the choice of compulsory baptism or expulsion. The baptized converts ("conversos") were called pigs because the Church suspected them of secretly remaining Jews (crypto-Jews). Even before the Catholic Kings passed the Edict of Expulsion in 1492 the Spanish Inquisition had, in 1478, started publicly burning conversos at the stake. The fact that many a Marrano had climbed high in society made the hatred and envy all the more fierce, and the consequence was the first racist laws on the "purity of our blood."[1]

On closer inspection, the head proves to be one of many quotations from art history in Kitaj's oeuvre: in this case, the head of a Franciscan monk from Giotto's fresco *Funeral of St. Francis*[2] | **p. 86**. In Kitaj's version, the monk's tonsure becomes a beret. In this way, he references the role of the Franciscan and above all Dominican orders, which as of the thirteenth century ran the Inquisition, and in Spain, with their tirades from the pulpit at the end of the fourteenth century, destroyed the notion of peaceful coexistence with the Jews in the already Christian part of the Iberian peninsula.

With the image of the social outsider of the 1970s, which Kitaj relates in the title to the Marranos of the fifteenth and sixteenth centuries, in 1976 he thus highlighted the entire range of non-conformism and adjustment, dual lives and ambivalence. Marco Livingstone is no doubt right to suggest that this painting has the essence of an avowal about it, "in the implicit understanding that this is an image of the artist himself openly avowing his Jewish origins."[3]

Not until the mid-1970s, at the age of 43, does Kitaj start with this image to reveal in a series of other paintings the hidden Jew in himself. The ground was laid by him breaking away from the backwoods of Troy in upstate New York, first as a sailor bound for Central and South America, and then as a soldier in Germany and France, followed by a period as a student in New York, Vienna, Oxford, and London, and as a lecturer and artist in England, California, Paris, Catalonia, and Amsterdam. By concerning himself with foreign cultures, Kitaj developed the ability to think himself into past ages: to understand experiences in the present by comparing them through the lens of the past. Life in foreign cultures is one of the basic experiences of the Diasporist, and from this Kitaj was to derive his method of a Diasporist art: "A Diasporist lives and paints in two

4 R. B. Kitaj, *First Diasporist Manifesto*, London/New York 1989, p. 19.

5 Ibid., pp. 35-36.

6 Ibid., pp. 41, 53.

7 Edouard Roditi, text with quotes from Kitaj, R.B. Kitaj papers (Collection Number 1741), Department of Special Collections, Charles E. Young Research Library, UCLA *(Kitaj papers)*, Box 136, Folder 12, p. 7.

8 Michael Podro, "Some Notes on Ron Kitaj", in: *Art International*, 22, 1979, p. 19.

9 "Autobiography of My Pictures," typescript, around 1989, p. 29f. in: *Kitaj papers*, UCLA, Box 126, Folder 7.

10 It appears again in the painting made at the same time and called *Pacific Coast Highway (Across the Pacific)*, 1973.

or more societies at once."[4] Such Diasporist art, he warns, "is contradictory at its heart, being both internationalist and particularist. It can be inconsistent, which is a major blasphemy against the logic of much art education, because life in Diaspora is often inconsistent and tense; schismatic contradiction animates each day."[5] Kitaj does not seek to create Jewish art, but expressly Diasporist art. Life in the Diaspora is a fundamental condition of Modernism. People are no longer forced into exile by racist, political, or ethnic violence, but also for social and professional reasons. Not only Jews are Diasporists, nomads and flaneurs. "Utterly American, longingly Jewish, Schools of London, I spin my years away from both my heartlands ... I suppose a case could be made for aJewish heartland of the mind ... rather than Jerusalem or even New York ... In the Diaspora I have known, one is free to dare anything; in many other places one can't."[6]

Walter Benjamin as Diasporist

Kitaj feels that Walter Benjamin is the prototypical Diasporist, dedicating his painting *The Autumn of Central Paris (after Walter Benjamin)* (1972–3) | p. 75 to him: "We were both, Benjamin and I, passionate book collectors, melancholics, prowlers of red-light districts, big-city creatures, obscurantists and, in our manner of composing a work, what I'm tempted to call 'montagists'. I love his style, his cult of the fragment, his inconclusive 'failures'. He and Kafka are, for me, the ultimate Diasporists."[7]

One photo from the estate | p. 75 shows him as a guest at Café Les Deux Magots on Place Saint Germain des Prés. In the painting he places Benjamin under the white marquise of this renowned meeting point for artists. With eyes closed behind the thick glasses, the Berlin Jew is dreaming for the last time of Paris, "his" capital of the nineteenth century, to whose labyrinthine arcades he dedicated his magnum opus, which remained a compilation of fragments. Then the nightmare begins, with the flaneur becoming a refugee. Benjamin left Paris on the last train in mid-June 1940 and died on September 26 on the Franco-Spanish border in Port Bou after overdosing with morphine pills the previous night. Kitaj says: "my own picture is set in the autumn time before Benjamin's suicide which foresaw a tyranny worse that any Baudelaire had mocked or Blanqui had conspired against. "[8]

In his notes, Kitaj compares the figures, staggered diagonally under the yellow marquise from the bottom right to the top left, to the image with a barricade "as in THE MOVIE POSTER."[9] They are painted as silhouettes, with a thin wash in red and yellow, and the odd dot of collaged green or blue. The red worker with the pick in the lower center catches the eye, going about his work behind the broad-shouldered man with the listening device whom Kitaj calls "THE POLICE-SPY/SECRET AGENT" (see Giotto's *Kiss of Judas* | p. 86) but who no longer lives there.[10] Anthony Sutcliffe's book *The Autumn of Central Paris. The defeat of town planning 1850–1970*, which gave rise to the picture's title, addresses the way in which the proletariat was driven out of the city, and is to be found in the Kitaj Estate. At the time when Kitaj painted the picture the old market halls in the center (Zola called them "Paris's belly") had been torn down. Thus the broken panes in the background, together with the pick in the foreground, could be read as a visual reference to the destruction of the old Paris of Baudelaire and Benjamin.

11 Jürgen Zänker, "Kitajs Benja-min-Bild," in: *Kritische Berichte*, vol. 11, 1983, no. 1, pp. 24–32, here p. 26.

12 Kenneth Anger, *Hollywood Babylon*, New York 1975, p. 196. See Marco Livingstone, *An American in Europe*, exh. cat., Oslo 1998.

13 Walter Benjamin, "The Work of Art in the Age of Mechanical Repro-duction," in: *Illuminations*, trans. H. Zohn, (Glasgow: Cape, 1970), pp. 235–6.

14 Manuscript on yellow lined paper, *Kitaj papers*, UCLA.

15 R.B. Kitaj, "Jewish Art—In-dictment & Defence: A Personal Testimony by R.B. Kitaj," in: *Jewish Chronicle Color Magazine Supple-ment*, November 30, 1984, p. 46.

16 A selection of his commentaries first appeared in Marc Livingstone's monograph *Kitaj* in 1985, and then in the catalog of the Tate Gallery's 1994 retrospective.

17 Leon Wieseltier, *Against identity* (New York, 1996), no. 4.

18 See also: Peter F. Althaus, *Information. Tilson, Phillips, Jones, Paolozzi, Kitaj, Hamilton* (exh. cat., Kunsthalle Basel, 1969), unpagina-ted.

Walter Benjamin is purportedly easy to make out[11] (as early as 1966 Kitaj had made a lithograph of the thinker), though he does not have Benjamin's face but, as a newspa-per clipping in the Kitaj Estate[12] shows, bears the striking head with the high forehead of George S. Kaufman "after winning his second Pulitzer Prize in 1937." Similarly un-mistakable is the expansive gesture by the right hand of the smoking theater critic, playwright and director. With what is his characteristic undercover operation, film en-thusiast Kitaj pays homage to Benjamin's theory of film as "the artwork in the age of mechanical reproduction." According to Benjamin, painter and cameraman are to each other as magician is to surgeon. "The painter maintains in his work a natural dis-tance from reality, the cameraman penetrates deeply into its web. There is a tremend-ous difference between the pictures they obtain. That of the painter is a total one, that of the cameraman consists of multiple fragments which are assembled under a new law."[13]

Thus, Kitaj hopes that in his picture there "would lie, like some secret life, Benjamin's fragmented fascination, on the one hand with early sound film and the mechanical reproduction of art, and, on the other hand, his dismay at (such) erosion of aura in human experience."[14]

Kitaj found in Benjamin's life and work "a parable and a real analogue to the very me-thods and ideas I had pursued in my own painting: a shifting urban complex of film-like fragmentation, an additive free-verse of an art, collected in the political and cultural urgencies of the diaspora Jew (albeit in his moment of greatest peril and horror)."[15]

For Kitaj, from the very outset sources of images and texts, texts in images and text com-mentaries on his images were all inseparably linked. His very first exhibition catalog, which he designed and compiled himself for his first solo show in February 1963 in London's Marlborough Gallery, took as its motto Horace's saying "as in painting, so it is in poetry (Ut pictura poesis)." Only by exchanging thoughts, memories, and feelings with others— with viewers of his pictures, friends with whom he spoke and corresponded, and imaginary partners in conversation—did he succeed in taking this path (see the essay by David N. Myers | p. 113). This is perhaps the reason for his obsessive need to communi-cate, for the wish to comment on his paintings. In 1963 he called his first show *Pictures with Commentary/Pictures without Commentary*.[16] At the same time, his sensitivity to and anger with critics of his work grew, in which he offered insights into how he establis-hed his own identity (see interview with Richard Morphet | p. 195 ff.). Thames & Hudson was supposed to publish the collected commentaries or "Prefaces" as an *Autobiography of My Pictures* and the Kitaj Estate includes the typescript ready to go to print.

Kitaj's artistic method does not focus on identity, as "identity, in other words, is a eu-phemism for conformity. It announces a desire to be subsumed, an eagerness to be known primarily by a common characteristic."[17] Instead, it generates and experiments with ever-new models of possible identities and tries to visualize the complexity of in-sights and statements.[18]

Kitaj's long path as an artist to his understanding of himself as a Jew, to his Jewish-ness or "Yiddishkeit" as it reads in Yiddish, was not without its contradictions and de-tours. For example, he repeatedly concerned himself with his status as an American in England, as in paintings such as *America (John Ford on his Deathbed)* (1983–84) and *America (Baseball)* (1983–4), after Velázquez.[19]

19 Diego Velázquez, *Royal Hunt*, around 1638, The National Gallery, London.

20 R. B. Kitaj, *First Diasporist Manifesto*, p. 31.

21 Leon Wieseltier, *Against identity* (New York, 1996), no. 1.

22 Kitaj, *Second Diasporist Manifesto* (New Haven and London, 2007), #16.

Confessions

When, just short of seventy and living in Los Angeles, Kitaj started to write his memoirs, he noticed how long he had been concerned with Jewish themes and famous persons, starting in Vienna or in Oxford in the 1950s, without him having been aware of the fact. "I've always been a Diasporist Jew, but as a young man I was not sure what a Jew was. ... Jews were Believers, I thought, and I assumed you were whatever you believed in, that if you became a Catholic or an atheist or a Socialist, that's what you were. Art itself was a church, a universalist edifice, an amazing sanctuary from the claims and decrepitude of modern life, where you could abandon self and marry painting. This was, I learned later, a classical assimiliationist pose."[20]

He called his memoirs *Confessions*, alluding to St. Augustine's *Confessiones*. Just as the latter had, twelve years after his conversion, penned a frank analysis of his vices in outlining his thirst for knowledge and his passionate search for God, Kitaj felt compelled to explain to the reader his path to discerning his Jewishness. In part, his *Confessions* read like an ideal biography in the tone of the story of a conversion and salvation, in which the hero has to survive all the adventures and adversities life can throw at him. For all the challenges and temptations of his life at sea as a sailor in the Merchant Navy on the "Romance Run" through the brothels of Latin American ports between Havana and Buenos Aires in the early 1950s, or on the Berkeley campus during group sex with his students in 1968, he remained true to himself in his wish to find his way back to his people as the lost sheep, to the lost roots of his Jewishness. With the means available to him as an artist he seeks to invent a new "Diasporist art," something that no Jewish artist before had done. Yet it was not to be a provincial, confessional, or regional art, but a synthesis, a summary of Modern painting. He thus regards among others Édouard Manet's *Execution of Emperor Maximilian* | p. 235 and Paul Cézanne's *Bathers*, the *Dances* by notorious anti-Semite Edgar Degas, Picasso's *Guernica* (painted in exile in Paris), and Matisse's light-suffused paintings of beaches, as exemplary works of Diasporism and declares their makers honorary Jewish artists. For their works arose from a feeling of "not belonging."

The *Confessions* are no story of salvation and conversion; they remained fragmentary and at the end meander into repetition and obsessions, culminating in brief diary entries. At the end what remains is the insight of Kitaj's friend and confidante Leon Wieseltier: "We call ourselves what we are, but also what we wish to be. This is inspiring and this is corrupting. For the ambiguity allows us to see the one in the other, to mistake what we wish to be for what we are."[21] While seeking his Jewishness Kitaj remains "a deeply religious nonbeliever,"[22] who used the Hebrew Bible, the Talmud, the Kabbalah, and other Judaic religious texts as sources of inspiration.

Name as Stimulator [23]

Kitaj's story starts with his mother's parents. Dave and Rose Brooks were Jewish immigrants from Russia. His grandfather was a member of the Socialist League in Russia, "on the run from the Czarist police. He passed on his religious skepticism to my mother, who brought me up as a freethinker with no Jewish education. Ours was a household full of secular Diasporists who seemed to be Jews only by the way. It would be many many more years before I learned that the Germans and Austrians who did

23 See Dietz Beiring, *Der Name als Stigma. Antisemitismus im Deutschen Alltag 1812–1933* (Stuttgart, 1992).

24 R. B. Kitaj, *First Diasporist Manifesto* (1988), p. 33.

25 R. B. Kitaj, *Confessions*, in: *Kitaj papers*, UCLA, Box 5, folder 1, p. 6.

26 Ibid., pp. 8 and 10.

27 Ibid., p. 14f.

28 Loc. cit.

29 *R.B.Kitaj Retrato de un hispanista*, (Bilbao, 2004), p. 125f.

what they did in that time, when I was playing baseball and cruising girls, made no distinctions between Believers or atheists or the one and a half million Jewish infants who had not yet decided what they were when they got sent up in smoke. One third of all Jews on earth were murdered in my youth."[24]

Then his step-father, Walter Kitaj, came into the equation. In 1938 he was forced to give up his position as a chemist at the University of Vienna and he emigrated to Cleveland, where in 1941 he married Jeanne Brooks, Ron's mother. Kitaj is the Russian word for China—presumably the epitome of the foreign and enigmatic for a youth. He gave this name pride of place over all others, including his first name, and announced that henceforth he wanted to be called not "Ron Brooks" or "Ron Brooks Kitaj," but only "R.B. Kitaj." His closest friends simply wrote "Dear Kitaj."

As a child and a youth in America's Midwest Kitaj lived at a far remove from the places devastated by the Shoah. Only slowly did he start to realize what had happened on the other side of the Atlantic during his childhood and youth.

His step-grandmother, who had had to flee Vienna, was the first to initiate him by persuading him to study at the Vienna Art Academy. "Her sisters, like Kafka's three sisters, had been murdered. It was almost too much to imagine—Third Man Vienna, 5 years after the great murder!"[25]

At this point in time, the Jewish part of his brain is "a vast underdeveloped country, its false virginity clouded with thoughtless thoughts. [...] I was mostly ignorant at age 18, of gents with names like Mahler, Schönberg, Freud, Wittgenstein, Karl Kraus, Musil, Klimt, Schiele, Berg, Webern, Joseph Roth, Gerstl, Loos—not to mention the fascinating Jewish monster Otto Weininger."[26]

His New Freedom

While studying in Vienna in 1951 Kitaj for the first time met a baptized Jew in the guise of Monsignore Leopold Ungar: "One thing that attracted me about this kindly priest was that the good Monsignore was a Jew. [...] I would see how many escapes were thrown open to the Jew in *His New Freedom* **| p. 142** Christianity, Assimilation, Communism, Zionism, Socialism, Modernism, Paris, America, Art, Hollywood, Invisibility and so on and on."[27] Whenever the talk was of a Jew who wanted to appear less Jewish his later friend and mentor declared, "banging his palm on a table: 'A Jew is a Jew like a table is a table'."[28]

From Vienna, in 1953 Kitaj traveled for the first time to Catalonia and in the small fishing village of Sant Feliu de Guíxols he met José (Catalan: "Josep") Vicente di Roma, whom from that point on he would visit almost every year. He admired Josep's search for his Catalan identity, and his critical enquiry into the Catalan language and culture, which he upheld came what may in the face of Dictator Franco's centralism. "The way Josep addressed his Catalan dream inspired and encouraged my own growing excitement in the Romance of Jewish studies. [...] The deepest currents in the history of Judaism were there in the Catalan Province of Gerona [Girona] where I was living and painting and learning to become a new kind of Jew! The Jewish Question was to envelop me in all its splendor and horror... To me, Josep, like St. Teresa, will be Marrano, among whatever else they are..."[29] After Franco's death in 1975, while he was busy painting *Marrano (The Secret Jew)*, he recalls that: "A Catalan cultural free-

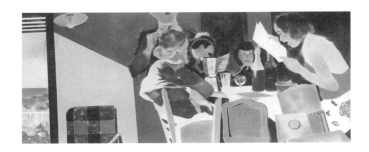

30 *Confessions*, p. 64.

31 See Michael Brenner, 2008, p. 196.

32 *Confessions*, p. 55.

dom would break out when Franco died and even before he died. Josep was thrilled with 'His New Freedom'... and so was I. My own, self-induced Jewish freedom, strange as it would be, was still a few years ahead."[30]

He never parted company with the incomplete portrait *José Vicente (unfinished study for THE SINGERS; 'Los cantantes')* (1972–4) | p. 51, and until his death it stood in his "Yellow Studio" in Los Angeles.

In his pastel and charcoal drawing *His New Freedom* (1978) we can discern these various experiences, the story with Monsignore Ungar in Vienna, and the Josep story in Catalonia. The figure, somehow distorted by the wide mouth that is slightly open so we can see the teeth, and whose sex we cannot guess clearly at first sight, looks through us into an uncertain future. The right hand, somehow a foreign body that is pulling the shirt collar to one side, quotes Giotto's allegory of anger from his series on the vices in the Arena Chapel in Padua. The face borrows from Peter Paul Ruben's portrait of his wife Isabelle Brant. Kitaj came across the unusual mouth in a newspaper clipping that is now housed in the Kitaj Estate. A contrived hand uses a brush to paint an outsized wide mouth with strongly made-up lips on the face of Jackie Kennedy. The montage photo goes with an article from the *Guardian* with the headline, "Only men are beautiful. Sally Quinn talks to makeup-artist George Masters" | p. 28.

In a commentary on it Kitaj writes: "This drawing represents all the new freedoms suddenly attractive to Jews around 1900, such as... Social Democracy, Secularism, Conversion, Assimilation, Art, etc." Here he alludes to the high cost of the new freedoms and rights in the framework of the political emancipation of the Jews in West and Central Europe in the nineteenth century. Assimilation meant Jews became more invisible. The face, frozen into a smile, is a physiognomic expression of the enforced "keep smiling" of the new citizens, whose confessions had now become a private affair. Glorious synagogues in the "Moorish style" arose with organs and rabbis clad like Protestant vicars and the prayers were held in German without reference to a return to Zion.[31]

The Desk Murderer

Until the Eichmann trial in 1961 in Jerusalem the Shoah had been a taboo among victims and perpetrators alike. After reading Hannah Arendt's account of the trial, the first installment of which appeared in the *New Yorker* on February 16, 1963, Kitaj confessed: "That broke the Jewish Ice for me. Not all at once, but through the sixties I would read the classics of what is called Holocaust Literature. Levi, Wiesel, Hilberg, Davidowitz and so on into my Morbid Period. Inch by inch I would proceed, after 1965, a young caterpillar of the universalist pretension of art, treading and reading and plotting softly, to emerge around 1970 as a Jewish butterfly of particularist energies, which might even lead me back or forward to a universal art, beyond good and evil."[32]

The notion of the "desk murderer" coined by Hannah Arendt crops up in the title of Kitaj's painting *Desk Murder* (1970–84) | p. 128. The piece was prompted by the obituaries on SS Obersturmbannführer Walther Rauff (1906–1984) who died in Chile. During World War II Rauff played a major part in developing the "gas trucks" that

33 See Heinz Schneppen, *Walther Rauff: Organisator der Gaswagenmorde. Eine Biografie* (2011).

34 Kitaj, quoted from Marco Livingstone (2010), p. 245.

35 *Confessions*, p. 86.

36 Reproduced in Marc Livingstone, *Kitaj* (2010), p. 12.

37 R. B. Kitaj, quoted from Marco Livingstone (2010), p. 35.

38 Julián Ríos, *Kitaj: Pictures and Conversations* (London, 1994), p. 105.

39 *R. B. Kitaj: A Retrospective*, ed. Richard Morphet (London: Tate Gallery, 1994), p. 132.

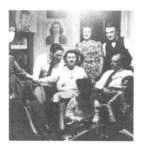

were supposed to replace mass firing squads.[33] For fourteen years, the painting alluded to the Political Police and to Paul Valéry's *Monsieur Teste* with the title *The Third Department (A Teste Study)*. "At last I knew what my odd device was. I had even obliged fate by draping my composition in mourning black and sketching in an unlaid ghost. The murder office is empty and my banal picture of evil, like Rauff, is finished, its purpose, as Helen Gardner said of *The Waste Land*, altered in fulfilment."[34]

For Kitaj, the Six Days War of 1967 was a key experience as it "touched the lives of every Jew in ways very well known. [...] Like millions of other Diaspora Jews, I wondered seriously about going to help... I have come to believe that since the Murder of the European Jews, every Jew is maimed to some degree, larger or smaller. It is that wound or hurt or deformation which, I feel, addresses itself to one's spirit and thus to my own painting. [...] The 6-Day War was the ferocious, existential answer to Eichmann in Jerusalem: Never Again! These have been a few of the things which have helped me declare The Jewish Question which Harold Rosenberg called 'The Tradition of the New.' My Cutting-Edge Question is: Nu Jew?"[35]

Joe Singer as Kitaj's Agent

In order to be able to approach that which could not be represented with painterly means, Kitaj sought a stand-in, whom he found in the form of a friend of his mother (Joe Singer) who stands wearing a waistcoat in the back right of a family photo,[36] | see above, with Kitaj's mother Jeanne Brooks seated in front of him on the floor. In the middle, in profile, we see Dr. Walter Kitaj: "In the late thirties, my mother was dating a guy named Joe Singer. [...] Then my mother told me she had expected him to ask her to marry him but meanwhile she fell in love with a handsome young refugee chemist from Vienna named Kitaj in their group of friends, and married him instead. [...] a figure who would offer a certain secular impression of Jewishness, a representation as it were of a Jewish presence in painted pictures which, it could be argued, was kind of taboo... and, behold, the guy almost became my dad and I almost became R. B. Singer!"[37]

Kitaj sends Joe Singer off as a stand-in to remote places in Europe, and exposes him to past situations that Kitaj himself was spared. Spanish writer Julián Ríos explains: "Joe Singer is your agent, the Jew you send in your place to those dangerous moments of the past, in which you couldn't be present. He could also be a father image or more exactly a father image of all your Diasporist predecessors. He is a versatile figure, changing face in each painting, isn't that so?"[38]

The painting entitled *The Jew, Etc.* (1976–9), which was never finished, | p. 197 can be considered the first Joe Singer personification. It shows a man in a gray suit and an elegant hat in a railway compartment. He is isolated from his surroundings in spatial and acoustic terms—and like Kitaj, as of 1975, he has a hearing aid. "In this picture, I intend Joe, my emblematic Jew, to be the unfinished subject of an aesthetic of entrapment and escape, an endless, tainted Galut-Passage, wherein he acts out his own unfinish."[39]

With Singer, Kitaj for the first time plays through, in exemplary form, what was frowned on, not to say tabooed in Modernist art: the invention of fictitious figures. He

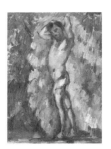

40 *Confessions*, p. 162.

41 R. B. Kitaj, *Paris diary*, in: *Kitaj papers*, UCLA, box 118, folder 16.

himself identifies with the traveling Diasporist, the mythical image of the Wandering Jew, but in concrete terms he portrays the film pioneer D.W. Griffith (1875–1948) on his director's chair, as is evidenced by the image found in the Kitaj Estate in UCLA | p. 156. Kitaj's enthusiasm for film went hand in hand with a love of Hollywood, the dream factory that offered so many Jewish directors and actors from all over the world a safe haven and that was accordingly attacked by anti-Semites in the 1930s. The Joe Singer cycle includes other images between 1979 and 1986 that present different situations in life: *Study for the Jewish School (Joe Singer as a Boy)* (1980) | **see above** and *The Jewish School (Drawing a Golem)* (1980), followed by *Bad Faith (Riga) (Joe Singer Taking Leave of His Fiancée)* (1980) | **p. 161**, and *The Listener (Joe Singer in Hiding)* (1980) | **p. 170**. Then Joe Singer's name crops up on one of the door nameplates in the second-hand book shops in *Cecil Court, London WC2 (The Refugee)* (1983–4) | **p. 140**. Thereupon, Kitaj explains, Joe Singer puts in two other appearances in his images *Germania (Joe Singers's Last Room)* (1987), and *The Cafeist* (1980–7) | **p. 114**.

The Cafeist in Paris between the Jewish Marais and the Drancy Deportation Camp

The picture of the Cafeist (see the essay by David N. Myers, | **p. 113**) at Café Central in Rue Blondel, who meets Joe Singer, references the year that Kitaj stayed in Paris with Sandra Fisher in 1982–3. Following time in Vienna, Oxford (where he met Aby Warburg through his teacher Edgar Wind), Catalonia, and London, Paris was another important stage for the Diasporist on the path to find the traces of his Jewish life. Here, he met Israeli painter Avigdor Arikha and his American wife Anne Atik. Together with them, Kitaj explored the old Jewish district of Marais and, with Anne Atik, visited the suburb of Drancy, the location of the camp for French Jews awaiting deportation to Auschwitz (see *Drancy*, 1984–6 | **p. 160**). Thanks to them, wrote Kitaj, "my Jewish quest took an intense turn in diverse ways." They became: "my live Jewish Paris. In Paris my Jewish Mishegoss [Yiddish for craziness, E. G.] exploded in my brain and heart. Arikha, the Survivor of Transnistria, the hellhole where the gifted Bukovina Jews were deported to, listened to Kol Israel every day, with me eager to hear the latest news of Jews and Arabs tearing each other's hearts out. Bekka, Sabra-Chatilla, Beirut. Jews in deep trouble as usual."[40] The Arab-Israeli conflict caught up with them in distant Paris. Goldenbergs, a Jewish restaurant in Marais where they often met, was targeted in a bomb attack.

In 1984–6 Kitaj painted *Notre Dame de Paris* | **p. 169**, a painted sum of his Parisian impressions as a dream image in which Christian and Jewish symbols, legends and allegories interweave. The composition is based on the Fra Angelico (1395–1455) painting *Dream of Innocent III* that tells the story of an episode from the legend of St. Dominicus (which usually is attributed to St. Francis of Assisi). The pope dreams that the Cathedral of Rome, the mother church of Christendom, threatened to collapse, but a monk held up the swaying walls with his naked hands. The pope recognizes Dominicus whose teachings save the church from breaking down. Fra Angelico captured this scene in a bold composition that Kitaj adopts in its entirety. The left side of the painting shows the tripartite Renaissance facade of the swaying church. Fra Angelico placed the sleeping pope in a partially open pavilion on the

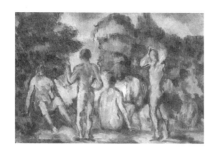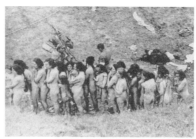

right in the background with a tower-like rotunda in front of him. Kitaj takes the same transparent structure, excludes the pope, and places the structure outside Notre Dame Cathedral, inspired by the Henri Matisse painting *Une Vue de Notre-Dame* of 1914 | **p. 133**.

Kitaj then has two paths, as the paths of life, run across the forecourt; the one zigzags across the plaza, the other is direct "from and upon which men stray toward 'sin'... as if there might be a better or 'right' or 'good' path. I have no idea if there be such a path but I rather enjoy listening to advocates of either way."[41] Kitaj's paths likewise ran from his studio flat in Rue Gallande past Notre Dame to the painted women in Rue St. Denis. He projected his painting *The Room (Rue St Denis)* (1982–3) | **p. 133**—a room the size of the red bed—onto the vaguely discernible façade of the Cathedral of Rome from Fra Angelico's painting. And now, on the red counterpane, lies a naked woman. This insight is accompanied by a man with the head of a bird who takes the place occupied by St. Dominicus in Fra Angelico's painting, as well as a prostitute with a bird's head who leans out of the window on the right. Here Kitaj is ironically quoting "the famous Haggadah called the Bird's Head Haggadah,[42] from the Middle Ages, which gives each painted figure a bird's head in order to circumvent the Second Commandment (against idolatrous graven images)"[43] | **p. 131**.

Commenting on the picture, Kitaj writes about "sin" in Judaism and his relationship to sexuality, which the Catholic Church considers a sin if not practiced for the purposes of reproduction. And he quotes Orthodox Rabbi Adin Steinsaltz[44] on sin in the Jewish faith: "Sin, from this (Jewish) point of view, is thus primarily an act (by deed or default) of rebellion. The sinner is one who will not obey, one who, on account of external or internal factors, refuses to accept the 'sovereignty of heaven' and prefers a different kind of rule, whether it be that of other men, other gods, or his own appetites."[45]

In Paris he jotted down his thoughts on being Jewish in his diary on July 21, 1982: "One stands almost alone; One has been largely despised for how many thousand years; One is subversive; One can hardly keep mum or cool it; One is aggressive and not allowed to be... Emancipated [...] There's a Modern Life in it all, modern temper [...]." That same day he concluded: "The English are not Krauts, but I just don't know if I can live among them any longer. S [Sandra] tells me not to dwell on that." [46] For all his doubts and thoughts of moving to the United States, Sandra and Kitaj resolved to return to London and chose a high Jewish wedding in London's oldest synagogue, the Bevis Marks Synagogue (see the painting *The Wedding*, 1989–93 | **p. 155**). Kitaj became a member of the Jewish community, but only for a short time in order to be able to marry.

"Sensualist" and Bather

In 1984, after the wedding in London, Kitaj painted his self-portrait *The Sensualist* (1973–84) | **p. 150**, trying out a new form of painterly expression. In a commentary on *The Sensualist* Kitaj explained he had painted a woman "the other way round. You can still see her pink head upside down at the bottom." The female head of 1973 was still defined by the precise "painted drawing" of fine layers of wash-like paint of the early 1970s, such as Kitaj had used for the Benjamin picture, in *Marrano* or The New Freedom. These wash-like oil paintings and pastels were influenced

42 In the Kitaj Estate there is a sheet showing a singing figure with a bird's head and cape at a lectern with a musical score on it, from the Bird's Head Haggadah, Germany, 14th century. See p. 131.

43 Ríos, *Pictures and Conversations* (1994), p. 155.

44 Adin Steinsaltz, *Sin*, in: *Kitaj papers*, UCLA, Box 96, Folder 5.

45 Adin Steinsaltz, in: Kitaj, *Autobiography of my Pictures*, typescript, c. 1989, p. 84, *Kitaj papers*, UCLA, Box 126, Folder 8.

46 *Paris diary*, in: *Kitaj papers*, UCLA, Box 118, Folder 16.

47 Titian, *The Flaying of Marsyas* (c. 1570–6), oil on canvas, 212 x 207 cm, Kromeríz, Státni Zámek, Czech Republic. The painting was on show at the Royal Academy when Kitaj painted *The Sensualist*.

48 Edgar Wind, *Pagan Mysteries in the Renaissance* (London: Faber & Faber, 1958).

49 Sarah Greenberg, interview with Kitaj for the Royal Academy Magazine.

50 "R.B. Kitaj in conversation with Colin Wiggins," in: *Kitaj in the Aura of Cézanne and Other Masters*, ed. Kate Bell (London: National Gallery Company, distributed by Yale University Press, 2001) pp. 7–51 (here p. 14).

by his study of Degas' oeuvre. Together with painter Sandra Fisher in the early 1970s Kitaj again drew after life, and amalgamated the schematic, abstract modules and quotes of his collage work in the 1960s with new, authentic portraits and observations from nature.

Ten years later Kitaj painted the semi-nude figure of the sensualist over the silhouette of a woman's head, the man walking at night past the prostitutes on a garishly lit street. He abuses the figure with coarse but careful brushstrokes, as Georg Baselitz did with his outsized wooden figures and was prompted to do so by the new Germany painting, that Kitaj felt was at long last self-confident and had started to focus on its own history (see the essay by Martin Roman Deppner | p. 105).

Kitaj's adaptation of Titian's *The Punishment of Marsyas* can be seen in this context.[47] Edgar Wind suggests the competition between Apollo and Marsyas is that of Dionysian darkness versus Apollonian clarity; it ends with Marsyas' flaying, "because this act itself was a Dionysian rite, a tragic and tortuous purgation that strips all ugliness from the outer man to expose the beauty of the inner self."[48]

In line with the ancient myth of man's double nature, Kitaj portrays the Sensualist as a restless nocturnal creature, driven by sensuality, out hunting for women, yet—in the footsteps of Warburg, Wind, and Panofsky—searching for intellectual clarity and aesthetic beauty. Asked what the meaning of the "Sensualist" was, Kitaj answered: "Sensualist means Sensualist: driven by a life of the senses. Look it up! In Munch's wandering years it meant Sex, Drink and Bohemia driven by and to his fantastic psychological, even psychotic, art leading to breakdown and renewal. Recalcitrant means recalcitrant: kicking against established, philistine, correct behavior. Look it up! In Munch it also meant incorrect art, hated by critics."[49]

With his bent posture, the half-naked "sensualist" with the red face and round glasses references an affinity to Paul Cézanne's famous *Bathers* | p. 91. Kitaj himself points out that, when painting over the female figure, of which only the head remains visible, he was inspired by *Le Grand Baigneur* (around 1885) | p. 150. The latter faces the viewer frontally, hands on hips, viewing his reflection in the water. Kitaj combines him with *Un Baigneur* (1879–82)| p. 90, who stands completely naked, his arms behind his head. In an interview Kitaj recollects how a "Cézanne madness crept upon me... I began to graduate from Degas, my favourite drawing master, to Cézanne, my favourite painter."[50] With this change in role models, Kitaj completes his transition from painting based on drawing and wash to an impasto expressive style instead.

Kitaj was forever fascinated by Cézanne's *Bathers*—and also irritated by them, less as harbingers of twentieth-century abstract art and more as representations of borderline figures who reflect their creator's disturbed self-image, not in harmony with nature but as a foreign body inserted into it. In *The Sensualist*, Kitaj construes himself as the unredeemed earthly Marsyas who seeks a higher spiritual sensuality. Kitaj speaks of "those clumped, hurt, awkward stilted bathers, with webbed feet, no ankles, moronic heads, slipping features."[51]

The Sensualist was preceded, as of 1978, by a series of bathers: all of them pastels with the exception of *Bather (Tousled Hair)* (1978) | p. 145, *Bather (Torsion)* (1978), *Bather (Wading)* (1978), *The Sailor (David Ward)* (1979–80) | p. 144, and *Bather (Psychotic Boy)* (1980). "All are 'estranged' figures; one, subtitled 'Torsion' is derived from

51 "Kitaj interviewed by Frederick Tuten, "Neither Fool, Nor Naive, Nor Poseur-Saint: Fragments on R.B.Kitaj," in: *Artforum* (New York), January 1982.

52 Timothy Hyman, "R.B. Kitaj: The Sensualist 1973-84," *For Art* (1991), no. 1, vol. 1, Oslo.

53 See Juliet Steyn, *The Loneliness of the Long Distance Rider*, typescript in the Kitaj Estate, p. 9.

54 *R. B. Kitaj: A Retrospective*, 1994, p. 218.

55 Steyn, op. cit., p. 9.

56 Page 191 of the brochure. Sonderkommando 4a, the staff unit of Einsatzgruppe C and two units from Polizeiregiment Süd, supported by the 6th Army, executed 33,771 Jewish men, women and children in the gorge of Babi Yar (Women's Gorge) on Sept. 29-30, 1941 on the outskirts of Kiev. The reverse shows a primitive gas chamber: "Foundation Hackenholt."

57 Kitaj, "Jewish Art—Indictment and Defence," in: *Jewish Chronicle*, Nov. 30, 1984, p. 46.

58 Kitaj, manuscript, *Kitaj papers*, UCLA.

a falling figure in Michelangelo's 'Last Judgement', and the general sense of all of them is of an awakening to dread."[52]

Kitaj called the best-known of these sheets *The Rise of Fascism* (1979–80) | p. 146, in which three women (in the tradition of the Three Graces but completely isolated from one another and without any relation to the distant beach) each occupies a space. Only the black cat (ostensibly a concealed reference to Manet's *Olympia* and the exploitation of female sexuality by men through prostitution[53]) at the lower edge of the picture connects the trio. The naked young woman who has Sandra's profile on the left, who provocatively offers up her sex to the viewer, is "the beautiful victim, the figure of fascism is in the middle and the seated bather is everyone else. The black cat is bad luck and the bomber coming over the water is hope."[54] Asked why he chose a middle-aged woman to personify fascism Kitaj answered: "the central figure is a typical hausfrau, a petite-bourgeois, a representative of that class which was the bed-rock of Nazism."[55] The two young women embody the victim and indifferent passivity in the face of violence. The older woman's black bathing costume contrasts with the red stockings of the woman staring, astonished, at the fascist danger—she literally has her hands in her lap. The red horizon and the blackened heavens evoke an apocalyptic mood.

There is a brochure on the Shoah with English explanatory texts dating from this period in the Kitaj Estate. Above the famous photo of naked women waiting to be shot to death in the Babi Yar gorge, Kitaj penned "Bathers!"[56] | p. 91. Initially, the term seems extremely odd, and it is possible that Kitaj uses it to reference the crime to Cézanne's vain artistic attempts to represent a paradisal original state of harmony in his paintings of bathers. Yet Kitaj sticks to his guns, declaring he would "do Cézanne and Degas over again after Auschwitz."[57]

The humiliated naked women in the photo in the midst of a river-shore setting that was to become a hellish ravine is also the theme of Kitaj's painting *If Not, Not* (1976) | p. 138. At first sight the image evokes a paradise-like landscape with palms and waters beneath skies ablaze with Bengali light. Kitaj said that he was inspired by *Le Bonheur de vivre* (1905–6) by Henri Matisse (quote by Kitaj in the middle right as a bright yellow and greenish miniature park) and Giorgione's *La Tempesta* | p. 67. On closer inspection one notices stranded persons scattered all over the picture, crawling on their bellies, lying on their backs, including (complete with hearing aid and gray suit, and supported by a naked woman) Kitaj's alter ego, Joe Singer, of *The Jew Etc.* Along with a human head the ruins of civilization float on the oil-sullied waters of a river. Above the miserable scene, like the gates to Hell, towers the gatehouse at Auschwitz. Kitaj was inspired in some of the details by T.S. Eliot's somber *The Waste Land* and wrote: "I've only played upon some of the many strings of this wonderful poem, so difficult, still so modern, always so elusive as it makes its way through many histories, public and personal. You must look up for yourself the general grounding of the poem in the Grail Legend and Eliot's other sources."[58]

The composition disintegrates into countless individual scenes and incoherent fragments, following Eliot's verses that describe a landscape out of kilter: "A heap of broken images, where the sun beats,/And the dead tree gives no shelter, the cricket no relief/And the dry stone no sound of water [...]"[59]

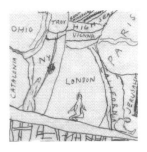

59 T.S. Eliot, *The Waste Land*, 1922. The reference in his notes on the poem to Jessie L. Weston's book on the Grail legend *From Ritual to Romance* draws a line to the painting that Kitaj borrowed from the work of Ralph E. Giesey, *If Not, Not. The Oath of the Aragonese and the Legendary Laws of Sobrabe* (Princeton University Press, 1968). The oath of the Aragonese people was: "We, who are worth as much as you, take you as our king, provided that you preserve our laws and liberties, and if not, not." In this way, Kitaj points to the Nazis' rupture of law and of civilization.

60 *R. B. Kitaj: A Retrospective*, 1994, p. 221.

61 Livingstone, 2010, p. 253.

Looking back on the Topography of his Life and forward to his new Babylon, Los Angeles

In 1989 Kitaj had a mild heart attack, followed by symptoms of depression. That year he noticeably painted various pictures with titles such as *Melancholy, Melancholy after Dürer, Up all Night (Fulham Road),* and *Burnt Out*.

The physical and mental crisis prompted him to paint a picture that takes first stock of his Diasporist life thus far: *My Cities (An Experimental Drama)* (1990–3) | **p. 210**: "The three main actors represent myself in youth, middle age and old age. Behind them is a drop-curtain inscribed with historiated capital letters of cities where I've lived or loved. Over the course of a few years these capital letters... have been sublimated by white paint... The idea for the painting comes from a page... of the old American magazine *Theater Arts*, showing a scene from what is described as 'an experimental drama'.... The catwalk stage upon which the figures tread and stumble through life becomes the roof of a baseball dugout in which I've tried half-heartedly to draw some of my demons..., colorless specters only thinly isolated from the three leading players above as in a predella."[60]

The theme of the three stages of life on a sloping catwalk is also to be found in a drawing he made on serviettes during his daily visit to cafés | **see above**. In the background Kitaj has charted the most important places and countries in his lifelong wandering: on the top left Ohio, where he was born, and next to it Troy, N.Y., where he went to high school before becoming a sailor on the high seas. Beneath this is Vienna; above it Darmstadt, struck through (he was stationed there briefly as a GI before being posted to the US Army European HQ in Fontainebleau). At the center lies his main residence for thirty-nine years, London, flanked by New York and California. On the far left and far right are Catalonia and Jerusalem, the places he yearned for.

With his personal "Tate War" which he waged in 1994 against the critics of his retrospective in the Tate Gallery (see Cilly Kugelmann in conversation with Richard Morphet | **p. 195**), the sudden death of his wife Sandra, and his farewell to London in 1997, the final chapter of Kitaj's life started in Los Angeles (see Tracy Bartley).

There, between 2000 and 2003, Kitaj painted 29 "Los Angeles Pictures", depicting a pair of naked lovers in erotic and lovingly tender situations, in part under palms and at the pool. His swimming pool outside the "Yellow Studio" is the object of two paintings, the titles of which he chose to reflect Henry David Thoreau's classic escape-to-nature account written in 1854: *My First Pool (Walden)*, 1998, and *My Walden (Yellow Studio)*, 1997-2000 | **p. 95**. The house and studio in Westwood become a haven to which Kitaj escaped, a place to which the "hermit painter" (as he called himself in a commentary on his two pool pictures) could withdraw.[61] Los Angeles itself, that hypertrophic garden city, becomes the Garden of Eden, in which Adam and Eve, the primordial couple in the man/woman drama, take the stage once more.

Here, for the last time Kitaj references Cézanne's bathers, in particular the legendary last three versions of the *Les Grandes Baigneuses* (*The Large Bathers*, Barnes Foundation in Merion, Philadelphia Museum of Art and National Gallery London), on which Cézanne worked from 1895 until his death in 1906 without being able to "complete" it. In response to the National Gallery's invitation to select paintings that were inspired by Old Masters in the gallery, Kitaj decided in favor of the London version of *The*

62 *Confessions*, p. 289 ff.

63 Aaron Rosen, pp. 92–5.

64 Peter Gay, *Freud: A Life for Our Time*, New York 1987.

65 Freud to the members of B'nai B'rith, undated [6 May 1926], letters, p. 381, quoted from Gay, pp. 675, 677.

66 *Confessions*, p. 329.

Large Bathers and presented it alongside the first seven versions of the Los Angeles pictures in 2001 in the exhibition *Kitaj in the Aura of Cézanne and other Masters*.

In this set of works, the theme of the bathers no longer interested him, as he turned his attention to the "lovers" as a motif (unfinished, 2001), a painted prologue that constitutes a frieze of figures very much influenced by Cézanne's bathers. "Then, like a shot, it came to me: Lovers would be Sandra and me. I would cast us as Angels – beings more than 'real' – Los Angeles – OK, sur-real. Sandra emerged into my life again from the dark of our loss into the bright lights of my (our) art. No more tears: she's back..."[62] In the sense of Warburg's interpretation of the Apollo-Marsyas myth, Kitaj left an earthly sensuous life behind him by bidding Europe farewell and nurturing a Platonic "heavenly" love for Sandra.

In his paintings, even during his final years in London, Kitaj was busy developing an "old style" as he put it: an open, almost sketched manner of painting, comparable with Cézanne's non-finito. Painting becomes a process of exploring the possible ways of expressing his "Jiddishness," of finding a response to the Jewish question, which he compares to the "Promised Land" in a text written in 2002 and now in the Kitaj Estate. He writes "of two Jewish Angels, painted by a Jew in the 3rd largest Jewish community in the world, (after N.Y. and Tel Aviv), and endowed with many Jewish attributes, proclivities and sources..." Analogously to the Talmud, in which we read "the Shekhinah followed the Jewish people into exile after the destruction of the First Temple,"[63] Kitaj believed that Sandra, as the female presence of God, would follow him to his personal Babylon of Los Angeles.

In the closing years of his life, Kitaj also sought for answers to the question of his Jiddishness in psychoanalysis. After the Los Angeles Pictures he produced the paintings *Ego*, *Super-Ego*, and *Id* | p. 222/23. When reading Peter Gay's monumental Freud biography, as he records in his diary in January 2004, Kitaj identified with Freud's position of the unbeliever who can also get nothing from the national pride of Zionism but who never denied his membership of the Jewish people.[64] For Freud being a Jew meant possessing "many dark powerful feelings, the more powerful, the less they can be grasped in words." On the other hand, he saw himself as a Jew "free of many of the prejudices that limit others in the use of their intellect."[65]

The method of psychoanalysis as the "Jewish science" becomes a secular religion for Kitaj: "In psychoanalysis, Freud is analyzing a human being as the Jews have for centuries been analyzing Torah!" He considered the Jewish question in a diary entry of January 15, 2004 as a psychological matter. In *Confessions* it became clear to him "that my strange commentaries could be likened to a kind of Psychoanalysis, or even self-analysis. My painting becomes the Analysand and my commentary becomes a Case-History! Because I am Jewish Art, it keeps coming to me through the ether."[66]

Warburgian Artist: R. B. Kitaj, Edgar Wind, Ernst Gombrich, and the Warburg Institute

Edward Chaney

1 From Fritz Saxl's lecture on "Warburg's Visit to New Mexico" as quoted by Kitaj in *Pictures with Commentary: Pictures without Commentary* (London: Marlborough Fine Art, February 1963), p. 8.

2 See the correspondence in the Registered Packet in the National Portrait Gallery, London, no. 5892. I reproduced this portrait in "Kitaj versus Creed," *The London Magazine*, April/May 2002, pp. 106–11.

3 A typed memo dated June 18, 1986 in the NPG file records a phone message from Gombrich that "His wife feels that she wishes to see one of Kitaj's portraits before they go ahead." It thus seems they may not have known Kitaj's *Jewish Rider*, a recent portrait of Gombrich's former pupil Michael Podro.

"Symbolic forms are coined in the depths of human experiences..." [1]

In the summer of 1986, after almost a year in which it had proved impossible to arrange a sitting with Lucian Freud, the National Portrait Gallery commissioned Kitaj to depict Professor Sir Ernst Gombrich, Director of the Warburg Institute from 1959–1976[2] |p. 100. Kitaj's particular appropriateness for this task was probably not as clear to the commissioners, or indeed to Gombrich himself (whose wife, Ilse, asked to see examples of the artist's work before committing), as it would have been to the artist.[3] For Kitaj's entire aesthetic, based as it was in symbolic forms and an intensely personal iconology, was profoundly indebted to Aby Warburg and the legacy associated with the institution he created in Hamburg, which in 1933 relocated to London. Interviewed in 2000, Gombrich took partial responsibility for what he eventually regarded as the failure of his portrait:

"On the second day of our sittings the first sketch showed a happy grin. I should not have intervened, but I asked him to wipe it off my face, and as a result, to my mind the features have no coherent expression at all."[4]

It could in fact be argued that the somewhat suspicious half-smile that survives in the completed portrait makes it all the more memorable as a work of art. Though politely describing it to the director of the NPG as "splendid" in October 1986, however, Gombrich clearly didn't like the image, and his wife liked it even less.

Gombrich's critical response may perhaps have related to his discovery of both the extent and nature of Kitaj's enthusiasm for Warburg, and the fact that Kitaj's introduction to Warburgianism had been at the hands of the latter's devoted disciple Edgar Wind, who in 1971 had reviewed his *Intellectual Biography* of Warburg so negatively.[5] Although both parties seem to have enjoyed the nine two-hour sittings, it is clear from Kitaj's recollection of their conversation about "modern aspects of Jewish history" that Gombrich would have realized the extent to which it was due to the influence of Warburg, Wind, and Fritz Saxl, as well as perhaps to that of Sigmund Freud and Walter Benjamin, that Kitaj had come to embrace his own Jewishness and what he identified as a distinctively Jewish cultural legacy.

Gombrich's distancing of himself from what Kitaj regarded as their common heritage may have been of a piece with the relative lack of status he accorded Robert Vischer's 'Einfühlung' or 'empathy' (in both an aesthetic and a more commonplace sense): an ingredient that Wind criticised as inadequately covered in his Times Literary Supplement review of Gombrich's intellectual biography of Warburg after its publication in 1970.[6] At the deepest level his relative lack of empathy for Warburg may have been a result of his discomfort with the irrational in general and his predecessor's mental instability in particular—what Wind euphemistically referred to in his review as 'the more volatile side of Warburg's personality.[7]

Gombrich would explain his own position in a lecture he delivered in November 1996 on being invited by the Austrian Cultural Institute in London to speak about Jewish influences on the visual arts at a seminar on "Fin de Siècle Vienna and its Jewish Cultural

4 National Portrait Gallery, London, Registered Packet, typescript note to item 5892.

5 *Times Literary Supplement*, 25 June 1971, p. 735; reprinted in E. Wind, *The Eloquence of Symbols*, ed. J. Anderson (Oxford, 1993), pp. 106–113.

6 'Unfinished Business: Aby Warburg and his Work', *Times Literary Supplement*, 25 June 1971, p. 735, published anonymously but reprinted in Wind's *The Eloquence of Symbols* (Oxford, 1983), ed. Jaynie Anderson, pp. 106-13. See Charles Hope's review of the latter and subsequent correspondence: 'Naming the Graces', a review of Kenneth Clark's *Art of Humanism* and Wind's *Eloquence of Symbols*, *London Review of Books*, vol. 6, no. 5, 15 March 1984, pp. 13-14. Subsequent correspondence includes Gombrich's reference to 'the book [Wind] found it his duty to drag through the mud.' *LRB*, vol.

6, no. 6,5 April 1984; see http://www.lrb.co.uk/v06/n05/charles-hope/naming-the-graces.

7 *TLS* review as reprinted in Wind's *Eloquence of Symbols*, p. 113.

8 E.H. Gombrich, *The visual arts in Vienna, circa 1900; &, Reflections on the Jewish catastrophe*, Preface by Emil Brix (London: Austrian Cultural Institute, 17.11.96), vol. 1, p. 40 [1997].

Influences." He responded angrily but agreed to participate with a talk that included the sentence: 'Of course I know many very cultured Jews, but, briefly, I am of the opinion that the notion of Jewish Culture was, and is, an invention of Hitler and his fore-runners and after-runners.'[8] If Kitaj read this essay he would not have ceased celebrating what he regarded ever more enthusiastically as the great Jewish contribution to Western civilization—least of all because Hitler had chosen to exploit racial distinction to such evil ends. His attitude accords more closely with what recent scholarship attributes to Warburg himself: that his life's work was a culturally positive response to anti-Semitism.[9]

In this identification with his Jewish origins, as in his temperament more generally (including a tendency to manic-depression), Kitaj resembled Warburg. He embraced a high-risk philosophy of life and art that perhaps inevitably acknowledged a wide range of emotions and an imaginatively diverging, occasionally tragic, Apollonian and Dionysian dualism.

Recalling his time at the Ruskin School in Oxford in the late 1950s, Kitaj acknowledged his debt to Edgar Wind in the following terms: "Wind led me to his master, Warburg, who died semi-mad in 1929 and Warburg led me to his legatees—Panofsky, Saxl, Bing, Wittkower, Otto Pacht, the younger Gombrich and all the rest."[10]

He continues: "If Freud's circle and work can be thought of, by friends and enemies alike, as Jewish Science, then the Warburg tradition and persuasion is also Jewish, in ways not yet explored." This linking of Freud and Warburg is surprisingly rare, despite their knowledge of each other and common sources in Lessing and perhaps even Charcot, where the concept of *Pathosformel* was concerned.[11] Freud's 1907 essay "Der Wahn und die Träume in W. Jensens 'Gradiva'" also suggests common interests, if not inter-influence, examining as it does the profoundly empathetic effect on a (fictional) archaeologist of an antique relief in the Vatican depicting a dancer of the type that Warburg claimed influenced Botticelli, and resembling one of the Maenads that so fascinated him and his followers.

One way or another, from his student days in Oxford until his death in Los Angeles half a century later, Kitaj referenced every major figure in Warburg's *Nachleben*. Where the Institute in particular was concerned, however, the relationship got off to a slightly tense start early on in Gombrich's directorship. As a thirty-year-old rising star in London's artistic firmament, in 1963 Kitaj complained in the catalog of his first major exhibition at Marlborough Fine Art that 'The Warburg Institute has refused permission to reprint Saxl's lecture on Warburg from which I have quoted in the notes to my paintings.'[12] In the extended caption to the work he completed in collaboration with Eduardo Paolozzi, *Warburg's Visit to New Mexico*, Kitaj quoted long excerpts from Saxl in any case, concluding his preface with an excerpt from Deputy Director Gertrud Bing's *Memoir* of her late partner on "the laziness of heart that hides behind red tape."

Kitaj knew Bing as a near neighbor in 162 East Dulwich Grove, Dulwich, whence she had moved with Saxl in the 1930s. In 1959, on gaining a place at the Royal College of Art, he, his wife Elsi, and their infant son Lem moved from Oxford to 27 Pickwick Road, Dulwich. Thanks to the success of his Marlborough exhibition, from which John Rothenstein bought *Isaac Babel Riding with Budyonny* for the Tate, the Kitajs were able to send Lem to Dulwich College and move to a larger house in nearby Burbage Road,

9 Charlotte Schoell-Glass, *Aby Warburg und der Antisemitismus. Kulturwissenschaft als Geistespolitik* (Frankfurt am Main: Fischer, 1998) and *Anti-Semitism: Political Perspectives on Images and Culture* (Wayne State University Press, 2008). Warburg described himself as "ebreo di sangue."

10 *Confessions*, p. 36.

11 Mary Bergstein, *Mirrors of Memory Freud, Photography, and the History of Art* (Ithaca: Cornell University Press, 2010), p. 96.

12 *R.B. Kitaj: Pictures with Commentary: Pictures without Commentary* (London, 1963), p. 3.

13 Marco Livingstone, *Kitaj*, 4th ed. (London, 2010), p. 21. There is a photograph of the young family outside the house taken in 1962 by Lord Snowdon.

14 *Confessions*, p. 43

15 *Confessions*, p. 33.

16 Information kindly supplied by Elayne Trapp. When the Kitajs left 131 Burbage Road they sold it to the great Michelangelo scholar, Johannes Wilde.

17 Livingstone, *Kitaj*, p. 15.

where they remained until 1967.[13] "For some reason," Kitaj writes in his *Confessions*: "Dulwich village had attracted Warburg scholars. The very interesting Fritz Saxl, whose lectures I still dip into 40 years later, lived and died there in leafy refuge from Hitler, as did Gertrude Bing, director of the Warburg Institute in Woburn Square. When I would visit her, she would exclaim: 'But you know so much about us!' as if she belonged to a secret society, which the Warburgers were as far as Modern Art was concerned. I would try to change that and my enemies marked it down in their deathly little notebooks: Kitaj the pretentious, obscurantist exegete."[14]

Kitaj must also have known that his former teacher, the Ruskin Master of Drawing at Oxford, himself a former pupil of Sickert, Percy Horton and his wife lived at 11 Pond Cottages on the other side of the Picture Gallery, their cottage being subsequently acquired by his neighbor, James Fitton RA. In his *Confessions*, Kitaj recalled that it was Horton "who really turned me on to Cézanne as well as insisting on regular life drawing."[15] **|p. 102**. Finally, by "Warburg scholars" Kitaj may have been thinking of yet another Jewish exile, Leopold Ettlinger, who worked at the Warburg Institute in this period. Ettlinger and his second wife, Madeleine, actually lived in Burbage Road, the same street as the Kitajs in the early 1960s, before migrating to America.[16]

Given the increasingly fraught state of the relationship between those who ran the Warburg Institute after it settled in London and Edgar Wind—who, with Saxl and Bing, had been responsible for relocating it in the early 1930s, and who, with Rudolf Wittkower, founded and edited the *Journal of the Warburg Institute*—it is likely that Bing's expression of surprise at Kitaj's knowing so much about them included an element of concern that Wind may have prejudiced him against them.

Introducing the young Kitaj to the ideas of Aby Warburg in early 1958 soon after he arrived in Oxford, Wind no doubt communicated to him something of his sense of ownership of Warburg's legacy, and a corresponding sense of his exclusion from the Institute in its post-War manifestation.

Remembering this period Kitaj wrote:

"Iconological studies had caught my interest by the time I was eighteen or so in New York. I had read into Panofsky long before I heard of Wind. You see, it was the *weirdness*, the unfamiliar ring of so much of the 'art' they would use to illustrate their theses... these studies, with their fabulous visual models and sources in ancient engravings, broadsheets, emblem-books, incunabula, were like buried treasure! [...] So—one of the first turn-ons had been purely *visual*... appropriate, after all, for a painter... But, of course, there were, for me, ideological discoveries in those obscure readings... It dawned on me that here were people who had spent their lives re-connecting pictures to the worlds from which they came."[17]

In 1937 Wind contributed an article to the first issue of *The Journal of the Warburg Institute* entitled "The Maenad under the Cross." He begins by quoting: "perhaps the shrewdest advice Sir Joshua Reynolds gave his students... that they should take hints from ancient masters and employ them 'in a situation totally different from that in which they were originally employed'." In expounding this rule, Wind writes, Reynolds hit upon "'a fundamental law of human expression'." He follows this with Reynolds's example:

"a figure of a Bacchante leaning backward, her head thrown quite behind her, which seems to be a favourite invention, as it is so frequently repeated in bas-relievos, cameos

18 *Journal of the Warburg Institute*, I (1937), pp. 70–71.

19 Ben Thomas points out to me that this may not be true, as Darwin had already referred to it in *The Expression of the Emotions*.

20 *R. B. Kitaj: A Retrospective*, ed. Richard Morphet (London, Tate Gallery, 1994), p. 84.

21 *Journal of the Warburg and Courtauld Institutes*, Vol. XXIII, 1–2 and Livingstone, *Kitaj*, pp. 15–16.

22 I am very grateful to Ben Thomas for a copy of his unpublished lecture, "An Art Historian's Dilemma," which makes it clear that Wind's negotiations in America strengthened Saxl's hand in negotiating the Warburg's incorporation into the University of London.

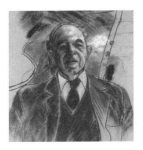

and intaglios; it is intended to express an enthusiastic frantic kind of joy. This figure Baccio Bandinelli, in a drawing that I have of that Master, of the Descent of the Cross, has adopted... for one of the Maries, to express frantic agony of grief. It is curious to observe, and it is certainly true, that the extremes of contrary passions are with very little variation expressed by the same action."[18]

Wind continues to explain that:

"Some time ago, the late A. Warburg, without knowing of this passage in Reynolds' Discourses... collected material which tended to show that similar gestures can assume opposite meanings. The pagan figure of the dancing maenad was the central theme of these studies, and their most poignant chapter contained the story of how Bertoldo di Giovanni, the early Renaissance sculptor, transformed the maenad into a Mary Magdalene moaning under the Cross."[19]

It may have been this article that inspired Kitaj to depict *Warburg as a Maenad*. | p. 23 Certainly the Maenad motif inspired the disturbing figure to the right of the major picture he did in the wake of his 1963 success at the Marlborough Gallery, *The Ohio Gang* (1964) | p. 57. In one of those detailed commentaries that the Tate perhaps injudiciously encouraged him to write for his 1994 *Retrospective*, Kitaj explained: "I was still under the Warburg spell in those early sixties and the Maenad-Nanny at the right is a memory of those pre-Christian wraiths the Warburgers detected at the base of crucifixions in art." Then, illustrating the way in which he brought together the archetypal with the profoundly personal in his pictures, he continues: "She is pushing a homunculus-manikin because I'd just bought a pram for a second child, who died at birth as I began this painting."[20]

From the second *Journal*, dated 1938–9, Kitaj derived his images of an obelisk and monument to Frederic the Great which illustrate Alfred Neumeyer's article on "Monuments to 'Genius' in German Classicism" for *The Murder of Rosa Luxemburg* (1960) | p. 20. Wittkower's 1942 article on "Marvels of the East" in Volume V of the *Journal* inspired motifs in several of Kitaj's early pictures, including his *Pariah* of 1960 and two 1962 images, *Welcome Every Dread Delight* and the *Isaac Babel* Riding with Budyonni | p. 32. That he subscribed to the Journals as they appeared is indicated by the fact that he used the surreal medieval figure of the silenced "Nobody," from an article in the 1960 *Journal* by Gerda Calmann in two pictures dating from the following year.[21]

Meanwhile, in 1939 Wind had left London for America, promoting the Warburg project there. Once war was declared he prepared for the possibility that the Institute would relocate to America.[22] From surviving correspondence it is clear that, although some felt that Wind had deserted the Institute, he was nevertheless expected to succeed Saxl as Director. Disagreements regarding teaching methods, relative status and salaries followed, however; and by the time Saxl died in 1948, Bing proposed that Henri Frankfort should be appointed.[23] When Frankfort suddenly died in 1954, Wind offered his services, but Bing's response was lukewarm and within a few weeks it emerged that she herself would succeed, to be succeeded on her retirement in 1959 by Ernst Gombrich.[24] By this time Wind had left Smith College in Massachusetts and returned to England as Professor of Fine Art at Oxford.

23 Enriquetta Frankfort's entry on Bing in the *ODNB* and Ben Thomas, "An Art Historian's Dilemma."

24 Wind's awkwardly worded letter (in English) and a copy of Bing's somewhat disingenuous reply are in the Warburg Institute Archive.

25 Special Collections, Bodleian Library, Wind Box 49 [III, 6, vii]. I thank Ben Thomas for this and the other references in the Wind Papers.

26 Letter dated November 1993 in the same box of Wind Papers.

27 *Confessions*, p. 40, and copy of Margaret Wind reply, Wind Papers, Special Collections, Bodleian Library, Wind Box 49 [III, 6, vii].

28 *Confessions*, p. 35.

29 Ibid., p. 38.

30 It is worth noting that even Yates was introduced to the Warburg Institute by Edgar Wind (c. 1936), a fact acknowledged by Gombrich in his only reference to Wind in *Tributes: Interpreters of our Cultural Tradition* (Oxford: Phaidon, 1984), p. 212.

A surviving note dating from the late 1950s among the Wind Papers in Oxford suggests that Wind not only influenced Kitaj's approach to the history of visual culture but also provided advice on his drawing to complement Horton's:

"Dear Professor Wind, a few weeks ago you suggested that you would have time to examine some drawings of mine after the end of term. Wise counsel would be most welcome should you find time. With thanks, Ronald Brooks Kitaj c/o Ruskin School."[25]

Decades later, in November 1993, when preparing for his fateful Tate retrospective, Kitaj wrote to Wind's devoted widow, Margaret, asking for a photograph of him to include in the catalog:

"30 years ago when I was a young art student in Oxford, Edgar Wind was very kind to me and he had a very great influence on me."[26]

Margaret Wind replied: "still vivid in my memory is your visit to Belsyre Court one afternoon many years ago." This is complemented by Kitaj's *Confessions*: "The great Edgar Wind also befriended me to my amazement and even had me to tea in his North Oxford flat."[27] Enlarging on this theme Kitaj writes:

"This was my first encounter with the world of Wind's master Aby Warburg. [...] I became aware that Warburg was to art history what Einstein was to physics, Wittgenstein to philosophy, Freud to the study of the mind, Eisenstein to film and so on: Jewish founding fathers of Modernism. Warburg was the prophet of Iconology and its child, iconography, as another Jew, Berenson, had been the prophet of the more familiar art-historical persuasion called, I guess, connoisseurship..."[28]

Fondly remembering Oxford's second-hand bookshops Kitaj writes:

"My greatest coup was a full set of Warburg Journals from their London inception (1937) to date. These journals describe a stunning face of the Jewish Diaspora in one of its grandest moments, its golden decades, an amidah (standing up to) Hitlerism."[29] Kitaj's interest included non-Jewish contributors to the Warburgian project, however, notably Frances Yates, whose illustrated articles on the Catalan mystic, Ramon Lull, inspired some of the iconography in *Specimen Musings of a Democrat* of 1961 | p. 25 shown in his 1963 exhibition.[30] The format of this early oil and collage, now part of the Wilson Gift in Pallant House, also reflects the influence of Warburg's Mnemosyne-Atlas.

In the works of his final decade, as an exceptionally literate artist (and a greater art critic than his critics), Kitaj continued to reference his Warburgian cultural memorials but now combined these with powerful expressions of yearning for a more recent past in the form of his relationship with his beloved wife Sandra Fisher, whose sudden death he blamed on the malicious reception of his Tate retrospective. Although rich iconographical sources still underpin his *Los Angeles* series—the very title referencing both place and subject—Kitaj no longer labored to explain them in detail. He returned instead to the philosopher who had encouraged both him and Warburg to treat the Dionysian and Apollonian with equivalent high seriousness, as Warburg had returned to Nietzsche's *Birth of Tragedy* when revisiting the subject of Dürer in the 1920s. "Nietzsche," he reminds us, "called tragedy 'the supreme art in the affirmation of life'." But even after what he eventually suffered with the loss of his wife, and despite—perhaps also thanks to—his ever-more fervent identification with Judaism, Kitaj maintained a sense of humor, often at his own expense. He kept a photograph of Ezra

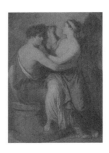

Pound on his studio wall, referring to him as "my favourite anti-Semite." He remained similarly loyal to T.S. Eliot, refusing to join those who accused him or Wyndham Lewis of anti-Semitism, rebelling instead against the aesthetic of artistic anonymity: "against my snooty countryman-of-genius, Eliot, I love personality in art," and citing as exemplary that other great writer-artist, Van Gogh, who "said he loves the man, then the art." Before he definitively left London for Los Angeles Kitaj went on one last visit to a Dutch brothel and concluded that "the only thing I'll miss about England is Holland." His sense of humor even prevailed in his late, great paintings of him and Sandra: those in which he depicted himself as the somewhat absurd, much older and smaller, white-bearded but still sexually charged man, embracing the beautiful, voluptuously serene young Sandra as the Kabbalah's Shekhina. In *Los Angeles No. 13* the two of them are pushing an old-fashioned pram with a Hockneyesque child in it, reminiscent of the pram ensemble pushed by a Warburgian Maenad four decades earlier in *The Ohio Gang*.

These paintings will, I believe, come to be recognized as the magnificent culmination of Kitaj's career, equivalent in his oeuvre not only to the "old-age-style" or *non-finito* works of Titian, Goya, Degas, Cézanne, Matisse, Bonnard, and his other artistic heroes, but also to Thomas Hardy's late, poignant poems of guilt and mourning after the sudden death of his first wife, or the equivalently cathartic "sorrow work" in Mahler, or Proust's recollections of lost time. Like these, Kitaj had spent a lifetime honing an artistic medium in which he could now express his grief and longing with extraordinary fluency.[31] His extraordinary visual and intellectual literacy and his intense aspiration to be part of the great tradition in art finally comes together in this series of portrayals, not of depressingly isolated individuals in the Freudian mode but in "'the greatest story ever told, the Woman-Man Story'." Kitaj writes that this:

"has become quite rare in painting since the death of Picasso. My Sandra was an exception. She often painted nude men and women embracing. Her example has been a major influence on me. So I've done about 20 of these love stories so far, and our romance need not die."[32]

In view of what he says about her role here it is especially appropriate that in one of the finest examples in this series, *Los Angeles No. 22 (Painting-Drawing)*, of 2001 |see above, Kitaj depicts himself with his by now much younger wife seated on his lap, sketching the shadow behind him. Still reflecting his commitment to the Warburgian *Nachleben der Antike*, this symbolic image is clearly based on the ancient account of the invention of art, the story of how a potter's daughter from Corinth drew her lover's shadow on the wall as a record before he departed for far-flung places.[33] In particular, Kitaj has surely based his brilliantly colored *Painting-Drawing* on *The Origin of Painting*, done in Rome in 1775 by the Scottish painter David Allan |see above. Even this picture, which normally hangs in the National Gallery of Scotland, would at least in Kitaj's mind have had a Warburgian provenance, for he very likely saw it when it featured in Gombrich's 1995 National Gallery of London exhibition and his accompanying publication entitled *Shadows. The Depiction of Cast Shadows in Western Art*.

Just as Wyndham Lewis's early familiarity with Cubism underpinned the later more figurative style he evolved in defiance of his ever more self-consciously avant-garde contemporaries, so Kitaj's pioneering Warburgianism encouraged him to reject the mere

32 R. B. Kitaj, *Los Angeles Pictures* (Los Angeles: L.A. Louver Publications, 2003), p. 10; cf. Livingstone, p. 254.

33 Pliny's *Natural History*, XXV, 151, as elaborated by later authors.

34 *Art and Anarchy* (London, 1964), p. 101.

35 Letter to the present author.

36 Ibid., postmarked January 8, 1974.

37 *Second Diasporist Manifesto*, no. 70.

38 He gave me permission to use *Blake's God* (2006) on the cover of the *New York Review Books* Classics edition of G.B. Edwards' *The Book of Ebenezer le Page*, published in July 2007 a few months before he ended his life.

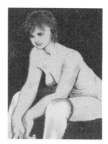

art-for-art's-sake formalism which Hegel anticipated and Wind condemned as the consequence of "this destructive tolerance [which] would one day be hailed as a form of 'progress'."[34] In a letter dating from October 1972, Kitaj wrote that he owned "a whole shelf of Wyndham Lewis... I haven't read into Lewis in many years but I was very moved by him—I read TARR almost 20 years ago!"[35] In 1969 he had used the jacket of Lewis's *The Caliph's Design* as one of his *In Our Time* screen-prints and, knowing better than George Steiner that it was in fact a *critique* of anti-Semitism, reproduced *The Jews: Are They Human?* in his *Second Diasporist Manifesto*. In January 1974 he responded positively to the idea of promoting Lewis's attack on *The Demon of Progress in the Arts*: "Your list of impending articles of attacks sounds very good—there is so much that needs to be said, needs to be done... The schools and journals and marketplaces are fetid and the various versions of Modernism continue to burden everything and everyone there..."[36] A few months before he died, Kitaj wrote of his wish to "invent a Jewish style, like the Egyptian figure style."[37] Warburgianly paradoxical to the last, however, as he became more self-consciously Jewish, he became less Judaically "text-centered" and more defiantly visual, eventually, in the footsteps of William Blake, breaking Moses' Second Commandment to the extent of depicting God Himself.[38]

When one surveys his fascinating career as a whole, Kitaj surely has few rivals in having maintained at such a superlative level the great tradition of painting and drawing that our cave-dwelling ancestors began so many thousands of years ago.

Letters to a Young German Painter
Martin Roman Deppner

2 *R. B. Kitaj: Pictures With Commentary: Pictures Without Commentary* (London: Marlborough Fine Art, Marlborough New London Gallery, 1963).

1 Martin Roman Deppner, "Spuren geschichtlicher Erfahrung. R.B. Kitajs 'Reflections on Violence'," in: *IDEA, Jahrbuch der Hamburger Kunsthalle*, III, 1984, pp. 139-66.

3 Aby M. Warburg, "A Lecture on Serpent Ritual," in: *Journal of the Warburg and Courtauld Institutes*, vol. 2, 1938–1939.

In Memoriam Christoph Krämer (1948–2010)

In 1980, Hamburger Kunsthalle acquired R.B. Kitaj's collage painting *Reflections on Violence* (1962) | p. **24**. Because of my interest in both the picture's subject matter and the art of this era, the curator responsible for the acquisition, Helmut R. Leppien, encouraged me to write an article on the work for the *IDEA* yearbook.[1]
Even after several attempts at finding a suitable form of text for a picture that appeared more complex the more I studied it, in the end Kitaj's *Reflections on Violence* defeated me. It was impossible to approach the fragmentary symbols, pictorial abbreviations, and textual messages by analyzing the form and content. Scatter diagram and splash structure on the one hand, and symbolic language plus legible lines of text with exact information on the other, led me to think about the work's significance in terms of the way art progressed after Abstract Expressionism, as well as about the large quantity of implied content on the subject of violence suggested by the title. The picture itself contains references to George Sorel's *Reflections on Violence* as well as to rape in colonies, the Cuba crisis, murder, the electric chair, and Native American pictorial languages.
In the catalog on his first exhibition,[2] Kitaj provides hints on his subject matter. He talks about the Wandering Jew, about a doctor for the insane, and about Aby Warburg's trip to New Mexico.[3] An artist providing pictures with notes was something new to me. Abstract Expressionism's rejection of European traditions, obviously still visible in Kitaj's splashes and diagrams, thus collides with images redolent with content. It would therefore appear negligent not to undertake an iconological analysis. However, if I were to follow Kitaj's directions I would be bound to end up in a cul-de-sac, if only because of the numerous references.
In March 1983, Kitaj replied in great detail to my first letter in which I confessed my perplexity. Among other things, he referred to an historical lineage in Modernism that I would never have dreamt about in connection with this picture. The line he mentions runs from the aestheticism of Huysmans in *À rebours* to the Vorticism of Ezra Pound to T.S. Eliot and on to James Joyce. Although initially this line of thought seemed fallacious, later I thought better of it because other artists in London with whom Kitaj socialized—such as Francis Bacon and David Hockney—also drew on the literature of English Modernism and the aestheticism of the closing years of the nineteenth century and also because one of Kitaj's concerns was to make use not only of the realism of violent history but also other traditional lines pursued by Modernism for his work. The iconic symbols referenced and interpreted the pictorial language of the Native Americans, buffalo hunts, and the battle at Little Big Horn that went down in history as the defeat of the "palefaces." The trip mentioned in the catalog made by Aby Warburg to the peace-loving tribes of New Mexico and the use of quoted pictorial sources revealed a knowledge of the iconology established by Warburg and Erwin Panofsky. Kitaj had met both at Edgar Wind's place during his time as a student at Oxford. Wind was one of Warburg's early assistants and was one of those art historians who not only administered the legacy of the Warburg library (which had been saved from the Nazis and moved to London) but also sought to move it forward. The continuing existence of pictorial formula from Classical Antiquity to the Renaissance, and right through to the nine-

4 Walter Benjamin, "The work of art in the age of mechanical reproduction," in: *Illuminations*, transl. H. Zohn (Glasgow: Cape, 1970), p. 243.

5 See Martin Roman Deppner, *Zeichen und Bildwanderung. Zum Ausdruck des "Nicht-Sesshaften" im Werk R.B. Kitajs* (Münster, 1992).

6 At the beginning of 1981, the exhibition *A New Spirit in Painting* at the Royal Academy of Arts in London brought Kitaj's work into contact with German painters, including Baselitz, Kiefer, Lüpertz, Richter, and Polke; the London scene was represented by Francis Bacon, David Hockney, Lucian Freud, Frank Auerbach, and Howard Hodgkin, the USA by Twombly, Warhol, Stella, and Ryman, with Picasso and de Kooning in historical positions.

teenth-century Modernists—something Warburg described as those "human treasures of suffering" that become "human possession"—obviously prompted Kitaj to develop a line of thought which queried whether the ongoing influence of historical pictorial testimonies could also form a valid basis for twentieth-century art. Early on, his collage painting *Reflections on Violence* demonstrated what was to distinguish his later work: its way of referencing historical images. At the end of the day, the Native American symbols modified by Kitaj dated from the second half of the nineteenth century and had been published in 1894 in the *Eleventh Annual Report of the Bureau of Ethnology to the Smithsonian Institution*.

The influence of Ezra Pound mentioned by Kitaj in his letter points in the same direction. As the head of London's Vorticists, Pound championed an aesthetic agenda that sought to link the "glories of the past" with the present. The principle used by Pound in his poems and cantos, namely of overlapping quotations from different times, is something that Kitaj later repeats in an altered way. The main reason for the substantive reference to the topic of violence was that Kitaj's sources stand for the kind of aesthetics that point to a link between violence and aesthetics—indeed, even talk about violence aestheticized by art. The "aestheticization of politics"[4] by fascism, as Walter Benjamin called it, is also relevant to later works.

The trails that Kitaj has laid in the picture vacillate, as I see it, between art and art history, literature and politics, and eras and artistic positions. Thinking about the interaction of the poles invoked is, as a method employed by art, unique to the 1960s; the identifiable sources only become symbols generating meaning when they overlap.

After my article was published, Kitaj thanked me and wrote that he was interested in symbols of suffering, just as I was. His letter also discussed the changes in his life and his current subject matter at the time, the Jewish passion: "So you can see, Martin, that your interest in these symbols of suffering are my interest as well. What shall stand for the Jewish PASSION as the cross?? a chimney with black smoke? I don't know; I shall try..." (letter of May 1985). Thus, at the time preoccupied with a dissertation on Kitaj's early work, I focused my attention on the Jewish passion.[5] Later, I was to receive further indications from Kitaj that required the inclusion of traditionally Jewish ways of thinking and thought structures in the interpretation of his art.

Visiting Kitaj's exhibition at the Marlborough Gallery of Fine Art, London, at the end of 1985 was to become a defining experience for me. It was the first exhibition where Kitaj displayed drawings and paintings on the Jewish passion, presenting the "cross" and "chimney" announced in the letter as an emblematic reaction to different experiences of suffering (*Cross and Chimney*, 1985). He contrasted the Christian symbol of the passion with a Jewish one. Also, what was surprising about the exhibited works was his choice of color and his method of painting. Both means of artistic expression referenced German art: firstly, the Expressionist use of color—for example, by Max Beckmann—and secondly, the eruptive method of painting used by current German artists such as Georg Baselitz and Markus Lüpertz.[6]

However, whilst Kitaj was attempting to achieve an even darker shade of black than Beckmann's (by adding Prussian blue) he transformed the gestural work of German artists into a specific way of accentuating cicatrices—as in his fictitious self-portrait *The Sensualist* | p. 150. The principal thinking behind this was to produce a reaction to

7 *R. B. Kitaj: Pictures With Commentary: Pictures Without Commentary* (London: Marlborough Fine Art, Marlborough New London Gallery, 1963).

8 See Marco Livingstone, *R. B. Kitaj* (Oxford, 1985).

the upside-down figures of Georg Baselitz. And whereas Baselitz's figures stand on their heads for no obvious reason, Kitaj's standing sensualist—who has been given an outstretched body—demonstrates the formal quality of an upside-down figure. Kitaj has taken this from Titian's painting *The Punishment of Marsyas* (1570–76), that was shown at the exhibition *The Genius of Venice 1500–1600* at the Royal Academy, London, in 1983–84. It shows a depiction of the martyr suspended with his head downwards prior to being flayed. Every brushstroke is executed with deliberation. Splotches, strokes, sweeps—all stylistic devices of impetuous painting—are applied with care. In Kitaj's case, the sensualist thus becomes a suffering figure to whom the traces of paint have been applied like stigmata.

My visit to the exhibition was followed by a personal conversation at Kitaj's studio where the artist made it clear how much he was struggling to link his studies of rabbinical texts with his interests in art and the history of art. He referred to the *Journal of the Courtauld and Warburg Institute*, of which he possessed every issue and which had served as inspiration to him for numerous paintings, from the days when he was studying with Edgar Wind. He saw it as an example of the cooperation between Jewish and non-Jewish academics, and a bridge between texts and art. In earlier catalogs he had introduced *Pictures With Commentary: Pictures Without Commentary*,[7] and he produced textual commentaries on art, a form that he later perfected with his "prefaces" to his most important works.[8]

The idea, so crucial to Kitaj's work, of linking opposing poles and of keeping track of the relationship between text and image, between religions, cultures and nationalities, and last but not least between abstraction and figuration, collage and drawing, makes it clear that his readiness as an artist to engage in dialogue was not only the result of reflections on the Jewish passion, but also corresponded to his associative notion of art, something that was even visible in his early work. Nevertheless, the reading of rabbinical texts in the tradition of the Midrash and the Talmud that he had now undertaken, with their commenting form of dialogue that had been cultivated for centuries and in different locations heightened his sensibilities in this respect.

After my visit, in January 1986, Kitaj wrote a letter in which he offered to set in motion a dialogue between a German and a Jewish painter in the form of "Letters to a Young German Painter." For this fictitious "German painter," composed of my "young painter friends" and myself ("Dear Hans...??"), he offered to ask "questions of interest to 'German' and 'Jewish' art" and to answer them in a "responsa." By "responsa" he meant a form of commentary from the rabbinical tradition that, since the Middle Ages, has sought to solve legal questions and to deal with Jewish problems in a non-Jewish environment.

The confident manner adopted by German artists such as Baselitz, Immendorf, Lüpertz, and Kiefer, who, for their part, referenced the traditions of German art and history, caused Kitaj to initiate a new artistic dialogue between Jewish and German aimed at following in the tradition of the links that existed before the Shoah. Accordingly, he wrote in a letter as long ago as May 1985: "I feel if there can be a new, good German art ... there can also be a new Jewish art.... Do you agree?"

Our correspondence now focused on the question of what form a dialogue between Jewish and German artists might take. Kitaj believed that the items of his work that he

9 See Martin Roman Deppner (ed.), exh. cat.: *Die Spur des Anderen. Fünf jüdische Künstler aus London mit fünf deutschen Künstlern aus Hamburg im Dialog* (Hamburg & Münster: Heine-Haus Hamburg, 1988).

10 See Emanuel Lévinas, *Die Spur des Anderen. Untersuchungen zur Phänomenologie und Sozialphilosophie*, transl., ed. and intro. by Wolfgang Nikolaus Krewani (Freiburg i.Br. & Munich, 1986).

11 R.B. Kitaj, *Erstes Manifest des Diasporismus*, ed. and designed by Max Bartholl, Christoph Krämer, and Ulrich Krempel (Zurich, 1988).

12 Ibid., p. 25.

had assembled under the title *GERMANIA* already constituted an offer of dialogue. I subsequently translated his request for a dialogue partner for the "Letters to a Young German Painter" into an offer that better corresponded to my abilities: in September 1986 I suggested to Kitaj that I might curate an exhibition by Jewish and German painters at the Heine-Haus in Hamburg. In October, Kitaj replied: "I have spoken with my friends and I must tell you they are nervous about the idea of the exhibition in the Heine-Haus which you suggest, but perhaps for complex reasons you may not have expected.... First, I must say that they agree! Freud, Auerbach and Kossoff allow me to lend small prints and drawings from my own collection of their works. My wife, Sandra Fisher would also like to lend small things, so there you have five Jewish painters from London."

The exhibition, entitled *Die Spur des Anderen*, took place from September 30 through October 22, 1988, with the participation of the five London-based artists mentioned by Kitaj, and five Hamburg-based artists: Jürgen Bordanowicz, Christoph Krämer, Florian Köhler, Jürgen Hockauf, and Gustav Kluge.[9] The project was sponsored by the Hanseatic City of Hamburg Culture Department and by Jan Philipp Reemtsma.

The exhibition followed an anthology by Talmud scholar and philosopher Emanuel Lévinas, whose expectations of a dialogue between the cultures primarily corresponded to Kitaj's understanding as regards the dimension of infinity.[10] Infinity, portrayed in uncompleted pictures, was also something that Kitaj greatly admired in Cézanne. Accordingly, the Other and the Infinite became elements of an understanding of art that resulted in the fact that what many of Kitaj's works corresponded to was an open dialogue, leading to changes that spanned a period of years. Moreover, by making works from his private collection available for the exhibition, Kitaj demonstrated how the path he was taking linked up with those pursued by the other artists.

In the case of Kitaj, everything points to a search for explanations that lead out into the world and yet remain strangely aimless, without the pithiness of his painting disintegrating. Everything is far removed from its relevant location. This virtually includes the things that are historical, too; however, here a new dimension is opened up, the dimension of memory in the pictorial act of looking together—it is not, for example, a mere picture puzzle, a hodgepodge of symbols.

On Kitaj's visit to the exhibition together with his wife everybody was talking about his book that also appeared in 1988, initially in German, *Erstes Manifest des Diasporismus*.[11] However, it was not until the English version was published one year later that *First Diasporist Manifesto* became a much-discussed work (see the essay by Inka Bertz | p. 179).

In the book, Kitaj writes: "In my time, half the painters of the great Schools of Paris, New York and London were not born in their host countries. If there is nothing which people in dispersion share in common, then my Diasporist tendency rests in my mind only and maybe in my pictures..."[12]

Kitaj talks about several Diaspora experiences, about those migratory movements by others, and also about the suffering in a sexual diaspora. He declares Picasso, who painted *Guernica* in exile, to be a Diasporist without doubting that being a foreigner

13 Ibid., p.37f.

14 R.B. Kitaj in conversation with
Timothy Hyman, "Eine Rückkehr
nach London," in *R.B. Kitaj*
(Düsseldorf: Kunsthalle Düsseldorf,
1982), p. 49; first published in:
London Magazine, vol 19, no. 11,
February 1980. The exact wording
is: "Reducing complexity is a ruse."

15 R.B. Kitaj, *First Diasporist
Manifesto*, p.39.

16 R.B. Kitaj, *Second Diasporist
Manifesto (A new kind of long
poem in 615 verses)* (New Haven &
London, 2007), #177.

in a different culture is a state of affairs familiar to Jewry since time immemorial:
"Abraham's journey from Ur becomes, in the name of 'good' picture-making (at my
own easel), Joe Singer's secret lives, escapes, deaths and resurrections."[13]

In his desire to amalgamate reflections on theology and art, literature and pictures,
into an artistic concept by means of an understanding of Diaspora as a temporary
sojourn in foreign cultures, Kitaj evaluates his own art and in this way highlights a
constant interplay. In his work the dialogue process makes itself felt in its method of
linking painting and drawing, literature and pictures, contemporary art and the
history of art, mysticism and philosophy, and in the way that he quotes different ar-
tists such as Cézanne or Beckmann, van Gogh or Mondrian, Degas or Chagall. For
him, the image of the wandering Jew that he mentions in his first catalog back in
1963 corresponds to the way that he himself wanders through different forms. In
Manifest des Diasporismus he also conformed to the idea by producing a concept. He
took his orientation from both the Surrealists' first manifesto and from Thomas Mann's
The Story of a Novel: The Genesis of "Doctor Faustus" . Accordingly, examples from
both the plastic arts and literature were just as important to him as the reflections
and attitudes they embody.

The interweaving of references that Kitaj once described as a ruse of reducing com-
plexity[14] is one of the not inconsiderable reasons why the art critics (who found it all
too much!) responded with incomprehension to Kitaj overstepping the boundaries of
Pop Art, which had been so successful for him. "One of the most recent of my hund-
red negative critics wrote in his review of my 1986 exhibition that it was 'littered
with ideas'. Heavens to Betsy, I hope that's true. My poor Diasporist mind urges me
to wander among ideas without rest, always the false-scholar, which is often how
we painters make our mark. The pursuit of ideas, both religious and secular, at any
cost, is often attributed to Jews by both well wishers and doubters. Hitler is said to
have accused the Jews of inventing conscience. Ideas and painting are inseparable.
The Diapsorist pursuit of a homeless logic of ethnie may be the radical (root) core of
a newer art than we can yet imagine…"[15]

In the *Second Diasporist Manifesto*, which was published in the USA in 2007, the year
of Kitaj's death, the references are even more numerous. His odyssey into the Talmud
caused him to perceive its qualities as a kind of personal statement for himself. He
writes that "The Talmud says that every passage in the Torah has 49 gates of purity
and impurity" and adds, "Each of my 'titles' has 49 steps of meaning."[16] His aim is to
stage the forty-nine assumed steps of meaning by ramifying the various aspects, en-
coding them, and yet stimulating the mind. As he sees it, this is an appeal by the
Other, who reveals himself in Talmudic texts that do not need a specifically expressed
subject. Creating an image of infinity by accepting the trail of the Other and passing
it on to be decoded is the intention that comes to light in the many intersecting art
trails laid in Kitaj's work. If we accept the offer of finding a route to engaging in ex-
change in this, we should still point out the unredeemed suggestion that he associa-
ted with his participation in the exhibition at the Heine-Haus and with the *Erstes Ma-
nifest des Diasporismus*. At the time, Werner Hofmann and his successor to the
position of Director of the Hamburger Kunsthalle, Uwe M. Schneede, expressed great
interest in exhibiting Kitaj's *GERMANIA* project, something that Kitaj in turn agreed

17 Ibid., #202.

18 This characteristic of R.B. Kitaj's means that his work offers the eye a great deal of variety and is, at the same time, ambiguous. A degree of research is required in order to decode it, as with paintings from days gone by, but it never cedes its secrets entirely.

19 "R.B. Kitaj and David Hockney Discuss the Case for a Return to the Figurative," *The New Review* 3-34-35 (January–February 1977), pp. 75–77.

20 This was a not insubstantial reason for Kitaj being described as a "learned" artist. Cf. Gina Thomas, "Ruhelos in Geist und Seele. Gelehrter Künstler: Der Maler Ron B. Kitaj wird siebzig," in: *Frankfurter Allgemeine Zeitung*, October 29, 2002, p. 39.

21 Cf. Klaus Herding, "Weltkultur aus der Diaspora?" in: Martin Roman Deppner (ed.), exh. cat.: *Die Spur des Anderen. Fünf jüdische Künstler aus London mit fünf deutschen Künstlern aus Hamburg im Dialog*, (Hamburg and Münster: Heine-Haus Hamburg, 1988), p. 14.

to. As Kitaj saw things, this form of presentation would be a meaningful dialogue with artists such as Anselm Kiefer or Gerhard Richter who best fitted in with his intentions either by highlighting German history and Jewish tradition (Kiefer) or in terms of a permanent change of style (Richter). There is talk of these things, too, in the letters. There we also encounter Kitaj's doubts and the question of whether his intention of carrying on a multi-perspective dialogue in art was "crazy."[17] His craziness is the result of his unusual combinations: as a painter he wrote texts—prefaces to his pictures and manifestos; as a conceptualist he painted pictures, as an exponent of the present he argued with tradition; his paintings are pervaded by drawings, and figuration is present in abstract structures composed of quoted fragments.[18] The resultant ambiguities—hybrid compositions using opposing techniques—are, translated into shapes, his symbols of the diaspora, testimonials to wanderings, exile, and the laying of trails. The resulting constellations broke down stylistic boundaries particularly in the way they overlapped media reflections (for example, in their colors) and life drawing, although they adhered to the traditional genre of painting.[19] Kitaj's "recourse to the figure," that became apparent during a stay in Paris in 1975 and was inspired by Edgar Degas' pastel drawings, marks a fundamental change in his cosmos of shapes. Drawing the human figure adds experienced and direct encounters to his arrangements of quotations. In Kitaj's work, this combination was to become a fundamental characteristic of encounters and tension within the pictures, something that could also be interpreted as questions and answers.

The method of dialogue increasingly used by Kitaj (based on Jewish sources) led to numerous changes in style, partly because of the different partners in this dialogue, but the method did make it possible to provide these combinations with the feel of a dialogue in progress in the picture. His letters and other texts revealed that he sought to transpose the complex teachings of rabbinical tradition that were developed in the over two-thousand-year-old experiences of the Jewish diaspora, and that had become the latter's matrix, to contemporary art.[20] The intercultural experiences of the diaspora, which took place and were recorded, reflected on, and offered up for dialogue in different countries and cultures, became an aesthetics concept for Kitaj. Something that was still formulated as a question on the occasion of the exhibition *Die Spur des Anderen*[21] can now be turned around into an answer: world culture from the Diaspora! This is Kitaj's legacy, and the legacy of his pictures, his manifestos, and his letters.

Reflecting on the Jewish Condition in the Kaffeehaus

David N. Myers

1 Kitaj, "My Jewish Art," Los Angeles Pictures (Venice, CA: LA Louver Publications, 2003).

2 With bravado, Kitaj opened the *Second Diasporist Manifesto* by announcing: "I've got Jew on the Brain." R. B. Kitaj, *Second Diasporist Manifesto* (New Haven: Yale University Press, 2007), Introduction. Not surprisingly, the epigram to the *First Diasporist Manifesto* was the line from Roth's *The Counterlife*: "The poor bastard had Jew on the brain." See the *First Diasporist Manifesto* (London: Thames and Hudson, 1989), p. 9.

"Clement Greenberg wrote: 'I believe that a quality of Jewishness is present in every word I write, as it is in almost every word of every other contemporary American Jewish writer.' That is the way I feel about my pictures." [1]

In the last ten years of his life—the L.A. Phase or, as he referred to it, the "Third Act"—Kitaj adhered to a carefully regimented daily ritual. He arose at 4:30 in the morning and set out for the Coffee Bean in Westwood Village at 5:30. Arriving at 6:00 when the café opened, he took his place at a table, where he wrote in his notebook, and often scribbled thoughts and drawings on Coffee Bean napkins, for the next four hours. At 10:00, he would leave the Coffee Bean to return home to his studio, where he would paint until lunchtime.

This phase of Kitaj's life, following his four decades in London, was a period of contrasting vectors: clockwork fixity in his daily habits alongside a wild and unrestrained imagination; increasingly dark bouts of solitude together with regular and happy familial engagement; ever-growing disenchantment with the art world and deeper immersion into a self-created spiritual universe in which his beloved late wife, Sandra, was deified. This was also an intensely Jewish phase in Kitaj's life: one in which he warmly embraced the condition described by his good friend Philip Roth as "Jew on the brain." [2]

In this phase of his life, the café assumed particular significance. It was there that Kitaj wrote, at once refining a craft he cherished and had practiced since youth and, at the same time, engaging in a deliberate act of rebellion against the London art critics who attacked him for relying on the written word to explicate, and thereby prop up, his paintings. To the extent that Kitaj believed this criticism to be motivated by anti-Semitism—that is, by a rejection of the constitutive commentarial act of the Jew—he came to see the café as a site of Jewish refuge, a place to write beyond the harsh judgment of the critics. The café, we might even say, became his sacred space, a kind of *Beis Midrasch* (study hall) where he learned, read, and developed his peculiarly secular Jewish theology. It was also the space, along with his atelier, where his Jewish imagination was most nurtured, where he dwelt in the company of his long-lost Jewish friends. Indeed, it was there that he fostered his sense of Jewish self as a Diasporist, authoring not one but two "diasporist manifestos." The café was *tout court* home.

Of course, Kitaj's predilection for the café long preceded his L.A. Phase. He had been imagining, drafting, sketching, and of course cavorting with women in cafés from the time of his earliest travels and throughout his entire European exile. He once recorded to himself that "Café-life is in my blood." [3] During the 1980s, he painted *The Cafeist*, |p. 114 modeled after his fictive Jewish friend, Joe Singer of *The Jew, etc.* fame |p. 136. In the accompanying text, he wrote:

I am a Caféist. So is Joe Singer, who is at least ten or twelve years older than I am. Here is Joe in 1987 in the café called Le Central at the east end of the Rue Blondel in Paris. A Caféist is one who prefers his own company, alone, in a café, with the life spinning around him, having nothing to do with him. The Caféist writes and sometimes furtively sketches in the café." [4]

Of course, there is an historical genealogy to the Caféist. He has his roots in what was called, at the fin de siècle, "Kaffeehaus Judentum." [5] The phrase was not a term

3 Notebook, *Kitaj papers*, UCLA. I would like to express appreciation to Dr. Eckhart Gillen for calling my attention to this notebook entry.

4 Ibid.

5 Erich Burin, "Kaffehaus Judentum," *Jüdische Turnerzeitung* 5/6: XII (May–June 1910).

6 Julia Schäfer, *Vermessen— gezeichnet—Verlacht: Judenbilder in populären Zeitschriften,*

1918–1933 (Frankfurt am Main: Campus Verlag, 2005), p. 163. My thanks to Pablo Vivanco for calling this book to my attention.

7 R. B. Kitaj, *Second Diasporist Manifesto*, Introduction.

8 *Second Diasporist Manifesto*, Introduction and #10.

9 *First Diasporist Manifesto*, p. 119.

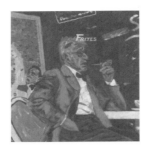

of endearment, but rather a contemptuous designation by early twentieth-century Zionists such as Max Nordau who advocated a competing Muskeljudentum marked not by idle hours spent in animated conversation, but rather by a vitalist commitment to action—and by the repair of the Jewish body. For Zionists of this ilk, the matter was simple: "*Der neue Jude* sollte den *Kaffeehausjuden* vergessen machen."[6]

And yet, the matter was not so simple. It turns out that Zionists also favored cafés. In the extraordinary cultural ferment of Weimar Berlin, Ostjuden met Germans, Hebrew speakers debated their Yiddish counterparts, and, yes, Zionists encountered their rivals, in sites like the Romanische Café. In the cacophonous din of the Berlin café, ideological differences were fiercely debated, rhetorical skills honed, and manifestos born. It was a culture in which ideas were not seen as inessential accoutrements, but rather necessary catalysts to action.

Kitaj knew that world and longed to be part of it. He loved its passion, intensity, and instinct for asking the big questions about art, politics, and life. I tend to think that he sought to reconstruct it in his own mind, drawing on his extraordinary imaginative powers. That is, as he sat in solitude in the Westwood Coffee Bean, he would engage in animated conversations about books and ideas with his Weimar-era friends and intellectual heroes. At the heart of their discussions stood the Jewish Question, which Kitaj called "my limit-experience, my Romance, my neurosis, my war, my pleasure principle, my death drive"[7]—in short, his obsession. Like the most sophisticated of his fellow caféists, and despite his own stubborn and doctrinaire tendencies, Kitaj understood that the resolution of that Question would not be achieved through simple, monistic formulae, as he indicated in his own self-prescription in the *Second Diasporist Manifesto*: "Assimilate and Don't in painting! Admix lessons from Host Art with stubborn Jewish Questions."[8]

His own admixture resulted from an utterly omnivorous nature, as he consumed books and ideas with the ferocity of a starving man and the unbridled joy of the autodidact. He was guided by his mythic Weimar-era café interlocutors, the first and most important of whom was Gershom Scholem (1897–1982), the German-born immigrant to Palestine whose pioneering labors in the study of Jewish mysticism would make him the most influential Jewish-studies scholar of the twentieth century. Kitaj learned from Scholem at least three important lessons. First, Scholem modeled for him a form of Zionism that navigated between the poles of universalism and particularism. Scholem's participation in the short-lived *Brit Schalom*, the group of largely Central European Jews who advocated a bi-national state in the 1920s and early 1930s, affirmed for him the possibility of asserting the Jewish right to a place under the sun without denying the Palestinians the same right. It was this prospect that must have accompanied him as, over the years, he painted his series of "Arabs and Jews" pictures |**p. 218**. Kitaj did not hold to the old Brit Schalom ideal. Of Arabs and Jews in Palestine, he wrote: "They both need separate homes. The idea of a bi-national secular state in Palestine can only happen in a month of Sundays, draped in blood. As humans go, it's hopeless."[9] Second, Scholem's seminal research into the Jewish mystical tradition imparted to Kitaj an appreciation for a kabbalistic hermeneutic that he made his own. Kitaj acknowledges Scholem's influ-

10 *Second Diasporist Manifesto*,
#28. Later in #553, Kitaj declared:
"SANDRA—SHEKHINA in my
paintings, and it is SHE to whom I
pray every dawn."

11 *First Diasporist Manifesto*, 29,
pp. 77–78.

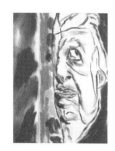

ence and then situates himself in the long tradition of Jewish commentarial dyna-mism in #15 of the *Second Diasporist Manifesto*: "Infinite interpretability, infinite lights shine in every word, says Scholem on Kabbalah. Fitful commentary waits pa-tiently by some of my pictures as it does in thousands of years of Jewish Commen-tary." Third, Scholem introduced to Kitaj not only the interpretive practices of the mystics, but the fundaments of kabbalistic theosophy, one aspect of which Kitaj stu-died with particular interest: the idea of the feminine Godhead or *Shekhinah*. This was an idea that he had learned about early in his reading of Scholem (see *Major Trends in Jewish Mysticism*), but which assumed great significance and urgency in the L.A. Phase. And that is for the simple reason that Kitaj, the avowed secularist, fervently attempted in his last decade to effect communion, in the mode of the Kab-balah, with the *Shekhinah*, which he understood to be none other than his late wife: "I have been slowly withdrawing from the social world for many years anyway. Sandra is, therefore, not only made in the image of God, but, as Shekhina, she's the aspect of what is called God, to which I cleave (DEVEKUT) in painting her."[10]

Kitaj's reading of and one-way conversations with Scholem continued throughout his adult life. They nourished his early intellectual and late theological reflections on the Jewish Question. He knew how deeply immersed his revered Weimar forebears and fellow caféists were in the theological dimensions of the Jewish question, including through the new mystical lens introduced by Scholem. But he also knew that the Berlin Jewish café culture was, if anything, polychromatic in complexion. It contained a wide range of colorful characters, not all of whom were German, not all of whom were inte-rested in theology, but all of whom were passionately interested in the Jewish Questi-on. A good example was the great Russian-Jewish historian, Simon Dubnow (1860–1940), who was a dominant figure in the Eastern European Jewish circles that assem-bled in Berlin after the First World War. Kitaj knew of Dubnow as "the great old theo-retician of Diaspora" who argued, against the Zionists, that the logical home of the Jewish nation was where its largest population concentration was, in Eastern Europe. The responsible response to their plight, according to Dubnow, was to call not for so-vereignty in the ancient homeland but for autonomy in their Diaspora homes—that is, state support for the preservation of Jewish cultural, educational, and linguistic practi-ces. In this regard, Dubnow was tapping into a once prominent though now lost strain of nationalist thought: a form that separated "nation" from "state" in advocating re-cognition of the rights of a cultural nation (e.g. the Jews) under and by a sovereign state power (e.g. Tsarist Russia).

In his mythic café conversations with Dubnow, Kitaj was clearly drawn to the older historian's views and, in particular, the belief that "his dispersed and despised people would find peace in the various places where they settled among enlightenment hosts." The cultural exercise of engaging with a wide range of hosts was the very source of creativity of the Diaspora Jew that Kitaj so valued. He expressed the hope that "Dubnow's dream for Diaspora will come true." For, he averred, "Diasporism is my mode. It is the way I do my pictures." But he was also fully cognizant that the end to Dubnow's Diasporist vision was brutal; "the Germans shot him," he reports, in the li-quidation of the Riga Ghetto in December 1941.[11]

In debating with Dubnow over Diasporism, Kitaj would have been joined by a fellow

12 See the discussion by Shulamit Volkov, "The Dynamics of Dissimilation: Ostjuden and German Jews," Jehuda Reinharz and Walter Schatzberg, eds. *The Jewish Response to German Culture from the Enlightenment to the Second World War* (Hanover, NH: University Press of New England, 1985), pp. 192–211.

13 See David Biale, *Gershom Scholem: Kabbalah and Counter-History* (Cambridge, MA: Harvard University Press, 1982), p. 105.

14 This appreciation for Achad Ha-am—and his agnosticism—was more pronounced in the Late London Phase, in which the Jewish Question was front and center, than in the L.A. Phase, when Kitaj's theological and mystical obsession with Sandra began to take hold.

15 *First Diasporist Manifesto*, p. 115.

traveler in the byways of the Jewish Question of whom he was quite fond: Achad Ha-am (1856–1927). Achad Ha-am was Dubnow's fellow Eastern European Jew, good friend, and ideological foil; his efforts to create an elite center of Jewish culture in Palestine were opposed to Dubnow's emphasis on Diasporism, as was made clear in an engrossing correspondence between the two in the first decade of the twentieth century. In fact, Dubnow and Achad Ha-am agreed that, in an ideal world, there should be both a robust Jewish life in the Diaspora and a robust Jewish center in Palestine. They disagreed vigorously on where the prime emphasis should be. For Dubnow, an historian who periodized the Jewish past according to its successive centers of influence, the present-day center that was worthy of attention and investment was the Eastern European concentration. For Achad Ha-am, by contrast, Erets Yisra'el was and always would be the center that radiated out rays of vitality to the periphery. These rays of vitality would revive a long-dormant Hebrew culture the world over and would lead to a rebirth in language, music, theater, and art.

Achad Ha-am's vision resonated deeply for a generation of early twentieth-century German-speaking Jews caught in the throes of "dissimilation"—that is, a movement of retreat from the deeply held ideal of their parents that they overcome the remaining hurdles in German society and effect a complete assimilation.[12] This circle, which included Hugo Bergmann, Hans Kohn, Ernst Simon, and Gershom Scholem, saw in his program of cultural revival for the Jewish nation a highly desirable path between the extreme routes of assimilation and a more hard-edged statist form of political Zionism. Scholem, for example, characterized himself as a "radical follower of Achad Ha-am."[13]

Kitaj, for his part, resonated deeply with Achad Ha-am's project of cultural revival, all the more so given its decidedly agnostic stance toward traditional religious faith.[14] He placed Achad Ha-am in exalted company, comparing him to Cézanne, one of his favorite painters. "They are both lighthouses, even bridges for me in 1987," he wrote in the *First Diasporist Manifesto*. What Achad Ha-am lent to Kitaj was a healthy measure of unapologetic Jewish pride that "proved to be a precious escape from the Dark Age in which many Jews were still buried." This, in turn, inspired Kitaj to attempt a Jewish art, "an affirmative painting art" that avoided the "contraction of the (Jewish) national 'ego'."[15]

One could imagine Kitaj sitting at a table in a Berlin café next to Dubnow and Achad Ha-am, listening to the two thinkers debate the fine points of a strain of Jewish nationalism in which culture was the shared and most precious property of the Jewish nation. Kitaj greatly appreciated the common emphasis on culture in this vision, as well as its deep commitment to affirming a strong form of Jewish ethnic identity. At the same time, he would have appreciated the differences between the two early twentieth-century thinkers, internalizing the strongest points of their respective Diasporism and Palestinocentrism, and discarding the weakest. His own thinking accomplished what they could not: a dynamically fluid swing between the poles of Diasporism and Zionism, reflecting his unabashedly dual loyalties to cosmopolitanism and particularism. Navigating between those poles, one could argue, has been the leitmotiv of the Jewish project of modernity, engaging a long and noble lineage of Jews from Moses Mendelssohn to the Kaffeehausjuden of Weimar Berlin to Kitaj, and beyond. Kitaj was

16 Ibid., p. 109.

17 Ibid., p. 95.

18 Walter Benjamin, "A Berlin Chronicle," *Reflections: Essays, Aphorisms, Autobiographical Writings* (New York: Schocken 2007), pp. 21–23.

19 *First Diasporist Manifesto*, p. 59.

especially drawn to those, like himself, who dwelt between the poles, in the rich if unsettled terrain in the center—in that space where distance from the poles of certainty encouraged creative innovation. It was in that space where many of his greatest Jewish inspirations and conversation partners could be found: first and foremost Kafka, whose sense of alienation from the world—and from himself—Kitaj apprehended as distinctly Jewish. The unique perspective that alienation afforded Kafka helped craft what Clement Greenberg called "an integrally Jewish literary art."[16] It also may have granted him, Kitaj suggested, special powers of clairvoyance into the darkness that would descend upon Jewish life in the Shoah. Although Kafka died before the "terrible Jewish passion," his work led Kitaj to believe that "[m]aybe he could it smell it coming."[17]

Kitaj's reverence for Kafka reminds us of one of the painter's rare gifts: his boundless intellectual openness. Kitaj was as receptive to and interested in the clearly formulated ideological agendas for Jewish national renewal of Achad Ha-am and Dubnow as he was taken by Kafka's remarkable literary articulation of the anomie of modern (Jewish) life. Many of us tend to favor one form of writing or thought at the expense of another, but Kitaj was perfectly capable of embracing both. In this regard, his Jewish obsession was decidedly catholic.

That said, he felt a particular affinity for the mix of alienation and yearning that Kafka embodied in his life's work. Kitaj came to intuit that the quest for a measure of Jewish holism was constant and yet unattainable, just as the Kabbalists believed that perfect comprehension of the Torah was a necessary, if ultimately unrealizable, aim. Accordingly, one had to accept living in a fragmentary world, while also seeing—again like the Kabbalists—the potential for redemption inhering in the fragment itself.

Few understood the redemptive potential of the fragment better than another of Kitaj's favorite "conversation partners": Walter Benjamin (1892–1940). Benjamin was almost recruited by his dear friend Scholem to immigrate to Jerusalem to teach at the newly created Hebrew University. For all of his attraction to this redemptive prospect, finally he could not bring himself to move to Palestine, nor for that matter, to acquire Hebrew and thereby gain access to a richer form of Jewish holism. Rather, he was conditioned to wander in his fragmentary Diaspora state—and, of course, to observe with a constantly probing eye. Incidentally, among those topics upon which Benjamin cast his gaze were the cafés of Berlin, including the Romanische. He understood the café as a site to which the parvenu (we might read "the Jew") came to see and be seen, only to be displaced by the next round of newcomers.[18]

Kitaj appreciated and emulated Benjamin's participation/observation of cafés—and, moreover, his keen eye, honed in and from the café. In fact, he sought to express in his paintings what his Weimar friend articulated with pen. He particularly admired Benjamin's penchant for seizing on and unpacking the "fragment," a decidedly ethical, as well as aesthetic, act of recovery. Even before he knew of Benjamin, he had done a painting entitled *His Cult of the Fragment*. After learning of him, he came to identify and engage in one-way conversations with Benjamin, who stood for him as "the exemplary and perhaps ultimate Diasporist."[19] There was in Benjamin, and even more in "the angel of history" whom he famously described in the ninth of his *Theses on the Philosophy of History*, a poignant reflection of the heroic but losing struggle to

20 *Second Diasporist Manifesto*, #553. It is important to add that Gershom Scholem's essay, "Walter Benjamin and his Angels," was one of the last texts—perhaps the last—that Kitaj read in October 2007. The text is included in Scholem, *On Jews and Judaism in Crisis* (New York: Schocken, 1976).

restore voice, agency, and justice to the forgotten among us. Kitaj's own homage to the figure of the angel in Benjamin—and to Klee's *Angelus Novus*, upon which the "angel of history" was based—came in the form of more than two dozen paintings assembled under the title "Los Angeles."[20] (IMAGE: Painting from Los Angeles series.) Benjamin and his angel gestured toward the alluring possibility of redemptive belonging, but both were ultimately consigned to Exile, in all its creative and tragic forms. To be sure, Kitaj gave frequent expression to a proud and defiant Jewish tribalism, particularly in the face of anti-Semitism. But at the end of the day, he chose, like Benjamin, to wander in exile. To bring our conversation full circle, we might say, in evocation of Heine and Steiner, that the café was his "portable homeland" in Exile. It was there, and especially in the Westwood Coffee Bean, that he engaged in the animating and defining oscillations of his life, between picture and word, Diasporism and Zionism, Jew and man.

5
Gallery of Character Types

The Neo-Cubist, 1976–87

Oil on canvas, 178 × 132 cm

"The later painting is a portrait of Hockney which I began in the seventies. […] In the later eighties, David described to me the death of his friend Isherwood in California. I took up the old portrait again and drew a kind of alter-figure across the original full frontal one, with Chris Isherwood in mind. Like Hockney, and unlike me, he had been a very optimistic and sublime personality so I made of them a sort of cubist doppelganger representing both life and death in the particular widely perspectival California setting they made their own in exile, and, I hope, in some harmony with David's recent neocubist theory for pictures."
• R. B. Kitaj, 1988/89

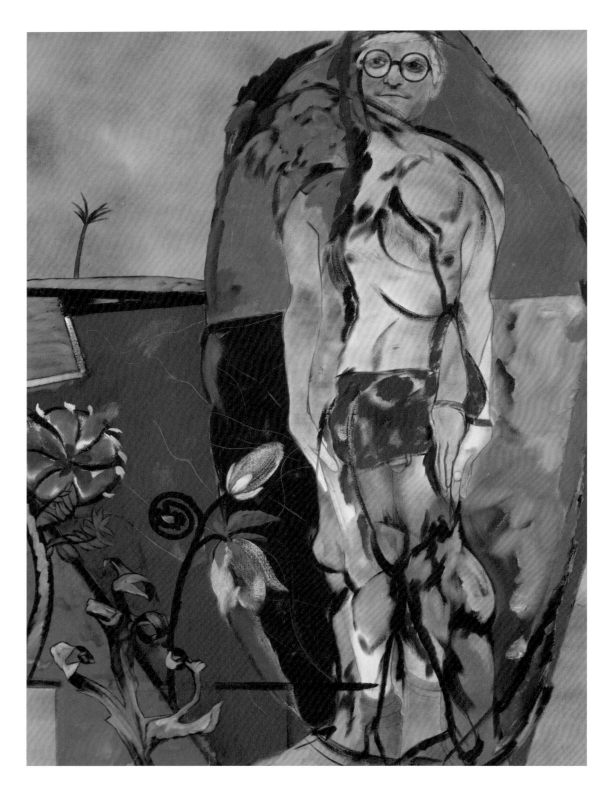

Batman, 1973
Oil on canvas, 244 × 76 cm

Superman, 1973
Oil on canvas, 244 × 76 cm

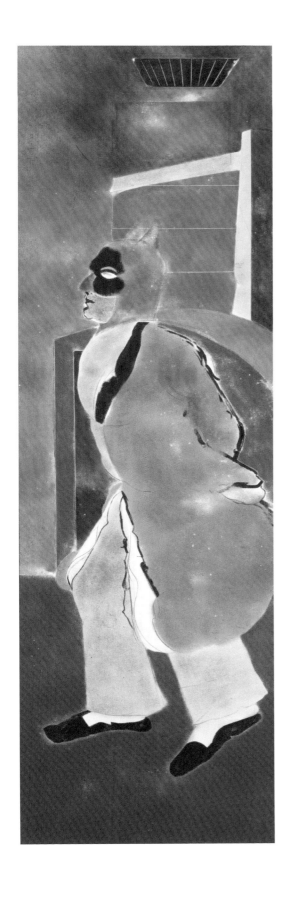

The Orientalist, 1975 – 77
Oil on canvas, 244 × 76 cm

The Arabist, 1975 | 76
Oil on canvas, 244 × 76 cm

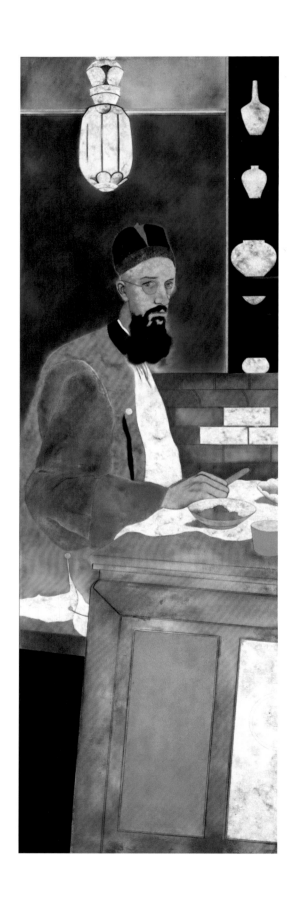

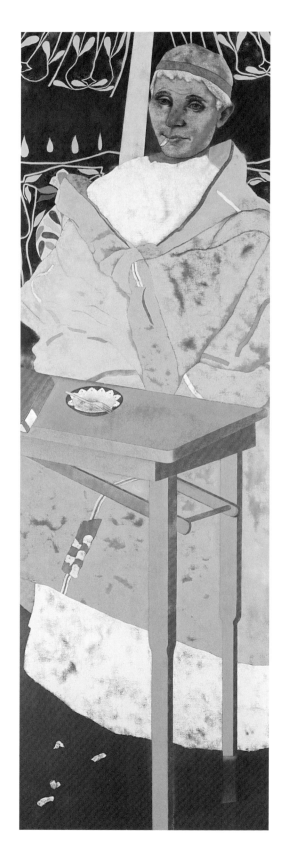

The Hispanist (Nissa Torrents), 1977 | 78
Oil on canvas, 244 × 76 cm

Smyrna Greek (Nikos), 1976 | 77
Oil on canvas, 244 × 76 cm

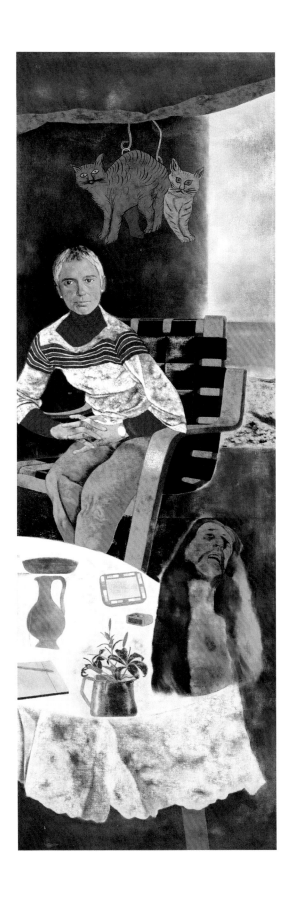

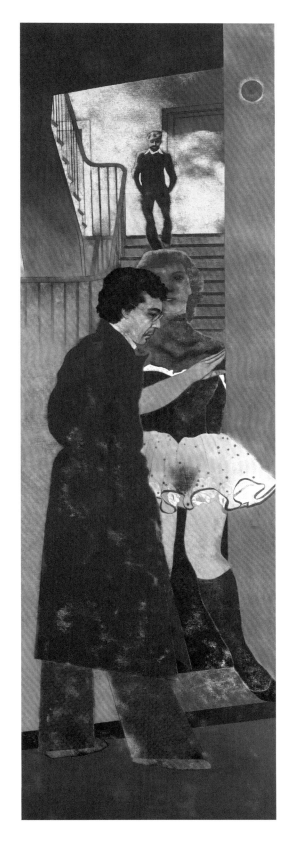

125

Catalan Christ (Pretending to Be Dead), 1976

Oil on canvas, 76 × 244 cm

"Diasporism has inspired those representations or fictions of types of people to whose pictures I have given titles ending in *ist* – Orientalist, Neocubist, Arabist, Remembrist, Cézannist, Sensualist, Communist and Socialist, Kabbalist, Caféist, Hispanist, and so on. I believe in a type-coining power for art. Some have been friends; all have been Diasporists (mostly not Jewish), folk who complicate one's world in strange and wonderful ways." • R. B. Kitaj, 1988

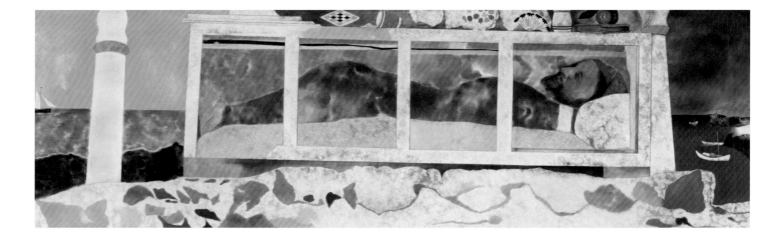

6
The Secret and the Public Jew

Desk Murder, 1970–1984
Oil on canvas, 76 × 122 cm

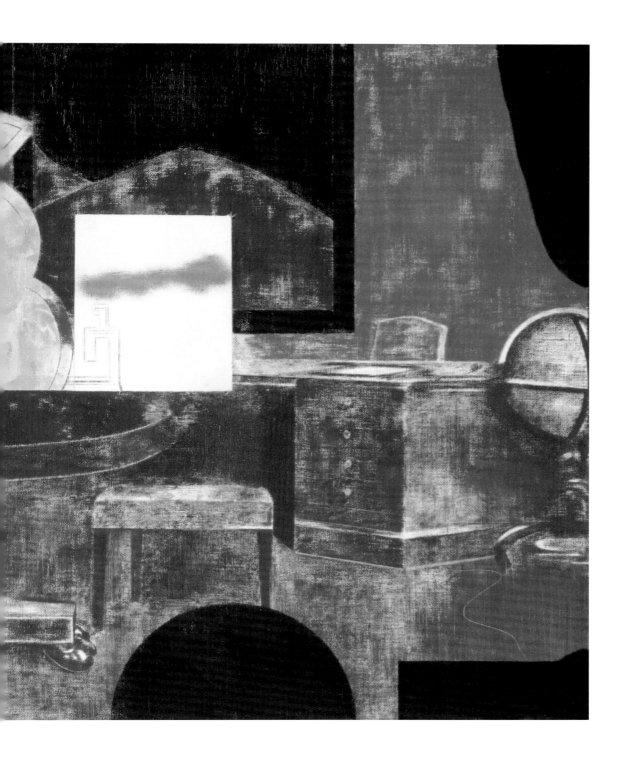

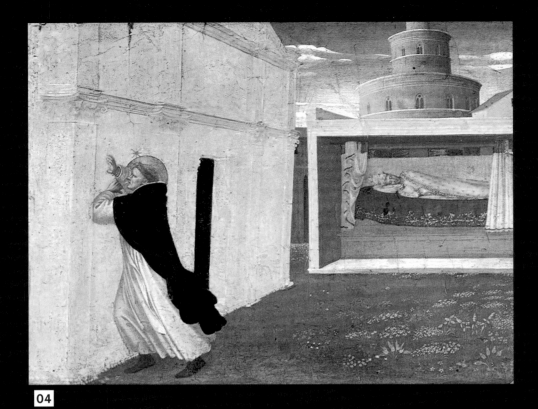

04

III

05

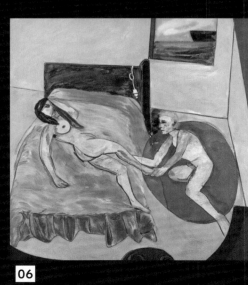

06

Notre Dame de Paris, 1984–86
Oil on canvas, 152 × 152 cm

The main compositional source is from Frau Angelico. There is a famous Haggadah called the Bird's Head Haggadah, from the Middle Ages, which gives each painted figure a bird's head in order to circumvent the Second Commandment (against idolatrous graven images). In Paris I had to pass by Notre-Dame to get to the Dames in Saint-Denis. All these saints and sinners mix beautifully as in life.

R. B. Kitaj, 1994

01

02

03

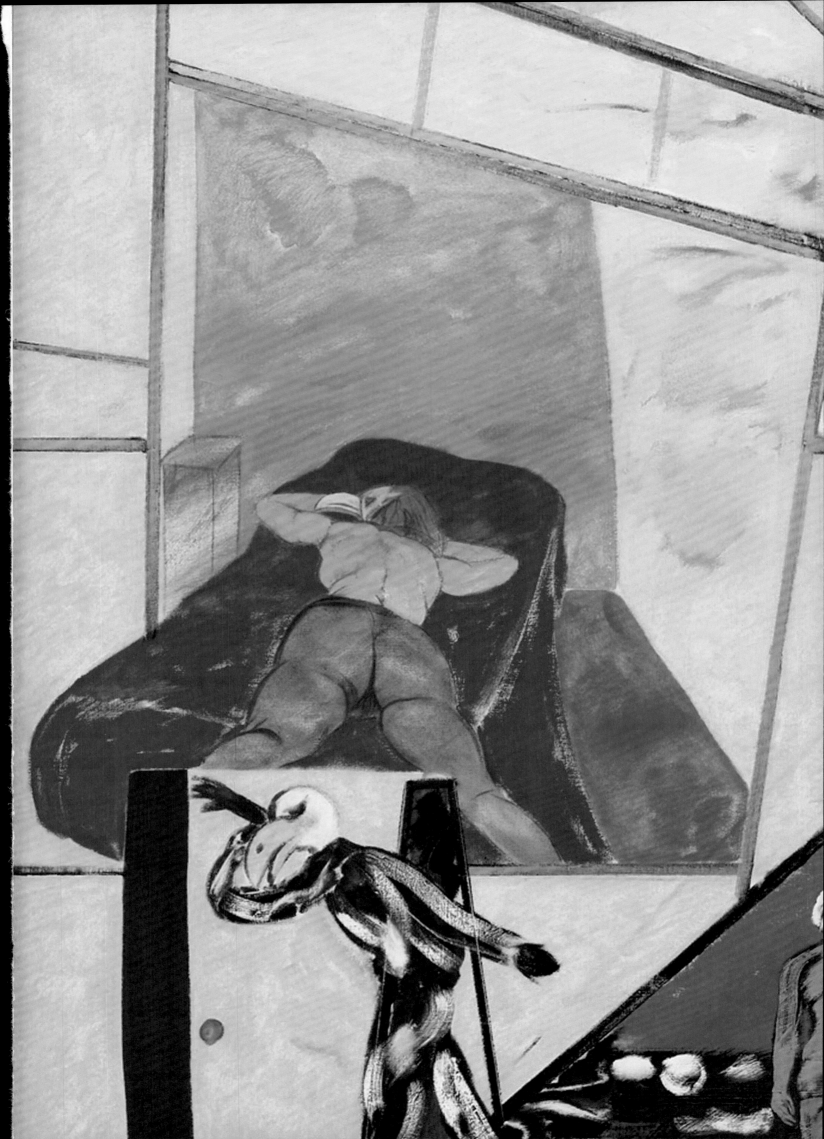

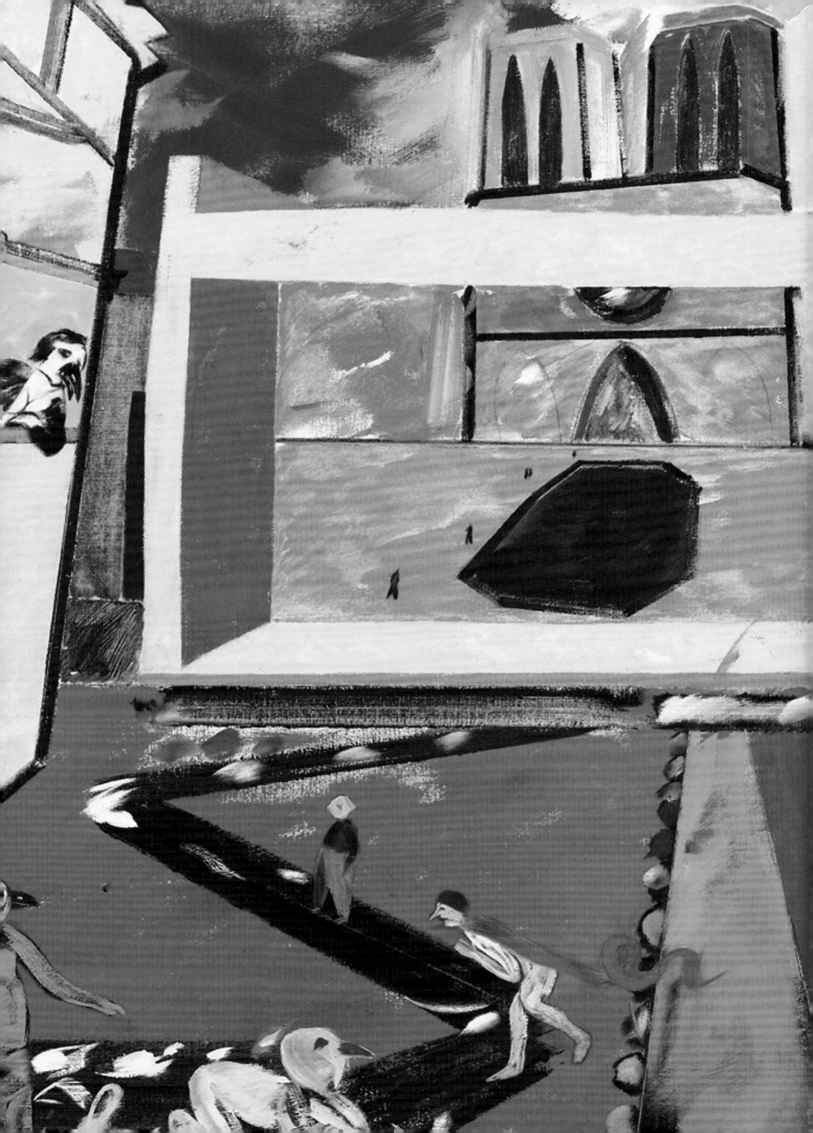

Sin

הטא

P recisely because evil is not grasped as an independent entity, however, man's attraction to it is seen as stemming not from a specific pull toward perversity but rather from other factors that have primarily to do with his weaknesses and not with some particular wicked quality. The conflict between body and soul often cited as an explanation for man's inner struggle is not really a conflict between good and evil; it occurs, rather, on account of man's preference for a partial, immediate view of things over a more comprehensive understanding, for the good of the moment over that which is everlasting, or, sometimes, on account of the incongruence between the merely pleasant and the truly desirable. Sin is also at times defined as forgetfulness, as a situation in which man temporarily fails to recall his obligations and his true needs and concerns himself with other things instead.

11

12

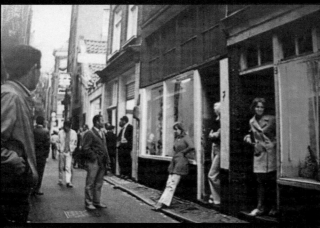

13

01 R.B. Kitaj in conversation with Julián Ríos, in: Julián Ríos, *Pictures and Conversations*, London 1994, p. 153.

02 Illustration from the Bird's Head Haggadah, early 14th century; the figures have bird-like heads, presumably because of the Biblical prohibition on creating images of humans.

03 R.B. Kitaj, *The Second Time (Vera Cruz, 1949) A Tale of the Maritime Boulevards*, 1990, oil on canvas, private collection, Connecticut.

04 Fra Angelico, *The Dream of Innocent III*, from the Predella panel of the coronation of the Virgin, 1434/35, Louvre, Paris.

05 R.B. Kitaj, *The Poet and Notre Dame (Robert Duncan)*, 1982, pastel and coal on paper, private collection.

06 R.B. Kitaj, *The First Time (Havana, 1949)*, 1990, oil on canvas, Marlborough International Fine Art.

07 Henri Matisse, *Une Vue de Notre-Dame*, 1914, oil on canvas, MoMA, New York.

08 R.B. Kitaj, *The Room (Rue St. Denis)*, 1982/83, oil on canvas, Marlborough Fine Art, London.

09 Adin Steinsaltz, quoted by R.B. Kitaj in a handwritten note in: *Kitaj papers*, UCLA.

10 R.B. Kitaj, *The Third Time (Savannah, Georgia)*, 1992, oil on canvas, private collection.

11 Adin Steinsaltz, "Sin", in: *Strife of the Spirit. A Collection of Talks, Writings, and Conversations*, Jerusalem 1998, p. 113ff.

12 Admission ticket *Sex Cinéma Venus*, Amsterdam, without date, in: *Kitaj papers*, UCLA.

13 Photography of the red light district in Amsterdam, without date, in: *Kitaj papers*, UCLA.

09

08

07

10

The Jew Etc., 1976–1979 (unfinished)

Oil and coal on canvas, 152 × 122 cm

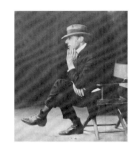

"In this picture, I intend Joe, my emblematic Jew, to be the unfinished subject of an aesthetic of entrapment and escape, an endless, tainted Galut-Passage, wherein he acts out his own unfinish. All painters are familiar with the forces of destiny embedded in happy accident and other revelations and failures which inform one's painting days. In that way, I'd like to expose Joe, in his representation here, to a painted fate not unlike the unpredictable case of one's own dispersion in the everyday world." • R. B. Kitaj, 1994

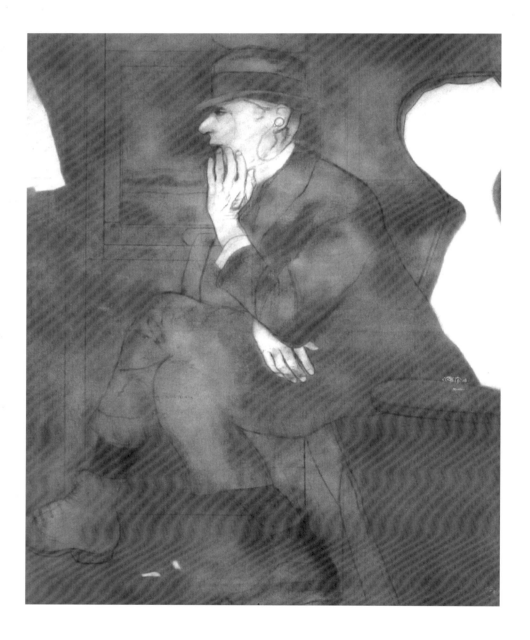

Marrano (The Secret Jew), 1976
Oil and coal on canvas, 122 × 122 cm

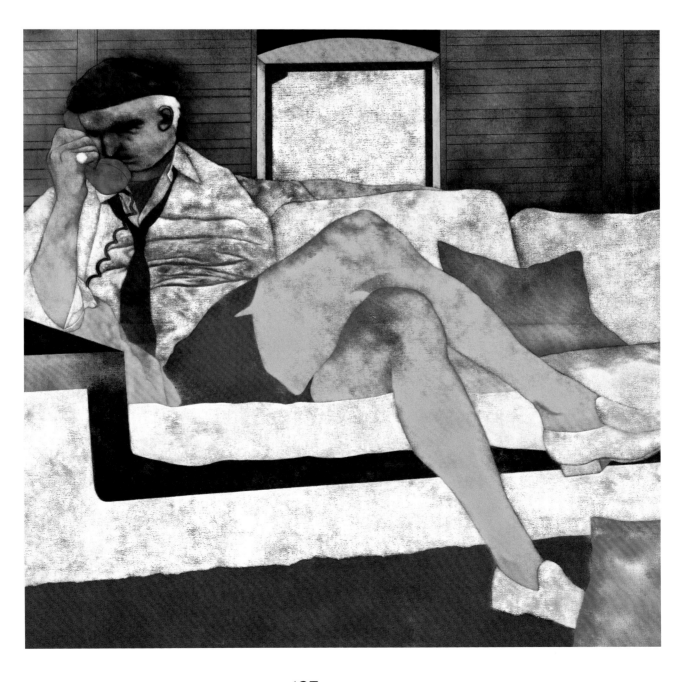

If Not, Not, 1975|76

Oil and black chalk on canvas, 152 × 152 cm

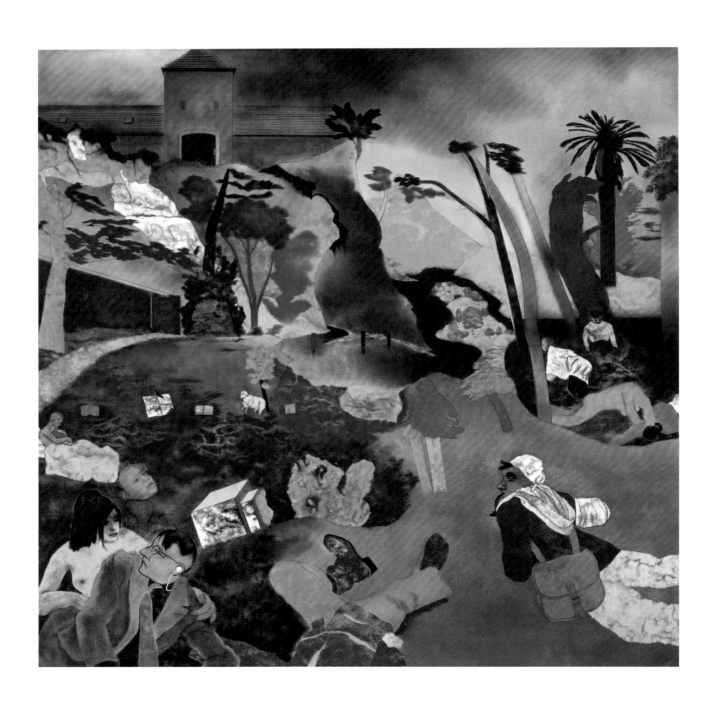

The Jewish Rider, 1984|85

Oil on canvas, 152 × 152 cm

"My friend Michael Podro posed for this painting and its few associated drawings off and on over the course of about one year. It is based, of course, on Rembrandt's Polish Rider in the Frick (my favorite picture there). Unlike Rembrandt's masterpiece there is no mystery about who posed for me or where he's going. […] I was inspired by a report someone wrote, who rode a train or trains from Budapest to Auschwitz to see what the doomed souls might have seen. He said the countryside was beautiful."
• R. B. Kitaj, n. d.

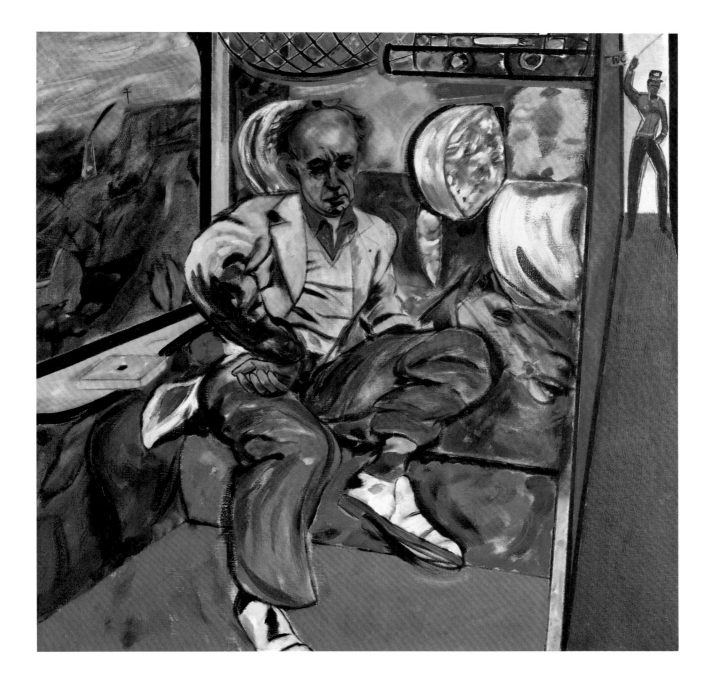

Cecil Court, London WC2 (The Refugees), 1983|84

Oil on canvas, 183 × 183 cm

"One of the first friends to see this painting (a seventy-five year old refugee) said the people in it looked meshuga. They were largely cast from the beautiful craziness of Yiddish Theatre, which I only knew at second hand from my maternal grandparents... I would stage some of the syntactical strategies and mysteries and lunacies of Yiddish Theatre in a London Refuge, Cecil Court, the book alley I'd prowled all my life in England, which fed so much into my dubious pictures from its shops and their refugee booksellers, especially the late Mr Seligmann (holding flowers at left) who sold me many art books and prints." • R.B. Kitaj, 1994

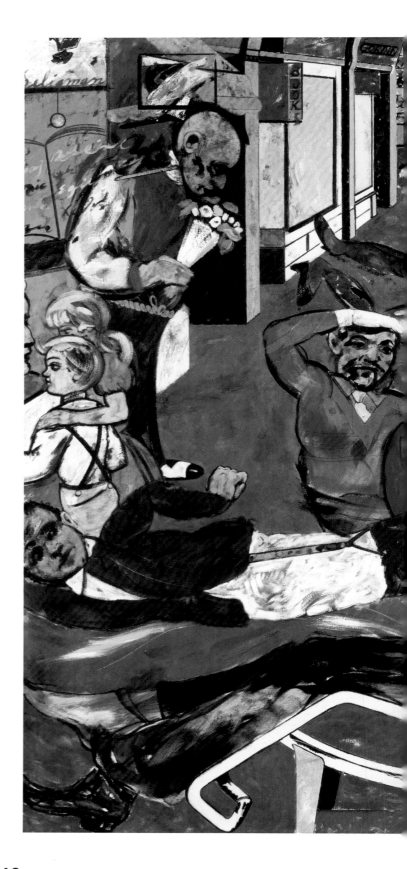

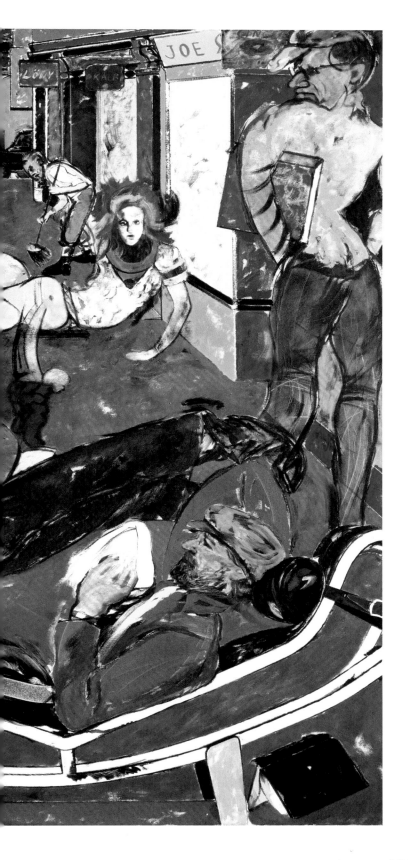

His New Freedom, 1978
Pastel and coal on paper, 77 × 56 cm

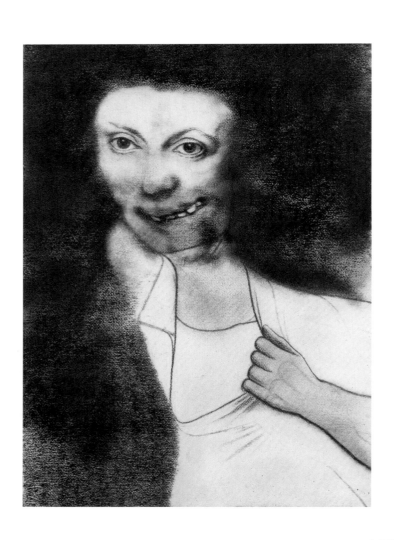

7
Distorted Bodies

The Sailor (David Ward), 1979|80

Oil on canvas, 152 × 61 cm

"When I got home, I looked up a photo of my old painting of *The Sailor*, done after a Black Chef I shipped to Brazil with forty years before in my seagoing youth. [...] I've portrayed him wearing what used to be called a 'West Coast Cap.' I've got him partly in the water, more symbolic than plausible for a merchant sailor. I remember once when I was sketching at sea, he asked me: 'What is Rembrandt?'... which now strikes me as a very large and imposing question."
• R. B. Kitaj, 1994

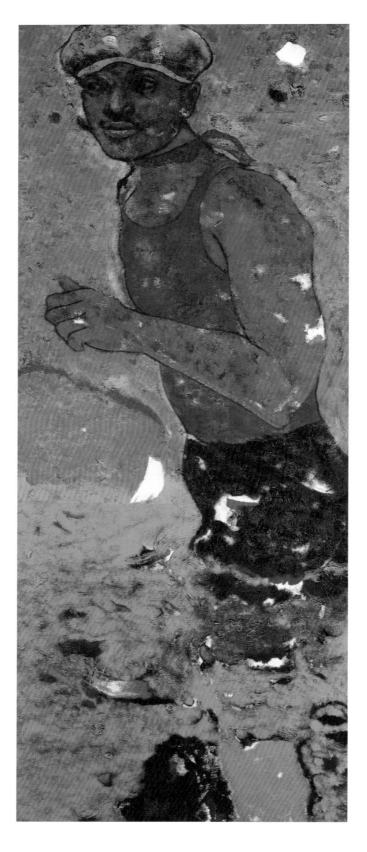

144

Bather (Tousled Hair), 1978
Pastel on paper, 122 × 57 cm

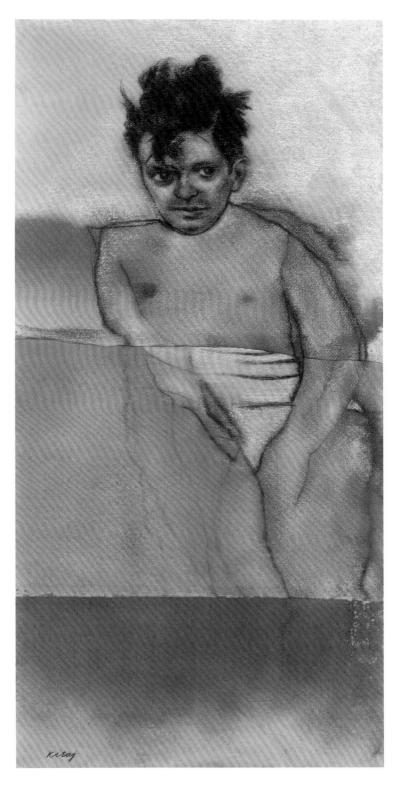

The Rise of Fascism, 1975–1979

Pastel, coal and oil on paper, 85 × 158 cm

"Hitler had identified the pimps in Frankfurt as Jews and condemned them as the perpetrators of a moral cancer in German society. What Hitler had failed to realise was that Jewish pimps were exploiting Jewish girls, and in doing so they had unwittingly aided the fascist cause [...]" • R. B. Kitaj, 1980

"I feel taken in: any artist can paint a voluptuous nude deployed for masculine delectation and call it anything he wants, 'The Free Woman,' 'The Sprit of Women's Liberation,' 'The Diasporist Manifesto,' or, alternatively, 'The Rise of Fascism'— (p. 47) take your pick. Since woman have no identity in themselves, they can signify anything the artist wants them to, as allegories, or, more obliquely, as the bearers of secret meanings, known only to the artist himself." • Linda Nochlin, 1998

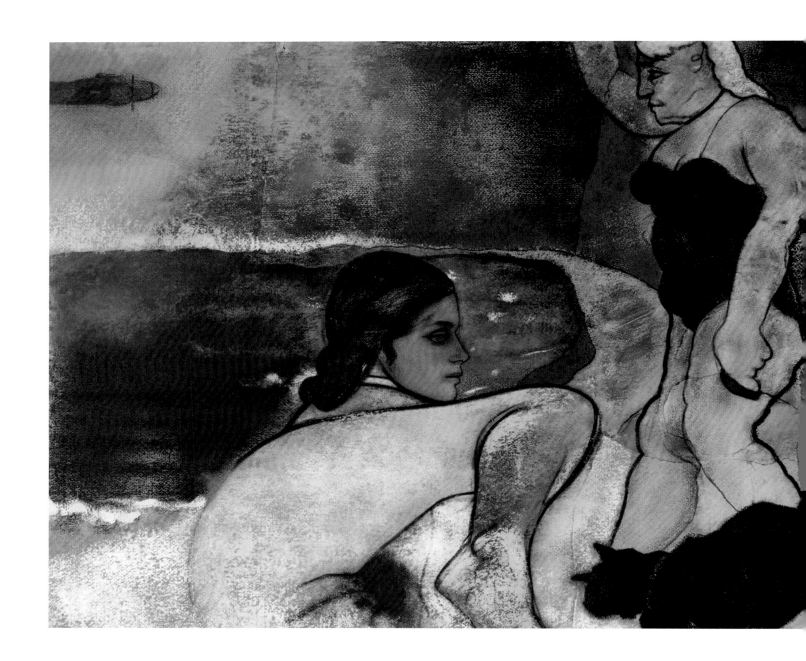

146

 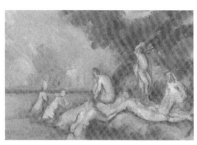

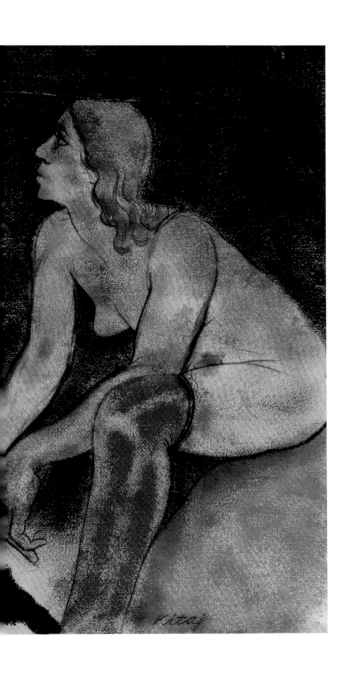

London, England (Bathers), 1982

Oil on canvas, 122 × 122 cm

"Well. I'm an old pessimist but this odd picture was painted that wonderful year in Paris, '82–3, and I was looking back at the English Isle—water all round, you see—in that difficult, oblique mode I adopt too often for my own taste and the tastes of countless critics of mine. [...] And in the end I left Paris, France, and returned to London, England, as usual because there seems to be a little less wrong with London than other places I've known." • R. B. Kitaj, 1994

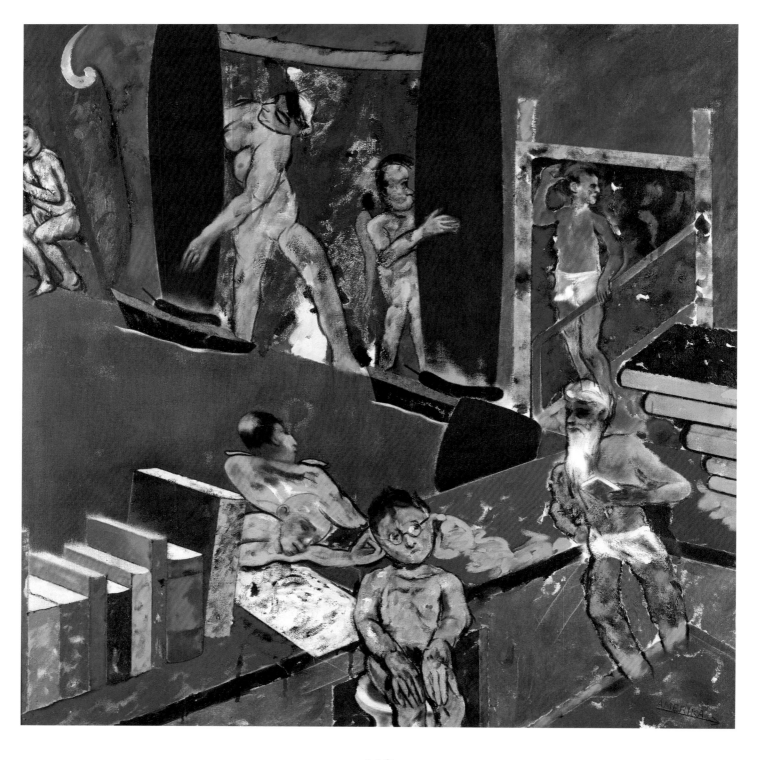

Self-Portrait in Saragossa, 1980
Pastel and coal on paper, 147 × 85 cm

"Hockney and I visited Warsaw
about 10 years ago and wandered
almost by chance into the Gestapo
Headquarters, preserved as a
Museum." • R. B. Kitaj, 1981

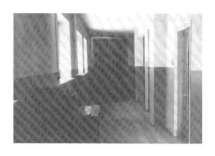

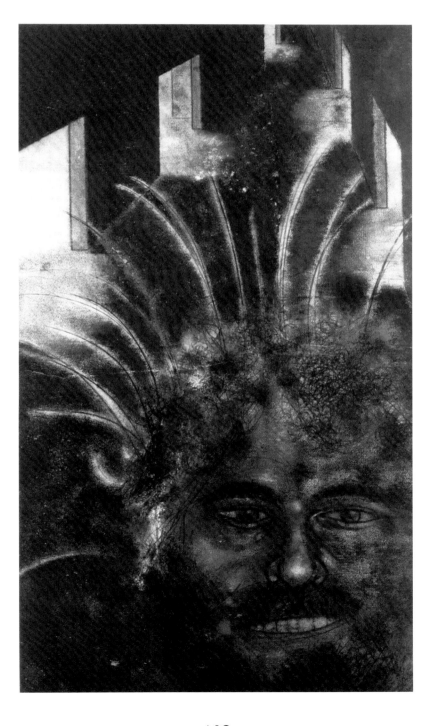

The Sensualist, 1973–84

Oil on canvas, 246 × 77 cm

"This (canvas) began life the other way round, as a woman. You can still see her pink head upside down at the bottom. I don't remember who she was but I think she represents the real woman in the Sensualist's life in the repainted picture. This studio picture was not painted from life. First, I painted over the woman a kind of copy of the famous Cézanne male 'Bather' of 1885 [...]. Then, the Titian 'Marsyas' came to the Royal Academy and blew everyone's mind. [...] In the end oneself is the making of it; not after life but about life, I think Pound said."
• R. B. Kitaj, 1994

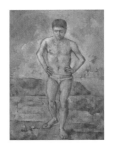

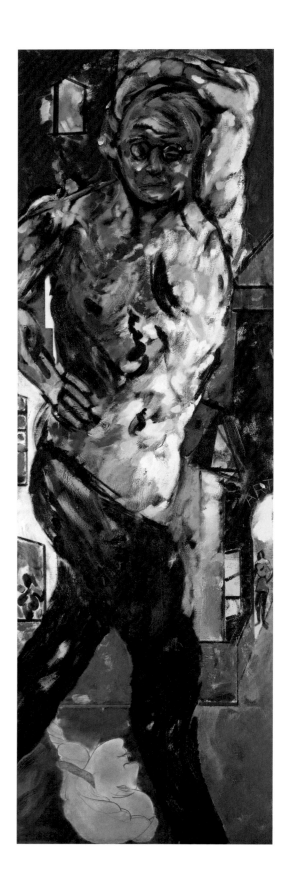

Self-Portrait as a Woman, 1984

Oil on canvas, 247 × 77 cm

"My name is Hedwig Bacher and I'm still alive, more's the pity. When the author of this painting was a nineteen-year-old art student in Vienna in 1951, I was his landlady and for about six months, we were also lovers. [...] (During the Nazi years) I slept with a Jew and got caught, so these thugs stripped me and I had to march naked through the streets... When I saw this painting of his in a book forty years later, I wrote to him in London saying I had no idea he felt close enough to my humiliation to have put himself in my place as it were, to have put himself into the picture." • R. B. Kitaj, 1994

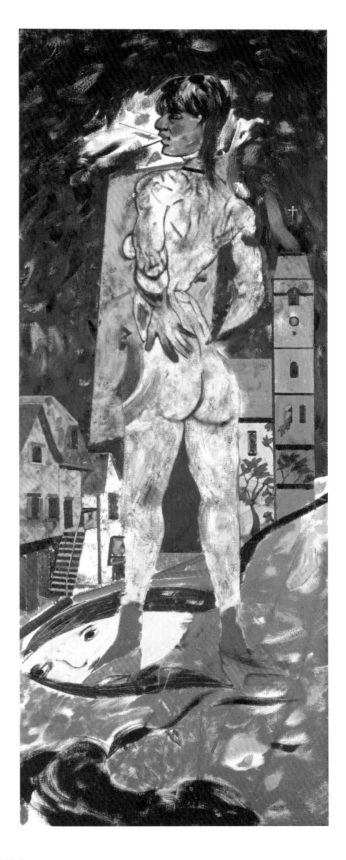

Mussolini (Emblem), 1978
Pastel on paper, 101 × 39 cm

Femme du Peuple II, 1978
Pastel, 77 × 56 cm

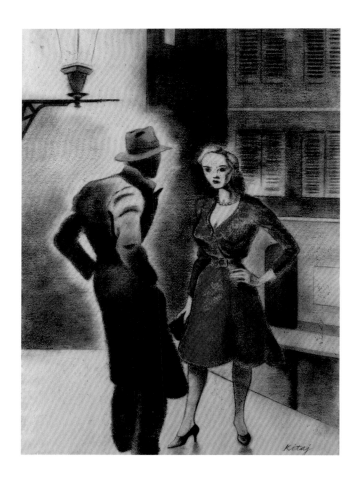

8
Obsessions

Germania (To the Brothel), 1987

Oil on canvas, 121 × 91 cm

"It was about one o'clock in the morning. I was exhausted, leaning against a wall in the passageway to Hamburg's largest brothel, preparing to return to my hotel (there I am in the painting, in the left), - when I saw him [...] this young man struck me as a worst case, malformed, throughout his body. I've not represented him awfully or artfully enough. I followed his halting steps down the alley to the brothel, wondering how or if he presented himself to the girls (behind the cobalt-violet wall at the left). At the entrance, he just peered…" • R. B. Kitaj, n.d.

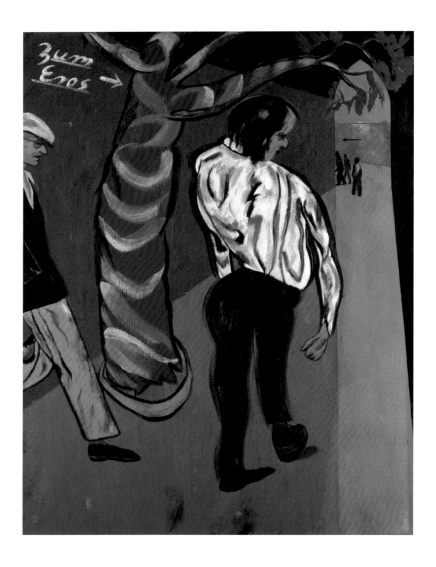

The Wedding, 1989–1993
Oil on canvas, 183 × 183 cm

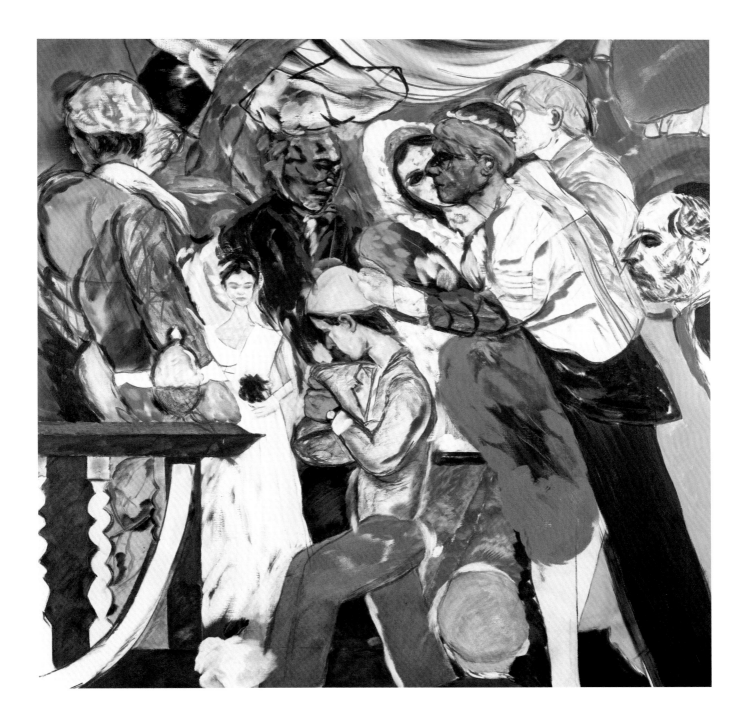

Passion (1940–45) Drawing, 1985
Oil on canvas, 56 × 43 cm

Passion (1940–45) Writing, 1985
Oil on canvas, 45.7 × 26.7 cm

"That epochal murder happened during my youth, and now, after the greatest trouble they were ever in, Jews find themselves in peril again. I found I could not proceed as a painter without that heightening sense in myself, in my pictures. "[...] it was the Christian Passion of the painter Rouault which helped me determine to embark on a Passion (1940–1945). [...] The appearance of the chimney form in some of my pictures in this exhibition is my own very primitive attempt at an equivalent symbol, like the cross, both, after all having contained the human remain in death." • R.B. Kitaj, 1986

Passion (1940–45) Reading, 1985
Oil on canvas, 46 × 51 cm

Passion (1940–45) Landscape/Chamber, 1985
Oil on canvas, 28 × 51 cm

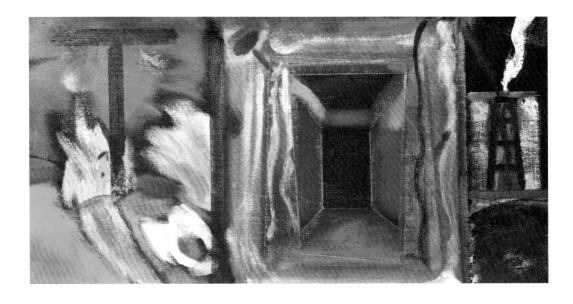

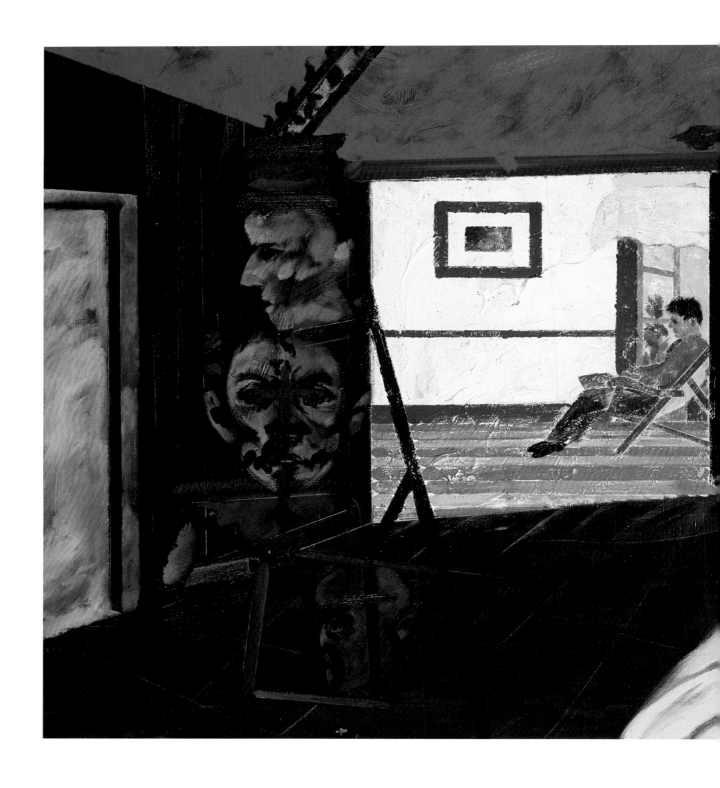

The Divinity School Address, 1983–85

Oil on canvas, 91 × 122 cm

"The young man in my painting is reading Emerson's Divinity School Address [...]. He is uncertain what to make of Emerson's great ode to the religious sentiment... I have cast my young reader in Emerson's 'refulgent summer,' the sunny outer room, where 'Man is the wonder-worker. He is sun among miracles.'

Let faith depart, 'Then falls the church, the state, art, letters, life.' This is a meaning of the foreground gloom, its interior oration. [...] The malignant shadow in my foreground and the Over-Soul born in the sunlit room are in fateful conflict still." • Kitaj, n.d.

Drancy, 1984−86

Pastel and coal on paper, 100 × 78 cm

"I wanted to visit Drancy, so Anne [Atik] and I did—We took a suburban train to what had become a nowhere town, largely foreign working-class I think. No taxis; so we walked and walked thru desolate streets… we found it, a massive housing estate for workers, Moslem I think. There were some crumby plaques in French and Hebrew. This was the Vichy holding-camp for rounded up Paris Jews in their thousands, awaiting their train rides to Auschwitz. [...] Later, Anne and I did a little publication called Drancy: her poem and my two drawings." • R. B. Kitaj, ca. 2003

Bad Faith (Riga)
(Joe Singer Taking Leave of His Fiancée), 1980
Oil, pastel and coal on paper, 94 × 57 cm

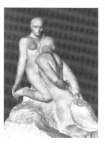

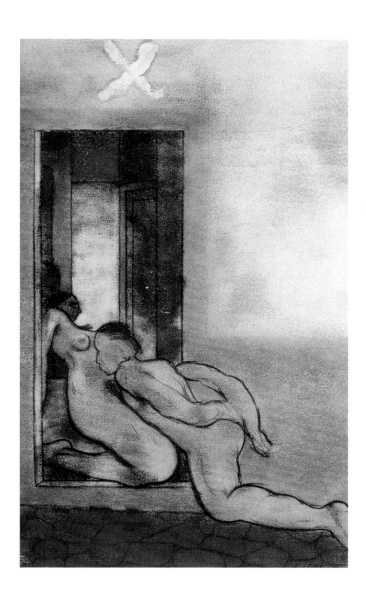

03

04

IV

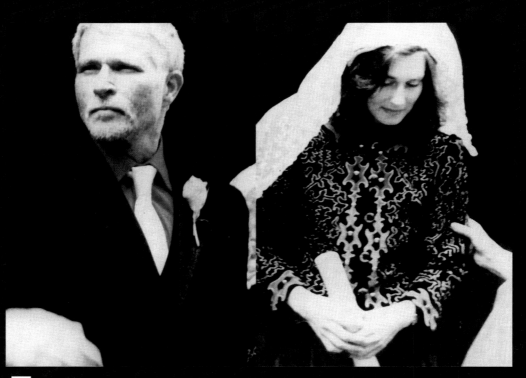

05

The Wedding, 1989–93

Oil on canvas, 183 × 183 cm

Sandra and I were married in the beautiful old Sephardic Synagogue (...). Under the chupa (canopy), aside from my children and the Rabbi in top hat, Freud is on the left, Auerbach in the middle, then Sandra and me, and Hockney (best man) is to the right of us. Kossoff appears at the far right, transcribed from a drawing by John Lessore. I worked on the painting for years and never learned how to finish it (...). In the end, instead of finishing it, I finished with it and gave it away to a deserving old friend.

R. B. Kitaj, 1994

01

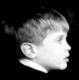

02

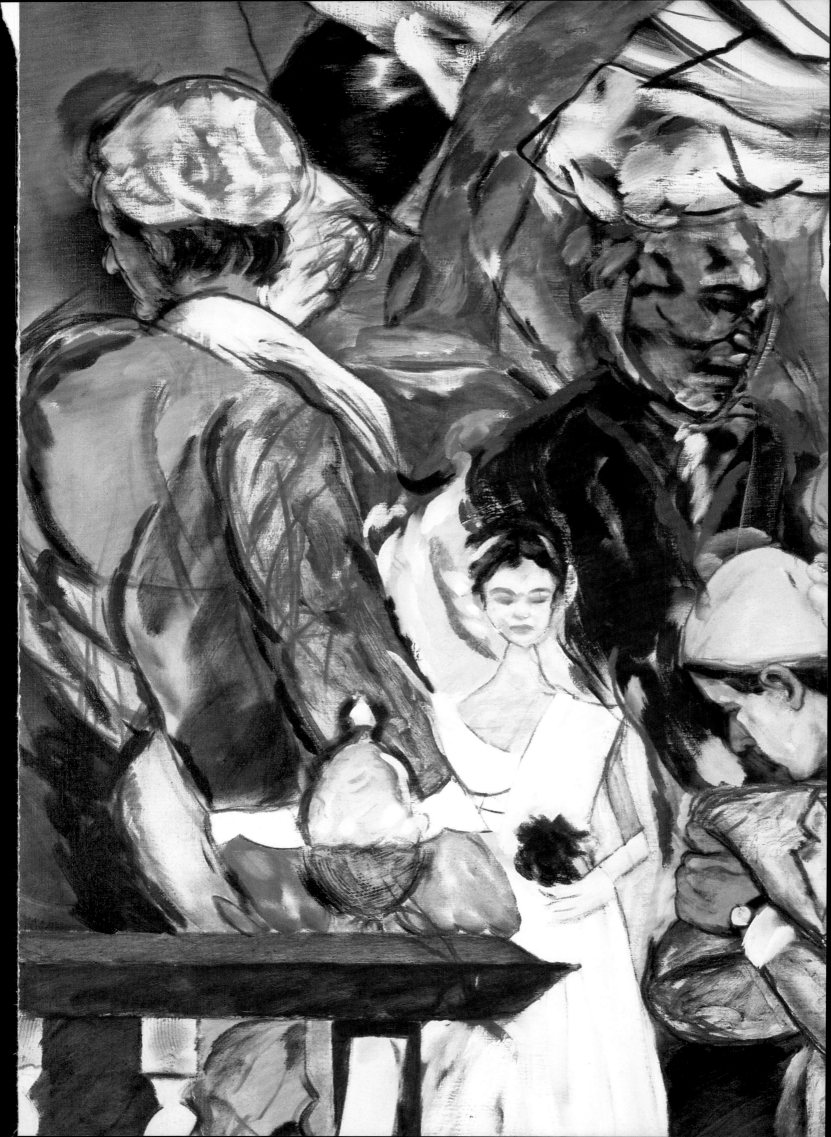

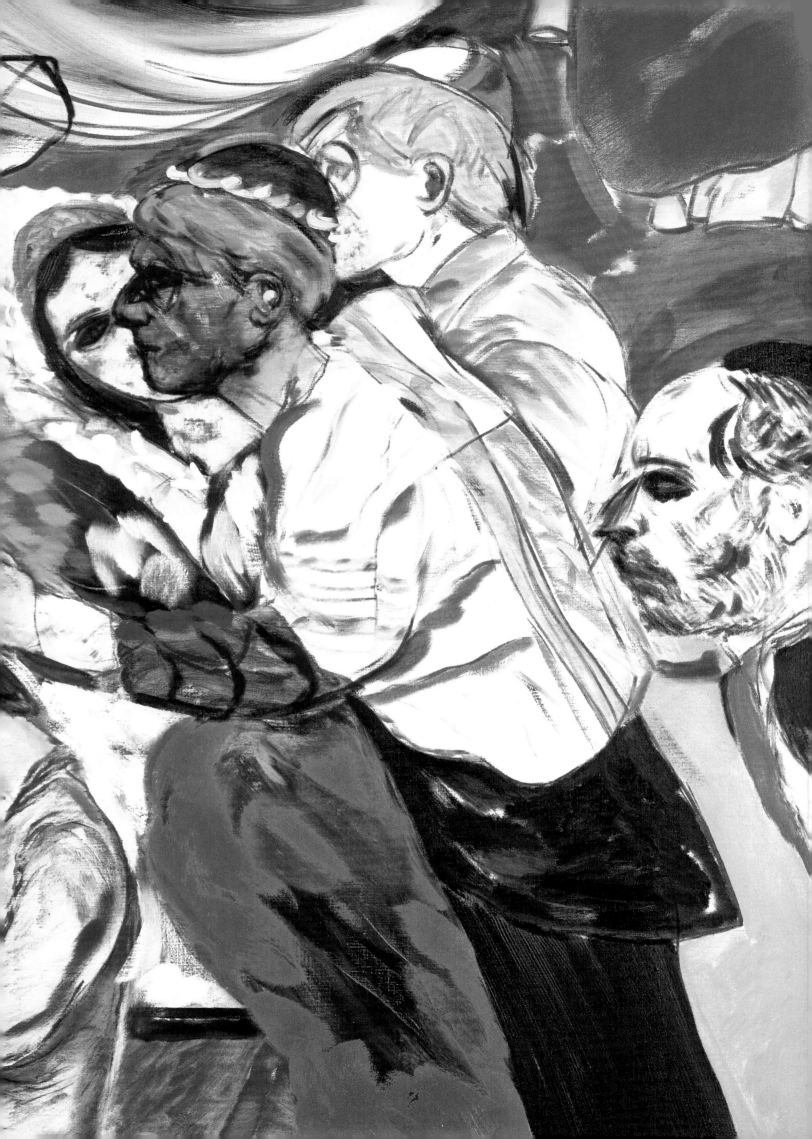

10

01 R. B. Kitaj, in: Richard Morphet (ed.), *R. B. Kitaj. A Retrospective*, London 1994, p. 120.

02 *Photo of Max*, in: *Kitaj papers*, UCLA.

03 R. B. Kitaj, draft of *The Wedding*, napkin, in: *Kitaj papers*, UCLA, Box 141, Folder 3.

04 Sandra Fisher at the wedding, in: *Kitaj papers*, UCLA, Box 141, Folder 1.

05 David Hockney, R. B. Kitaj and Sandra Fisher at their wedding, photograph, 1983.

06 Picture of an East-European bride accredited to Isidor Kaufmann in: Hayyim Schneid, *Marriage*, Jerusalem 1973, p. 7.

07 Wedding of Sandra Fisher and R. B. Kitaj, two photographs, in: *Kitaj papers*, UCLA.

08 Wedding dress, in: Hayyim Schneid, *Marriage*, Jerusalem 1973, p. 22. (Kitaj owned one copy of the book.)

09 Brochure of the Bevis Marks Synagogue, London, in: *Kitaj papers*, UCLA, Box 141, Folder 2.

10 Notarially certified letter of Jeanne Brooks Kitaj, in: *Kitaj papers*, UCLA:
Nov. 16, 1983
"Dear Sirs:
This is to affirm that my son, R. B. Kitaj was born of both, a Jewish father and Jewish mother.
I am in Florida for the winter;
Therefore, I am unable to provide a document. I have a marriage document of my parents, but it is in a box in the bank, so there is no way I can get it in my bank in Toledo, Ohio. (until April)
This is to certify that the above is the truth.
Jeanne B. Kitaj."
State of Florida, County of Broward "

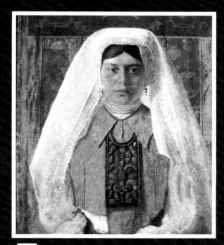

06

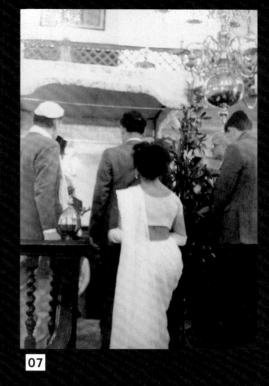

07

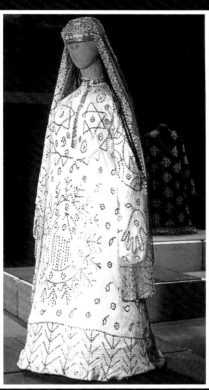

08

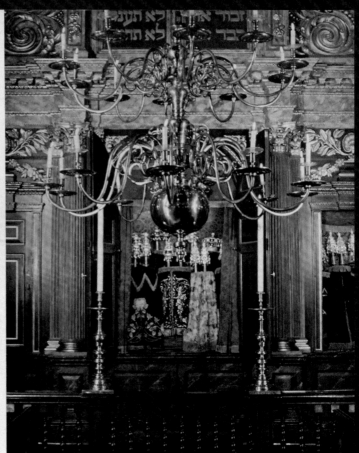

THE BEVIS MARKS SYNAGOGUE

RICHARD D. BARNETT *and* ABRAHAM LEVY

09

Notre Dame de Paris, 1984–86
Oil on canvas, 152 × 152 cm

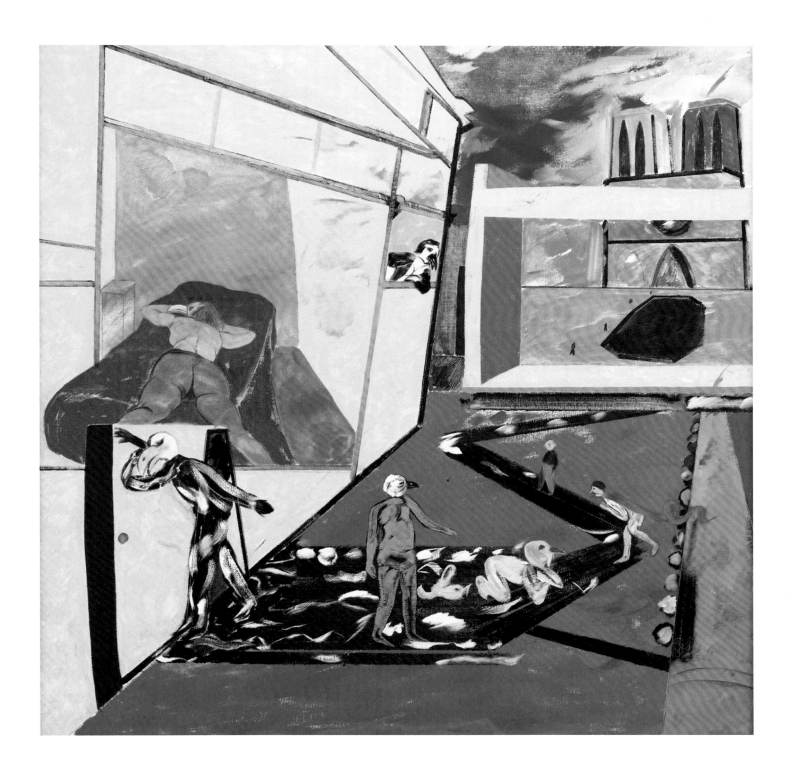

The Listener (Joe Singer in Hiding), 1980
Pastel and coal on paper, 103 × 108 cm

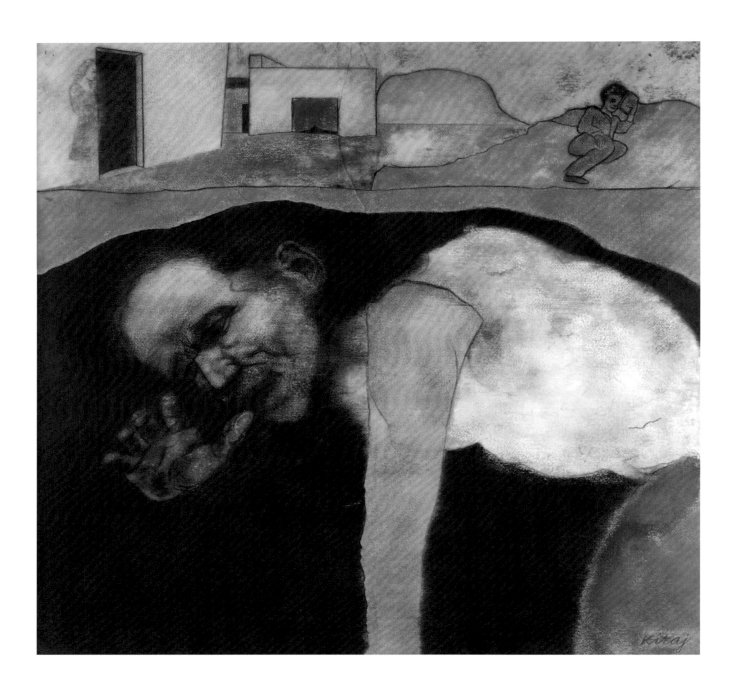

9
The Library as a Diasporic Home

Unpacking my Library, 1990|91

Oil on canvas, 122 × 122 cm

"I'm a bibliomaniac (not a scholar) as peculiar as any that the book disease has infected, mainly because my books feed into the pictures I make with an untutored passion. Vast libraries have crowded around my painting easel all my life and the spectres in books have haunted me, some would say ruined me, and now and again they even breathe life into some of my dubious art."
• R. B. Kitaj, ca. 1990

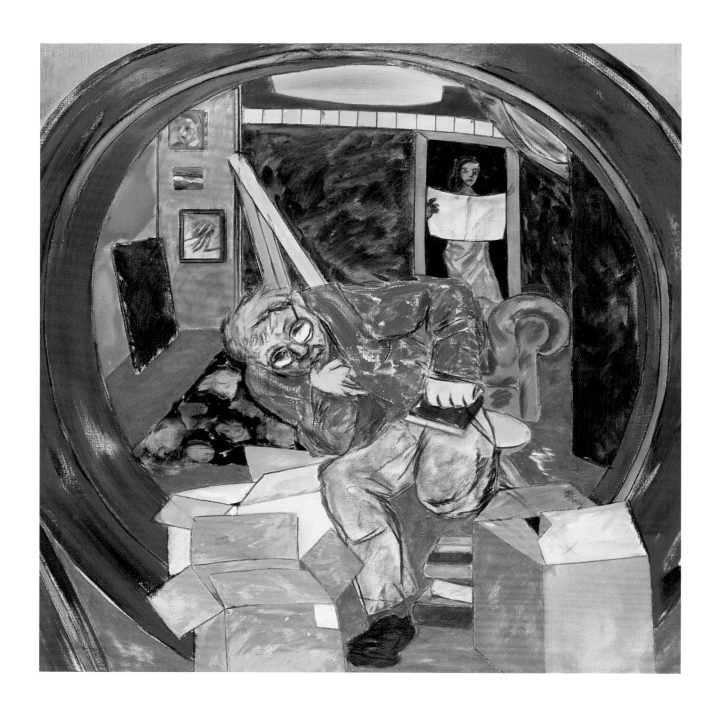

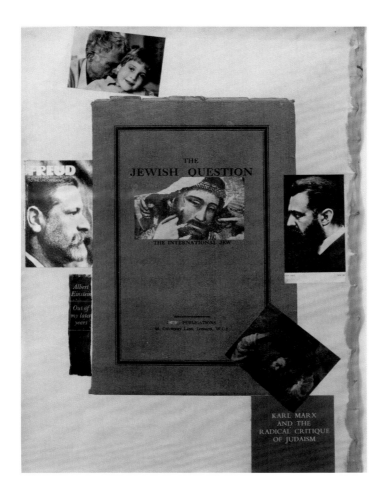

In Our Time: Covers for a Small Library
after the Life for the Most Part, 1969

50 screen prints, 78 × 57 cm, 57 × 79 cm

"I like those screen prints of mine best which are influenced by Duchamp, like my book covers In Our Time, almost but not quite readymades. I think Duchamp's readymades are a distinguished moment in art." • R. B. Kitaj, 2003

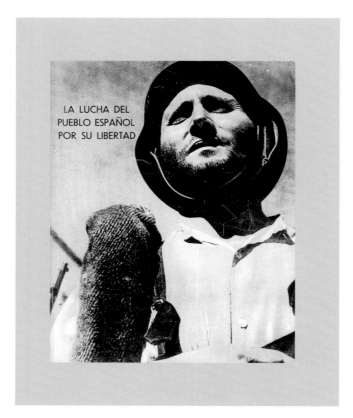

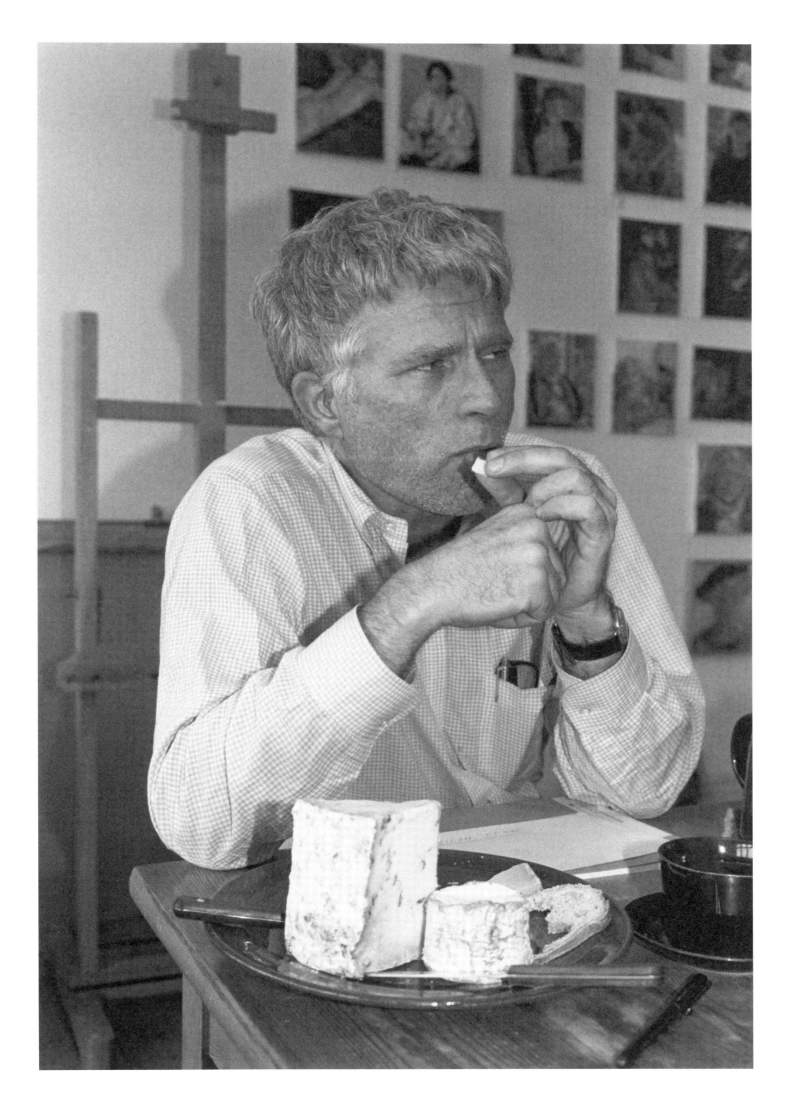

"Will I be the Herzl (or Ahad Ha'am) of a nu [!] Jewish Art???"
R.B. Kitaj's Manifestos of Diasporism

Inka Bertz

1 For texts and excerpts from these manifestos see: Vivian Mann, *Jewish Texts on the Visual Arts* (Cambridge, 2000); Natalie Hazan-Brunet (ed.): *Futur antérieur. L'avantgarde et le livre* *yiddish (1914–1939)*, (Paris, 2009); Inka Bertz, "Jüdische Kunst als Theorie und Praxis vom Beginn der Moderne bis 1933," in: *Das Recht des Bildes. Jüdische Perspektiven in der modernen Kunst*, Hans Günter Golinski & Sepp Hiekisch-Picard (eds.), (Bochum, 2003), pp. 148–61; as well as Margret Olin, *The nation without art. Examining modern discourses on Jewish art*, (Lincoln, 2001).

Of all the texts that, since Martin Buber's speech to the 5th Zionist Congress in 1901, have concerned themselves theoretically and programmatically with the question of a Jewish art,[1] Kitaj's Diasporist Manifestos, written in 1988/9 and 2007, are the only ones to proclaim a new "ism" and to take the stage as "manifestos," that text-genre so central to the twentieth-century avant-gardes.[2]

In 1984, four years before the *Erstes Manifest des Diasporismus* came out, R. B. Kitaj first aired his thoughts on Jewish art in the *Jewish Chronicle* in an article entitled "Jewish Art—indictment and defence: a personal testimony."[3] The questions he posed there form the starting point for his deliberations in the two following decades. Compared with his later, more aphoristic texts, here Kitaj followed a clear line of argument. He started by asking the question that was to interest hum until his death:

"Why is there no Jewish art of any real consequence? I mean great Jewish art? Why do we not have a Chartres or a Sistine Chapel or a Hokusai or a Goya or a Degas or a Matisse? Both Rembrandt and Picasso seem to have loved the Jews but no artist of that quality has ever arisen among us, a people gifted way beyond our small number. We can only speculate."

Hardly surprisingly, his first attempt at an answer tackled the issue of so-called aniconism. Visits to Jewish museums did nothing to lessen his sense of helplessness in the face of theological issues: "The Commandment could account for the thousands of years of mediocre adorning, hiddur mizvah the rabbis called it: 'adorning the precepts,' the result of which may be seen in the well-meaning museums of Jewish art we've all stumbled into. Full of what? Liturgical, archaeological tchatchkeles and even those are no match, some megilot and Hagadot (such as the medieval Bird's Head Hagada) notwithstanding within that selfsame genre for, say, the Celtic Book of Kells, the supreme Girona Beatus Apocalypse, let alone Botticelli's illustrations to Dante."

Kitaj developed the idea that good art requires a specific environment and tried to offer a second answer: "The next factor that comes to mind is that the Jews were kicked out of their land. Two things occur to me: one is that the exile, dispersal and relentless persecution of a people is not exactly conductive to the creation of either a collective miracle in art, like a great cathedral or a singular artistic miracle which requires a context, a milieu." Secondly, he argued: "I believe the painters simply didn't have enough *time* (as guests who were merely tolerated) to develop a tradition like the French and Italians, who had the time *and* a place. I simply don't know."

The notion that Jewish art could only arise in a "national home" is already to be found in Martin Buber's speech to the 5th Zionist Congress, and the question whether there could be such a thing as Jewish art per se and how it would differ from non-Jewish art fired many a debate in the first half of the century. Initially Kitaj did not discuss this in any greater depth but reported on his personal focus on the theme: "The Jewish spirit in me was a long time in the forming and coming. It began to stir seriously about five years ago." He realized that "one third of our people were being murdered while I was playing baseball and going to the movies and high school and dreaming of being an artist." He was never to be able to shrug off the helpless sense of guilt given the parallel occurrences and this is repeatedly present in his later texts, too.

"Instinct led me through reading and thinking and meeting people, not to the rumoured origins of the Jews but to something that has proved far more seductive for my art

2 Wolfgang Asholt (ed.), *Manifeste und Proklamationen der europäischen Avantgarde* (Stuttgart, 1995); Friedrich Wilhelm Malsch, *Künstlermanifeste. Studien zu einem Aspekt moderner Kunst am Beispiel des italienischen Futurismus*, (Weimar, 1997).

3 R. B. Kitaj, "Jewish art – indictment & defence: a personal testimony," in: *Jewish Chronicle Colour Magazine*, Nov. 30, 1984, pp. 42-6.

4 Derived from the traditional concept of "Yiddishkait," the term "Jewishness" became topical with the interest in cultural identity that arose in the 1970s and 1980s.

5 Nicolaus Pevsner, *The Englishness of English Art* (London, 1956).

6 R. B. Kitaj, "Brief aus London," in: Martin Roman Deppner (ed.), *Die Spur des Anderen. Fünf jüdische Künstler aus London mit fünf deutschen Künstlern aus Hamburg im Dialog*, (Hamburg, 1988), p. 10.

7 R. B. Kitaj, *First Diasporist Manifesto* (London / New York, 1989).

– a rumour of Jewishness. The famous phrase ranging in my mind – the Englishness of English art became for me the Jewishness of Jewish art." In other words, he did not seek Jewishness in the religious sense but a far broader notion of Jewishness, namely a style and feeling of life, a sensibility bound up with a sense of origin.[4] Perhaps his reading of Nicolaus Pevsner's book, to which he alludes here,[5] also shows what he was not interested in here, namely art geography or a history of style. In contrast, Kitaj found answers to his questions among the academic heretics of the Warburg school, whose interests he shared in the dovetailing of image and text, image atlases and library. And thus he turned his attention to Jewish intellectual history, to Achad Ha'am, Franz Rosenzweig, Walter Benjamin, and Franz Kafka. It was only via this detour that he found himself back with art.

This reference to Jewish writers and thinkers of the 1920s forced him to start thinking about the Holocaust and assimilation again. Walter Benjamin's fate made it readily apparent to him that assimilation was simply not an option: "It just didn't matter if you were a religious Jew or not, or if you thought you were any kind of Jew or thought you were not or willed yourself not to be. They'd kill you anyway. And they still might!" On the other hand, Kitaj found the path to religion blocked, too: "Like Kafka, I've never made a frank deposit into the bank of belief." For the avowed cosmopolitan, secular nationalism was out of the question. So what remained was art: "I've stumbled into an understanding that my own art has turned in the shadow of our infernal history. [...] Cézanne said something that's become very famous: he said he'd like to do Poussin over again, after nature. [...] I took it into my cosmopolitan head that I should attempt to do Cézanne and Degas and Kafka over again: after Auschwitz."

That said, what was "the Jewish" element if Auschwitz was not to be the sole reference point? "A tremendous lesson began to form itself for my art: if it was Jewishness which condemned one and not the Jewish religion, then Jewishness may be a complex of qualities, a *force* of some kind, and might be a presence in art as it is in life. Can it be a force one *declares* in one's art? Could it not be a force one *intends* for one's art? Would it be a force *others* attribute for better or worse?" Was that "Jewish" intention or interpretation? The questions went unanswered, the contradictions unresolved. For Kitaj there was at the end no answer but only, as in his later texts, fragments, quotes and further questions.

Das Erste Manifest des Diasporismus

Since the mid-1980s many of Kitaj's works revolved around the theme of the Holocaust. His "Germania" series was exhibited in 1985 at the Marlborough Gallery. Martin Roman Deppner and a group of Hamburg-based artists were prompted by it to organize an exhibition in 1988 in the Heine-Haus in Hamburg with a title borrowed from Emmanuel Lévinas: "Die Spur des Anderen." A small catalog was published, to which Kitaj contributed a "Letter from London"[6] (see the essay by Martin Roman Deppner, | p. 105).

A few months before the show opened at the end of September, namely in May 1988, Zurich's Arche Verlag published Kitaj's *Erstes Manifest des Diasporismus*.[7] Artist and typographer Christoph Krämer, one of the artists included in the exhibition, joined up

8 Such as the "Schwarze Reihe" books brought out by Fischer Taschenbuch Verlag.

9 Harald Hartung, "Schatten. Der Maler R. B. Kitaj," in: *Frankfurter Allgemeine Zeitung*, Oct. 29, 1988.

10 R. B. Kitaj, *First Diasporist Manifesto*, (London/New York 1989), p. 109.

11 At about that time, above all French theorists such as Gilles Deleuze devised concepts of the Nomadic and the Minoritarian. US writers such as Paul Gilroy (The Black Atlantic, 1993) considered the situation of the Diasporic and Minoritarian to offer the basis for a "different Modernism."

12 R. B. Kitaj, *First Diasporist Manifesto*, (London/New York 1989), p. 35f.

with graphic designer Max Bartholl to design the *Manifesto*—and presumably the small exhibition catalog, too. The two volumes are of the same format and use the same paper, whereby the *Manifesto* can be clearly recognized as an artist's book. The san serif font was set bold and in italics. The illustrations are always on the left-hand page, the copy on the right-hand page, and the pagination next to the gutter. Copy and image interact closely, showing that the artist and the book designers worked hand-in-glove.

The only element of color in the book is a bright pink vertical on the right edge of the front and back covers. It is the only indication of Kitaj's strong use of color, as his works are reproduced only in grainy black and white in the book. The visual leitmotif is a deep satiny black. In this way, if only by its design, the book kindles associations with the books and exhibitions of the time on the theme of the Holocaust.[8] While this alluded to an important aspect of its content, Kitaj's considerations went far further. The second key leitmotif, namely the age of Kafka and Benjamin, is referenced by the Gill font, which was developed in the late 1920s in England.

The text has a foreword and then three parts: the "Manifesto" is the first, a text of some 45 pages, followed by a second piece, "How I came to make my Diaporist pictures (untimely thoughts)," that alludes to Nietzsche by offering terse aphoristic reflections on the topic of Diasporism, while the third section "Diasporist Quotations" consists of lengthier commentaries on quotes from Primo Levi, Isaiah Berlin, Max Beckmann, Pablo Picasso, Clement Greenberg, Gershom Scholem and others.

Unlike the established manifestos as written by Marinetti, Breton or the Dadaists, as the reviewers at the time saw, "there's nothing strident or aggressive about it. The tone is very personal, intimate even to the point of pathos."[9] Yet Kitaj also announces his new "ism," and not just with the wish to radically renew art, but also to link art with the world, history and life.

In 1984, Kitaj found the answer to the question he had asked in an extensive concept of Diaspora. In his 1984 text he only uses the term "Diaspora" once, in a purely descriptive manner. The almost coincidental mention in connection with Kafka leads us to the quote by Clement Greenberg that Kitaj reflects on in the third section of *The First Diasporist Manifesto*. "Kafka," as Kitaj quotes Greenberg, "wins through to an intuition of the Jewish condition in the Diaspora so vivid as to convert the expression of itself into an integral part of itself; so complete, that is, that the intuition becomes Jewish in style as well as in sense… the only example I know of an integrally Jewish literary art that is fully at home in a modern Gentile language."[10]

By pursuing this idea, Kitaj finds that the concept of the Disaporist enables him to link origin, situation in life, and artistic expression with Jewishness without relying on the category of the national or a tradition based in religion.[11] He reflects in the manifesto on the existential Diasporist situation, which he does not limit to Jews, but also to homosexuals, women, Palestinians, Afro-Americans, and many of the Modernist artists he so admired: "Diasporist art is contradictory at its heart, being both internationalist and particularist. It can be inconsistent, which is a major blasphemy against the logic of much art education, because life in Diaspora is often inconsistent and tense (…), that's Diasporism, which welcomes interesting, creative misreading"[12]

13 For the reception in Germany, see in particular *Kunstforum Internatio-nal*, no. 111 (1991), with articles by Martin Roman Deppner, Doris van Drahten, and Klaus Herding.

14 Andrew Forge, "At the Café Central," in: *London Review of Books,* March 2, 1990, p. 11.

15 Hilton Kramer, "Memoir into myth," in: *Times Literary Supplement*, Sept. 1–14, 1989, no. 4510.

16 Gabriel Josipovici, "Kitaj's manifesto," in: *Modern Painters*, vol. 2, no. 2, summer 1989, pp. 115–6.

17 Linda Nochlin, "Art and the Condition of Exile: Men/Women, Emigration/Expatriation," in: Susan Rubin Suleiman (ed.): *Exile and Creativity. Signposts, Travelers, Outsiders, Backward Glances* (Durham & London, 1998), pp. 37–58, here p. 45.

18 Richard Morphet (ed.), *R. B. Kitaj. A Retrospective*, exh. cat. (Tate Gallery, London, 1994), p. 64.

19 Alex Danchev took sections from the first and second manifestos for his collection of *100 Artists' Manifestos* that Penguin Books brought out in 2011.

The volume finishes with a section entitled "Error." Here, Kitaj quotes a notion of Maurice Blanchot: "To err means to drift, unable to tarry and rest... The land of the drifter is not truth, but exile; he lives in the outside." Here, wandering and wondering, topos and logos, interconnect.

First Diasporist Manifesto

The design of the English edition, which Thames & Hudson brought out in 1989, is not dissimilar to the German: a bold font (a Garamond), the black bars next to the page numbers, and above the picture captions, the black and white reproductions that run to the gutter, the coarse grain—all combine to create a slightly somber feel, but their stringency is reminiscent of the avant-garde journals.

Countless reviews took the book seriously, but they were not uncritical.[13] Artist and art critic Andrew Forge, and writer and essayist Gabriel Josipovici, commented on the mixture of personal confession and general manifesto, asking: "Historical generalization or confessio? Both of course, but without clear borders, the two strands are ever more profoundly intertwined. And then behind all there are his pictures."[14]

Hilton Kramer, the *New York Times'* conservative art critic, was unable to follow Kitaj's drive to open out the concept of Diasporism to include other minorities and modern artists.[15] He countered that Kitaj's theory did not provide a critique in the Kantian sense of an analytical tool to distinguish one kind or art from another—a point Gabriel Josipovici also criticized.[16] The latter felt the real importance of the manifesto was that it offered a way out of the general view of the history of Modernist art as a history of formal solutions to formal problems artists and critics tended to adopt: "The cluster of associations Kitaj builds around the word 'Diasporist' has only one aim: to free him from the nagging modernist feeling that the art he creates in the peace and quiet of his studio is merely a private whim and nothing more than an indulgence, subject only to his own shifting moods and fancies."

Linda Nochlin was fiercely critical from a feminist perspective. Kitaj, she said, wrote "Old Boy's Diaspora [...] where women exist to swell the crowd in a sexy way, to pose as anonymous victims perhaps, but rarely to have a subject position offered them, either inside or outside the picture." She cited as evidence the selection of men he cited and his art, which she felt excluded her: "Turning away from his female nudes to his series of portraits of literary and art historical friends, I want to know why Anita Brookner (the novelist) can't turn around (charming and revealing though the back view image is), face us, and assert her dominion over the picture space as do Philip Roth, Sir Ernst Gombrich, or Michael Podro as The Jewish Rider? Obviously there is an exile within the exile so poignantly enacted by Kita's images: the exile of women." She criticized the fact that "I, as a Jewish woman, have been exiled from Jewish exile by the mere fact of my sex; it is men who lay claim to the diasporist tradition of Modernity."[17]

Yet over and above all these objections and Kitaj's later doubts as to whether he should have published the text,[18] and all the private obsession it contains, *Das Erste Manifest des Diasporismus* offers an alternative view of the history of Modernism.[19] Above all, it also makes a key contribution to the question of the Jewish identity after the Holocaust. Unlike the debates conducted in the 1990s, Kitaj is less interested in the issue of the possible representation of the Holocaust, and more in the impact the Holocaust has on art per se.

20 Excerpts appeared in 2005 in the catalog of the exhibition "How to reach 72 in A Jewish Art" and, in 2007, in the first issue of the new journal *Images. Jewish Art and Visual Culture*.

21 Esther Nussbaum, "Second Diasporist Manifesto," in: *Jewish Book World*, vol. 26, 2008, no. 1, p. 34.

22 See the publisher's announcement and the reviews by Benjamin Ivry, "Remembering Kitaj," in: *Commentary*, January 11, 2008; Jude Stewart, "'Paint it Jewish!' What does 'Diasporist' art look like? R.B. Kitaj tried to show us," in: *Tablet*, Feb. 7, 2008; Jed Perl in the *New Republic*.

23 Kitaj, 1991, quoted from Livingstone, *R. B. Kitaj* (2010), p. 43.

24 The reference to Ezra Pound (whom Kitaj forgave his anti-Semitism) is also to be found in *Erstes Manifest des Diasporismus*, p. 140f.

25 Livingstone, *Kitaj*, 2010, p. 56.

Second Diasporist Manifesto

The *Second Diasporist Manifesto* appeared in September 2007 shortly before Kitaj's death as "a new kind of long poem in 615 free verses," published by Yale University Press in New Haven.[20] The manifesto was mainly reviewed against the backdrop of his demise, with one critic opining it was seen "more as a poignant farewell than the provocative collection of thoughts about Jewish art and artists that it is,"[21] commenting in admiration (if somewhat perplexedly) that was "wonderfully idiosyncratic," a "provocative collection of thoughts," and a "dazzling literary achievement."[22]

Kitaj wrote in 1991 to Marco Livingstone how he construed the second manifesto, which he had announced in the first: "If I were to write down a second manifesto it would be very short and I think it would wish to address what I have called assimilationist aesthetics because I find I don't wish to escape the tremors of European host-art from Giotto to Matisse."[23]

Kitaj now, more clearly than in *Erstes Manifest*, placed his work in the lineage of the avant-garde manifestos, dedicating the volume to "the Manifest predecessors, Tristan Tzara (Sammy Rosenstock) and Marcel Janco, the Jewish founders of DADA." The text's form as a numbered sequence of brief, aphoristic sections is reminiscent of Ezra Pound's *Cantos*,[24] Wittgenstein's *Tractatus Logico-Philosophicus*,[25] and not least André Breton's Surrealist Manifestos. The number of 615 verses emulates the Jewish tradition of the 613 Mitzvots, with two added: Emil Fackenheim's 614th Mitzva—not to hand Hitler posthumous victories—and another one, probably in memory of Sandra Fisher. Marinetti's Futurist Manifesto had a similar numerical structure, adding an eleventh to the Ten Commandments.

As in the dedication, in the introduction, which Kitaj entitled "Taboo Art," he referred to the lineage in art as of the beginning of Modernism, since Gaugin and Monet, Freud, theoretical physics, social utopias and the avant-gardes.[26] With his reference to Modernism, Kitaj was himself part of the tradition of proposals for a Jewish art. For Modernism had always been a central category in that project, even if the term assumed different meanings. While for Buber and his contemporaries around 1900 Modernism offered a path away from historicism to something "of our own," for the Russo-Jewish avant-garde it pointed a path "out of the ghetto westwards." By contrast, for Kitaj Modernism stood for the Diasporist and thus for the universalization of Jewishness. Yet unlike the status in the first half of the twentieth century, it is now no longer a utopia but a canon, from which the concept of the Diasporist can be derived and justified. For this reason, the absence of a Jewish champion of the fine arts in this canon poses a fundamental problem for Kitaj and is not just a matter of ethnic pride. What started in 1983 as reflection became ever more associative and fragmentary: While the 1984 version had a clear argument running through it, *Erstes Manifest des Diasporismus* of 1988/9 is a rambling text that vacillates between general statement and personal confession, and the *Second Manifesto* 2007 is more a flow of thoughts, sketchy aphorisms that primarily follow how he read things, his idiosyncrasies, his obsessions and how he staged himself: indeed, his "cult of the fragment." Between them lay the "Tate War." Like Kitaj's overall work as an artist and publicist post-1994, the text was shadowed by his fight with his critics, whom he felt were responsible for the death of his wife Sandra Fisher:[27] "My enemies have increased my Jewish Aesthetic

26 While at the time the concept of the avant-garde was subjected to incisive critique, e.g. among those who contributed to the journal *October*, see Rosalind Krauss, *The Originality of the Avant-Garde and Other Modernist Myths* (Cambridge, Mass., 1985).

27 See on this Anne Vira Figens-chou, *Dialogue of Revenge*, Oslo 2002 (MA thesis), online at www.forart.no (April 10, 2012), as well as the essay by Cilly Kugelmann in the present volume.

28 "My enemies have increased my Jewish Aesthetic Madness tenfold on their Killing Field. Werner Hanak, Interview with R. B. Kitaj," in: *R.B. Kitaj. An American Painter in Europe*, exh. cat. (Oslo, Madrid, Vienna & Düsseldorf, 1998), pp. 131–4, here p. 134.

29 R. B. Kitaj, undated typescript with hand-written corrections and additions, in: *Kitaj papers*, UCLA.

Madness tenfold on their Killing Field."[28] In memory of his wife, Kitaj now realized the project the two had planned together: a journal in the style of a small avant-garde magazine. He called the series *Sandra* and declared the *Second Diasporist Manifesto* its 14th issue.

The sense of alienation and the resulting critical impulse characterizing his earlier texts give way, in the *Second Diasporist Manifesto*, to a "battle" with his enemies. Kitaj links his private "Tate War" to the history of the artistic avant-gardes, relying on military metaphors. Thus at the end he seems to corroborate in a troubling way the famous dictum attributed to Schopenhauer that became a leitmotif of Modernism: "A happy life is impossible; the best that a man can attain is a heroic life."

Third Diasporist Manifesto

In the Kitaj papers there are two short sketches on a planned Third Diasporist Manifesto. The first manuscript is entitled "The Jew Etc." and addresses his relationship to Modernism and the avant-garde. The second text is titled "My Own Jewish Art / Third Diasporist Manifesto,"[29] consists of terse sentences, and begins: "Jewish Art is not a popular concept, nor I daresay will it ever be. A lot of Jewish artists dislike the concept of Jewish Art. Jews are not a popular people, nor will we ever be. That's why I speak of My Own Jewish Art which is easier to defend."

Here Kitaj avoids the oscillation between subjective confession and the wish for universal validity, something that forever irritated the reviewers, in favor of a radically subjective position, visualized by the use of the upper case "m" in "My Jewish Art." He thus solved an old problem the avant-garde always faced in his own terms, namely the utopia of combining "art" and "life," simply by declaring art to be life. In other words, he did not try and transpose the Jewish into art, or seek it in art, instead making art one form of Jewishness: "Jewish Art is one of the things I want to do with my life. (...) What one is! What we are! That's Jewish art too." Here, "Jewish art" is not understood as a style or concept, but as a way of life, namely that of the Diasporist. Unlike in aestheticism, life is not an artwork, but art a way of life.

Nonetheless, as in his early lecture in 1983–4, Kitaj continued to bemoan the absence of a "major" tradition of Jewish fine arts: "There has never been a Jewish Giotto or Matisse." He seems to be reassuring himself when he points out that "Japanese, Egyptian art etc. flourished during certain periods, as a special style... thus Jewish art may too." And it sounds like great fantasy—and perhaps also self-irony—when he then asks: "Will I be the Herzl (or Ahad Ha'am) of a nu [!] Jewish Art???"

The Skeptical God-Seeker
Michal Friedlander

1 Hand-written letter from Jeanne B. Kitaj confirming R. B. Kitaj's Jewish heritage, notarized 6.11.1983. (see p. 166) In: *Kitaj papers* (Collection Number 1741). Department of Special Collections, Charles E. Young Research Library, UCLA, Box 141.

It was my father's seventieth birthday and there was going to be a big bash at the Hyde Park Hotel in London on June 9, 1997. At the sit-down dinner, I had been given a place of honor to the right of the artist R. B. Kitaj. As I took my place next to him, he smiled at me apologetically and pointed to his hearing aid. I knew that he did not suffer fools gladly and not a word was exchanged between us. He left early. It wasn't my best evening.

Kitaj was not one for party chit-chat and although much of his work is read as overtly autobiographical and confessional, he maintained a high level of privacy, saving certain intimate thoughts for himself, his close confidantes, and "his rabbis." Personal faith was one such private matter. It is unquestionable that Kitaj had a strong Jewish identity, but what was his relationship to Judaism as a form of *religious* identity?

Kitaj's mother Jeanne was Jewish[1] and, moreover, a life-long atheist. According to the strictest Jewish law (*halacha*), there are two ways to be accepted as legally Jewish. Either a child is born to a Jewish mother, or a person becomes Jewish through the process of conversion. A child who is born to a Jewish mother maintains his or her Jewish status, even if he or she is not a religiously observant Jew.

Kitaj did not grow up in a home where the Jewish religion was practiced and he left for adventures on the high seas when still a teenager. He only began to wrestle with questions of Jewish and religious identity in his thirties, after reading Hannah Arendt's coverage of the Adolf Eichmann trial in *The New Yorker*.

Hannah Arendt's coverage of the trial was later published in book form in 1963 as *Eichmann in Jerusalem. A Report on the Banality of Evil*. The book created a storm of controversy. In the American Jewish community, it was felt that Arendt had questioned the behavior of Jewish leaders and organizations under the Nazi dictatorship leading to an implicit co-responsibility for events. Arendt had also critically analyzed Eichmann's conduct, presenting him as a bureaucrat who administered mass murder, rather than the depraved, violent, anti-Semitic criminal of the popular imagination. The Eichmann trial was the first court trial to be broadcast internationally on television. This landmark event of public Holocaust remembrance, as well as the public discussion of Arendt's contentious stance, intensified "Holocaust consciousness" within American Jewry. It led to a re-evaluation of Jewish identity for many individuals; the Holocaust and its aftermath was to become a marker of Jewish identity for Kitaj as well. For the rest of his life, Kitaj would be preoccupied with developing his own, very individual ideas about what "Diasporism" and "Jewishness" meant to him.

However, how did Kitaj relate to Jewish religion? Did he study or relate to Jewish scripture? Did he participate in Jewish ritual in any way or attend religious services? In order to come closer to answers, it makes sense to see which rabbinical figures Kitaj chose to paint, and to examine his relationships with these men.

Rabbi Dr. Albert H. Friedlander—*The Reform Rabbi*

Hannah Arendt's critique of the German and East European Jewish leadership during the Nazi regime together with a perceived exoneration of Eichmann was too much for the Jewish-American world, where she was roundly denounced. Her texts also raised questions for a young rabbi in New York. Rabbi Albert Friedlander was the Jewish Chaplain at Columbia University from 1961–1966 and was one of the few Jews to

187

2 Letter from Albert H. Friedlander to Hannah Arendt, June 20, 1963. The Hannah Arendt Papers at the Library of Congress Correspondence-Organizations-Jewish-B-F-1963-1965 (Series: Adolf Eichmann File, 1938–1968, n.d.).

3 E-mail to the author from Philippa Bernard, 21.03.2012.

4 Letter from Albert H. Friedlander to Kitaj, 17.10.1985. Personal Correspondence 1951-2007, Box 44, Folder 31. Friedlander, Rabbi Albert 1985–1997. *Kitaj papers*, UCLA.

5 The Jewish School, 1980. Hand-written notes on a sheet of yellow lined paper. *Kitaj papers*, UCLA.

give Arendt a platform to respond to her critics. He invited her to Columbia to speak to Jewish students on July 23, 1963.[2]

Friedlander, like Arendt, was a German-Jewish refugee who had ultimately found refuge in the United States. Rabbi Friedlander moved to London, with his English wife Evelyn, in 1966. He had many interests and acquaintances in common with Kitaj but it was not until the early 1980s that their paths crossed.

Kitaj was an avid bibliophile. He enjoyed browsing in London's secondhand book-shops, collecting, debating, and swapping books with his close friends. One of his fa-vorite haunts was Chelsea Rare Books at 313 Kings Road, close to his home in Elm Park Gardens. The Jewish proprietors of the shop, which existed from 1974–1999, were Leonard and Philippa Bernard:

"[...] The books he bought were almost all on art ... and I'm afraid he used to cut out pictures from them for his own use. [...] He liked to talk to Leo when the shop was empty about Judaism and art and philosophy and almost anything. There was always coffee on offer. His view about Judaism was, I think, rather more philosophical and historical than religious. He had little time for organized religion or synagogues..."[3]

Nonetheless, Leo introduced Kitaj to his rabbi, Albert Friedlander, who was then the minister of Westminster Synagogue in Knightsbridge. A long-term friendship ensued. Friedlander was an intellectual with an agile mind and Kitaj could talk to him as easily about Freud, Kafka or Benjamin as discuss the scores of the World Series, which both baseball fans followed avidly. Friedlander was a scholar of post-Holocaust theology, a subject to which they would frequently return in their discussions over the years.

"Dear Kitaj, [...] I still find myself very much involved in the reasons and the experience of the Holocaust. When you are ready, I would feel privileged to look at the work you have begun – as you know, there is really no artist who has been able to come up with a major statement within your discipline. I hope and believe that you are doing something which is of great significance."[4]

Kitaj's own thinking about the Holocaust had become intertwined with questions of religious faith: "Where was God during the Holocaust? [...] My relations with religious belief are not at all rich, steeped in ignorance, but growing complex. There seem to be many and contradictory 'answers' to the question with which I began – a virtual theo-dicy of the Holocaust..."[5]

Kitaj continues and cites different theories, including the ideas of Martin Buber—the philosopher and religious thinker—formulated in Buber's 1952 book *Eclipse of God*. Kitaj interprets this as meaning that God is "sometimes hidden and sometimes re-vealed." In spite of, or perhaps because of these feelings, it was important to Kitaj and his second wife, the artist Sandra Fisher, for their young son Max to develop a sense of Jewish identity and to be able to articulate his own questions about faith and fate. Consequently, they sent him to religion school at Westminster Synagogue.

Although Kitaj made financial contributions to the religion school, he never joined the Westminster Synagogue as a member. Rabbi Friedlander gently encouraged Kitaj to participate in Jewish ritual—such as attending synagogue services—and failed drama-tically: "Dear Kitaj, [...] First of all, do let me tell you how much I respect your attitude. I do not feel that religion and Jewish life is only lived inside the synagogue. I appreciate your coming to services, and only regret that you did have some discomfort trying to

188

6 As above, letter from Friedlander to Kitaj, 17.10.1985.

7 Albert H. Friedlander, *Riders towards the Dawn* (London: Constable and Company,1993), p. 193.

8 R. B. Kitaj, *Confessions*, pp. 131f. Rabbi Leo Baeck (1873-1956) was a teacher and leader of Progressive Judaism in Germany. He was a Holocaust survivor.

9 This refers to a statement made by Eliot in 1933, in "Reasons of race and religion combine to make any large number of free-thinking Jews undesirable." See T.S. Eliot, *After Strange Gods – A Primer of Modern Heresy.* The Page-Barbour Lectures at the University of Virginia, 1933, p. 19.

10 Letter from R. B. Kitaj to Albert H. Friedlander, November, 1990. *Kitaj papers*, UCLA.

struggle with the liturgy and with the structure of public worship. I know that you and Sandra will search out other aspects of Jewish life which will help surround Max with the knowledge of his heritage..."[6]

Kitaj was no fan of public worship and notably walked out of the synagogue during Yom Kippur services. His extreme antipathy to organized ritual manifested itself physically, and even entering the synagogue building to drop off Max would make him feel unwell. One Passover, he attended the ritual Seder meal at the Friedlander's home. He left after the first course, although Sandra remained. Friedlander was not offended by Kitaj's abrupt departures, which he understood.

A thinker who interested both men was the French-Jewish existentialist philosopher, Emmanuel Levinas, who was: "[...] himself aware of human problems which cannot be solved by pious religious instructions. [...] Levinas sees the anguish and self-doubt which besets many Jews living in a world where they are still suspect, in a doubting faith where they assume that the relationship between the Jew and God is liturgical and confined to the synagogue: they have forgotten that Judaism is a total life."[7]

Kitaj asked Rabbi Friedlander if he could paint his portrait, which was completed over the years 1990–1994. The title of the painting is *Reform Rabbi* | p. 229 but how is this reflected in the portrait? Friedlander is not wearing a kippah and is clean-shaven, as is often the case for male progressive rabbis. Kitaj saw in Friedlander a kindred Diasporic Jew, representing the post-war continuity of German Liberal Judaism, and he describes Friedlander as a "protégé of Leo Baeck."[8] Indeed he had studied with Baeck at rabbinical school and was a noted scholar of his works. In the painting, Friedlander is wearing his worn cashmere winter coat and he is painted at an angle. This may be to indicate that he is *davening* (a back-and-forth swaying motion, which is usually combined with the recitation of Jewish liturgical prayers). But *davening* was never part of Friedlander's ritual. He appears as the European intellectual on the move: perhaps even as an embodiment of the eternally displaced Jewish refugee who is unable to find stability or a firm footing anywhere. Kitaj gives Friedlander oversized hands, bringing attention to the book he is holding (the book is a frequent motif in Kitaj's work). From childhood, Albert Friedlander always had a book in front of his nose or in his pocket | p. 192. As revealed in a preliminary photograph, he is dipping into *The Levinas Reader*—for him, a typical light read | p. 229.

During the period when Rabbi Friedlander sat (or rather stood) for Kitaj, he received the following note: "Albert, my dear friend, I speak to you here the way I always have, as a skeptical God-seeker, as a free-thinking Jew, (in T.S. Eliot's nice words, skeptical as he was about Jews)[9] and not least as an out-of-step painter who assumes that God-seeking and free-thinking may have something to do with painting pictures now as always. I want to ask you what you must have been asked a thousand times, except this time could you respond to an inveterate ponderer fearful how a God in eclipse concerns the spiritual in art: Can you put the case for a Supreme Being on a postcard while standing on one leg? Didn't Akiba do a similar trick 2000 years ago? Love, Kitaj."[10] Kitaj defines himself here as a "skeptical God seeker," a Jew looking for proof of God's existence. He sought answers and he sought God. At the time I asked my father, Albert Friedlander, why he did not take up the postcard challenge, which Kitaj had so often reiterated? He just shook his head.

13 R. B. Kitaj, *Second Diasporist Manifesto (A New Kind of Long Poem in 615 Free Verses)*. (New Haven: Yale University Press, 2007), #58. See also #82–84.

11 Richard N. Ostling, "Giving the Talmud to the Jews," in *Time*, January 18, 1988.

12 Jeffrey M. Green, "Backstage at the Steinsaltz Talmud Factory," *Midstream* (December, 1989), p. 19; *Kitaj papers*, UCLA.

14 *Eve*, 1992; *Sarah Laughing*; 1992; *Abraham*, 1992; *Rebecca*, 1994; *Rachel*, 1994; *Leah*, n.d. See *R. B. Kitaj – Graphics 1974–1994* (London: Marlborough Graphics Ltd., 1994), exh. cat. Nos. 14–18. All illustrated, except for *Leah* which only appears on the price list.

15 R. B. Kitaj, *First Diasporist Manifesto* (New York: Thames and Hudson Inc., 1989), p. 121.

16 Adin Steinsaltz, *Biblical Images* (Jerusalem: 2010), p. 13. Here, Steinsaltz relates Abraham to the Messiah.

Rabbi Adin Even Israel Steinsaltz—*The Orthodox rabbi*

Rabbi Adin Steinsaltz has been hailed as "a once-in-a-millennium scholar" in a much-cited *Time* magazine article.[11] In 1965, he began a monumental project to translate the Babylonian Talmud into Hebrew and other languages, supplemented by his own new commentary. He completed the Hebrew edition in forty-five years, making this fundamental Jewish work accessible to a wider readership rather than just for those who can decipher the arcane abbreviations and linguistic Aramaic back-flips of the traditional version.

A magazine article among Kitaj's clippings discusses the innovative layout of the Steinsaltz Talmud page, which differs from the layout of the traditional Talmud.[12] Kitaj writes on the clipping, "Is there a pic here?, [sic] a style?" We see him searching in central Jewish religious texts for a connection to his art and for a "Jewish visual form."

"I'm too old to study Talmud seriously but I love having some volumes of Steinsaltz's English Talmud lying around my studio to dip in and to remember that 50 years ago I was the first to introduce my own written Commentary on to the surfaces of my paintings. Ever since then, I've done Commentaries about some of my pictures, an ancient Jewish visual form on each page of Talmud..."[13]

Kitaj sought deeper insight into biblical texts and produced several works relating to biblical personalities (e.g. Moses, Ruth, and King David). Steinsaltz's *Biblical Figures* (1984) was a source of inspiration for a series of lithographic prints that portray biblical figures, which he worked on from 1992–1994.[14] The only male figure in the series was Abraham—the first great patriarch of Judaism—with whom Kitaj particularly identified. Kitaj uses a quote from Abraham as a heading in his *First Diasporist Manifesto*: "I am a stranger and a sojourner." (Genesis 23:4)[15]

The first patriarch is an outsider, a traveler without a home. In this textual passage, Abraham confesses to being a stranger and attempts to establish a place, a home appropriate as a burial site for his wife, Sarah: fundamental problems that Kitaj, the Diasporist, also tried to confront.

In 2004, Abraham reappears in a triptych painting as a huge Ego | p. 222, which is simultaneously a self-portrait of Kitaj, with biblical snow-white beard and hair. The patriarch is shown face-on, slightly ambivalently riding in on the wild horse Id, which he is attempting to control. Kitaj had a tremendous ego, but on occasion he could also laugh at himself. One cannot ignore the reference to the Messiah, who is supposed to arrive at the End of Days on a donkey.[16] Kitaj's connection to Abraham was more than a visual metaphor: in his Jewish marriage certificate (*ketubbah*) from his 1983 wedding to Sandra Fisher, it shows that his Hebrew name was in fact Abraham.

It is November 22, 2011, and by chance I am introduced to Thomas Nisell in a Jerusalem hotel lobby. He just happens to be the Managing Director of the Israel Institute for Talmudic Publications, which is overseen by Rabbi Steinsaltz, whom he sees daily at the office. Oh My Goodness.

I ask, tentatively: "Have you ever seen a portrait painting of Rabbi Steinsaltz by R.B. Kitaj?" "Seen it? I took the call! A woman I know called me from New York and said 'Rabbi Steinsaltz is hanging in MOMA[17] and I'm looking right at him!'"[17]

17 In an e-mail to the author of June 5, 2012, Cora Rosevear, Associate Curator at the Museum of Modern Art in New York states that there are no museum records showing that the painting has ever been shown at MOMA. Mr. Nisell suggests that the painting may rather have been shown at the Kitaj retrospective at the Metropolitan Museum of Art in 1995.

18 The Department of Paintings, Drawings and Prints, the Fitzwilliam Museum Cambridge, Acc. Nos. iPD.18_2009*f.1 & 2.

19 Jane Kinsman, *The Prints of R. B. Kitaj* (Aldershot: Scolar Press, 1994), p. 135 and footnote 19, p. 139.

20 Thomas Nisell in conversation with the author.

21 Rabbi Steinsaltz, conversation with the author, Jerusalem 23.11.11.

22 William Frankel, *Tea with Einstein and other Memories* (London: Halban Publishers Ltd., 2006), p. 211.

Rabbi Steinsaltz and his staff had no knowledge of the painting, prior to this incident. Subsequent to our meeting, both Thomas Nisell and I set off to do some investigating. He discovers that Rabbi Steinsaltz gave a lecture in Oxford to the Balliol Union at the invitation of Balliol College in March 1990. I have the good fortune to discover images of a rabbi inscribed in ballpoint pen on the verso "AS 6 March 90" in the collection of the Fitzwilliam Museum in Cambridge[18] | p. 193. A long-time admirer of Rabbi Steinsaltz's work, Kitaj had attended the lecture and sketched him. He also sketched him specifically for the painting during a Steinsaltz lecture at the University of London.[19]

Kitaj did not meet Rabbi Steinsaltz in person until 1994. Nisell telephoned Kitaj and told him that Rabbi Steinsaltz would be in London the following week, should he wish to meet him. Kitaj responded with great excitement: "Are you telling me that I can see him? He changed my life! He has had more impact on my life than anyone else!"[20]

Back in Jerusalem, some seventeen years later, Thomas Nisell also makes the kind and spontaneous offer that he will try and arrange a meeting for me with Rabbi Steinsaltz. Late at night, Rabbi Steinsaltz welcomes me into his office. He puffs on a pipe whose smoke has long since yellowed all it touched. A cup of black coffee and a stack of Hershey chocolate bars sit on the desk. I am relieved that even a genius needs sustenance to work all hours.

He told me about a meeting with Kitaj shortly after the death of his second wife: "One of the themes he was preoccupied with, at the time, was how he could keep his son Jewish." Rabbi Steinsaltz spent three hours in a private exchange with Kitaj and summarized his encounter with him: "He was interesting as a person. Surely not a professional philosopher, but a thinking person. That is what remained with me..."[21]

Kitaj had painted a portrait of Steinsaltz during the same period as the Friedlander painting: from 1990–1994. Kitaj is indisputably a master draughtsman and portraitist, but the painting captures the energetic spirit of Rabbi Steinsaltz and his body language, rather than a facial likeness. The *Orthodox Rabbi* has a long white beard and black suit, as one might expect, but the blue sock indicates an unconventional side to the rabbi, which is appropriate. The evening that I met Rabbi Steinsaltz he wore a sky-blue shirt.

The portrait of Rabbi Steinsaltz was kept by Kitaj in his private collection and was only sold after his death. Its whereabouts are currently unknown.

Rabbi Dr. Abraham Levy—*The Wedding* rabbi

As fate, God, or the wonders of Jerusalem would have it, Rabbi Abraham Levy was also in the same hotel lobby on that serendipitous evening. Rabbi Levy officiated at Kitaj's marriage to Sandra Fisher, represented in Kitaj's painting *The Wedding* | p. 155. William Frankel, former editor of the London *Jewish Chronicle*, was a good friend of Kitaj and Sandra. In his autobiography, he relates that the pair wished to marry, "[...] primarily because Sandra wanted to have a child. [...] Both he and Sandra wanted a Jewish wedding ceremony in a synagogue, but they were anxious that it should be a beautiful synagogue."[22]

Frankel recommended Bevis Marks, the Spanish and Portuguese synagogue in the City of London, as "a noble setting." Kitaj and Sandra viewed the beautiful sanctuary

23 Telegram, 13.12.1983. C. Kitaj and Sandra Fisher Wedding. Box 144. *Kitaj papers*, UCLA.

24 Letter from the Secretary of the Bevis Marks Synagogue to R. B. Kitaj. *Kitaj papers*, UCLA.

25 Hayyim Schneid, *Marriage* (Keter Publishing House Jerusalem Ltd., Jerusalem: 1973), pp. 7 and 22.

26 Rabbi Abraham Levy, conversation with the author, Jerusalem 22.11.11.

and found it enchanting. The couple met with the senior rabbi, Rabbi Dr. Abraham Levy, as is usual when planning a Jewish wedding, to discuss practical and spiritual matters. It turned out to be difficult for them to marry in an Orthodox synagogue. A tiresome process followed in which Kitaj was asked to prove that he was Jewish according to the normative religious statutes of Jewish Orthodoxy. The couple was only permitted to marry at Bevis Marks synagogue once a telegram from an Orthodox rabbi arrived, which testified that Kitaj was Jewish and had never been married previously.[23] Apparently, he did not know about Kitaj's first marriage to Eli Roessler from 1953–1969—that wedding had taken place in a Protestant church in New York. Kitaj did not recover from his anger and shock at the process, nor did it warm him to institutionalized religion. In November 1983, he joined the synagogue as a member, but specified that it was only for the purpose of marriage[24] and the membership was not prolonged. The marriage was solemnized on December 15, 1983, at 11:00 a.m.

No guest list from the occasion has been found, but Rabbi Levy had the foresight to ask many of those present to sign a piece of paper. The list includes twenty-nine non-family members, reflecting the couple's inner circle of friends. Many of the guests had Jewish backgrounds, such as the painters Lucian Freud, Frank Auerbach, and Leon Kossof, the art historian Michael Podro, and Lady Natasha Spender, who accompanied her husband, the poet Sir Stephen Spender. The best man at the wedding was David Hockney, not a Jew.

The Wedding was painted years after the event, over the period 1989–1993. Kitaj includes his sons, Lem and Max, in the painting. Max makes a surprise appearance at the forefront of the painting; he was not born until 1984. Lem has a wristwatch on and both children wear kippot, which may signalize Kitaj's hope for the transmission and continuity of Jewish identity in the family. Kitaj, the groom, dons a red shirt and velvet suit, deviating from traditional cultural conventions for a groom's dress. Yet he adheres to the demands of Jewish traditional ritual and demonstratively paints himself under the marriage canopy (*chuppah*), wearing a kippah and a Jewish ritual prayer shawl (*tallit*).

Considerable thought was given to the bride's unconventional clothing. It seems that Sandra's headdress was based on two source photographs reproduced in a book about Jewish marriage which was part of Kitaj's library: a Bukharan bridal costume and a painting of an East European bride, attributed to Isidor Kaufman[25] | p. 165.

Rabbi Levy is included in the painting. He is wearing a silk top hat, but his face is somewhat indistinct. Levy's own interpretation is that his face has been erased by the artist: "He was still annoyed with me for questioning his Jewish status."[26]

Kitaj was definitely able to hold a grudge. Despite this, Rabbi Levy was invited to Kitaj's studio some time after the wedding. Levy brought kosher cakes with him and put up a mezuzah on a doorpost of the family home. Why would Kitaj agree to a mezuzah? He referred to Jewish ritual objects as "liturgical tchatchkeles." A mezuzah is a ritual object that has many interpretations. It serves as a reminder to think about God's presence and some view it as a house amulet, but whatever the interpretation it is undeniably a signifier to the world that the residents of the house are Jewish.

As we have seen, Kitaj had an ambivalent and often contradictory relationship towards traditional religious Jewish rites and rituals. He was skeptical about the

27 Arthuhr Steiner, "Adin Steinsallz – A Modern Mystic" in: *Midstream*, December 1989, clipping in: *Kitaj papers*, UCLA, Box 96, folder 4.

existence of God, but desired to be otherwise convinced. Kitaj wanted to be included in the "Tribe," as he often called the Jewish people—but on his own terms. Ultimately, Kitaj the "free-thinking Jew" created his own vision of (Diasporist) Jewish Art and a very "Personal Judaism." His new kind of religion gave free rein to his personal inconsistencies, contradictions and ambivalence, which he codified in the 615 verses of his *Second Diasporist Manifesto*.

In his last years, Kitaj became preoccupied with Jewish mysticism through the works of Gershom Scholem. He went so far as to unashamedly deify his deceased wife Sandra as the *"Shechina"*—the divine female side of God. He painted and communed with her with what can only be described as religious fervor, enabling him to fuse the spiritual with his art.

How, then, did Kitaj deal with Jewish ritual with respect to death and Abraham's quandary to choose a place of burial for his Jewish wife? In 1994, Kitaj's second wife, Sandra, suddenly and unexpectedly died from a brain aneurysm at the age of forty-seven. Kitaj was utterly devastated and shattered by this terrible occurrence. He turned to Rabbi Friedlander for help, and a very small ceremony was held for Sandra at Westminster Synagogue, which Kitaj and son Max attended. Sandra was buried in a London Jewish cemetery, but Kitaj did not go to the funeral. Rabbi Friedlander was presented with a unique and harrowing situation: he was the only person in attendance.

Kitaj was buried at sea.

The following quotation from Rabbi Steinsaltz was highlighted by Kitaj in his clippings collection.

"I have very limited experience," he says, "surely not great wisdom, but I'm trying to attune to the Jewish people, to our heritage. Sometimes I may be wrong, I didn't hear properly, didn't listen properly, But I'm trying to *see* something. Between the lines there are enormous gaps."[27]

I would particularly like to thank Rabbis Steinsaltz and Levy, Thomas Nisell, Evelyn Friedlander, and above all: AHF, RB and S – ז"ל.

"I Accuse!" Kitaj's "Tate-War" and an interview with Richard Morphet

Cilly Kugelmann

1 All details of the events leading up to the "Tate War" have been taken from the excellent in-depth Ph.D. thesis written in 2010 by Anne Vira Figenschou, *Dialogue of Revenge*, available on the Internet at *http://www.forart.no*

2 Ibid., p. 13.

3 Ibid., p. 14ff.

1994 was to be a dramatic year for R.B. Kitaj, a turning point that would change his life and his career once and for all. At the time, Kitaj was a renowned American artist who had been living in London for almost forty years. He was considered a brilliant drawer with a masterly eye for color, and was instrumental in establishing the "School of London," a group of artists who, rejecting the fashion for abstract art in the 1960s, opted instead for figurative painting. Kitaj was a member of the American Academy of Arts and Letters and, in 1982, was awarded an honorary doctorate by the University of London. In 1991, he became the third American, after Benjamin West and John Singer Sargent, to be accepted by the British Royal Academy of Arts.

When, in 1990, the Tate Gallery decided to honor him with a major exhibition, he was at the zenith of his career. The exhibition at the Tate was to open on June 16, 1994, under the title *A Retrospective*.[1] The curator of the exhibition, Richard Morphet, who at the time was the Keeper of the Modern Art Collection at the Tate, gave Kitaj a major say in the exhibition. A hundred and fifteen works were presented in eight rooms, including eighteen collage-like works dating from the 1960s, sixty items from the 1970s and 1980s that were considered the best of his oeuvre by art critics and collectors alike, and thirty-four new works that Kitaj had produced specially for the retrospective. Kitaj wrote both shortish and longer texts on these objects that were hung next to the works themselves. For him, this provided a concentrated concept of visual expression and literature, art and its interpretation, and, for him, his art was only truly realized if the two were taken together. In this analytical level of the exhibition he revealed his sources of visual inspiration, as well as notes on what he was reading and on his investigations of political and historical events. Using texts and quotations he made reference to the fractured character of the world and the theme of the lack of a homeland, which, for him, was most obvious in the subject of Jewish identity after the Holocaust. Within this perspective he also consciously referred to the Midrashim, the Jewish tradition of interpreting Talmudic texts. Ever since he had become interested in the mass extermination of European Jews Kitaj had been deeply concerned with the question of what approach an artist who was also a non-practicing and non-Zionist Jew could take to this collective experience of extermination.

Before the exhibition actually opened, Kitaj gave several interviews in which he provided information about himself as an artist and his search for identity. He was aware that, by interpreting his own work, he was crossing a boundary that says a work of art in an exhibition requires no interpretation. In the exhibition catalog he wrote, "I know that many people have been brought up to believe that gentlemen don't explain—especially modern art gentlemen."[2]

On the day the exhibition opened, an entire generation of British art critics immediately felt provoked by Kitaj, and they reacted with angry, dismissive comments. Alongside a number of positive articles, important newspapers and periodicals such as the *Evening Standard*, the *Financial Times*, the *Sunday Times*, the *Independent* and the *Daily Telegraph* published reviews that ranged between scornful to virulent.[3] Kitaj was dubbed a vain and narcissistic painter with an exhibitionist and sexually charged notion of Jewry. His art was deemed to be ugly, childish, and feeble teenage garbage. Many critics found it outrageous that Kitaj wanted to present himself as a foreigner, a stateless person, a dissenter, an outlaw, and a Jew, and that he was placing himself on a par with

4 http://www.independent.co.uk/
arts-entertainment/exhibitions--
draw-draw-is-better-than-jaw-jaw-
r-b-kitaj-gives-great-interview-
but-would-he-be-a-better-painter-
if-he-spent-less-time-talking-
about-his-work-1423597.html

5 Anne Vira Figenschou, Dialogue
of Revenge, p. 18.

6 http://www.andrewgrahamdixon.
com/archive/readArticle/899

7 Anne Vira Figenschou, Dialogue
of Revenge, p. 22.

8 Ibid., p. 23.

9 Ibid., p. 24.

10 Ibid., p. 29.

11 Amongst others, William Blake,
Oscar Wilde, James McNeill
Whistler, James Joyce, Alfred
Dreyfus, Charles Baudelaire,
Gustave Flaubert, Gustave Courbet,
Émile Zola, Egon Schiele, and
gulag victims.

the most important artists in art history. Tim Hilton's headline ran: "Draw draw is better than jaw jaw: R. B. Kitaj gives great interview. But would he be a better painter if he spent less time talking about his work?"[4] Hilton ridiculed Kitaj for being arrogant and vain, and dismissed his style as superficial, pornographic, and tasteless. John McEwan's headline read: "A navel-gazer's album of me, me, me." He reported that the exhibition left him cold, simply because it contained autobiographical and confessional material.[5] For James Hall of the Guardian Kitaj's paintings were superficial parodies which he dismissed as Teflon-coated pictures; his piece was entitled "Teflon Ron." Most critics were unimpressed by Kitaj's numerous texts and thought that his approach to the subject of the Holocaust was trivial and cheap. They called him a name-dropper and a mediocre illustrator who had not even succeeded in drawing attention to himself with autobiographical brothel scenes. Graham-Dixon concluded his text for the Independent with the mocking words: "The Wandering Jew, the T. S. Eliot of painting? Kitaj turns out, instead, to be the Wizard of Oz: a small man with a megaphone held to his lips."[6]

In the States, the press was surprised by this reaction to the retrospective. Ann Landi of Art News was reminded of the intrigue against French artillery officer Alfred Dreyfus who was demoted and sent into exile in 1894 for alleged treason;[7] for Ken Johnson of Art of America the British reviews were based on personal antipathies and lacked any analytical substance.[8] Robert Hughes of Time magazine was shocked at the response by the British press, which, in a few weeks, had expressed more hateful things about Kitaj than most artists have to endure in a lifetime. He praised Kitaj's reflections on the state of the world, comparing his work with Picasso's Guernica.[9] The British critics reminded John Ash, who wrote for Artforum, of the reactions by the Nazi Reichskulturministerium (Ministry of Culture) to Max Beckmann and Emil Nolde. Ash assumed that Kitaj's interest in sexuality and Judaism had insulted the moral sensibilities of the British middle classes.[10] Snobbishness and anti-Semitism may also have played a part in what was, at the end of the day, an incomprehensible degree of cynicism as well as a personal attack on Kitaj, although in general the British art scene cannot be accused of bourgeois conservatism; on the contrary, it tends to be avant-garde and radical.

"War is hell. It kills people on both sides, wounds and disfigures."[11] This comment marks the beginning of Kitaj's handwritten text "I Accuse," which he wrote based on Émile Zola's pamphlet in which the latter demanded clarification of the conspiracy against Dreyfus. Two weeks after the retrospective, on September 18, 1994, his wife Sandra Fisher unexpectedly succumbed to an aneurysm, shortly after his mother had died in the United States—two dreadful blows for Kitaj. He interpreted Sandra's death as the result of the public bullying by the despicable critics.

From this point on, he divided those around him into friends and enemies; henceforth the feeling of splendid isolation to which he had always been prone intensified, and he let off steam in attacks on the critics. He was never to recover from this catastrophe. In "I Accuse," his accusation, he contrasts his self-image of a misjudged, hurt outsider, offered support by the testimonials of important kindred spirits, with the perfidy of a caste of critics whom he described as "the living dead." He formulated his reproaches in eleven articles, similar to Biblical commandments. He accused the critics of despising modern art, and his exhibition texts and writings. He charged them with envying his success, with xenophobia and anti-intellectualism, and finally laid the blame for

12 Quoted from Janet Wolff, "The impolite boarder: 'Diasporist' art and its critical response," in: James Aurich and John Lynch, (eds.) *Critical Kitaj, Essays on the Work of R.B. Kitaj* (Manchester, 2000), p. 33.

13 *http://www.independent.co.uk/ arts-entertainment/ right-of-reply- -hit-or-myth-the-tates-r-b-kitaj- retrospective-received-a-critical- pummelling-richard-morphet-the- shows-curator-and-keeper-of-the- gallerys-modern-collection-fights- his-corner-1412219.html*

Sandra's death at their door. He compared their attitude to his work with Hitler's railings against "degenerate art," and finally polemically conceded that at least they had made him the "most-discussed living painter."

Notwithstanding his continuing success and the unbroken value of his work on the market, he expressed his despair about Sandra's death and about the way the critics had wounded him in a series of works that he wanted to be considered "magazines." These mixed-media installations are his method of coming to terms with his wife's death, and a highly emotional way of settling his score with the critics which, in turn, led to a reprise of his publicly conducted dispute with them. *Sandra One*, the first "issue," went on show at the Royal Academy in the summer of 1996 and it has gone down in history as "The Critic Kills," the words that Kitaj painted over the portrait of his deceased wife in an unequivocal message. *Sandra Two*, a work with an autobiographical motif, appeared in October 1996 as a publication to accompany an exhibition in Paris. The third "issue," *Sandra Three*, was produced for the 1997 summer exhibition at the Royal Academy, at the center of which a painting entitled *The Killer-Critic Assassinated by his Widower, Even* |p. 211 celebrated his revenge on his opponents both grimly and violently. Kitaj placed himself in the picture as one of two armed figures shooting at a ghastly hydra, which stands for the British journalistic fraternity. Out of the mouth of this monster uncoils a long ribbon on which viewers can read the words "yellowpressyellowpress killkill-killkill the heretic always kill heresy." After this last attack on the British art press Kitaj left London with the words, "I don't have a close enemy in London,"[12] never to return.

Interview with Richard Morphet

Richard Morphet, the curator of the retrospective at the Tate Gallery, whom the *Independent* conceded the "right to reply" to the malicious reviews in its pages on July 7, 1994,[13] never publicly expressed any views on the events of 1994. Now, however, after almost two decades have elapsed, he has declared himself willing to comment on our questions regarding the "Tate War."

A Retrospective was the title of the Tate exhibition in 1994. What was the concept of the exhibition and, given that title, why were so many recent art works included?

The central aim of the exhibition was to present a detailed overview of the development of Kitaj's art from 1958 to 1994. This fully justified the word "retrospective" in the exhibition's title, and the many rooms devoted to work made before 1985 constituted a large-scale conspectus of nearly three decades. The relatively fuller coverage of the years 1986 to 1994 was owing to this work having been seen much less widely. Many major works were shown for the first time; the Gallery shared Kitaj's view that they showed exciting new developments. The exhibition as a whole gave a strong sense of continuity of vision from 1958 to its end.

How was the decision made to treat the text with the same importance as the paintings? Was it clear from the beginning that the texts would be granted considerable wall space?

Though texts played a vital role in both exhibition and catalogue, the visual art was always given pride of place. In both cases the layout made it easy to experience the

images directly, without reading any texts or by reading only the work's title, date, medium, and ownership. It was decided at an early stage that numerous texts would be made available in the exhibition at point of viewing, but the phrase "granted considerable wall space" is misleading if it gives the impression that texts were as prominent as pictures. The texts (which were provided for only some of the pictures) constituted both an aid to understanding Kitaj's aims and an invitation to still fuller engagement with the pictures' subject matter. Both processes started and finished with Kitaj's facture on a flat surface, and with the physical and imaginative procedures of his image-making. The result of these decisions about the installation was that large numbers of visitors had a powerful experience of the pictures and also found reading the texts both absorbing and rewarding.

How did the Tate react to the series of negative reviews? Did the institution publish anything on behalf of their exhibition? How was the "bad press" discussed inside the museum among colleagues?

In the *Independent*, July 7, 1994, I attempted to refute a number of the main themes of the critics' attacks, not least as made in that newspaper (which allowed me much less space than their hostile review). I did so in greater detail in lectures. My own view of the "bad press" (shared, I believe, by many Tate colleagues) is that while it was sincerely felt it told one more about the critics than it did about Kitaj's art. The Gallery was keen, as am I, on the expression of frank and open comment, but my personal view is that it would be easier for readers of unusually adverse reviews to reach their own conclusions if they were offered a reasoned favorable response in the same paper.

How do you explain to yourself that a relevant part of the reviewers wrote offending and abusive reviews, not only discussing the art but also attacking the artist?

As I see it, the hostile reviews relate to five key features of Kitaj's art. The first is that as the years passed Kitaj gave increasing prominence in his work to his own person and his personal experiences and beliefs. The second is that he was both a painter and a writer and that, while each of these modes took its own distinct form, the matters they addressed were closely interlinked. The third is the emphasis Kitaj gave, in his art and his writing, to the intensity of his admiration for great artists and writers of the past (for example, Degas, Cézanne, and Kafka). The fourth is that in later decades he increasingly explored new techniques for drawing the imagery in his paintings; this involved increasing simplification, boldness, and rawness of mark-making, and almost a delight in a certain rough "awkwardness" in the final image. The fifth is the degree to which directness itself, whether in subject, technique, or confessional self-exposure, permeated all four of the features already described. In my view, the ways in which Kitaj deployed these various qualities greatly enriched visitors' experiences in the exhibition, as well as enriching his art and art in general.

Though concerned with motifs or ideas that exist independently of the artist, the works of most important western artists of the modern era also embody and transmit the individual artist's personality in ways that are intrinsic to each work they make. Thus, however much an artist may seek to express a specific insight or a universal truth, he or she is also asserting their own existence in the world and their own view of it. To

make this assertion, each artist must choose the mode they will adopt, invent, or extend. Kitaj increasingly chose modes that would enable him to draw insistent attention to his own experience of the world, to his beliefs, and to his fantasies. In much of the hostile criticism of his 1994 retrospective there was a sense that, in being so explicit and so forceful, Kitaj was exceeding the bounds of the acceptable, or that in addressing topics so numerous and diverse he was being over-ambitious. But criticism along such lines contravenes two important principles. The first is that any mode or attitude is acceptable in principle, in terms of art, if it is the most effective means of communicating a distinctive vision. Kitaj's alleged "excess" is thus as acceptable as are exquisitely refined restraint, rigorous painting from observation, or lyrical abstraction. The second principle is that one should welcome the position when, in their work, an artist insists on being true to him- or herself. It should not be a question of whether a critic, personally, likes the result (which they are entitled to admire or to hate). The choice to make abundance of motif and idea, self-exposure and imaginative invention central features of his work was Kitaj, who believed that in terms of trying to make a distinctive kind of art one could not be too ambitious. He also believed that one should not be afraid of offending against good taste (as some of the criticism suggested he did). He succeeded in creating a world of his own and in enabling others to enter it, as many did with delight.

It follows from the points made above that Kitaj's wish to make texts available at point of viewing, offering his own commentary on the work, was a natural part of his artistic practice (as of that of many past artists). Critics complained that by providing the artist's interpretation the Tate was preventing the works speaking for themselves or being interpreted freely by others, but the very content of the hostile reviews disproved this. Moreover, while Kitaj himself stressed that his was not the only way of seeing the works, very many found his texts helpful, precisely because they were by the artist.

Another persistent criticism was of Kitaj's frequent invocation of the names and achievements of great artists and writers of the past. Ludicrously, it was implied or stated that such invocation implied that Kitaj saw himself as these forbears' equal. The nature of his admiration gives the lie to this, but more generally it seems profoundly unfair that an artist should be attacked for avowing his debts openly when inspiration from past art is integral to the practice of most significant artists. Just because most internalise the inspiration it does not follow that it is invalid or demeaning for others to address it in their work explicitly. Andrew Graham-Dixon, writing for *The Independent* (June 28, 1994), accused Kitaj of being "an inveterate name-dropper who claims Muse-like inspiration from a quite remarkable number of major writers and painters." But to Kitaj great art and its remarkable makers was a natural subject of permanent and urgent exploration, irrespective of his own standing. It makes no sense to criticise him for making whatever was important to him a major subject of his art. The key issue, of course, was how effective the result was. Many critics found it ineffective, some exhilarating. While open expression of hostile opinion was vital, non-specialist readers whose newspapers published extreme attacks would have benefited from being offered both sides of the argument. Severe critical demolition might otherwise deter them from visiting the exhibition.

The boldness, rawness, and (creative) awkwardness of the recent work attracted criticism variously for its alleged "slapdash" character and for its allegedly operating merely as "illustration" of Kitaj's ideas. But Kitaj was inventing as he drew. "Illustration" or not, each given theme comes alive in the intensity of the physical handling. Paint and subject become one. Roughness expresses the urgency, for Kitaj, both of the subject and of the idiom of "painting-drawing" that he was developing with great excitement. Each picture is complete; Kitaj worked (for however long or short a time) till he reached a point where it could stand alone as image, idea, and object. Though there are many connections between Kitaj and other artists of his period, no one was working in quite this way. Its relative unfamiliarity may be one reason why many critics found it so difficult to take.

While there are exceptions on both sides of the Atlantic, much American art exhibits a bracing, blunt factuality with regard to both materials and emotions, in contrast to a no less estimable, more nuanced sensibility in English art. For all the deliberate ambiguity of narrative in some of the more film-like scenes he painted, in this respect Kitaj maintained an American approach. Like the persona revealed in his writings as a whole, the manner of his paintings was frank and exposed. Together with the insistence with which both paintings and texts conveyed messages (whether about himself or about life), this was, for many English critics, a bit much. It was as though the topics Kitaj raised were judged admissible but the force with which he projected his thoughts was not, whether in art or in texts. This supposed "problem" (which in my view was anything but) was compounded when, as in the Tate retrospective, the two modes of communication were employed together. Surely, however, it would have been more helpful of critics to welcome Kitaj's exceptional and focused vitality and to celebrate and explore the enrichment of English culture, in both his modes, by an artist of whom nothing quite like had been seen before?

Why do you think these reviews affected Kitaj so deeply? Do you have an idea why he could never forget the "case"?

My sense is that the combined mass of hostile reviews seemed to him like a public repudiation of his project and almost of his *raison d'être*, in the city that he had made his home. He must also have resented the fact that after he had worked with such intensity, both in painting and in writing, and had achieved a large-scale exhibition that presented the nature of his endeavour so clearly, the reviews did little to explain or to explore what he was trying to do. The atmosphere of the exhibition's opening was supportive and almost euphoric; it is important, too, to remember that favourable reviews did appear, some of them early on. By the end of the opening celebrations Kitaj must have felt that his impassioned undertaking was recognised and appreciated. The shock must therefore have been acute when, shortly afterwards, it was so widely rejected in public print, and with a passion that answered his own. To admirers of Kitaj's art the hostile outburst seemed beyond reason and also, in the unusually personal nature of the assault, beyond what was acceptable morally.

As if this were not enough to prevent Kitaj ever forgetting the "case," the tragic and unexpected death of his wife Sandra two weeks after the close of the Tate exhibition branded the experience indelibly in his memory. As she had shared and suffered the

critical assault with him he could not but associate her death with the extremity of the attacks.

A major point to which many critics took exception was the persona that Kitaj projected for himself. The hostility they displayed to him personally must therefore have been among the most painful features of a denigration that amounted almost to dismissal. It is for this reason that one can understand how it was that Kitaj believed a strong strand in the attacks to be anti-Semitic. For among the many self-identities that Kitaj proposed in his art the central one, in the later decades, was as a Jew. It is therefore possible that Kitaj's belief that the attacks were anti-Semitic sprang not from any specific thing written—I am not aware of anything written that one could define in such terms—but rather from what he perceived as the whole package of persecution of a person of such an identity—and one, moreover, who placed historical and often tragic Jewish experience at the heart of his explorations. On July 29, 1994, during the run of the Tate showing of the exhibition, the American art writer David Cohen was quoted as commenting in *Forward* on the attacks: "He's never acquired the English art of understatement.... They don't like the fact that he is a brash American Jewish name-dropper. That doesn't go down well. But that doesn't mean they don't like Americans or Jews."

My Years with Kitaj

Tracy Bartley

I have sat down to begin this essay many times. It has been much more difficult than I imagined—I think because I know the ending—and it still weighs heavily on my heart. My nearly ten years as Kitaj's assistant were formative in my life. The years were full. I loved my work—and the man I worked for. He would joke with people that my job was like being his wife—without sharing a bed. I became his confidante—and tried to be his crusader. Our routine together shaped my days. His absence from our lives is still felt, five years after his death.

I first met R.B. Kitaj at his home in the quiet Westwood neighborhood of Los Angeles on a late summer day in 1997. As I pulled up to his driveway I had no expectations. I was not very familiar with his work—or the events that had prompted him to move, with his young son Max, to Los Angeles: the harsh criticism of his retrospective, and the death of his beloved wife, Sandra. My friend and mentor, Mildred Constantine, who was working with me at The Getty Conservation Institute, had insisted that we go meet the new-to-L.A. Kitaj and invite him to speak at a conference we were organizing on the conservation of contemporary art.

We arrived promptly at 4:30 in the afternoon—as we had been directed—and were greeted at the door by his assistant Charlotte, who had traveled to Los Angeles from London with Kitaj and his young son Max. Kitaj met us in the kitchen; we were offered juice or water, and invited to sit down. I didn't notice that there was very little furniture in the house—but I was enthralled with the piles of books on the floor and the stacks of artwork against the walls. Kitaj was still in the process of unpacking his vast library and his art collection—though many of these stacks and piles remained untouched through my years with him. A talkative cat, Kitty Kitaj, wandered through it all. I noticed immediately the bright yellow studio in the back garden, its roof still under construction.

Our meeting wasn't without debate. Kitaj began by insisting that he didn't care about the future of his work. He ended with a nod to the value of legacy, and the promise to speak at the conference that next spring.

We kept in touch and one day late in the fall I got a call from him, inviting me once more for a visit. He told me the news that Charlie would be returning to England, and extended an invitation to me to board at the house, in exchange for some light clerical work and the job of driving Max to and from school. He gave me a new copy of Philip Roth's *Sabbath's Theater* to read. He explained that the main character of the book was fashioned after him, based on conversations he'd had with his close friend Roth over the years, and especially after the death of Sandra. He showed me his own worn copy—with careful red checkmarks beside each reference he attributed back to himself.

I read the book cover to cover. I accepted his proposal.

Kitaj fondly called the house in Westwood "West West" after Kafka's Count in *The Castle*. It had been built in 1935, and was rumored to have been the home of Peter Lorre | **p. 224**. Kitaj turned every room save Max's into a gallery and library: most famously the "Jewish Library" and the "Cézanne Room." He had the architect install bookshelves throughout the house that came halfway up the walls and he filled them with his vast collections: Art History (with a special collection of Cézanne), Film, Judaica, American Poetry...

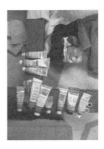

He continued to build his collection in Los Angeles. He was a constant scourer of used bookstores, and we would make regular pilgrimages around Los Angeles to the select few that remained in this city: Gene de Chene Books (now closed); Wilshire Books (also, sadly, closed); Alias Books; and Berkelouw Book Dealer (not too far away to fit nicely with a visit to the Los Angeles County Museum of Art). I would visit amazon.com daily to order books that piqued his interest, found in his morning reading.

Our relationship grew, and the arrangement evolved over the coming months. I soon moved out—but also agreed to leave the Getty for a full-time position as Kitaj's assistant. The next nine years I spent Monday through Friday with Kitaj, from his return from the café at 10:30 in the morning, through his early evening rituals. I would accompany him on trips, and chauffeur him around Los Angeles. We explored the museums and bookshops together. I would take him to visit friends in their homes and studios, and assisted him as he was invited to lecture around the city. He was my primary companion.

Kitaj's days had a steady rhythm:
4:30: alarm rings
5:30: depart the house to walk into "Westwood Village" with stop for the *Los Angeles Times*, and on Fridays and Sundays the *New York Times*.
6:00: arrive at The Coffee Bean as it opens, to ensure he gets his favorite table. Order large black coffee, plain bagel with butter, and bran muffin. Read and write.
10:00: depart café for walk home
10:30: return to West West and head straight to one of the studios (drawing or painting)
12:30: break for lunch. Soup or cereal, and discussion
1:30: siesta (reading and resting)
3:30: return to painting studio
4:30: receive visitors or continue painting
5:30: television (news, movie, or Cleveland Indians game)
6:30: dinner (Thursdays and Sundays with family)
8:00: bed, to read and to sleep
Repeat.

The morning hours—the walk to the café, during which he would profess to speak to Sandra and ask for her guidance—and the time at the café spent reading and writing were crucial to the work in the studio. He would be reading multiple books at once, as well as the *New York Times*, the latest *Times Literary Supplement*, the *New Republic*, and art magazines picked up at the local newsstand. He would return with pages of yellow legal paper filled with his careful script—always in red pen—for me to transcribe, as well as napkins from the café with compositions, preparatory sketches, and notes on the work he was developing. He wrote his *Second Diasporist Manifesto* during those mornings. And many essays, short stories, and the beginnings of an autobiography. He began to write his autobiography, his unfinished *Confessions: How to Reach X Years in Jewish Art*, in 2001, as a carefully formulated remembrance of his life—rushing through his childhood to his time as a merchant marine and on to his experiences in Europe: "I was born on a Norwegian cargo ship..." When the writing of his

past caught up to his present, he transitioned to daily diary entries, ending on March 1, 2007: "Failure, failure as always!..." Daily I would receive his café writings to type up on the computer. He would take the neat white pages back the next day, edit them, and continue writing on his yellow paper. This process would build on itself, until he had a document he was pleased with.

Kitaj's home in Westwood was the incubator for his thoughts, writings, and artwork. Every room was filled with memories and mementos and touchstones to experience. The sparse furnishings were punctuated with pieces that held great meaning: the large octagonal table set in the front room and covered with calling cards, books, and clippings that once had a life in London, where meals were served by Sandra and it was surrounded by The School of London painters, poets, family, and friends; the paint-splattered stool in his studio that had traveled with him and Max from London. But it was the art and books that one could not escape. The house was full, the memories and stories palpable. Kitaj once told me that one's home is one's greatest work of art. His home and studio were a testament to a man who lived for beauty and knowledge. The front room of the house was his drawing studio with walls designed to take pushpins and large blank sheets of his "porridge paper" hung from top to bottom. His friend David Hockney had introduced him to this rough textured paper in the 1970s. Hockney had received some but didn't like it, so he passed it on to Kitaj. There are few drawings on any other paper surface from that time on. And Kitaj worried about what he would do when his supply ran out, as it was no longer available from the manufacturer. The drawings would be done with pencil and charcoal—and on occasion with the addition of paint. He would spray them with fixative until they had the leathery texture he liked. The same paper would be coated with a transfer medium so it could be used to create a stone for his lithographs—a method developed for him by Master Printer Stanley Jones at Curwen Press that allowed the artist to work in the manner he was most comfortable with.

The drawings would be moved up and down the walls as he was working on them. Many would be worked at the same time. A thin bead of charcoal and pastel dust would line the room as he worked and reworked the surfaces. Next to each, or on the floor below, would be newspaper and magazine clippings that were used as source material. When not in active use, these clippings were kept carefully in a folder. Kitaj would sometimes use the same image many times over. He referred to them as a kind of "repertory company"—going back to the same "actors" again and again.

The painting studio was a garage conversion accessed through the back garden. Designed by Barbara Callas of Shortridge Callas, it was designed and near completion when Kitaj arrived in Los Angeles in 1996. It included a zinc panel roof, meticulously installed and finished by hand in a process that continued as I worked for Kitaj. The roof of the garage had been removed and the new one was lifted and tilted to allow a bank of clerestory windows and the much-desired northern light of a painting studio. Kitaj would refer to this as his "Yellow Studio": a bright chrome yellow that was reflected in the adjacent black-bottomed pool. It was the yellow of Van Gogh's house in Arles and of Monet's dining room. It was set next to the pool, overlooking the patio and gardens. Kitaj had told me of the time and care he had taken with his garden in London. Here in Los Angeles he took less interest—but he enjoyed the giant ferns, fig trees, and colorful blooming trees and bushes that grow so easily in Southern California.

He would often comment how un-L.A. it was: an intimate space, as he did not desire the large industrial spaces favored by most L.A. artists. A Mies van der Rohe daybed and shelves of books occupied one end, and more books covered the floor in stacks. The main space was filled with three easels, set on scattered carpets. The walls were covered with source images, drawings, and mementos. The studio was filled with paintings in various stages of completion—and ever-present were the portrait of his friend José Vicente, smoking, and the portrait *Sandra in Armani Suit*.

In actuality, the entire house was Kitaj's studio—though the two spaces were where most of the work was developed. Every room was filled with books, tear-sheets of inspiration, and works he had collected over the years by those he admired most: Hockney, Auerbach, Kossoff and others.

The time in the studio was followed by lunch. There were so many stories. Most days Kitaj had only a bowl of soup—which meant more time for conversation. He would share stories of his youth, of growing up in Cleveland, of his father, Sigmund Benway, of the move to Troy, and of his mother and his stepfather, Dr. Walter Kitaj. He would wonder where Sigmund—who left his family and moved west to Los Angeles when Kitaj was a toddler—might be buried. He remembered the high school art teacher who gave him a failing grade, and then later appeared at an opening at Marlborough New York. He spoke of his time in Vienna, and of meeting Elsi: their move to Oxford, and then to the Royal College of Art where he was admired by the other students for his status as an older, married man with an automobile. Of his young family. Of his early identification of Hockney, a fellow student, as a burgeoning star—and the luck of purchasing early student drawings from him: drawings of skeletons that hung in pride of place in the front room of West West. Of his earlier years in California, teaching at Berkeley and at the University of California Los Angeles. And of course of his time in London. Of the early parties and later home-life. Of Sandra and her work as an artist. Of young Max and the joy of family. Of great sadness and the tragedy of Sandra's death. Of the circumstances that led to his fleeing the London he knew so well. Of how coming to Los Angeles really did feel like coming home in many ways—with his birth father buried here, his eldest son and his grandsons around the corner, and his daughter up the coast. And with memories of Sandra, whom he first met in Los Angeles, and with his dear friend David Hockney nearby. In spite of all that, he would still tell me how he felt like an outsider—rejected in England for being an American, and in America for spending so many years in England.

We would discuss methods and materials, their history. His favorite paint colors. (I loved visiting the art supply stores with him where new colors with new fantastic names would be dropped into the basket for the sheer joy of their nomenclature.) His move from large canvases finished with size and white ground to the small linen canvases with only rabbit-skin glue. His "painting-drawing." His search for "A Jewish Art."

He would read to me: usually something humorous. Often a paragraph from what he was reading—or something sparked by our conversation that reminded him of a passage.

After lunch he would return to the studio for a period of solitude and focused work. On days when we were in the same room we wouldn't speak to each other, working silently side by side. Other days I would leave him in his Yellow Studio, the door open to the sweet air of his garden. He would sit and stare at the canvas, then carefully lay a line of color.

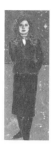

His mid-afternoon siesta was as much another time for reading as a time to rest. He would retire to his bedroom (also filled with books and art alongside the meager furnishings: only a bed placed alongside bookcases and flat-files filled with prints).

I would knock on his door at 4:00, to ensure he was prepared for visitors to arrive at 4:30, or to return to his studio. Visits were paid by friends, family, colleagues, collectors, and admirers. There were visitors from his childhood, and first meetings. Some he enjoyed more than others—and a few he didn't enjoy at all. The 4:30 timeslot allowed for gracious, albeit sometimes abrupt, goodbyes, as dinner would be on the table at 6:30 and he preferred some time in front of the television beforehand.

His meals were meager. Since a heart attack in the 1980s he had worried about his weight, and he checked it daily. He would save his appetite for the gourmet family meals prepared by his daughter-in-law on Sundays—which he would recount to me in detail on Monday. After dinner he would return to the television: a baseball game during the season, or a movie on cable. He would have a copy of his TV Guide by his side, searching for favorites: *The Red Shoes*, *49th Parallel,* anything by Michael Powell, Westerns. Classics, anything with Julia Roberts or Andie MacDowell.

To bed at 8:00: he would read again, before falling asleep. He told me he would often dream of reuniting with Sandra. He looked forward to those dreams coming true, he would tell me—if that were a possibility.

In his final year the routine changed. And that, I believe, was the beginning of the end. He was diagnosed with Parkinson's disease. He suffered terrible back pain—a pinched nerve—that made it difficult to stay in one position for long, and even more difficult to move. He began to carry a cane, fearful his shuffle might cause another fall. The notes in the calendar that lived on the kitchen desk changed. Visits from curators, fans, and friends, became visits to various doctors, and appointments with the physical therapist. As he was no longer able to walk to the café in the morning, those early morning hours he had walked through Westwood, talking to Sandra, were lost. We worked at recreating a place to read and write at the house, but it wasn't the same. This took its toll on his mood and outlook.

I read an article once that advised one never to work as a personal assistant to a person suffering from depression. It was late in my time with Kitaj—and I believed I had come to understand his suffering: his "black dog." I now realize its magnitude was greater than I could imagine.

I remember a man who made me laugh, who held kindness in the highest regard, who put family first, who was unwaveringly true to himself, who was uncomfortable with things that were not in his control. He was a man I admire greatly.

Sabbath's Theater was only the first of many books Kitaj gave to me during those years. The final book he gave me was *Monsieur Proust*, by Céleste Albaret. It is her recollection of the nine years she worked for Marcel Proust—and of being at his side when he died. Unfortunately I did not read it until after Kitaj's death.

The new owners of the house in Westwood have painted the Yellow Studio brown. I drive by and crane my neck to see it through the jacaranda blooms. But it is gone.

10
Self Retreat

My Cities (An Experimental Drama), 1990–1993
Oil on canvas, 183 × 183 cm

"The three main actors represent myself in youth, middle age and old age. Behind them is a drop-curtain inscribed with historiated capital letters of cities where I've lived or loved. Over the course of a few years these capital letters... have been sublimated by white paint... The catwalk stage upon which the figures tread and stumble through life becomes the roof of a baseball dugout in which I've tried half-heartedly to draw some of my demons (Don't Ask!), colourless spectres only thinly isolated from the three leading players above as in a predella."
• R. B. Kitaj, 1994

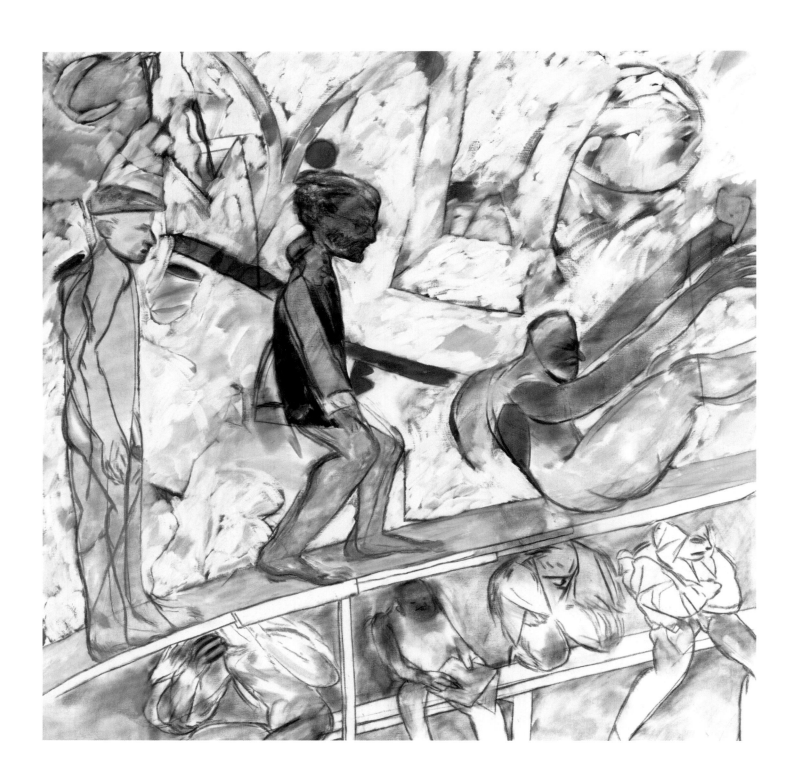

The Killer-Critic Assassinated by his Widower, Even, 1997
Oil and collage on canvas, 152 × 152 cm

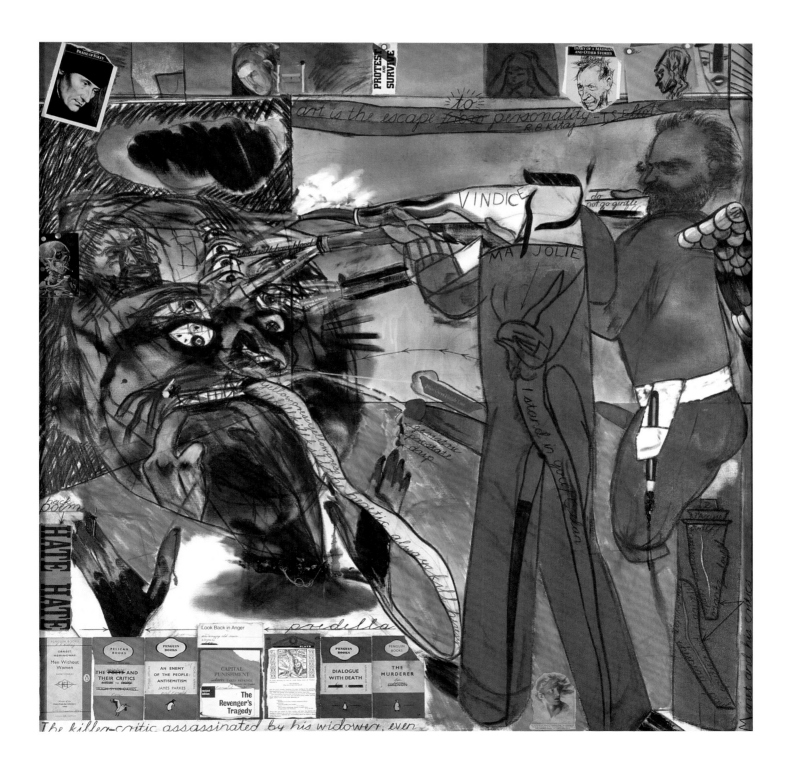

The Last of England (Self Portrait), 2002

Oil on canvas, 122 × 122 cm

"Then I left England forever."
• R.B. Kitaj, ca. 2003

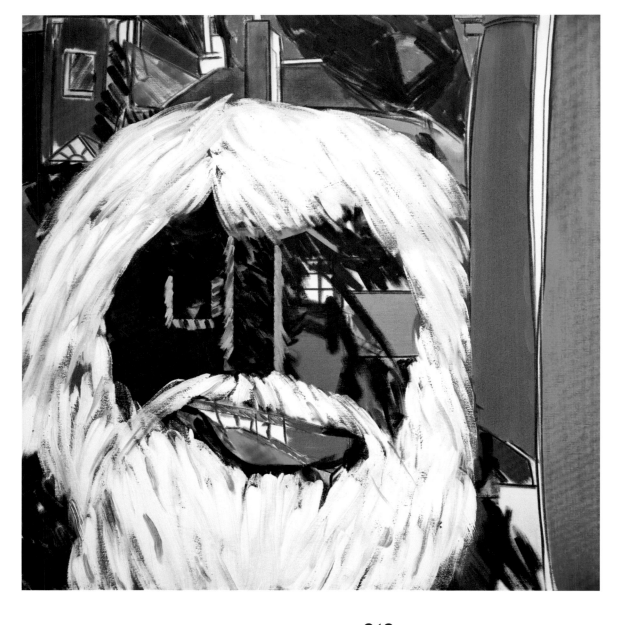

Dreyfus (After Méliès), 1996–2000

Oil on canvas, 91 × 91 cm

"A hundred years ago, Oscar Wilde, Whistler and Dreyfus were attacked and savaged by hatred for the outsider, the foreigner, the Jew. All three fought back against enemies who savaged them in unjust warfare. And they fought back against the odds, against a cowardly press and its dogs of war. [...] These little wars were like antechambers to a miserable century in which far more real wars would murder many millions of outsiders, foreigners and Jews. More often than not, Jews were all three objects of hate at once, as I was in the fateful summer of 1994 when my Tate War opened to friends and enemies by the River Thames." • R. B. Kitaj, ca. 1997

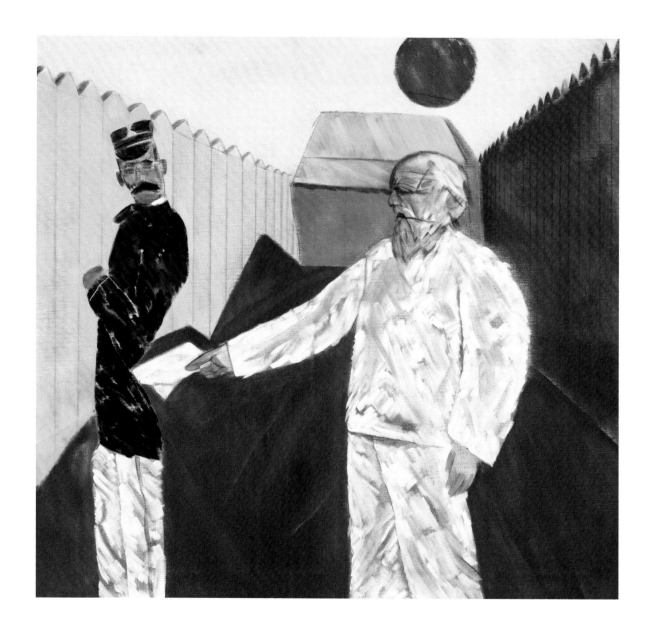

4 a.m., 1985

Oil on canvas, 92 × 117 cm

"One of the main sources for *4 a.m.* is an Uccello panel showing men trying to break down a door to kill a frightened family of Jews in a room, the inside of which Uccello also shows. I've crowded the room like Benjamin's hashish vision. The odd chair on the left is a traditional circumcision chair. The little girl is peeping through the spyhole, reporting the progress of the men battering the door down."
• R.B. Kitaj, 1994

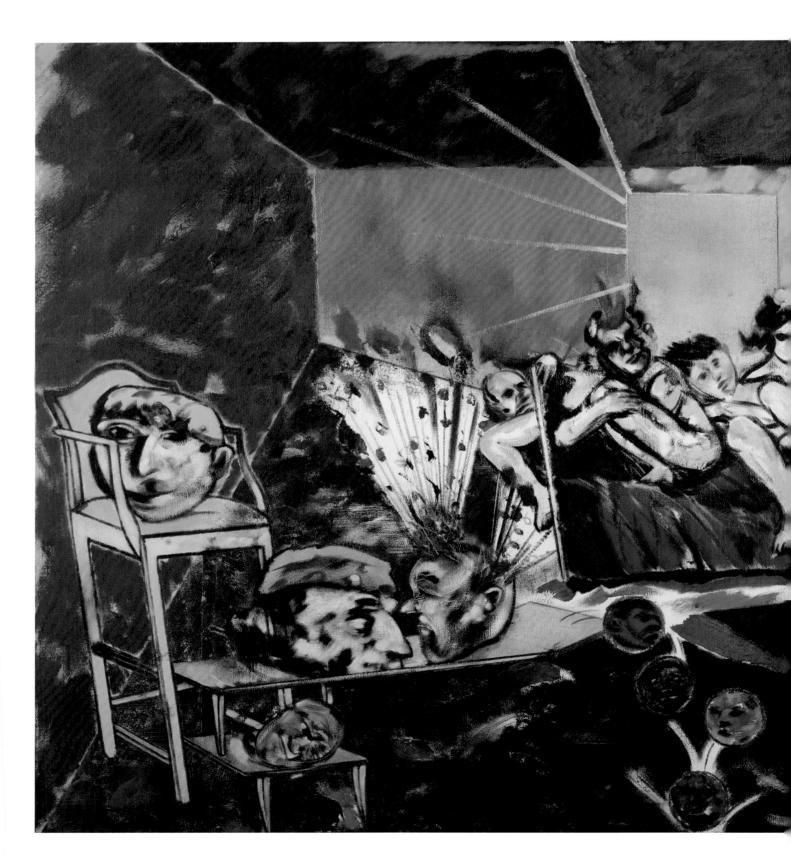

Eclipse of God (After the Uccello Panel
Called "Breaking Down The Jew's Door"), 1997–2000
Oil and coal on canvas, 91 × 122 cm

Los Angeles No. 9, 1969–2002

Oil on canvas, 152 × 121 cm

"In the sixties, I made this silk-screen canvas in London and forgot about it for 35 years. When I unpacked it in L.A. I saw that the lower right quarter was blank and I could paint in there, so I did. I painted a version of the black car famously photographed by Robert Frank, with Sandra (hair dyed red) and me. The Angels, in conversation in the car. Abstraction-Creation was an avant-garde group of abstractionists in Paris and this issue of their magazine was published in 1932, the year of my birth. I've re-issued it 70 years later in Los Angeles in my 70th year." • R. B. Kitaj, 2003

abstraction création art non figuratif 1932

Los Angeles No. 19 (Fox), 2003

Oil on canvas, 91 × 91 cm

"My picture shows Sandra and me
in front of my yellow studio by the
pool at Westwest. The Fox tower
was suggested by the one on the
deco movie theater just down my
street in Westwood Village."
• R.B. Kitaj, 2003

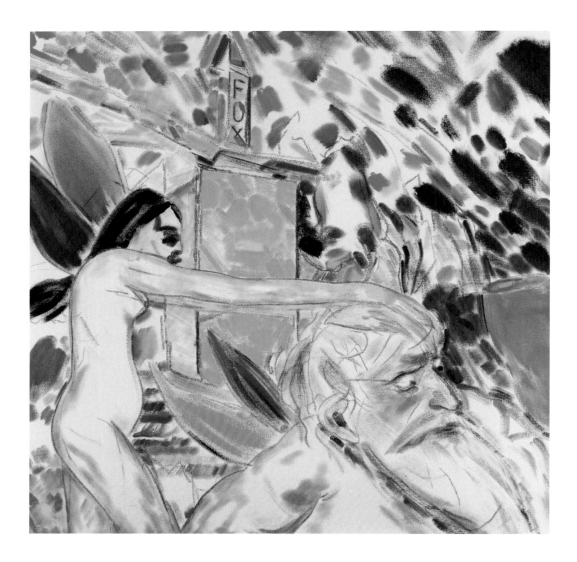

Arabs and Jews (After Ensor), 2004

Oil on canvas, 91 × 91 cm

"This is my 3rd painting called
Arabs and Jews, a fight I expect will
never end. This picture is based on
Ensor's painting *The Fight*. You
may choose which is Arab and
which is Jew." • R.B. Kitaj, 2005

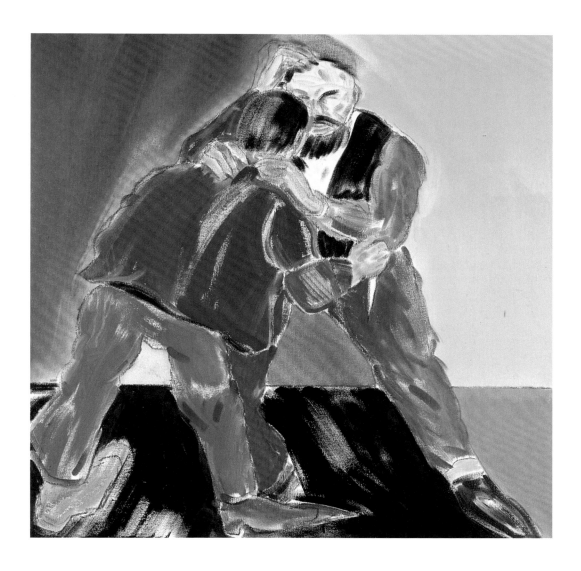

Ego (Three Famous Jews), 2004

Oil on canvas, 91 × 91 cm

"This EGO is based on the figure of Abraham, which has decorative borders, found in the Synagogue of Dura-Europus in Syria. EGO is riding the wild horse ID as in Freud's famous example of EGO controlling ID. The border colors were stimulated by Moshe Idel's discussion of Color Theory in Cabbalistic prayer." • R. B. Kitaj, 2005

Id (Three Famous Jews), 2004

Oil on canvas, 91 × 91 cm

"My ID was inspired by an archival photo in the Jerusalem Post of an unnamed Yiddish actor in pre-Shoah Eastern Europe. Freud wrote that ID 'is the dark (I've used sepia), inaccessible part of our personality... a cauldron full of seething excitations... needs subject to the observance of the pleasure-principle.' Repressed EVIL is associated with ID in the Unconscious. This painting is my first try at the prophetic concept of the Jewish Science which would soon smite European Everyman and murder the Yiddish actor." • R. B. Kitaj, 2005

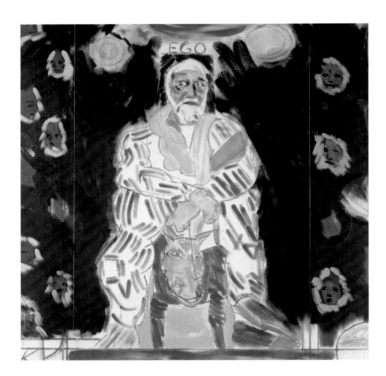

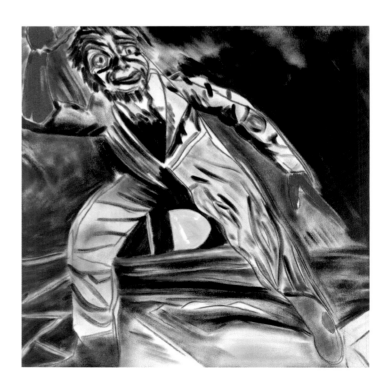

Superego (Three Famous Jews), 2004

Oil on canvas, 91 × 91 cm

"SUPER-EGO. This is the most complex of the three to discuss. In my old age, one of the difficult ideas that excites me is to somehow combine abstract painting and human form. For this painting I turned to what I'm tempted to call a Jewish School of painters and critics: Stain Painting [...] The central caput mortem stain carries the burden of features of the human face. This is the 'face' of CONSCIENCE, Freud's 3rd Jewish guy, SUPER-EGO." • R. B. Kitaj, 2004

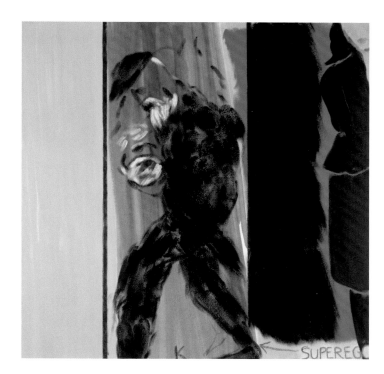

Peter Lorre, 2005
Oil on canvas, 36 × 36 cm

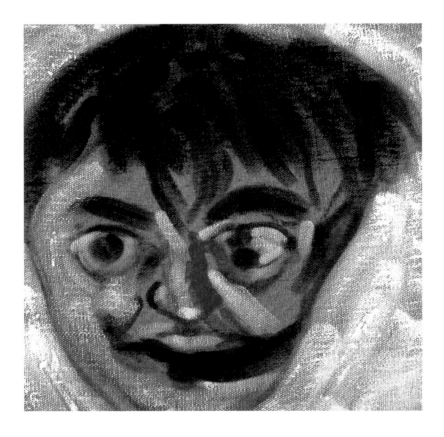

G. Scholem, 2007

Oil on canvas, 46 × 31 cm

"When I discovered Benjamin in the mid-sixties... I also tripped across his best friend Gershom Scholem who was to become the leading scholar of Kabbalah. Scholem fascinated me because of the way he took his life into his own hands at an odd and sinister moment in Germany, turning toward this really neglected study (of Mysticism) as no one has before or since, and, toward Palestine where he landed early and for good in 1923, after having uncannily seen and felt the hopeless plight of European Jewry." • R. B. Kitaj, n.d.

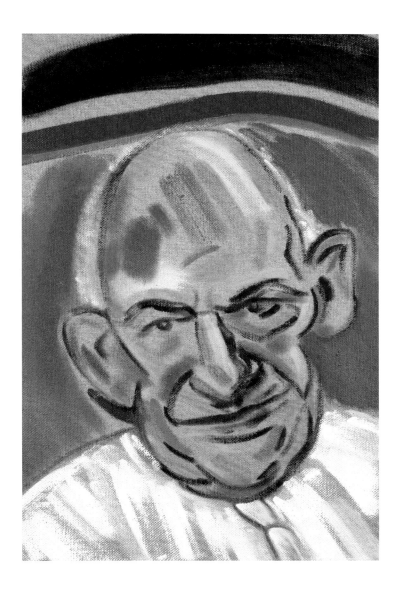

Kafka's Three Sisters, 2004

Oil on canvas, 31 × 46 cm

"January 2004
Freud's 4 sisters were murdered in
the German gas oven.
So were Kafka's 3 sisters.
So were Auerbach's parents.
So were my grandmother Helene's
2 sisters." • R.B. Kitaj, 2004

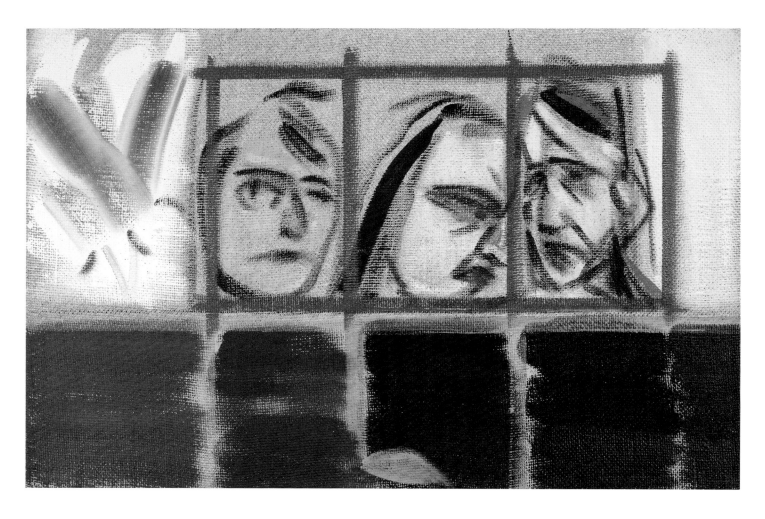

Paul Celan (Black Flakes), 2006

Oil on canvas, 31 × 31 cm

"Kafka, Proust, Freud, Wittgenstein,
Benjamin, Celan etc. etc. did not
depart Europe. They wrote in a
Host-Language! So, one re-invents,
in art, a Host-Tradition (Giotto-
Matisse) in that way, infusing in
with what one is!"
• R. B. Kitaj, 2004

Portrait Albert Friedlander, 1990–1993

Coal on paper, 19 × 15 cm

for Albert with love from Kitaj

Reform Rabbi (Albert Friedlander), 1990–1994
Oil and coal on canvas, 101 × 76 cm

A Jew in Love (Philip Roth), 1988–1991
Coal on canvas, 59 × 34 cm

Isaiah Berlin, 1991 | 92
Coal on canvas, 51 × 46 cm

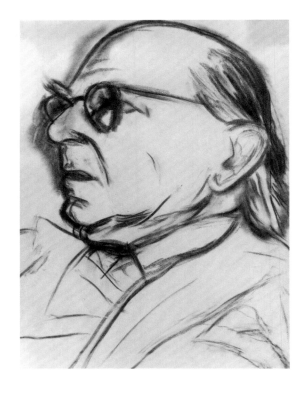

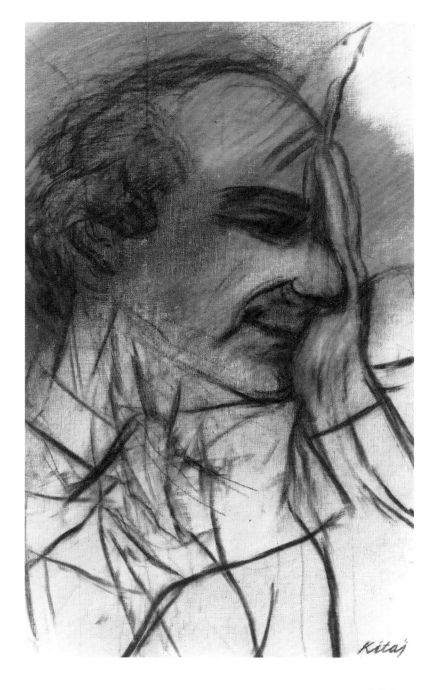

Wollheim and Angela, 1980
Coal on paper, 56 × 77 cm

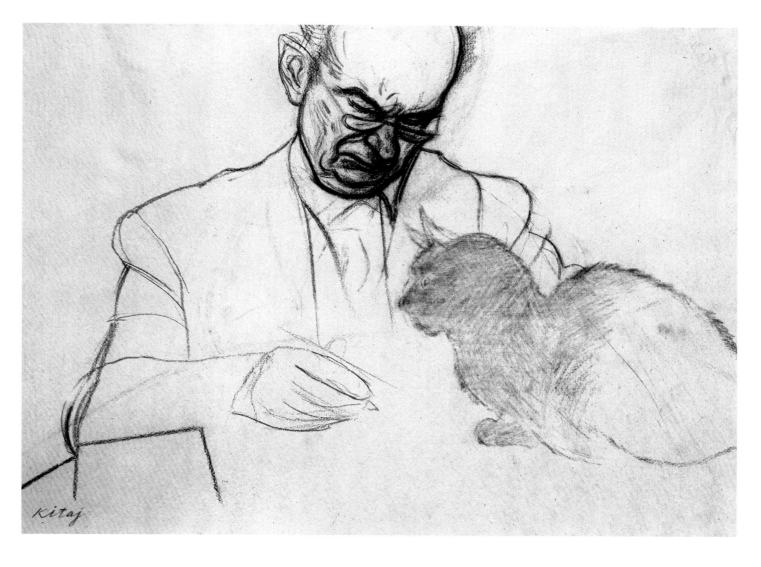

Degas on his deathbed, 1980
Pastel on paper, 73 × 51 cm

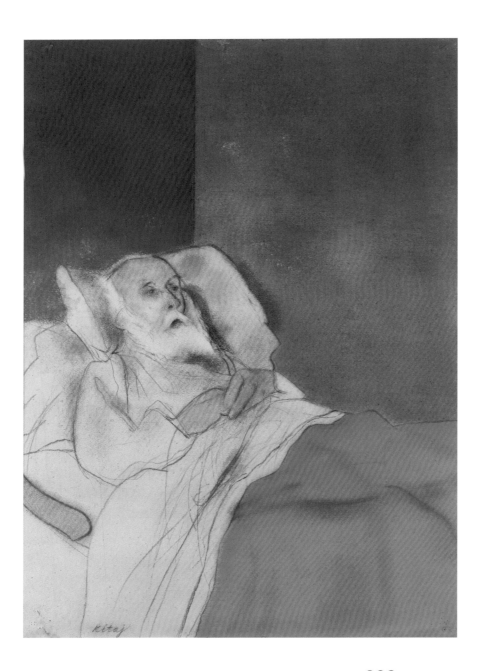

The Philosopher-Queen, 1978|79

Pastel and coal on paper, 77 × 56 cm

"*The Philosopher-Queen.* I think there was someone, a king, called the philosopher-king? That inspired my title. I don't remember if the title came first or after the pastel was done.
[...] The daydream is set in the Greenwich Village flat where we lived for a year in 1979 and has no more meaning than a dream has. Sandra, who appears twice, as you can see, and I were almost happy there on that stage."
• R. B. Kitaj, 1994

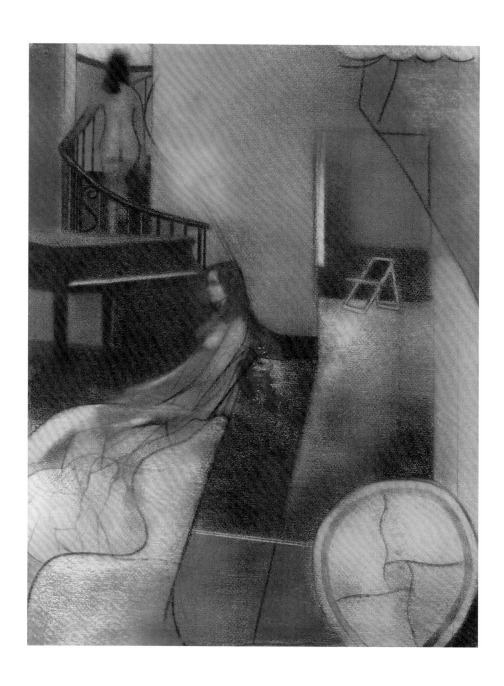

04

05

08

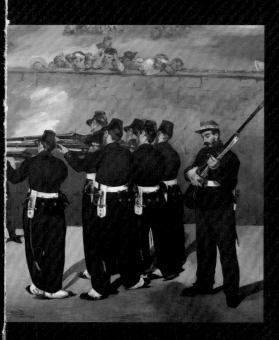

07

10

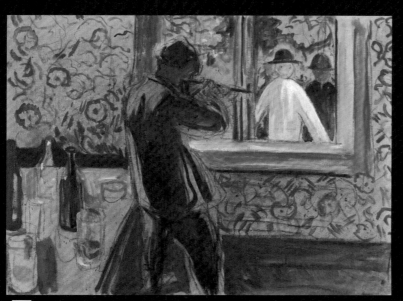

09

The Killer-Critic Assassinated by his Widower, Even, 1997
Oil and collage on canvas, 152 × 152 cm

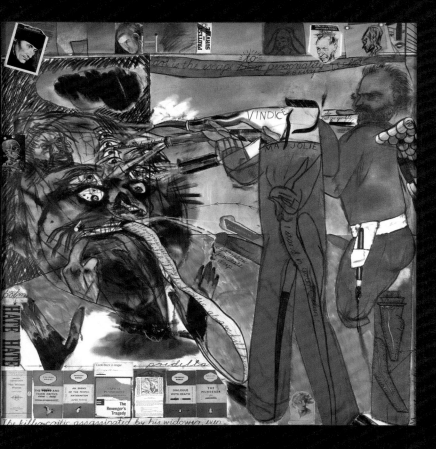

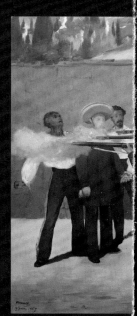

The GENTLE
ART of MAKING
ENEMIES

James McNeill Whistler

03

06

01

22 September

My beloved friend,

 You are Job. I don't know what else
to say. I was taught to say, before those
in mourning, "may you be comforted among
the mourners of Zion and Jerusalem", but
I don't believe that you will be comforted,
at least for a ling time, perhaps not ever.
And I understand why not: you lived with
an angel, and even at this great distance,
I, who knew Sandra not very well, feel
robbed. Max is blessed that he knew her
as a boy, and I have no doubt that she
will live in him, and blessed also that he has
you; but as your friend I must say that I
am grateful that you have him, because I know
that for his sake, and for your love of him,
you will repel the extreme of bitterness that
would cause you in any way to leave your life.
He needs you, & I am glad of it.

 The enclosed is a strange present for
you. It is the Zohar on the book of Exodus,
published in Amsterdam in 1805. After we hung
up, my hand suddenly reached to my shelf &
seized it for you -- not because you can
read it, but because you can't. It is impenetrable,
like what has happened to you. But keep it close,
because it is also it will warm you by its
presence, sort of a hug from your forefathers.

 We'll speak often. You loom in my thoughts,
which are bested by all this.

02

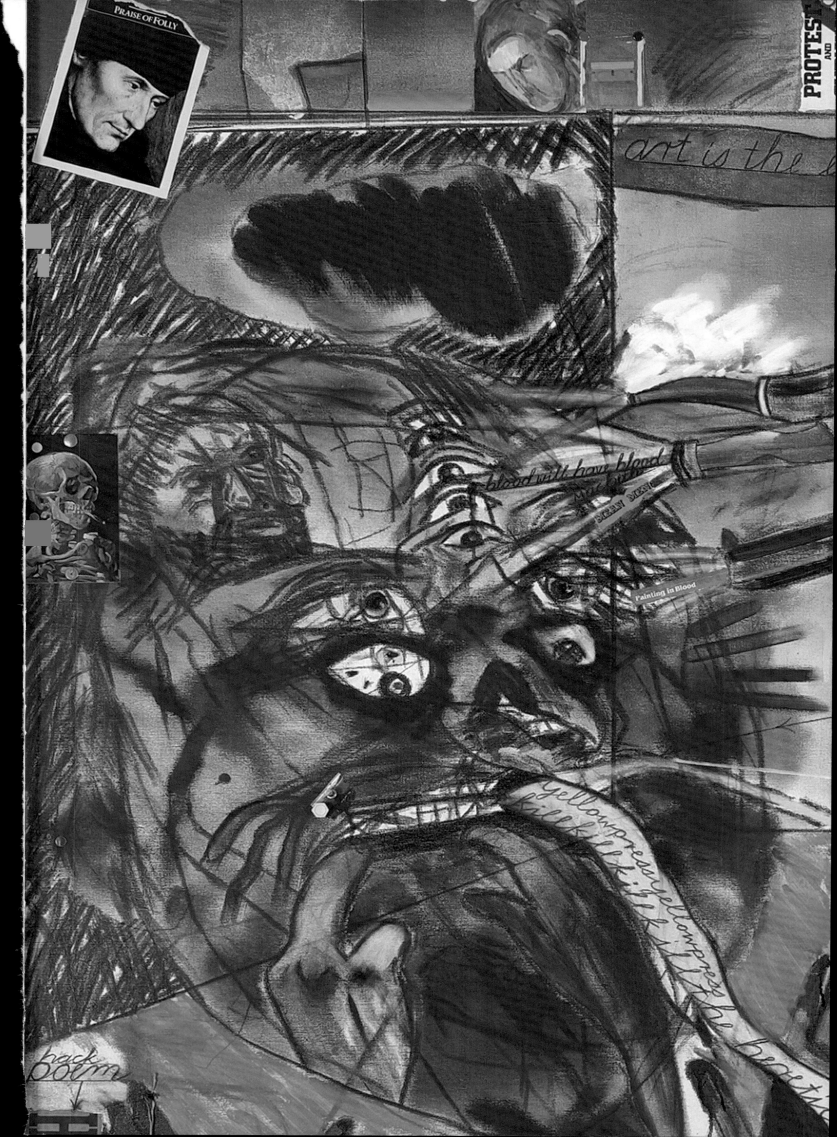

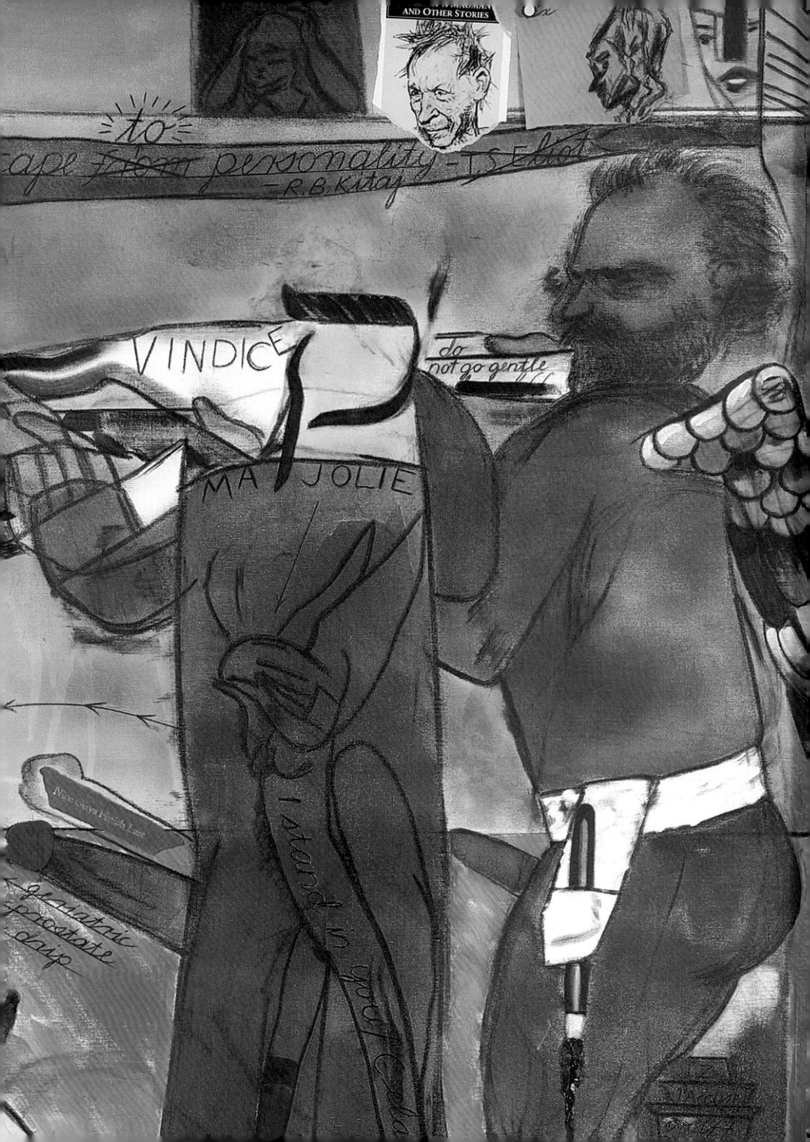

16

17

01 Pierre-Paul Prud'hon, *Head of the divine revenge*, ca. 1805, colored crayon.

02 Leon Wieseltier, letter of condolence to R. B. Kitaj, 22 September 1994, in: *Kitaj papers*, UCLA , Box 29, Folder16.

03 Book cover: James McNeill Whistler, *The Gentle Art of Making Enemies*.

04 Book cover: Erasmus von Rotterdam, *The Praise of Folly*.

05 Book cover: Nikolai Gogol, *Diary of a Madman* (English paperback edition).

06 Edouard Manet, *The Execution of Emperor Maximilian*, 1868/68, oil on canvas, Mannheimer Kunsthalle.

07 R.B. Kitaj, draft for *London's famous Yellow Press*, in: *Kitaj papers*, UCLA.

08 R.B. Kitaj, *Starting a War*, 1980/81, oil on canvas, whereabouts unknown.

09 Edvard Munch, *Uninvited Guests*, 1905, oil on canvas, Munch Museet.

10 R.B. Kitaj, draft for *The Killer Critic Assassinated by his Widower*, napkin, in: *Kitaj papers*, UCLA, box 38.

11 Félix Nadar: photography of Edouard Manet, Reproduction in: *Kitaj papers*, UCLA.

12 R.B. Kitaj, photograph of his studio in Elm Park Road, London, in: *Kitaj papers*, UCLA, Box 90, Folder 14/15.

13 R.B. Kitaj, photograph of his studio in Elm Park Road, in: *Kitaj papers*, UCLA, Box 90, Folder 14/15.

14 Brian Sewell, "Tales half-told in the name of vanity", in: *The Evening Standard*, 16. 6. 1994.

15 Book cover: Ernest Hemingway, *Men without Women* (English paperback edition).

16 Book cover: Hugh Sykes Davies, *The Poets and Their Critics*.

17 Book cover: Georges Simenon, *The Murderer* (English paperback edition).

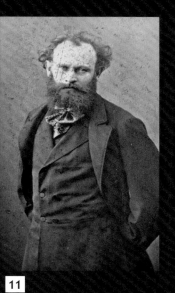

11

V

15

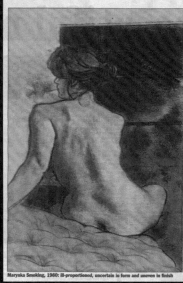

EVENING STANDARD

Tales half-told

FOR THE past two weeks or so it has scarcely been possible to open a magazine or broadsheet newspaper without finding in it some lengthy article on Ron Kitaj, an exegesis, or an interview with this American expatriate in England, friend and contemporary of David Hockney, and inventor of the term "The School of London".

All part of the juggernaut of publicity that the Tate Gallery now so expertly sets on a thundering progress whenever it mounts an exhibition, these scribblings hammer home the man's proclaimed position as "one of the leading figurative painters in the world", his revitalised faith as a Jew, his concerns with sex, history, philosophy, politics and poetry, his friendships with the famous and his artistic relationships with the old masters of the past, Massaccio to Matisse, Uccello to Cézanne, Giorgione to Degas (I'd like to add Carpaccio's Venetian tarts).

The exhibition catalogue continues in like vein with an introductory essay by a panjandrum of the Tate, from which we gather that Kitaj is a painter who not once in his life fumbled, bumbled or lost his way with a picture, every one a work of absolute perfection and himself a creature of constant genius. The same panjandrum then interviews the artist (the fifth interview I've read — there may well be more), enabling the horse's mouth to confirm all that his apologists claim for him.

The Director of the Tate, the eximious Serota, contributes a foreword larded with expressions of the low kowtow — "We are delighted ... we owe an immense gratitude to Kitaj ... it has been a privilege and pleasure to work so closely with the artist ... we are indeed deeply grateful", all this in one page; and a famous philosopher (philosophers, I observe in passing, are as foolish as psychoanalysts when they work on the mysteries of art) is allowed to ruminate, recall, reflect, and conclude that to the question "What is Art?" Kitaj is the answer.

"Kitaj draws better than almost anyone else alive," said Robert

Marynka Smoking, 1980: ill-proportioned, uncertain in form and uneven in finish

14

12

13

Mary-Ann on her Stomach (Face Right), 1980
Pastel and coal on paper, 56 × 76 cm

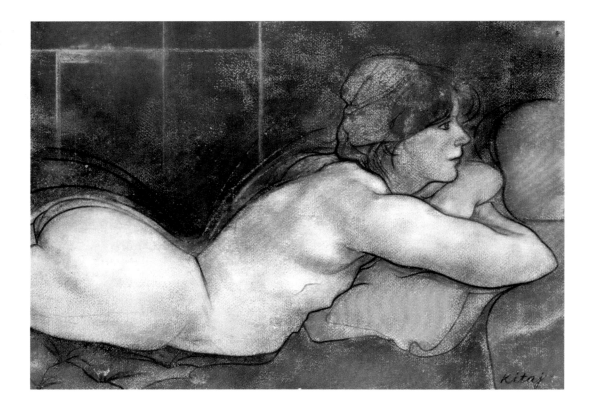

Marynka Pregnant II, 1981

Pastel and coal on paper, 56 × 77 cm

"Marynka was a redhead Trilby who blossomed among our version of late 20th Century bohemia of free love and all that. Hockney made an intimate supper—just the two of us. Stunning Marynka came through the kitchen door wearing nothing but stockings, garter belt and high heels, carrying a birthday cake for me. She and I went into David's bedroom and fucked. Then she became my favorite model— what the Jews call 'saftig'—not too plump and not thin."
• R. B. Kitaj, 2003

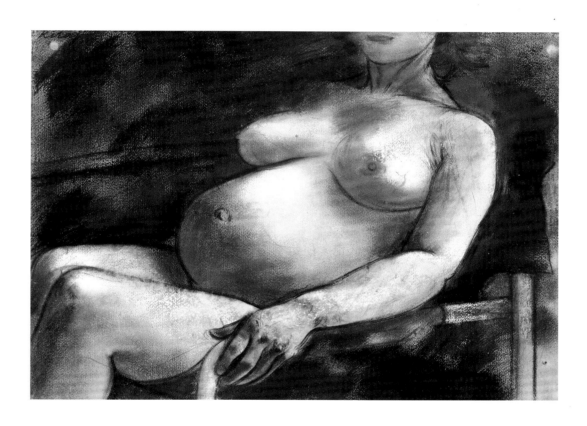

The Jew Etc., Etc., 1989–2004
Oil on canvas, 92 × 92 cm

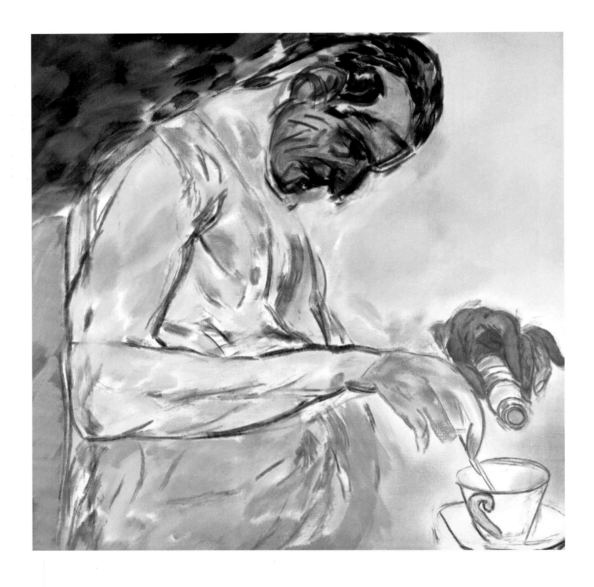

Self-Portrait (Hockney Pillow), 1993 | 94
Oil on canvas, 102 × 51 cm

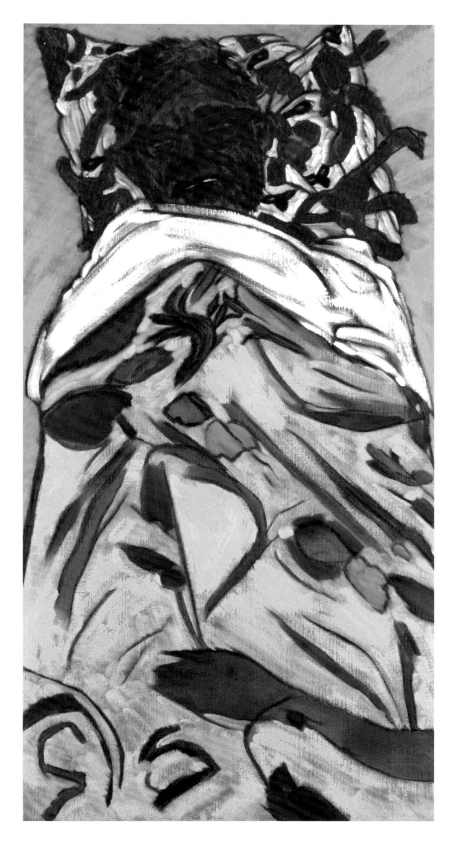

After Cimabue, 2006
Oil on canvas, 30 × 30 cm

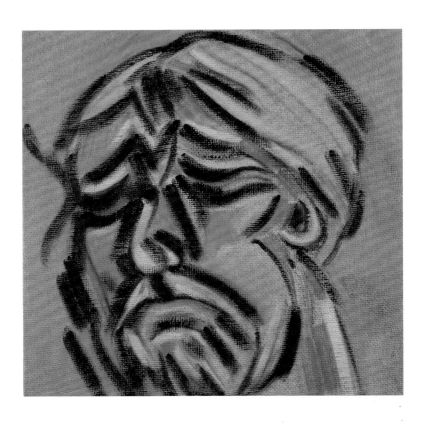

Duccio or Cimabue (Self Portrait), 1997–2001
Oil on canvas, 41 × 30 cm

Self Portrait, 2004

Oil on canvas, 65 × 65 cm

"Mid-Aug 05
Here I am again after a year or so, still alive, still an irritant.
I have Parkinson's disease, but it's OK so far. I love my cane, draw, study, and write (in my Coffee Bean) everyday. The best thing about Parkinson's is my addiction to Chocolate Fudge Sundaes. The worst thing is the medication. So, I don't take it, which drives my neurologists at UCLA (on my street) nuts. Parkinson's has no cure yet. I give myself 5 yrs with 'luck'." • R. B. Kitaj, 2005

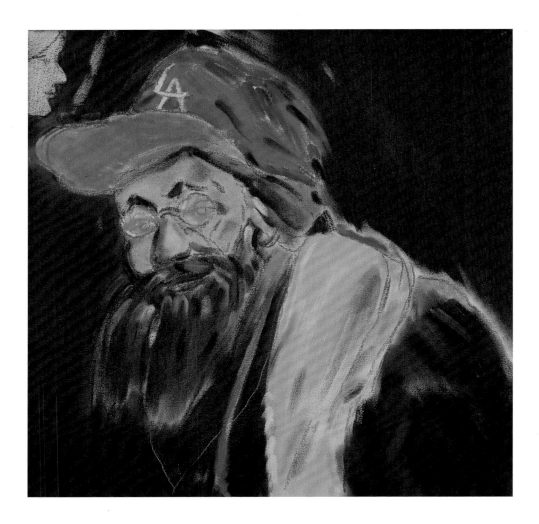

Self Portrait, 2007
Oil on canvas, 20 × 20 cm

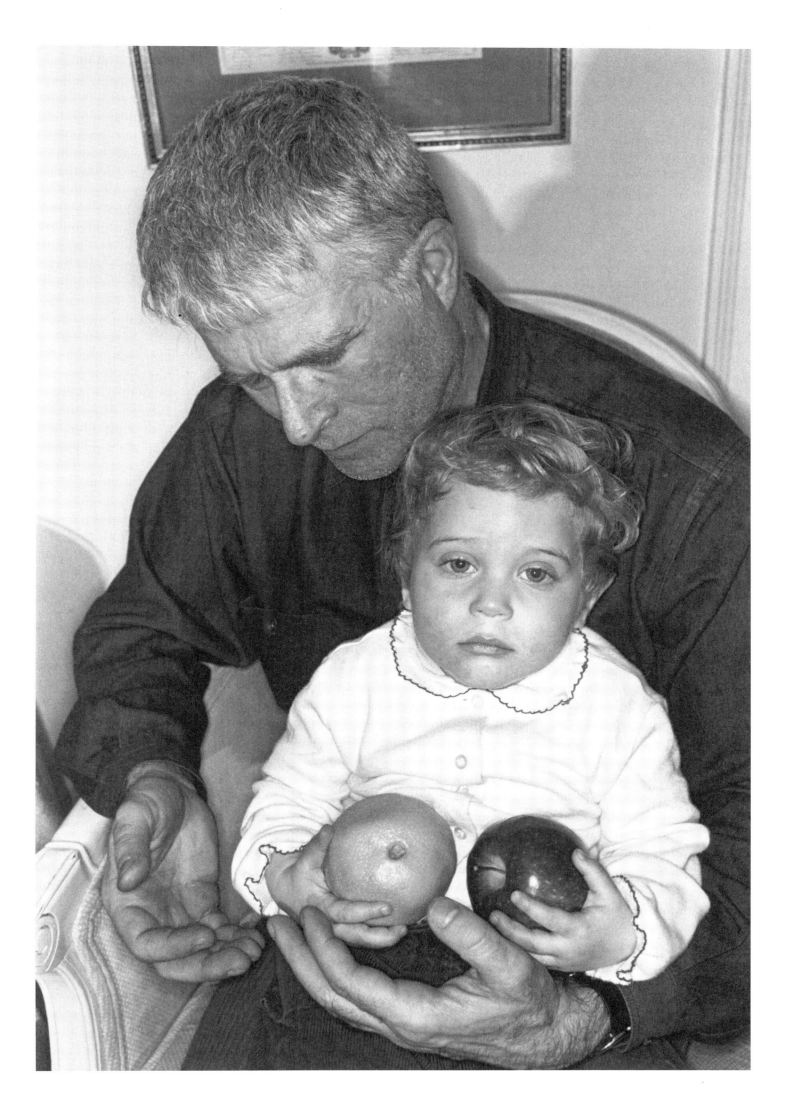

R. B. Kitaj
Biography

R. B. Kitaj
as a curator

1932
born in Chagrin Falls near Cleveland, Ohio. His mother, Jeanne Brooks, was the daughter of Jewish-Russian immigrants; he never knew his father, Sigmund Benway

1941
Jeanne Brooks married Walter Kitaj, a Viennese Jew, who emigrated to the United States in 1938

1949
Kitaj signed up as a merchant sailor with the SS Corona; until 1950 he worked, with interruptions, as a sailor on cargo ships

1950
studied at the Cooper Union for the Advancement of Science and Art

1951 | 52
studied at the Akademie der Bildenden Künste in Vienna

1952
second year of studies at the Cooper Union

1953
married Elsi Roessler in New York Returned to Vienna; made first trip to Catalonia

1956 | 57
stationed in Darmstadt and Fontainebleu, as a soldier in the U.S. Army

1957 – 59
studied at the Ruskin School of Drawing and Fine Art in Oxford

1958
birth of his son Lemuel (Lem)

1959 – 61
studied at the Royal College of Art in London; start of a lifelong friendship with David Hockney

1963
first solo exhibition at Marlborough Fine Art in London

1964
adopted a daughter, Dominie

1965
exhibition at the Marlborough-Gerson Gallery in New York

1967 – 68
taught at the University of California in Berkeley

1969
death of Elsi

1970 | 71
taught at UCLA

1978 | 79
taught at Dartmouth College

1981 | 82
retrospective at the Hirshhorn Museum and Sculpture Garden, Washington; at the Cleveland Museum; and at Kunsthalle Düsseldorf

1982
sojourn in Paris

1983
married Sandra Fisher in London

1984
birth of son Max

1988
Erstes Manifest des Diasporismus was published (initially in German)

1989
First Diasporist Manifesto was published

1994
retrospective at the Tate Gallery, London; death of Sandra Fisher

1995
awarded the Golden Lion at the Venice Film Festival

1997
returned to the United States with son Max; started living and working in Westwood, Los Angeles

1998
retrospectives at the Astrup Fearnley Museum in Oslo, the Reina Sofía in Madrid, the Jewish Museum Vienna, and the Sprengel Museum in Hanover

2003
exhibition at the Louver Gallery in Los Angeles

2007
Second Diasporist Manifesto was published; R. B. Kitaj committed suicide on October 21

1975
The Human Clay

1980
The Artist's Eye

1996
Sandra One, Royal Academy's summer exhibition

1997
Sandra Three, Royal Academy's summer exhibition

2001
In the Aura of Cézanne and other Masters

List of Exhibited Works

4 a.m., 1985
Oil on canvas, 92 × 117 cm,
Private collection •214

After Cimabue, 2006
Oil on canvas, 30 × 30 cm,
Private collection •244

The Arabist, 1975 | 76
Oil on canvas, 244 × 76 cm,
Museum Boijmans Van
Beuningen, Rotterdam •124

**Arabs and Jews
(After Ensor), 2004**
Oil on canvas, 91 x 91 cm,
Collection of R. B. Kitaj Estate
•221

**The Autumn of Central
Paris (after Walter
Benjamin), 1972 / 73**
Oil on canvas, 152 × 152 cm,
Private collection • 75

The Baby Tramp, 1963 | 64
Oil and collage on canvas,
183 × 61 cm,
Gemeentemuseum, Den Haag •56

**Bad Faith (Riga)
(Joe Singer Taking Leave
of His Fiancée), 1980**
Oil, pastel and coal on paper,
94 × 57 cm, not in the exhibition,
Private collection •161

**Bather
(Tousled Hair), 1978**
Pastel on paper, 121 × 57 cm,
Courtesy of Kaare Berntsen,
Oslo, Norway •145

Batman, 1973
Oil on canvas, 244 × 77 cm,
Private collection Cologne •123

Books and Ex-Patriot, 1960
Oil on wood, 74 × 22 cm,
Pallant House Gallery, Chichester •33

Boys and Girls!, 1964
Screen print, 61 × 43 cm,
Los Angeles County Museum of Art,
Gift of Lee Friedlander and
Mrs. Maria Friedlander •36

**Catalan Christ (Pretending
to be Dead), 1976**
Oil on canvas, 76 × 244 cm,
Collection of Halvor Astrup •126

**Cecil Court, London WC2
(The Refugees), 1983 | 84**
Oil on canvas, 183 × 183 cm,
Tate: Purchased 1985 •140

Collage, 1965
Mixed media and collage,
51 × 43 cm,
Private collection • 36

**Degas on his deathbed,
1980**
Pastel on paper, 73 × 51 cm,
Collection of Halvor Astrup •232

Desk Murder, 1970 – 1984
Oil on canvas, 76 × 122 cm,
Birmingham Museums & Art
Gallery •128

**Dismantling the Red Tent,
1963 | 64**
Oil and collage on canvas,
122 × 122 cm,
Los Angeles County Museum of Art,
Michael and Dorothy Blankfoot
Bequest •62

**The Divinity School
Address, 1983 – 1985**
Oil on canvas, 91 × 122 cm,
Private collection •158

Drancy, 1984 – 86
Pastel and coal on paper,
100 × 78 cm,
Fondation du Judaïsme Français,
Paris, on permanent loan in Musée
d'art et d'histoire du Judaïsme,
Paris •160

**Dreyfus (After Méliès),
1996 – 2000**
Oil on canvas, 91 × 91 cm,
Collection of Michael Moritz &
Harriet Heyman, USA •213

**Duccio or Cimabue
(Self Portrait), 1997 – 2001**
Oil on canvas, 41 × 30 cm,
Leon Wieseltier •245

**Eclipse of God (After the
Uccello Panel Called
Breaking Down the Jew's
Door), 1997 – 2000**
Oil and coal on canvas,
91 × 122 cm,
The Jewish Museum, New York
Purchase: Oscar and Regina Gruss
Memorial and S. H. and Helen R.
Scheuer Family Foundation Funds,
2000 – 71 •216

**Ego (Three Famous Jews),
2004**
Oil on canvas, 91 × 91 cm,
Charles E. Young Research Library,
UCLA. Library Special Collections.
•222

Erasmus Variations, 1958
Oil on canvas, 105 × 84 cm,
Tate: Accepted by H. M. Govern-
ment in lieu of inheritance tax and
allocated to Tate 2007 •19

Femme du Peuple II, 1975
Pastel, 77 x 56 cm,
Collection of Halvor Astrup •152

**From London (James
Joll and John Golding),
1975 | 76**
Oil on canvas, 152 × 244 cm,
Private collection • 72

**Germania (To the Brothel),
1987**
Oil on canvas, 121 × 91 cm,
Laing Art Gallery, Newcastle
upon Tyne •154

G. Scholem, 2007
Oil on canvas, 46 × 31 cm,
Collection of R. B. Kitaj Estate
•225

**Good God, Where is the
King?, 1964**
Collage, 85 × 59 cm,
Los Angeles Art, Gift of the Estate
of R. B. Kitaj •37

His New Freedom, 1978
Pastel and coal on paper, 77 × 56 cm,
Collection of R.B. Kitaj Estate
•26, 142

**The Hispanist
(Nissa Torrents), 1977 | 78**
Oil on canvas, 244 × 76 cm,
Museo de Bellas Artes de Bilbao
•125

**Homage to Herman
Melville, 1960**
Oil on canvas, 137 × 96 cm,
Royal College of Art Collection
•18

**Id (Three Famous Jews),
2004**
Oil on canvas, 91 × 91 cm,
Charles E. Young Research Library,
UCLA. Library Special Collections
•222

If Not, Not, 1975 | 76
Oil and black chalk on canvas,
152 × 152 cm,
Scottish National Gallery of Mo-
dern Art, Edinburgh •66, 138

**In Our Time. Covers for a
Small Library after the Life
for the Most Part, 1969**
18 of a series of 50 screen prints,
78 × 57 cm, 57 × 79 cm,
Marlborough Graphics, London;
private collection •174

Passion (1940–45)
Writing, 1985

Oil on canvas, 45.7 × 26.7 cm,
Charles E. Young Research Library,
UCLA. Library Special Collections
•156

Paul Celan (Black Flakes),
2006

Oil on canvas, 31 × 31 cm,
Collection Tel Aviv Museum of
Art, Gift of Mark Glatman, London,
through the British Friends of the
Art Museums in Israel, 2007 •227

Peter Lorre, 2005

Oil on canvas, 36 × 36 cm,
Collection of R. B. Kitaj Estate
•224

The Philosopher-Queen,
1978 | 79

Pastel and coal on paper,
77 × 56 cm,
Astrup Fearnley Collection, Oslo,
Norway •233

Portrait of Aby Warburg

Oil on canvas, 15 × 13 cm,
Private collection, London •22

Portrait Albert Friedlander,
1990–1993

Coal on paper, 19 × 15 cm,
Friedlander Family Collection
•228

Priest, Deckchair and
Distraught Woman, 1961

Oil on canvas, 127 × 102 cm,
Pallant House Gallery, Chichester
•33

The Red Banquet, 1960

Oil on canvas, 122 × 122 cm,
Walker Art Gallery •21

Reflections on Violence, 1962

Oil and collage on canvas,
153 × 153 cm,
Hamburger Kunsthalle •24

Reform Rabbi (Albert
Friedlander), 1990–1994

Oil and coal on canvas,
101 × 76 cm,
Private collection •229

Republic of the Southern
Cross, 1965

Collage on wood, 124 × 64 cm,
Private collection •36

The Rise of Fascism,
1975–1979

Pastel, coal and oil on paper,
85 × 158 cm,
Tate: Purchased •146

The Sailor (David Ward),
1979 | 80

Oil on canvas, 152 × 61 cm,
Astrup Fearnley Collection,
Oslo, Norway •144

Second Diasporic Mani-
festo, 1970–1996

Collage, 77 × 56 cm,
Charles E. Young Research Library,
UCLA. Library Special Collections
•173

Self Portrait, 2007

Oil on canvas, 20 × 20 cm,
Private collection, London •247

Self Portrait, 2004

Oil on canvas, 61 × 61 cm,
Private collection •246

Self-Portrait as a Woman,
1984

Oil on canvas, 246 × 77 cm,
Astrup Fearnley Collection,
Oslo, Norway •151

Self-Portrait (Hockney
Pillow), 1993 | 94

Oil on canvas, 102 × 51 cm,
Lent by the National Portrait
Gallery, London •243

Self-Portrait in Saragossa,
1980

Pastel and coal on paper,
147 × 85 cm,
Collection of the Israel Museum,
Jerusalem. Gift of the Artist •149

The Sensualist, 1973–84

Oil on canvas, 246 × 77 cm,
FORART – Institute for Research
within International Contemporary
Art •150

Smyrna Greek (Nikos),
1976 | 77

Oil on canvas, 244 × 76 cm,
Museo Thyssen-Bornemisza,
Madrid •125

Specimen Musings of a
Democrat, 1961

Collage, 102 × 128 cm,
Pallant House Gallery, Chichester
•25

Superego (Three Famous
Jews), 2004

Oil on canvas, 91 × 91 cm,
Charles E. Young Research Library,
UCLA. Library Special Collections
•223

Superman, 1973

Oil on canvas, 244 × 76 cm,
Private collection Köln •123

Synchromy with F. B. –
General of Hot Desire
(Diptych), 1968 | 69

Oil on canvas, Diptych,
both 152 × 91 cm,
Private collection •60

Two London Painters:
(Frank Auerbach and
Sandra Fisher), 1979

Pastel and coal, 56 × 78 cm,
Los Angeles County Museum of Art,
Michael and Dorothy Blankfoot
Bequest •77

Unpacking my Library,
1990 | 91

Oil on canvas, 122 × 122 cm,
Collection of Joseph Kitaj •172

A Visit to London
(Robert Creeley and Robert
Duncan), 1977

Oil and coal on canvas,
183 × 61 cm,
Museo Thyssen-Bornemisza,
Madrid •76

Walter Lippmann, 1966

Oil on canvas, 183 × 213 cm,
Collection Albright-Knox Art
Gallery, Buffalo, New York:
Gift of Seymour H. Knox, Jr., 1967
•58

Warburg as Maenad,
1961 | 62

Oil and collage on canvas,
193 × 92 cm,
Stiftung Museum Kunstpalast,
Düsseldorf •23

The Wedding, 1989–1993

Oil on canvas, 183 × 183 cm,
Tate: Presented by the artist 1993
•155, 162

Where the Railroad Leaves
the Sea, 1964

Oil on canvas, 122 × 153 cm,
Museo Nacional Centro de Arte
Reina Sofía, Madrid •50

Wollheim and Angela, 1980

Coal on paper, 56 × 77 cm,
Collection of R. B. Kitaj Estate
•231

Work in Progress, Eduardo
Paolozzi, 1962

Collage, paper and sheet metal in
wood frame, 85 × 100 cm,
Scottish National Gallery of
Modern Art, Edinburgh •35

Citations

The primary source used for this catalog is the Kitaj Estate at the University of California Los Angeles (UCLA). The material is archived under "*R. B. Kitaj papers (Collection Number 1741)*. Department of Special Collections, Charles E. Young Research Library, UCLA."
Short form: *Kitaj papers*, UCLA.

Cover
Ill.: R. B. Kitaj, *Marrano (The Secret Jew)*, 1976 (detail).

1
Ill.: R. B. Kitaj, *The Last of England (Self Portrait)*, 2002 (detail).

2
Ill.: R. B. Kitaj, *The Autumn of Central Paris (After Walter Benjamin)*, 1972 | 73 (detail).

3
Ill.: R. B. Kitaj, *The Baby Tramp*, 1963 | 64 (detail).

4
Ill.: R. B. Kitaj, *General of Hot Desire*, 1968 | 69 (detail).

5
Ill.: R. B. Kitaj, *Where the Railroad Leaves the Sea*, 1964 (detail).

6
Ill.: R. B. Kitaj, *The Ohio Gang*, 1964 (detail).

7
Ill.: R. B. Kitaj, *Batman*, 1973 (detail).

8
Ill.: R. B. Kitaj, *Juan de la Cruz*, 1967 (detail).

18
Cit.: Letter from Kitaj to Julián Ríos,1988, *Kitaj papers*, UCLA, Box 51, Folder 10 / 11, pp. 3f.

19
Cit.: *R. B. Kitaj. A Retrospective*, exh. cat., Tate Gallery, London 1994, p. 68.

20
Cit.: *Confessions*, around 2003, in: *Kitaj papers*, UCLA, Box 5, Folder 1, p. 60.
Ill. left: Johann Heinrich Dannecker, *Denkmal für Friedrich den Großen und seine Generäle*.
Ill. right: Body of Rosa Luxemburg 1919, photography; both featured in: *Journal of the Warburg Institute*, no. 2 (October 1938), p. 164.

21
The citation is part of the painting.
Ill. left: Giovanni Bellini, *The Blood of the Redeemer*, approx. 1500, National Gallery, London
Ill. right: Le Corbusier, *VIlla Stein*, 1927/28
Both featured in: Fritz Saxl: *Science and Art in the Italian Renaissance. Lectures I*, London, 1957, plates 64 and 62.

22
Ill.: Aby M. Warburg with a snake dancer in Oraibi, around 1896; from *R. B. Kitaj: Pictures With Commentary: Pictures Without Commentary*, exh. cat., Marlborough Gallery, London, 1963, p. 15.

23
The citation is part of the painting.
Ill.: Maenad, copy of a marble statue by Scopas, 1st century CE; Staatliche Kunstsammlungen Dresden, Sculpture Collection.

24
Cit.: *Retrospective*, exh. cat., Tate Gallery, London 1994, p. 74.

25
Cit.: *Retrospective*, exh. cat., Tate Gallery, London 1994, p. 215.

36
Cit.: *R. B. Kitaj*, exh. cat., Marlborough-Gerson, New York 1965, unpaginated.

38
Cit.: *R. B. Kitaj*, exh. cat., Marlborough-Gerson, New York 1965, unpaginated.

50
Cit.: R. B. Kitaj, *Confessions*, around 2003, in: *Kitaj papers*, UCLA, Box 5, Folder 1, p. 70.

51
Cit.: R. B. Kitaj, *Confessions*, around 2003, in: *Kitaj papers*, UCLA, Box 5, Folder 1, p. 20.
Ill.: Martín Santos Yubero, Dolores Ibárruri, (detail)

52
Cit.: *R. B. Kitaj. Pictures with Commentary: Pictures Without Commentary*, exh. cat., London 1963, p. 9.

54
Cit.: *Retrospective*, exh. cat., Tate Gallery, London 1994, p. 78.
Ill.: Nationalists advancing in the suburbs of Madrid, 1937, newspaper clipping, in: *Kitaj papers*, UCLA.

57
Cit.: R. B. Kitaj, handwritten comment on a lined yellow pad, around 1988 / 89, in: *Kitaj papers*, UCLA.

58
Cit.: *Retrospective*, exh. cat., Tate Gallery, London 1994, p. 88.

59
Ill. left: German soldiers in the Soviet Union
Ill. right: Field Marshal Erwin Rommel with German and Italian soldiers in the Africa Corps, photographies, both featured in: *Bertolt Brecht, Kriegsfibel*, Basel 1965, p. 62 and 36.

60
Cit.: R. B. Kitaj, *Confessions*, around 2003, in: *Kitaj papers*, UCLA, Box 5, Folder 1, p. 93.

62
Cit.: *Retrospective*, exh. cat., Tate Gallery, London 1994, p. 216.

63
Cit.: *Retrospective*, exh. cat., Tate Gallery, London 1994, p. 90.

64
Ill.: Dr. Heinrich Hoffmann: *Die Geschichte vom Zappel-Philipp*, in: Dr. Heinrich Hoffmann, *Der Struwwelpeter*, 1858.

74
Cit.: R. B. Kitaj, undated handwritten note, in: *Kitaj papers*, UCLA.

75
Ill. left: R. B. Kitaj in front of the café Les Deux Magots
Ill. right: Newspaper clipping with photo of George S. Kaufman, 1937. Both from *Kitaj papers*, UCLA.

76
Cit.: Julián Ríos, *Kitaj. Pictures and Conversations*, London 1994, p. 67.

77
Ill.: R. B. Kitaj, photo of Frank Auerbach and Sandra Fisher, in: *Kitaj papers*, UCLA.

78
Cit.: R. B. Kitaj, handwritten note, around 1993, in: *Kitaj papers*, UCLA.

86
Ill. left: Giotto di Bondone, *Kiss of Judas*, 1304–1306, fresco, Cappella degli Scrovegni, Padua (detail).
Ill. right: Giotto di Bondone, *Burial of St. Francis*, 1325, fresco, Cappella Bardi, Santa Croce, Florence (detail).

88
Ill.: R.B. Kitaj, *To Live in Peace (The Singers)*, 1973-4, oil on canvas, private collection.

89
Ill.: Joe Singer in the late 1930, , featured in Marco Livingstone, *Kitaj*, London 2010, p. 12.

90
Ill. right: R.B. Kitaj: *Study for the Jewish School (Joe Singer as a Boy)*, 1980, pastel and charcoal on paper.
Paul Cézanne: *Un Baigneur, 1879–82*, oil on canvas.

91
Ill. left: Paul Cézanne, *Groupe de baigneurs*, 1890–94.
Ill. center: Women in the Babi Yar ravine before their execution, photography 1941.
Ill. right: Newspaper clipping with the word "Bathers!" handwritten by Kitaj, in: *Kitaj papers*, UCLA.

94
Ill.: R.B. Kitaj, sketch of the places he has lived, paper napkin, in: *Kitaj papers*, UCLA.

95
Ill.: R.B. Kitaj, *My Walden (Yellow Studio)*, 1998, oil on canvas, private collection.

100
Ill.: R.B. Kitaj, *Sir Ernst Gombrich*, 1986, pastel and charcoal on paper, National Portrait Gallery, London.

102
Ill. left: David Allan, *The Origin of Painting*, 1775, National Gallery of Scotland.
Ill. center: R.B. Kitaj, *Los Angeles No. 22 (painting-drawing)*, 2001, whereabouts unknown.
Ill. right: Percy·Horton, *Nude*, approx. 1955, drawing on paper, Edward Chaney Collection.

103
Ill.: R.B. Kitaj, *Barceloneta*, 1979, four-color print, limited edition of 100 copies.

107
Ill.: Letter from R. B. Kitaj to Martin Roman Deppner.

109
Ill.: Letter from R. B. Kitaj to Martin Roman Deppner.

114
Ill.: R.B. Kitaj, *The Caféist*, 1980–87, oil on canvas, private collection.

115
Ill.: R.B. Kitaj, *Hannah Arendt in Jerusalem*, 2006, oil on canvas, Collection of R. B. Kitaj Estate.

122
Cit.: From an undated letter to Julián Ríos, around 1988 / 89, in: *Kitaj papers*, UCLA, Box 51, Folders 10 / 11.
Ill.: R.B. Kitaj, *David* 1976 / 77 (incomplete), whereabouts unknown.

126
Cit.: R.B. Kitaj, *Erstes Manifest des Diasporismus*, Zürich 1988, p. 81.

136
Cit.: *Retrospective*, exh. cat., Tate Gallery, London 1994, p. 132.
Ill. left: Griffith in the director's chair, book clipping, in: *Kitaj papers*, UCLA.

139
Cit.: R.B. Kitaj, handwritten note, in: *Kitaj papers*, UCLA.
Ill. left: R.B. Kitaj: photo of Michael Podro in London, in: *Kitaj papers*, UCLA.
Ill. right: Rembrandt van Rijn: *The Polish Rider*, 1656, The Frick Collection, New York.

140
Cit.: *Retrospective*, exh. cat., Tate Gallery, London 1994, p. 158.

141
Ill.: R.B. Kitaj, photo of Cecil Court, London WC2, in: *Kitaj papers*, UCLA.

144
Cit.: Kitaj, "Autobiography of My Pictures", unpublished script, 1989, in: *Kitaj papers*, UCLA, Box 126, Folder 7.

146
Cit. above: R. B. Kitaj in conversation with Timothy Hyman, "A Return to London", in: *London Magazine*, 19.2.1980, p. 26.
Cit. below: Linda Nochlin, "Art and Condition of Exile: Men/Women, Emigration/Expatriation", in: Susan Rubin Suleiman, *Exile and Creativity. Signposts, Travelers, Outsiders, Backward Glances*, Durham/London 1998, p. 47.

147
Ill. left: Paul Cézanne, *La Barque et le baigneurs*, 1890–94
Ill. right: Nude photo, magazine clipping, in: *Kitaj papers*, UCLA.

148
Cit.: Julián Ríos, *Kitaj. Pictures and Conversations*, London 1994, p. 115.

149
Cit.: Kitaj 1981 in a lecture given at Hirshhorn Museum, Washington D. C., noted by Livingstone in a letter dated March 21, 2011 to Eckhart Gillen.
Ill.: R. B. Kitaj, photo of the Gestapo prison in Warsaw, 1972, in: R. B. Kitaj, *First Diasporist Manifesto* London, 1989, p. 52.

150
Cit.: *Retrospective*, exh. cat., Tate Gallery, London 1994, p. 126.
Ill.: Paul Cézanne: *Le Grand Baigneur*, around 1885, The Museum of Modern Art, New York.

151
Cit.: *Retrospective*, exh. cat., Tate Gallery, London 1994, p. 144.

154
Cit.: Kitaj, undated handwritten note, in: *Kitaj papers*, UCLA, Box 118.

156
Cit.: Foreword to Catalogue *R. B. Kitaj*, November–December 1985, Marlborough Gallery, New York 1986, p. 111.

159
Cit.: Kitaj, undated handwritten comment on a lined yellow pad, in: *Kitaj papers*, UCLA.

161
Ill.: Auguste Rodin, *L'Amour ou éternelle l'idole*, 1889, Musée Rodin.

172
Cit.: R. B. Kitaj, Letter to Lee Friedlander, ca. 1990, in: *Kitaj papers*, Box 45, Folder 3.

174
Cit.: R. B. Kitaj, *Confessions*, around 2003, *Kitaj papers*, Box 5, Folder 1, p. 66.

192
Ill.: Albert H. Friedlander, phtography, 1935, Friedlander Family Collection

193
Ill. left: R.B. Kitaj, Sketch of *Adin Steinsaltz*, FitzwIlliam Museum, Department of Paintings, Drawings and Prints.
Ill. right: R. B. Kitaj: *Orthodox Rabbi*, 1990–94, oil on canvas, whereabouts unknown.

198
Ill.: R. B. Kitaj, *The Killer-Critic Assassinated by his Widower, Even*, oil and collage on canvas, Astrup Fearnley Collection, Oslo, Norway, (detail).

201
Ill.: R. B. Kitaj, *Sandra One*, 1995, collage, whereabouts unknown.

204
Ill.: Robert Wedemeyer, photo of the studio floor in the 'Yellow Studio' in L. A., 2007.

205
Ill.: R.B. Kitaj, *Melancholy after Dürer*, 1989, oil on canvas, British Council.

207
Ill. left: R.B. Kitaj, *Sandra in Armani Suit,* 1990–2007, oil on canvas, private collection.
Ill. right: Robert Wedemeyer, photo of the 'Yellow Studio,' exterior, 2007.

210
Cit.: *Retrospective,* exh. cat., Tate Gallery, London 1994, p. 221.

212
Cit.: R.B. Kitaj, *Confessions,* ca. 2003, in: *Kitaj papers,* UCLA, Box 5, Folder 1, p. 24.

213
Cit.: *Tate War (I accuse!),* after 1997, in: *Kitaj papers,* UCLA, Box 118, Folder 13.

214
Cit.: Julián Ríos, *Kitaj. Pictures and Conversations,* London 1994, p. 113.

215
Ill.: Paolo Uccello, *La Profanazione dell'Ostia,* 1465–1468, Urbino, Galleria Nazionale delle Marche im Palazzo Ducale, Urbino.

218
Cit.: R.B. Kitaj, *How To Reach 75 in A Jewish Art,* exh. cat. Marlborough Gallery, New York 2005, p. 23.

220
Cit.: *Los Angeles Pictures,* exh. cat., Los Angeles 2003, p. 37.

221
Cit.: *How To Reach 72 In A Jewish Art,* exh. cat., Marlborough Gallery, New York 2005, p. 52.

222
Cit. left: *How To Reach 72 In A Jewish Art,* Marlborough Gallery, New York 2005, p. 28.
Cit. right: ibid., 2005, p. 29.

223
Cit.: Diary, February 18, 2004, in: *Kitaj papers,* UCLA.

226
Cit.: Diary, January 2004, in: *Kitaj papers,* UCLA.

225
Cit.: R.B. Kitaj, comment on the painting *The Kabbalist,* in: *Kitaj papers,* UCLA.

227
Cit.: Diary, January 22, 2004, in: *Kitaj papers*, UCLA.

229
Ill.: R.B. Kitaj, photo of Albert Friedlander in Kitaj's London apartment, in: *Kitaj papers,* UCLA.

239
Cit.: Julián Ríos, *Kitaj*. Pictures and Conversations, London 1994, p. 109.

241
Cit.: *Confessions,* ca. 2003, in: *Kitaj papers,* UCLA, Box 5, Folder 1, p. 126.

246
Cit.: R.B. Kitaj, Diary, 2005, in: *Kitaj papers,* UCLA.
Ill.: Rembrandt van Rijn: Self-Portrait as Democritus, approx. 1669, oil on canvas, Wallraf-Richartz-Museum, Cologne.

Authors

Acknowledgments

Tracy Bartley

studied Painting and Art Conservation. She has worked at the Getty Conservation Institute, where she helped organize the *Mortality Immortality. The Legacy of 20th Century Art* conference and documented the production of Andy Goldsworthy's temporary installation *Earthen Spiral*. Moreover, she also documented the state of religious paintings and icons in the Casa Na Bolom in Chiapas, Mexico. On behalf of the Museum of Contemporary Art in 1997-1998 she accompanied the Charles Ray exhibition as the official exhibition curator. In 1999 she was made Kitaj's personal assistant. Today she works as the studio director of the R. B. Kitaj Estate.
•203

Inka Bertz

is Director of Collections and Curator for Art at Jüdisches Museum Berlin. She has curated exhibitions and published extensively on Jewish art and cultural history, including *Eine neue Kunst für ein altes Volk. Die Jüdische Renaissance in Berlin 1900-1924* (Berlin, 1991) and *Familienbilder. Selbstdarstellung im jüdischen Bürgertum* (Cologne, 2004).
•179

Edward Chaney

is Professor of Fine and Decorative Arts and Leverhulme Research Fellow at the Southampton Solent University. His Ph.D. thesis for the Warburg Institute was published in 1985 as *The Grand Tour and the Great Rebellion*. He is the author of numerous books and articles on topics including British twentieth-century art; he is a Fellow of the Society of Antiquaries, of the Royal Historical Society and Commendatore of the Republic of Italy.
•97

Martin Roman Deppner

has a Ph.D. in Art History and is Professor of Media Theory in the Design Department at Bielefeld University of the Applied Sciences, as well as Lecturer in Intercultural Jewish Studies at Oldenburg University. He has published articles on topics including Jewish thought in the context of media theory and Modernist art. He works curatorially for the Felix Nussbaum Haus Osnabrück.
•105

Michal Friedlander

Judaist, studied Oriental Studies (Classical and Modern Hebrew, Aramaic) at Cambridge University, England. She has worked for museums in New York, Los Angeles, and Berkeley, and has curated countless exhibitions and published on various Jewish themes. Since 2001 she has been Curator of Judaica and Applied Art at Jüdisches Museum Berlin.
•187

Eckhart Gillen

has a Ph.D. in Art History, and has curated exhibitions on twentieth-century art, including *Deutschlandbilder* (1997-1998) and, together with S. Barron, *Art of Two Germanys/ Kunst und Kalter Krieg* (2009). He has authored countless publications on art history, including the book *Feindliche Brüder? Der Kalte Krieg und die deutsche Kunst 1945-1990* (Berlin, 2009). He is working as a curator for Kulturprojekte Berlin GmbH.
•83

Cilly Kugelmann

is an Educationalist and Deputy Director of Jüdisches Museum Berlin. She is joint editor of the magazine *Babylon. Beiträge zur jüdischen Gegenwart*.
•195

Richard Morphet

was a curator at Tate Gallery from 1966–98, and from 1986 onwards Keeper of the Modern Collection. He has published extensively on twentieth-century art and also on Kitaj's 1994 retrospective in the Tate Gallery and on the 2000 exhibition *Encounters. New Art from Old* in London's National Gallery.
•197

David N. Myers

is Professor of Jewish History and Head of the History Department at the University of California, Los Angeles. He has authored countless books and articles on Modern Jewish intellectual and cultural history. He was a close friend of Kitaj when the latter lived in Los Angeles.
•113

The Jewish Museum Berlin would like to thank:

the Kitaj family

especially Lem Kitaj, for their enormous trust and for their generous support of our exhibition project

Tracy Bartley

Director of R. B. Kitaj Studios, for her support of the exhibition project from the very start

Geoffrey Parton

and his colleagues at Marlborough Fine Arts in London

Tara K. Reddi

Vice President of Marlborough Gallery New York, and her team

Genie Guerard

Head of the Manuscript department at the Charles E. Young Research Library, University of California Los Angeles (UCLA), for giving us access to the artist's estate, and for her committed and competent assistance with archival research work

Norma Williamson

who is in charge of the estate, and who helped the curator examine and classify the extensive material with instinctive certainty and precision

For their information and assistance we would also like to thank:

Stephanie Barron, Jan Brockmann, Marion Deshmuk, Carol Eliel, Dag Erik Elgin, Leslie Freudenheim, Tom Freudenheim, David Glasser, Doreet Harten, Shelley Harten, Henry Meyrinc Hughes, Garrit Jackson, Gertrud Koch, Andrea Kroksnes, Marco Livingstone, Simon Martin, Marilyn McCully, David N. Myers, Michael Raeburn, Juliet Thorp, Leon Wieseltier, Jens Ziehe.

Bibliography

By R. B. Kitaj

Atik, Anne, and R. B. Kitaj, *Drancy*, London, 1989.

Kitaj, *The Human Clay. An Exhibition Selected by R. B. Kitaj*, exh. cat., London, 1976.

Kitaj, introduction to *The Artist's Eye. An Exhibition selected by R. B. Kitaj at The National Gallery London*, May 12 – July 21, 1980.

Kitaj, "Jewish Art—Indictment & Defence: A Personal Testimony by R. B. Kitaj," in: *Jewish Chronicle Colour Magazine Supplement*, November 30, 1984.

Kitaj, "Kitaj, Brief aus London," 1988, in: *Die Spur der Anderen. Fünf jüdische Künstler aus London mit fünf deutschen Künstlern aus Hamburg im Dialog*, ed. Martin Roman Deppner, Hamburg: Heine-Haus, 1988.

Kitaj, *Erstes Manifest des Diasporismus*, Zurich, 1988.
In English: *First Diasporist Manifesto*, London & New York, 1989.

Kitaj, *Second Diasporist Manifesto (A New Kind of Long Poem in 615 Free Verses)*, New Haven & London, 2007.

Additional Information

The most extensive bibliography on Kitaj is to be found in *R. B. Kitaj. A Retrospective*, London: Tate Gallery, June 16 – Sept. 14, 1994), edited by Richard Morphet; the most up-to-date bibliography is in Marco Livingstone's *Kitaj* (London, 2010).

Monographs

Aulich, James and John Lynch (eds.), *Critical Kitaj. Essays on the work of R. B. Kitaj,* Manchester, 2000: with essays by Janet Wolff, David Peters Corbett, John Lynch, Giles Peaker, Pat Gilmour, Simon Faulkner, Terry Atkinson, James Aulich, Alan Woods, and Martin Roman Deppner.

Deppner, Martin Roman, *Zeichen und Bildwanderung. Zum Ausdruck des "Nicht-Sesshaften" im Werk R. B. Kitajs*, Münster, 1992; also Ph.D. thesis, University of Hamburg, 1988.

Friedlander, Lee, *Kitaj*, San Francisco, 2002.

Kinsman, Jane, *The Prints of R. B. Kitaj*, Aldershot, 1994.

Lambirth, Andrew, *Kitaj*, London, 2004.

Livingstone, Marco, *R. B. Kitaj*, 1st ed. Oxford and New York, 1985; 2nd revised ed. with new title, *Kitaj*, London and New York, 1992; 3rd revised ed. London, 1999; 4th revised ed. London, 2010.

McCorquodale, Duncan (ed.), *Kitaj. The Architexts—Colin St John Wilson and MJ Long*, London, 2008.

Ríos, Julián, *Impresiones de Kitaj (La novela pintada)*, Madrid, 1989; in English: *Kitaj. Pictures and Conversations*, London, 1994.

Catalogs of retrospectives

R. B. Kitaj, Hanover: Kestner-Gesellschaft, January 23 – February 22, 1970. Introduction by Wieland Schmied; two texts by Kitaj.

R. B. Kitaj, Washington: Hirshhorn Museum and Sculpture Garden, September 17 – November 15, 1981. Preface by Abram Lerner; texts by John Ashbery, Joe Shannon, and Jane Livingston; interview with Kitaj by Timothy Hyman; republished as *Kitaj. Paintings, Drawings, Pastels*, London, 1983.

R. B. Kitaj. A Retrospective, London: Tate Gallery, June 16 – September 14, 1994. Edited by Richard Morphet; essays by Richard Morphet and Richard Wollheim.

R. B. Kitaj. An American in Europe, Oslo: Astrup Fernley Museet for Moderne Kunst, January 10 – March 22, 1998. Edited by Marco Livingstone; essays by Marco Livingstone, Francisco Javier San Martín, and Ulrich Krempel. Spanish/English edition for Museo Nacional Centro de Arte Reina Sofía, Madrid; German/English edition for Jüdisches Museum Vienna and Sprengel Museum Hanover.

Catalogs

R. B. Kitaj. Pictures with Commentary: Pictures without Commentary, London: Marlborough Fine Art, February 1963.

R. B. Kitaj, New York: Marlborough-Gerson Gallery, February 1965.

R. B. Kitaj. Paintings and Prints, Los Angeles: Los Angeles County Museum of Art, August 11 – September 11, 1965; introduction by Maurice Tuchmann.

R. B. Kitaj, Berkeley: Worth Ryder Art Gallery, University of California at Berkeley, October 7 – November 12, 1967; text by R. B. Kitaj.

R. B. Kitaj. Complete Graphics 1963–69, Berlin: Galerie Mikro, May 10 – June 15, 1969; introduction by Werner Haftmann; essay by R. B. Kitaj.

R. B. Kitaj. Pictures from an Exhibition Held at the Kestner-Gesellschaft, Hanover, and the Boymans Museum, Rotterdam 1970, London: Marlborough Fine Art, April/May 1970.

R. B. Kitaj. Pictures, New York: Marlborough Gallery, February 2–23,1974; essay by Frederic Tuten.

R. B. Kitaj. Pictures, Edinburgh: New 57 Gallery, August 18 – September 12, 1975.

The Human Clay. An Exhibition Selected by R. B. Kitaj, London: Hayward Gallery, August 5–30, 1976.

R. B. Kitaj. Pictures/Bilder, London: Marlborough Fine Art, April – June, 1977; Zurich: Marlborough Galerie, June – July, 1977; introduction by Robert Creeley, German/English edition.

R. B. Kitaj. Fifty Drawings and Pastels, Six Oil Paintings, New York: Marlborough Gallery, March 31 – April 28, 1979; introduction by Thomas Hyman.

The Artist's Eye. An Exhibition Selected by R. B. Kitaj at the National Gallery London, London: National Gallery, May 21 – July 21, 1980; introduction by R. B. Kitaj.

R. B. Kitaj. Pastels and Drawings, London: Marlborough Fine Art, October 8 – November 7, 1980; introduction by Stephen Spender.

R. B. Kitaj, London: Marlborough Fine Art, November/December 1985; introduction by Kitaj.

R. B. Kitaj. A Print Retrospective, London: Victoria and Albert Museum, June 8 – October 9, 1994; introduction by Rosemary Miles.

R. B. Kitaj. Graphics 1974–1994, London: Marlborough Fine Art, June 8 – August 20, 1994.

R. B. Kitaj. Recent Pictures, London: Marlborough Fine Art, June 8 – August 20, 1994.

R. B. Kitaj. Recent Pictures, New York: Marlborough Gallery, February 8 – March 4, 1995.

Sandra Two, Paris: FIAC, October 2–7, 1996.

R. B. Kitaj. How to Reach 67 in Jewish Art—100 Pictures, Madrid: Marlborough, September 12 – October 14, 2000; New York: Marlborough, October 31 – December 2, 2000; essay by Leon Wieseltier.

Kitaj in the Aura of Cézanne and Other Masters, London: National Gallery, November 7, 2001, to February 10, 2002.

Los Angeles Pictures. R. B. Kitaj, Venice: L. A. Louver, May 21 – July 5, 2003; preface by Peter Goulds; texts by Kitaj.

Kitaj. Retrato de un hispanista. Portrait of a Hispanist, Bilbao: Museo de Bellas Artes de Bilbao, May 31 – August 1, 2004; preface by Javier Viar; essays by Marco Livingstone and Javier San Martín.

R. B. Kitaj. How to Reach 72 in Jewish Art, New York: Marlborough, March 1 – April 2, 2005; essays by Adam Phillips, "Second Diasporist Manifesto"; other texts by Kitaj.

Kitaj. Little Pictures, London: Marlborough Fine Art, November 22, 2006–January 6, 2007.

R. B. Kitaj. Passion and Memory. Jewish Works from His Personal Collection, Los Angeles: Skirball Cultural Center, January 11 – March 30, 2008.

The Collection of R. B. Kitaj, London: Christie's auction catalogue, February 7, 2008; preface by Amy Cappellazzo; essays by Jonathan Safran Foer and William Paton; words of thanks by David Hockney and Frank Auerbach.

R. B. Kitaj. Little Pictures, New York: Marlborough, April 10 – May 3, 2008; appreciations by Marco Livingstone, Leon Kossoff, Norman Rosenthal, Maria Friedlander, Nicholas Serota, Jed Perl, Leon Wieseltier, David N. Myers, Richard Morphet, and David Hockney.

R.B. Kitaj. Portraits and Reflections, Kendal: Abbot Hall Art Gallery, July 9 – October 8, 2011; texts by Marilyn McCully and Michael Raeburn.

Miscellaneous

Brun, Hans Jakob, et al. (eds.), *Dobbel Virkelighet/Double Reality*, exh. cat., Oslo: Astrup Fearnley Museet for Moderne Kunst, April 16 – October 9, 1994; essay on R. B. Kitaj by Wenche Volle.

Calvocoressi, Richard, et al. (eds.), *From London. Bacon Freud Kossoff Andrews Auerbach Kitaj*, exh. cat., Edinburgh: The British Council and the Scottish National Gallery of Modern Art, July 1 – September 5, 1995; essays by David Cohen and Bruce Bernard.

Chaney, Edward, "Kitaj versus Creed", in: *The London Magazine*, April / May 2002, pp. 106-11.

Cieskowski, Krzysztof Z., "Problems in Kitaj, Mostly Iconographic," in: *Art Libraries Journal*, vol.14, no. 2, 1989.

Deppner, Martin Roman, "Bilder als Kommentare. R. B. Kitaj und Aby Warburg," in: Horst Bredekamp et al. (eds.), *Aby Warburg. Akten des internationalen Symposions Hamburg 1990, Schriften des Warburg-Archivs im Kunstgeschichtlichen Seminar der Universität Hamburg*, vol. 1, Weinheim, 1991.

Deppner, Martin Roman, "Kitaj, Kiefer," in: *Dialog mit dem Anderen. Kunstforum*, vol. 111, January/February, 1991, pp. 148–165.

Deppner, Martin Roman, "Änigma und Rebus. Die ,Flucht der Bilder' in Kitajs Mahler-Zyklus," in: *R. B. Kitaj—Mahler Becomes Politics, Beisbol*, Hamburg, 1991, pp. 7–35.

Figenschou, Anne Vira, *Dialogue of Revenge*, Ph. D. thesis, Oslo, 2002–3, Ph.D., can be downloaded online at www.forart.no

Francis, Richard, "The Red Banquet by R. B. Kitaj," in: *Annual Reports and Bulletin of the Walker Art Gallery*, Liverpool, 1971–4, pp. 84–7.

Hicks, Alistair, *The School of London. The Resurgence of Contemporary Painting*, Oxford, 1989.

Huxley, Paul (ed.), *Exhibition Road. Painters at the Royal College of Art*, with an essay by Marco Livingstone, "Prototypes of Pop," Oxford and London, 1988.

Hyman, Timothy, *Kitaj. A Prodigal Returning*, in: *Artscribe*, 25, October, 1980.

Livingstone, Marco, *Pop Art. A Continuing History*, London, 1990.

Long, M. J., *Artists' Studios*, London, 2009.

M. J. Long and Colin St. John Wilson, *The Architects*, London 2008.

Nochlin, Linda, "Art and the Condition of Exile: Men/Women, Emigration/Expatriation," in: Susan Rubin Suleiman, *Exile and Creativity. Signposts, Travelers, Outsiders, Backward Glances*, Durham and London, 1998, pp. 37–58.

Rosen, Aaron, "R. B. Kitaj. The Diasporist Unpacks," in: *Imagining Jewish Art. Encounters with the Masters in Chagall, Guston, and Kitaj*, London, 2009, pp. 77–100.

Schear, Catherine, *The Significance of the Principles of Photomontage in the Early Work of R. B. Kitaj*, M.A. thesis, University of California, Berkeley, January 25, 1984.

Steyn, Juliet, *The Jew. Assumptions of Identity*, London and New York: Cassell, 1999, Chapter 9: "The Defiant Other. Accusation and Justification in the Work of R. B. Kitaj," pp. 153–172.

St John Wilson, Colin, and M. J. Long, *Kitaj: The Architects*, ed. Duncan McCorquodale, London, 2008.

Tuten, Frederic, "Neither Fool, Nor Naive, Nor Poseur—Saint: Fragments on R. B. Kitaj," in: *Artforum*, January 1982.

Zänker, Jürgen, "Kitajs Benjamin-Bild," in: *Kritische Berichte*, vol. 11, no. 1, 1983.

Imprint exhibition

Obsessions
R. B. Kitaj
1932–2007

An exhibition by the Jewish Museum Berlin in collaboration with Kulturprojekte Berlin GmbH, 21 September 2012 – 27 January 2013. The exhibition will be presented in two parts at Jewish Museum London and Pallant House Chichester from 24 February to 16 June 2013 and at Hamburger Kunsthalle from 18 July to 10 November 2013.

Stiftung Jüdisches Museum Berlin

Museum Director:
 Prof. Dr. W. Michael Blumenthal
Managing Director:
 Börries von Notz
Program Director:
 Cilly Kugelmann
Head of temporary exhibitions:
 Helmuth F. Braun
Idea and concept:
 Cilly Kugelmann,
 Eckhart Gillen
Project management:
 Margret Kampmeyer
Curator:
 Eckhart Gillen,
 Kulturprojekte Berlin
Scientific trainee:
 Katja Hauser
Assistance of temporary exhibitions:
 Klaus Hans Teuschler
Trainee:
 Julia Bosson
Translations:
 Allison Brown,
 Johann Christoph Maass
PR Consultant:
 Ingeborg Wiensowski
Collection management:
 Petra Hertwig,
 Gisela Märtz,
 Katrin Strube,
 Laetitia Ramelet,
 Susanne Lehmann
Conservators:
 Barbara Decker,
 Ingeborg Fries,
 Sarah Daum

Exhibition organization:
 Peter Dallmann,
 ICT Gunther Giese
Transport:
 museumlogistics.com |
 a division of Brandl Transport GmbH, Köln/Cologne

Exhibition scenography

Holzer Kobler Architekturen Berlin, Barbara Holzer, Tristan Kobler, Kira Schnieders, Simone Haar, Roland Lehnen, Cornelia Schwarte
Production management:
 Holzer Kobler Architekturen Berlin, Phil Peterson,
 Kira Schnieders
Exhibition graphics:
 Holzer Kobler Architekturen Berlin, Rüdiger Schlömer

Documentary Tables

Concept:
 Margret Kampmeyer,
 Katja Hauser
Design:
 Holzer Kobler Architekturen Berlin, Kira Schnieders,
 Rüdiger Schlömer

Audio guide

Project management:
 Julia Cartarius
Translations:
 Michael Ebmeyer,
 Johann Christoph Maass
Editors:
 Margret Kampmeyer,
 Julia Bosson,
 Klaus Hans Teuschler
Production:
 World voice,
 Andreas Fuhrmann
Equipment:
 Pickup, Fa. Dataton,
 Linköping Schweden

Exhibition Guide

Project management:
 Katja Hauser
Text:
 Margret Kampmeyer,
 Katja Hauser
Translations:
 Kate Sturge
Design:
 e o t . essays on typography Lilla Hinrichs + Anna Sartorius, Simone Müller
Print:
 Druckerei Conrad GmbH, Berlin

Installation

Bel-Tec GmbH, Berlin
Exhibition lighting:
 Victor Kégli, Berlin
Production exhibition graphics:
 PPS Berlin
Set up:
 Thomas Fißler Exponateinrichtungen, Berlin und Leipzig
Painting:
 Stordeur & Rankewitz, Berlin
Electrical installation:
 Resto GmbH Berlin

Design of advertising campaign

e o t . essays on typography Lilla Hinrichs + Anna Sartorius

Website

Michael Butschkau,
Dagmar Ganßloser,
Etta Grotrian
Graphics:
 chezweitz und partner

The exhibition team would like to thank the staff at the Jewish Museum Berlin:

Yvonne Niehues, Gesa Struve, Julia Jürgens (supporting program); Christiane Birkert (visitor research); Nina Wilkens (accompanying educational program); Gerhard Stahr, Alexander Buchholz (copyright); Sascha Brejora, Roman Labunski, Hartmut Götze (contracting authority); Bärbel Hagel, Odette Bütow (accounting); Iris Blochel-Dittrich (database management); Jürgen Thuns, Anja Jauert, Kathleen Köhler, Malte Starostik (IT); Theresia Ziehe, Valeska Wolfgram, Sarah Link (photograph management); Sascha Perkins, Gesine Tyradellis, Katrin Möller (marketing); Katharina Schmidt-Narischkin, Franziska Windisch (press and public relations); Naomi Lubrich, Doreen Tesche (online editorial).

Our special thanks go to: Inka Bertz and Michal Friedlander, who provided great support during the conceptualization phase and who each contributed a text to the catalog. We would also like to thank Denis Grünemeier, who took care of the legal matters for the documentary.

Media partners:

Transportation partner:

Imprint publication

Image credits

This publication is published to accompany the exhibition:
Obsessions, R. B. Kitaj (1932–2007)
A retrospective by the Jewish Museum Berlin in collaboration with Kulturprojekte Berlin GmbH.

Editors:
 Cilly Kugelmann,
 Eckhart Gillen,
 Hubertus Gaßner
Editorial staff:
 Eckhart Gillen,
 Cilly Kugelmann
Copyediting and Coordination:
 Sonja Altmeppen,
 Christine Marth,
 Marie Naumann
Image editing:
 Christine Marth,
 Ulla Menke,
 Klaus Hans Teuschler
Rights:
 Alexander Buchholz,
 Hartmut Götze,
 Gerhard Stahr
Translations:
 Jeremy Gains,
 Petra Gains
Copyediting and Proofreading:
 Sarah Quigley

Concept and Graphic design:
 e o t . essays on typography
 Lilla Hinrichs + Anna Sartorius

Project management Kerber Verlag:
 Martina Kupiak

Realisation/Typesetting Kerber Verlag:
 Petra Merschbrock

Printed and published by:
 Kerber Verlag, Bielefeld
 Windelsbleicher Str. 166–170
 33659 Bielefeld, Germany
 Tel.: + 49 (0) 521/9 50 08–10
 Fax.: + 49 (0) 521/9 50 08–88
 info@kerberverlag.com
 www.kerberverlag.com

The Deutsche Nationalbibliothek lists this publication on the Deutsche Nationalbibliografie; detailed bibliographic data is available on the Internet at http://dnb.d-nb.de.

KERBER publications are available in selected bookstores and museum shops worldwide (distributed in Europe, Asia, South and North America).

ISBN 978-3-86678-731-5

www.kerberverlag.com

Printed in Germany